Praise for Gino van den Bergen's *Collision Detection in Interactive 3D Environments*:

"Having read this book from cover to cover, I can summarize my opinion in two words from a mathematician's lexicon: elegant and beautiful. There is very little to criticize in this exquisite work."
—Ian Ashdown, byHeart Consultants, Inc.

"Building a real-time collision detection system is by no means a trivial task. A firm understanding is required of the geometry and mathematics for intersection testing, especially when the objects are in motion. The skilled use of convexity is essential for distance calculations. The system must be designed carefully to support high-performance physical simulations. In particular, spatial partitioning and tight-fitting bounding volumes must play a role in minimizing the computational requirements of the system. The system is sufficiently large that the principles of software engineering apply to its development. Moreover, collision detection is notoriously difficult to implement robustly when using floating-point arithmetic. The challenges of architecting and implementing a collision detection system are formidable!

Collision Detection in Interactive 3D Environments is an elegantly written treatise on this topic. Gino guides you through the basic concepts, provides insightful discussions on how to cope with the problems inherent in floating-point arithmetic, covers the all-important topic of computing distance between convex objects, and presents an informative summary of the spatial data structures that are commonly encountered in practice. And as an artisan of the field, Gino finishes the story with a case study—the design and implementation of his own working collision detection system, SOLID.

This is the first book to provide all the details necessary to build a collision detection system that *really* works. I hope you will find, as I did, that the amount of material in this book is incredible, making it an extremely valuable resource."
—Dave Eberly, president, Magic Software, Inc., and author of *3D Game Engine Design*, co-author with Philip Schneider of *Geometric Tools for Computer Graphics*, and author of *Game Physics*.

Collision Detection in Interactive 3D Environments

The Morgan Kaufmann Series in Interactive 3D Technology
Series Editor: David H. Eberly, Magic Software

The game industry is a powerful and driving force in the evolution of computer technology. As the capabilities of personal computers, peripheral hardware, and game consoles have grown, so has the demand for quality information about the algorithms, tools, and descriptions needed to take advantage of this new technology. We plan to satisfy this demand and establish a new level of professional reference for the game developer with **the Morgan Kaufmann Series in Interactive 3D Technology**. Books in the series are written for developers by leading industry professionals and academic researchers, and cover the state of the art in real-time 3D. The series emphasizes practical, working solutions and solid software-engineering principles. The goal is for the developer to be able to implement real systems from the fundamental ideas, whether it be for games or for other applications.

3D Game Engine Design: A Practical Approach to Real-Time Computer Graphics
David H. Eberly

Collision Detection in Interactive 3D Environments
Gino van den Bergen

Forthcoming Titles

Essential Mathematics for Games and Interactive Applications: A Programmers Guide
Jim Van Verth and Lars Bishop

Real-Time Collision Detection
Christer Ericson

AI for Synthetic Characters: Behavior, Learning, and Motor Control
Bruce Blumberg

Collision Detection in Interactive 3D Environments

Gino van den Bergen

AMSTERDAM • BOSTON • HEIDELBERG • LONDON
NEW YORK • OXFORD • PARIS • SAN DIEGO
SAN FRANCISCO • SINGAPORE • SYDNEY • TOKYO

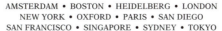

ELSEVIER

Morgan Kaufmann Publishers is an imprint of Elsevier

MORGAN KAUFMANN PUBLISHERS

Morgan Kaufmann Publishers

Senior Editor	Tim Cox
Publishing Services Manager	Simon Crump
Editorial Coordinators	Stacie Pierce, Richard Camp
Project Manager	Sarah Manchester
Cover Design	Chen Design
Copyeditor	Ken DellaPenta
Full Service Provider	Keyword Publishing Services Ltd
Interior Printer	The Maple-Vail Book Manufacturing Group
Cover Printer	Phoenix Color

Designations used by companies to distinguish their products are often claimed as trademarks or registered trademarks. In all instances in which Morgan Kaufmann Publishers is aware of a claim, the product names appear in initial capital or all capital letters. Readers, however, should contact the appropriate companies for more complete information regarding trademarks and registration.

Morgan Kaufmann Publishers
An Imprint of Elsevier
500 Sansome Street, Suite 400
San Francisco, CA 94111
www.mkp.com

Printed in the United States of America

07 06 05 04 03 5 4 3 2 1

Library of Congress Control Number: 2003059350

ISBN: 1-55860-801-X

This book is printed on acid-free paper.

To Jeanne

Contents

Figures, Algorithms, Theorems, and Lemmas xiii

Preface xix

Chapter

1 Introduction 1

1.1 Problem Domain 2

1.2 Historical Background 5

1.3 Organization 7

Chapter

2 Concepts 11

2.1 Geometry 11

 2.1.1 Notational Conventions 11

 2.1.2 Vector Spaces 12

 2.1.3 Affine Spaces 14

 2.1.4 Euclidean Spaces 17

 2.1.5 Affine Transformations 19

 2.1.6 Three-Dimensional Space 21

2.2 Objects 22

 2.2.1 Polytopes 23

 2.2.2 Polygons 29

 2.2.3 Quadrics 32

 2.2.4 Minkowski Addition 33

 2.2.5 Complex Shapes and Scenes 38

2.3 Animation 41

2.4 Time 46

2.5 Response 49

2.6 Performance 53
 2.6.1 Frame Coherence 54
 2.6.2 Geometric Coherence 54
 2.6.3 Average Time 56
2.7 Robustness 57
 2.7.1 Floating-Point Numbers 57
 2.7.2 Stability 60
 2.7.3 Coping with Numerical Problems 62

Chapter

3

Basic Primitives 67

3.1 Spheres 67
 3.1.1 Sphere-Sphere Test 67
 3.1.2 Ray-Sphere Test 68
 3.1.3 Line Segment–Sphere Test 71
3.2 **Axis-Aligned Boxes** 72
 3.2.1 Ray-Box Test 73
 3.2.2 Sphere-Box Test 76
3.3 **Separating Axes** 77
 3.3.1 Line Segment–Box Test 80
 3.3.2 Triangle-Box Test 81
 3.3.3 Box-Box Test 82
3.4 **Polygons** 84
 3.4.1 Ray-Triangle Test 84
 3.4.2 Line Segment–Triangle Test 87
 3.4.3 Ray-Polygon Test 88
 3.4.4 Triangle-Triangle Test 90
 3.4.5 Polygon-Polygon Test 92
 3.4.6 Triangle-Sphere Test 97
 3.4.7 Polygon-Volume Tests 101

Chapter

4

Convex Objects 105

4.1 **Proximity Queries** 105
4.2 **Overview of Algorithms for Polytopes** 108
 4.2.1 Finding a Common Point 108

4.2.2 Finding a Separating Plane 110
4.2.3 Distance and Penetration Depth Computation 115

4.3 **The Gilbert-Johnson-Keerthi Algorithm** 121
4.3.1 Overview 121
4.3.2 Convergence and Termination 123
4.3.3 Johnson's Distance Algorithm 126
4.3.4 Support Mappings 130
4.3.5 Implementing the GJK Algorithm 139
4.3.6 Numerical Aspects of the GJK Algorithm 141
4.3.7 Testing for Intersections 145
4.3.8 Penetration Depth 147

Chapter

5 Spatial Data Structures 171

5.1 **Nonconvex Polyhedra** 172
5.1.1 Convex Decomposition 172
5.1.2 Polyhedral Surfaces 173
5.1.3 Point in Nonconvex Polyhedron 174
5.2 **Space Partitioning** 175
5.2.1 Voxel Grids 175
5.2.2 Octrees and k-d Trees 177
5.2.3 Binary Space Partitioning Trees 180
5.2.4 Discussion 190
5.3 **Model Partitioning** 192
5.3.1 Bounding Volumes 193
5.3.2 Bounding-Volume Hierarchies 199
5.3.3 AABB Trees versus OBB Trees 201
5.3.4 AABB Trees and Deformable Models 206
5.4 **Broad Phase** 209
5.4.1 Sweep and Prune 210
5.4.2 Implementing the Sweep-and-Prune Algorithm 212
5.4.3 Ray Casting and AABBs 215

Chapter

6 Design of SOLID 219

6.1 Requirements 219

6.2 Overview of SOLID 222

6.3 Design Decisions 228

 6.3.1 Shape Representation 228

 6.3.2 Motion Specification 233

 6.3.3 Response Handling 235

 6.3.4 Algorithms 237

6.4 Evaluation 242

6.5 Implementation Notes 244

 6.5.1 Generic Data Types and Algorithms 244

 6.5.2 Fundamental 3D Classes 247

Chapter

7 Conclusion 251

7.1 State of the Art 251

7.2 Future Work 253

Bibliography 257

Index 267

About the CD-ROM 277

Trademarks 278

Figures, Algorithms, Theorems, and Lemmas

Figures

1.1	Elite, the first 3D game on a home computer.	6
2.1	An affine transformation in \mathbb{R}^2.	16
2.2	The group of affine transformations.	20
2.3	An object is convex if it contains all the line segments connecting any pair of its points.	23
2.4	A taxonomy of primitive types.	24
2.5	The linkage of edge nodes in a winged-edge structure.	26
2.6	The Dobkin-Kirkpatrick hierarchical representation of a polytope.	28
2.7	Fixing a hole in a polygon.	30
2.8	The three quadric primitives: (a) sphere, (b) cone, and (c) cylinder.	33
2.9	The Minkowski sum of a box and a sphere.	33
2.10	A pair of convex objects and the corresponding CSO.	38
2.11	The conventional use of yaw, pitch, and roll.	43
2.12	Problems when detecting collisions at discrete time steps: (a) too late; (b) missed.	47
2.13	Solutions for simplified four-dimensional intersection tests on rotating objects.	49
2.14	The contact region described by a contact point **p** and a contact normal **n**.	50
2.15	Computing a contact point and contact normal of fixed-orientation objects by performing a ray test on the CSO of the objects.	50
2.16	For a pair of closest points **p** and **q** at $t = 0$, the difference **p** − **q** is a good approximation of a contact normal.	51
2.17	Using the penetration depth vector for approximating a contact normal: (a) fairly accurate and (b) inaccurate.	53
2.18	The amount of geometric coherence in a collection of triangles: (a) little coherence and (b) much coherence.	55

3.1 The distance α of the origin to the line $\overline{\mathbf{st}}$ is found using the Pythagorean theorem, $\alpha^2 + \beta^2 = \gamma^2$. 70

3.2 A ray cast for axis-aligned boxes using techniques from Cohen-Sutherland and Liang-Barsky line clipping. 74

3.3 Computing the penetration depth of a sphere A and a box B for the case where the sphere's center \mathbf{c} is contained by the box. 77

3.4 The vector \mathbf{x} is a separating axis of A and B, whereas \mathbf{y} is not a separating axis. 77

3.5 The projection of a box with center \mathbf{c} and extent \mathbf{h} onto an axis \mathbf{v} is the interval $[\mathbf{v} \cdot \mathbf{c} - \rho, \mathbf{v} \cdot \mathbf{c} + \rho]$, where $\rho = |\mathbf{v}| \cdot \mathbf{h}$. 79

3.6 A separating-axis test for two relatively oriented boxes A and B on an axis \mathbf{v}. 82

3.7 The line segment $\overline{\mathbf{st}}$ intersects the triangle if the bases $\{\mathbf{v}_i, \mathbf{v}_{i\oplus 1}, \mathbf{r}\}$ are either all right-handed or are all left-handed, and the endpoints \mathbf{s} and \mathbf{t} of the line segment are located on different sides of the triangle's supporting plane. 87

3.8 Computing the point of intersection of a ray and a polygon's supporting plane. 89

3.9 The edge $\overline{\mathbf{p}_0\mathbf{p}_1}$ is almost parallel to triangle B's plane, and thus is regarded as nonintersecting by the finite-precision ray-triangle test. 91

3.10 A pair of nonconvex polygons intersect iff the intersections of each polygon with the other polygon's supporting plane overlap. 93

3.11 When computing the intersection of a nonconvex polygon and a plane, the intersection points of the edges are found in the order in which they appear along the boundary of the polygon. 93

3.12 The intersection of two line segment sequences. 96

3.13 Computing a point \mathbf{x} common to a sphere and a plane $H(\mathbf{n}, \delta)$. The point $\mathbf{x} = \mathbf{c} + \lambda\mathbf{n}$, where $\lambda = -(\mathbf{n} \cdot \mathbf{c} + \delta)/\|\mathbf{n}\|^2$. 103

4.1 The line segment $\overline{\mathbf{vw}}$ contains a vector \mathbf{u} for which $\|\mathbf{u}\| < \|\mathbf{v}\|$ only if $\|\mathbf{v}\|^2 - \mathbf{v} \cdot \mathbf{w} > 0$. 107

4.2 For a weakly separating axis \mathbf{v}, we have $\mathbf{v} \cdot s_A(-\mathbf{v}) \geq \mathbf{v} \cdot s_B(\mathbf{v})$. 111

4.3 Four iterations of the CW algorithm. 112

4.4 Voronoi regions of the features of a box. 117

4.5 A local minimum condition. 119

4.6 Four iterations of the GJK algorithm. 123

4.7 Vertex \mathbf{p} has a very high degree and slows down hill climbing on this polytope. 133

4.8	Computing a support point for a cone.	136
4.9	A support mapping for the convex hull of spheres A and B.	139
4.10	Two types of oscillations in GJK when the termination conditions are not met due to an ill-conditioned error bound.	145
4.11	Incremental separating-axis computation using ISA-GJK.	147
4.12	For a convex polytope that contains the origin, a point \mathbf{v} on the affine hull of an edge closest to the origin is an internal point of the edge.	148
4.13	A sequence of iterations of the expanding-polytope algorithm.	149
4.14	A naive split of the triangle $\{\mathbf{y}_0, \mathbf{y}_1, \mathbf{y}_2\}$ by adding the support point $\mathbf{w} = s_{A-B}(\mathbf{v})$ as a vertex.	153
4.15	Splitting triangle $\{\mathbf{y}_0, \mathbf{y}_1, \mathbf{y}_2\}$ by adding support point \mathbf{w} causes the polytope to become concave.	154
4.16	The silhouette of the polytope as seen from support point \mathbf{w} is marked by thick lines.	154
4.17	Adjoining triangles are stored in the order given by the vertices.	156
4.18	Constructing an initial polytope for the EPA, in the case where GJK returns a line segment $\overline{\mathbf{y}_0 \mathbf{y}_1}$ containing the origin.	159
4.19	In the case where GJK returns a triangle $\mathbf{y}_0, \mathbf{y}_1, \mathbf{y}_2$ containing the origin, we also construct a hexahedron as the initial polytope for the EPA, but this time we need to add only two vertices, \mathbf{y}_3 and \mathbf{y}_4.	161
4.20	A hybrid technique for a faster penetration depth computation when interpenetrations are small.	167
4.21	If the lower bound $\delta = \mathbf{v} \cdot \mathbf{w}/\|\mathbf{v}\|$ for the distance between the original objects is greater than $\mu_A + \mu_B$, the sum of the margins, then the enlarged CSO does not contain the origin, and thus the enlarged objects do not intersect.	168
5.1	Convex decomposition methods.	173
5.2	Two hierarchical structures for partitioning space into rectangular cells: (a) octree and (b) k-d tree.	178
5.3	A query object can overlap fewer fat cells than thin cells: (a) octree vs. (b) k-d tree.	179
5.4	A taxonomy of recursive hierarchical space partitioning structures.	181
5.5	A polygon and its BSP tree representation.	181

5.6 Choosing a partitioning plane. 183

5.7 Using offset surfaces for approximating the CSO of a polyhedron and a sphere. 185

5.8 Two spatial data structures used in GIS: (a) quadtree and (b) fieldtree. 191

5.9 The primitive is classified as positive, since its midpoint on the coordinate axis is greater than δ. 202

5.10 Two models that were used in our experiments: (a) Utah Teapot and (b) Stanford Bunny. 204

5.11 Distribution of axes on which the SAT exits in the case of the boxes being disjoint. 205

5.12 The smallest AABB of a set of primitives encloses the smallest AABBs of subsets of the set. 207

5.13 (a) Refitting versus (b) rebuilding a model after a deformation. 208

5.14 Incrementally sorting a sequence of endpoints: (a) $t = 0$ and (b) $t = 1$. 211

5.15 Each endpoint maintains a counter containing its stabbing number: (a) $t = 0$ and (b) $t = 1$. 214

5.16 Indexing endpoints in box structures. 215

5.17 Ray casting AABBs using 3D-DDA on a nonuniform grid. 216

6.1 A pyramid relative to its local coordinate system. 223

6.2 A diagram of the SOLID framework. 225

6.3 Two environment simulation architectures: (a) monolithic architecture and (b) networked architecture. 230

6.4 Vertex arrays are maintained by the client. 231

6.5 The closest points of a pair of objects in a given coordinate system may not be the closest points after scaling the coordinate system nonuniformly. 234

6.6 Although it is usually larger in size, we use the world-axes-aligned bounding box of the AABB tree's root box rather than the smallest world-axes-aligned bounding box of a complex shape, since it can be computed much faster. 238

6.7 An OMT diagram of the class hierarchy of shape types used in SOLID. 241

6.8 Both Minkowski addition and convex hulls can be used for detecting in-between-frames collisions. 243

Algorithms

2.1	Computing an independent set S of vertices of polytope P.	27
3.1	A ray cast for a ray $\overline{\mathbf{st}}$ and a sphere centered at the origin having radius ρ.	70
3.2	An intersection test for a line segment $\overline{\mathbf{st}}$ and a sphere centered at the origin having radius ρ.	72
3.3	A ray cast for a ray $\overline{\mathbf{st}}$, where $\mathbf{s} = (\sigma_1, \sigma_2, \sigma_3)$ and $\mathbf{t} = (\tau_1, \tau_2, \tau_3)$, and a box centered at the origin having extent (η_1, η_2, η_3).	75
3.4	A ray cast for a ray $\overline{\mathbf{st}}$ and a triangle with vertices \mathbf{p}_0, \mathbf{p}_1, and \mathbf{p}_2.	85
3.5	The crossings test for testing the containment of a point (β_x, β_y) in a polygon with vertices $(\alpha_x^{(i)}, \alpha_y^{(i)})$, where $i = 0, \ldots, n - 1$.	90
3.6	Detecting overlap in two sorted sequences of intervals.	95
3.7	Computing the intersection of two sequences of collinear line segments.	96
4.1	The theoretical GJK distance algorithm.	125
4.2	Computing a support point $\mathbf{p} = s_P(\mathbf{v})$ using hill climbing on the polytope's vertex adjacency graph.	132
4.3	Computing a support point $\mathbf{p} = s_P(\mathbf{v})$ using hill climbing on a multilayered vertex adjacency graph.	134
4.4	The numerical GJK distance algorithm.	145
4.5	The GJK separating-axis algorithm.	146
4.6	The theoretical expanding-polytope algorithm in 2D.	151
4.7	Recursive flood-fill algorithm for retrieving the silhouette as seen from \mathbf{w}.	156
4.8	The theoretical expanding-polytope algorithm in 3D.	157
4.9	Testing a tetrahedron $\{\mathbf{p}_0, \mathbf{p}_1, \mathbf{p}_2, \mathbf{p}_3\}$ for containment of the origin.	161
4.10	The numerical expanding-polytope algorithm in 3D.	165
4.11	Penetration depth of objects that are enlarged by a margin.	169
5.1	Recursive algorithm for constructing a solid-leaf BSP tree of a set of boundary facets P.	182
5.2	Testing a point \mathbf{p} for inclusion in a polyhedron represented by a BSP tree.	184
5.3	Dynamic plane-shifting BSP traversal for testing a convex object $B + \{\mathbf{p}\}$ for intersection with an environment represented by a BSP tree.	186
5.4	Determining the first time of impact of a moving convex object $B + \{\mathbf{p}_t\}$ and a static environment represented by a BSP tree.	188

Theorems

2.1 Let A and B be convex objects. Then, $A + B$ is also convex. 34

2.2 Let A and B be polytopes. 34

3.1 For a pair of nonintersecting polytopes, there exists a separating axis that is orthogonal to a facet of either polytope, or orthogonal to an edge from each polytope. 78

4.1 Let A and B be convex objects and $\mathbf{a} \in A$ and $\mathbf{b} \in B$, a pair of closest points. 107

4.2 Suppose that unit vector \mathbf{u} is a weakly separating axis of A and B, and that \mathbf{v}_k is not a weakly separating axis. 113

4.3 Let X and Y be features of disjoint convex polyhedra A and B, and let $\mathbf{x} \in X$ and $\mathbf{y} \in Y$ be the closest points of X and Y. 118

4.4 $\|\mathbf{v}_{k+1}\| \leq \|\mathbf{v}_k\|$, with equality only if $\mathbf{v}_k = v(A - B)$. 124

4.5 $\|\mathbf{v}_k - v(A - B)\|^2 \leq \|\mathbf{v}_k\|^2 - \mathbf{v}_k \cdot \mathbf{w}_k$. 125

4.6 Let s_A be a support mapping of object A, and $\mathbf{T}(\mathbf{x}) = \mathbf{Bx} + \mathbf{c}$ an affine transformation. 137

4.7 For each kth iteration, if $\mathbf{v}_k \neq v(A - B)$, then $\mathbf{w}_k \in W_{k+1}$. 141

4.8 Let P be a d-dimensional polytope that contains the origin, and, for each $(d - 1)$-dimensional boundary feature X of P, let $\mathbf{v}_X = v(\text{aff}(X))$, the point closest to the origin on the affine hull of X. 149

Lemmas

4.1 Let \mathbf{v} and \mathbf{w} be vectors. 107

4.2 $\|\mathbf{v}\|^2 - \mathbf{v}_k \cdot \mathbf{w}_k \geq 0$, with equality only if $\mathbf{v}_k = v(A - B)$. 124

Preface

Beauty is our Business.

—Edsger W. Dijkstra

Over the past decade, I have devoted varying portions of my time to the study of geometric algorithms, specifically, algorithms for detecting collisions between 3D objects. The reason for doing so was, and remains, partly academic interest and partly professional necessity. It is easy to become intrigued by the quest for the "ultimate" algorithm for solving a geometric problem, especially if the reward is a real-life application, such as a 3D game, that is able to meet the given timing and memory constraints.

This book is the accumulation of my findings in the field of collision detection of 3D objects. Most of the algorithms found in this book were discovered and written down by other people. I felt it was time to collect and categorize these algorithms into a single publication. This is by no means a complete compilation of all the solutions that have been proposed in this field. It probably would take over a thousand pages more to cover everything. What is collected here is what I found to be useful in practical applications, and, of course, I am totally biased towards my own work ;-).

The solutions offered in this book are presented as abstract algorithms rather than compilable source code in some programming language. I feel that in order to explain a geometric algorithm in a concise and clear way, it is often helpful to keep the focus on mathematics rather than to elaborate on programming issues. Surely, I do not dismiss the task of implementing these algorithms on a computer as trivial. I simply question the usefulness of current programming languages for describing geometry. Algorithms should in the first place be human-readable, and what better language for describing geometric entities than common mathematical notation?

Challenging as it may be, contriving beautiful algorithms is not a goal unto itself. In the end what counts is how well an algorithm performs on the target computer. I discovered that the main effort in implementing a geometric algorithm is not to make it run fast but to make it run reliable. Finite-precision arithmetic contaminates the otherwise immaculate mathematical predicates of our proofs. In order to warrant reliability, we have to allow for rounding errors in the computed values.

xix

Fixing algorithms for finite-precision arithmetic can be messy, but with the proper understanding of the source of the errors it does not have to be black magic.

Although this book as well as the SOLID library have up until now been solo projects for me, they would not have seen the light of day without the help of others. Firstly, I would like to thank Dave Eberly for allowing me to make an addition to his series. Many thanks to Tim Cox, Stacie Pierce, and Richard Camp, at Morgan Kaufmann Publishers, Sarah Manchester at Elsevier, and Sue Nicholls at Keyword Publishing Services for support, as well as all the anonymous people who helped out with this book. I thank the reviewers for the book: Ian Ashdown from byHeart Consultants Ltd., Neil Kirby from Lucent Technologies, Stephen Cameron from Oxford University, and the three reviewers who chose to remain anonymous. Furthermore, I would like to thank Ton Roosendaal at Not a Number, Bas Vermeer and Ton Veth at Cebra, and Rogier Smit at Playlogic for enabling me to work on SOLID in my professional time. And last but not least, I thank the people in the field that feed me with ideas and provide me with the necessary feedback: Erwin "Coockie" Coumans, Jan Paul "Mr. Elusive" van Waveren, Stan Melax, Pierre Terdiman, Gabriel Zachmann, Brian Mirtich, Chris Hecker, Jeff Lander, and all the people who frequently share their ideas on the *comp.graphics.algorithms* newsgroup.

Gino van den Bergen
June 24, 2003

<div align="right">

Chapter | **1**

Introduction

</div>

<div align="right">

One never notices what has been done.
One can only see what remains to be done.
—**Marie Curie**

</div>

Current state of the art in computer graphics enables us to interactively explore three-dimensional data, such as architecture and scientific visualizations. In many applications, these data represent environments with behavior, for instance, in games and simulators. Often, the goal of such applications is to simulate some aspects of the real world as accurately as possible. A term often used for this type of application is *virtual reality*, although this term typically refers to immersively experienced environments that utilize devices such as head-mounted displays and data gloves.

One aspect of the real world that greatly affects the manner in which we experience an environment is the constraint that two material objects cannot occupy the same point in space at the same time. Occasionally, we regard this constraint as undesired, since it restricts our motions. However, impenetrability enables manipulations, such as pushing and stacking objects. Also the fact that we can stand and walk depends on the ground being impenetrable.

In general, object representations in simulated environments do not impose impenetrability. If we want a simulated environment to behave according to the real world with respect to the impenetrability of material objects, we need to incorporate a mechanism that enforces this constraint. An important task of such a mechanism is detecting configurations of interpenetrating objects, which are called *collisions*.

This book focuses on the problem of detecting collisions in computer-simulated interactive 3D environments. At first glance, the problem of determining whether or not two geometric objects interpenetrate seems purely mathematical. As might be expected, this book offers the mathematical background and algorithms for performing geometric queries on a variety of shape types currently used for modeling 3D environments. However, the constraints imposed by current computer platforms

complicate matters tremendously. First of all, interactive applications require that these queries are performed within a given time frame. In order to meet this real-time requirement, we have to use the limited amount of processing power as efficiently as possible. Second, the limited precision imposed by floating-point number formats causes rounding errors in the results of arithmetic operations. Numerical precision is particularly tight in the context of collision detection, since an incorrect answer to a collision query can result in a significantly different behavior of the environment. The final constraint that we have to deal with is the amount of available memory. The memory usage of certain collision detection methods can be quite large in comparison to other tasks performed by the application, and should be taken into consideration.

Of course, the reason for performing collision detection is to have some form of response to collisions. Often, additional data pertaining to the configuration of the colliding objects is needed for handling collisions. The problem of computing these so-called *response data* is closely related to the collision detection problem. So obviously, we also devote some space to methods for computing response data. Without delving too deeply into the subject of physics-based simulation, this book explains how to compute the response data necessary for resolving collisions in a physically convincing way.

1.1 Problem Domain

In this book, we address the problem of detecting collisions between three-dimensional objects. A *collision* is a configuration of two objects occupying the same point in space. We are interested, in particular, in configurations that change over time; that is, at least one of the objects is moving. The motion may be the result of a change of position and orientation or of deformation. A proper definition of what is understood by "a configuration of objects" follows in Chapter 2, which makes distinguishing between different types of motion a little more meaningful.

We experience motion as a continuous flow of object configurations. Computer animation systems simulate this continuous flow by updating object configurations at discrete time steps. Although collisions may not occur for these discrete time steps, we can often tell that a collision must have occurred, based on the trajectories of the objects. For instance, a bullet fired inside a closed room should at some point in time hit some part of the room before leaving it, even though the generated sequence of object configurations may not show a collision.

Detecting these in-between collisions accurately for all types of objects and motions is a daunting task, especially with the limited amount of processing time we are given in interactive applications. However, by trading some accuracy for performance, we are able to detect in-between collisions with sufficient accuracy to render faithful behavior for most applications. This book discusses a few "tricks" for detecting in-between collisions.

The meat of this book deals with performance issues. With the proper background in mathematics, designing algorithms for collision detection between a variety of object types is, in itself, not that hard. The real challenge is to perform collision detection for complex environments with lots of moving objects at interactive rates. Whether the rate at which object configurations are updated is considered "interactive" depends on the application. The human eye can be fooled into experiencing smooth motion by displaying a sufficient number of frames per second. Currently, interactive 3D applications typically shoot for frame rates between 30 and 60 frames per second. Our sense of touch is even more responsive. Haptic feedback should be updated at rates over 500 Hz. In order to meet the real-time requirements of interactive applications, we exploit two fundamentals:

- *Spatial coherence:* An object usually spans only a relatively small portion of the space, and collisions between objects are fairly rare. In general, collisions are resolved rather than maintained.

- *Temporal coherence:* Configurations change relatively little in between consecutive updates. Motions are usually smooth.

Spatial coherence assures us that the number of (possibly) colliding object pairs is far less than the actual number of object pairs. Temporal coherence suggests that we can avoid a lot of unnecessary computations by saving and reusing data from previous configurations.

Further speedups can be obtained by reducing the complexity of the used shapes. Simple shapes generally take less time to query for collisions than complex shapes. So, by substituting simpler shapes for more complex shapes in collision queries, the computational load of collision queries can be reduced substantially. Whether this trade-off of accuracy against performance is acceptable depends of course on the application.

We do not treat static objects any differently than moving objects. It turns out that there is no added benefit to be had by special treatment of static objects, other than the fact that collisions between static objects are generally not very interesting and can thus be ignored. Whether or not two objects collide depends solely on the relative configuration of

the objects. The knowledge that one of the objects is static does not give us an extra clue for optimizing the collision test. Ignoring certain collisions is simply motivated by the choice not to respond to them. However, this choice does not rely purely on the fact that objects are static, since there are collisions between moving objects we do not wish to respond to either.

The amount of processing is not the only constraint we have to deal with. On most computer platforms, the amount of available storage and the numerical precision are also limited. These issues are addressed as well in the discussion of the presented collision detection algorithms. Numerical problems that arise from finite-precision arithmetic can have a severe impact on the correctness of an algorithm and thus demand a comprehensive look at the way floating-point numbers are processed. This book tries to point out the potential problems that may arise from using finite-precision number formats and presents possible solutions to meet these problems.

This book discusses methods for detecting collisions and computing response data for objects represented by shape types that are commonly used for modeling interactive 3D environments. The shape types that we consider are

- basic primitives, such as boxes, spheres, ellipsoids, cones, and cylinders
- convex polytopes, such as line segments, triangles, and convex polyhedra
- complex shapes, such as polygonal and tetrahedral meshes.

Furthermore, we look at two compound shape types that are not very common in interactive visualization, but are quite useful for collision detection. These compound shapes are constructed using the following construction methods:

- *Minkowski sum:* The convex shape that is the result of "adding" two convex shapes, that is, sweeping one shape along the point set of another.
- *Convex hull:* The smallest convex shape that contains a given collection of convex shapes.

Convexity plays an important role in this book, as might be deduced from the list of shape types presented above. We will discover that a single algorithm, the Gilbert-Johnson-Keerthi (GJK) algorithm, can be used for testing collisions between any two objects represented by shapes from this large family of convex shape types.

1.2 **Historical Background**

The earliest applications of 3D collision detection are found in robotics and automation [12]. Here, product assembly or test facilities are simulated on a computer in order to verify interference problems. The different objects to be checked for interference are usually represented by polyhedra. Interference checking in robotics simulations is often performed on a continuous rather than a discrete time axis; that is, the objects are checked for interference in continuous four-dimensional space-time [13, 14, 17]. This approach is applicable only for a limited class of objects and motions. Even on current computer hardware, exact space-time interference checking is still not quite feasible for interactive 3D applications.

A lot of techniques used for collision detection have been borrowed from 3D visualization. In the early years of computer graphics, innovations were mainly pushed by the need to render lifelike images of 3D content. The problem of determining the visible objects in a scene has a lot of common ground with the problem of detecting collisions, in the sense that in both cases large collections of objects need to be queried for intersections. So, not surprisingly, similar algorithms and spatial data structures, such as voxel grids, octrees, and binary space-partitioning (BSP) trees, pop up as solutions in both areas [46, 53, 122].

Almost in parallel to the early developments in computer graphics, which were mainly triggered by innovations in computer hardware, the interest in geometric algorithms from a mathematical viewpoint evolved into a new research area called *computational geometry* [104]. This area spawned numerous publications on algorithms and data structures for problems such as convex hull computation, intersection detection and computation, distance computation, and linear programming. Many solutions for collision detection problems are drawn from this wealth of literature. However, contrary to the common practice in computational geometry of analyzing algorithms for their theoretical worst-case time complexity, we stay a little closer to the hardware in our performance analysis and choose algorithms based on run-time measurements.

Interactive 3D applications did not show up until the early 1980s. At that time, video games started to become popular with the arrival of the first game consoles and home computers. The first video game to feature interactive 3D content on a home computer was Elite, a space combat game written in 1984 by Ian Bell and David Braben for the BBC Microcomputer (see Figure 1.1). Although this game shows spaceships and space stations modeled by polyhedra, collisions between game objects are determined based on simpler shapes, such as spheres and boxes. This practice was very common at the time since computers simply did not have enough processing power to perform exact collision detection in real time.

Figure 1.1 Elite, the first 3D game on a home computer.

In computer animation, the first uses of collision detection are found in physics-based simulation [4, 63, 91]. Traditionally, animation sequences are created by defining key frames that describe predetermined trajectories of the moving objects. The animator has full control over the motion, and thus can avoid undesired collisions by carefully crafting the motion curves of the objects. However, with the use of physics-based simulation techniques, the animator loses this control. Hence it became necessary to resolve collisions automatically, preferably in a physically convincing manner. Although these early attempts to handle collisions were not directly aimed at interactive applications, it was observed that collision detection was a complex matter and that special techniques were needed to reduce the computational cost. Baraff was the first to exploit coherence in between frames in order to improve the performance of collision detection [5]. As computers became more powerful, many of Baraff's solutions found their use in interactive applications.

Exploiting temporal coherence is the key to reduce the cost of collision detection to a level such that it can be used in interactive applications. A typical example of a technique that applies this principle is the feature-walking algorithm by Lin and Canny for computing the distance between convex polyhedra [79]. Here, the closest features (vertices, edges, facets) of a pair of polyhedra are cached and incrementally updated in each new frame. Without prior knowledge, finding the closest features of a pair of polyhedra takes time that is linear in the number of features. However, an update of the closest feature pair takes roughly constant time when frame

coherence is high. The Lin-Canny algorithm is applied in I-COLLIDE, which is the first collision detection library for interactive applications to become publicly available [24]. After Lin-Canny, other incremental algorithms for convex polyhedra that have the same time complexity followed [15, 23, 40, 88, 128].

Current state of the art in interactive 3D graphics allows the use of shapes composed of thousands of primitives. In order to reduce the number of pairwise primitive intersection tests in collision detection of objects represented by such shapes, spatial data structures are often applied. Spatial data structures are a means to capture and exploit spatial coherence. They are used to quickly reject a large number of primitives from intersection testing based on the region of space they occupy. In the last few years, spatial data structures that are used for this purpose have received a lot of attention. Probably the best-known space-partitioning technique used in 3D games is the BSP tree. In Quake, a classic 3D game for the PC developed by Id Software, BSP trees are used both for visible-surfaces determination and collision detection.

Currently, model-partitioning techniques incorporating bounding-volume hierarchies are most often used. Bounding-volume types that have been used in tree structures for model partitioning include spheres [73, 102], axis-aligned boxes [127], oriented boxes [59], and discrete-orientation polytopes [76, 135]. Most of these structures are static and are thus applicable only to rigid objects. However, applications of bounding-volume trees for collision detection of deformable objects are found as well [127].

Hierarchical data structures are expensive in terms of memory usage. The storage cost of, for instance, a bounding-volume hierarchy for a triangle mesh is many times higher than the storage cost of the plain mesh. Since advances in rendering hardware enable the use of more complex environments, the memory usage of these data structures has become a bottleneck, most notably on game consoles. Compression techniques for bounding-volume hierarchies are currently a hot topic [57, 124].

Other challenges that remain are improving the robustness and performance of exact intersection tests and response computation algorithms. With the growing interest in interactive physics in the last few years, most of the innovations in 3D collision detection are aimed at improving these two qualities; however, further research is still necessary.

1.3 Organization

The rest of this book is organized as follows. In Chapter 2, we define the concepts used in this book. Here, notational conventions, as well as a

number of geometric concepts, are briefly explained. We discuss different types of shape representations and methods for constructing complex shapes from primitives. Furthermore, we briefly discuss methods for positioning and moving objects in three-dimensional space. We look at the different types of response data needed for resolving collisions. Finally, we provide some background on performance considerations and numerical stability.

In Chapter 3, we discuss algorithms for collision detection of a number of commonly used primitive shapes. The primitive shapes that are considered are spheres, axis-aligned boxes, line segments (rays), triangles, and general nonconvex polygons.

Chapter 4 describes algorithms for collision detection of convex objects, mostly algorithms for convex polyhedra. We discuss algorithms for finding a common point, for finding a separating axis, for computing the distance, and for computing the penetration depth. In particular, we look into incremental algorithms that exploit frame coherence. The main part of this chapter is dedicated to the Gilbert-Johnson-Keerthi algorithm (GJK) and related algorithms. We will show how to use GJK for distance computation and collision detection of general convex objects. We conclude with a discussion of the expanding-polytope algorithm (EPA), which is used for computing the penetration depth of an intersecting pair of convex objects.

In Chapter 5 we discuss spatial data structures that are used for speeding up collision detection of models composed of a large number of objects. We cover space-partitioning techniques, such as voxel grids, octrees, k-d trees, and BSP trees, and model partitioning techniques, such as AABB trees and OBB trees. We conclude this chapter with a discussion of Baraff's incremental sweep and prune scheme [6] for maintaining a set of pairs of overlapping AABBs, and we show how this scheme can be used for ray casting.

In Chapter 6 we describe the design of SOLID, a collision detection library for interactive 3D computer animation. SOLID incorporates the following innovative features:

- Models composed of a mix of shape types, including boxes, cones, cylinders, spheres, simplices, convex polygons, and convex polyhedra.

- Deformations of complex shapes.

- Object placement using position, orientation, and nonuniform scaling.

- Extruded and spherically expanded objects by means of Minkowski addition.

- Convex hulls of arbitrary objects.

- Penetration depth computation. The penetration depth can be used for approximating the contact points and contact plane of a pair of colliding objects in physics-based simulations.

The accompanying CD-ROM contains the complete C++ source code and API documentation of SOLID version 3.

Finally, Chapter 7 summarizes the results in the field and presents some pointers to interesting topics for future work.

<div align="right">

Chapter | **2**

</div>

Concepts

<div align="right">

Don't reinvent the wheel. Just realign it.
—Anthony J. D'Angelo

</div>

In this chapter, we first will define the concepts that are relevant within the context of this book and discuss a number of commonly used methods for representing objects. We will also describe different types of motion used in computer animation and discuss the problems with sampled motion. Then, we will look into the computation of response data for physics-based simulations. We will cover some efficiency considerations, such as coherence and memory, and discuss the difficulties in measuring performance. Finally, we will explain the problems that may arise when using finite-precision number representations and arithmetics in geometric algorithms.

2.1 Geometry

Most of the geometric properties and algorithms are described in a mathematical language. The language we use is based on what is commonly used in geometry literature, so a reader who is familiar with the basics of geometry should have little trouble understanding the notation used in this book. This section is presented as a mini-primer in geometry. Although the content of this section is explained similarly, and often more thoroughly, in the bulk of the geometry literature, for instance in [107], we still find it useful to include it since it serves as an easy reference and an introduction to the notation used in this book.

2.1.1 Notational Conventions

In this section we establish the notational conventions used throughout this text. The reader is assumed to have a basic grasp of linear algebra and set theory; it is not our objective to provide all the formalities of the mathematical concepts used in this book.

<div align="right">

11

</div>

The set of real numbers is denoted by \mathbb{R}. In the context of vector spaces, real numbers are referred to as *scalars* and denoted by lowercase Greek letters, such as α, β, γ. The vector space of d-(dimensional) tuples $(\alpha_1, \ldots, \alpha_d)$ is denoted by \mathbb{R}^d. Elements of \mathbb{R}^d are referred to as *vectors* and denoted by lowercase boldface letters, such as \mathbf{a}, \mathbf{b}, \mathbf{c}. The *zero vector* is denoted by $\mathbf{0}$.

Matrices over \mathbb{R} are denoted by uppercase boldface letters, such as \mathbf{A}, \mathbf{B}, \mathbf{C}. The matrix $\mathbf{A} = [\alpha_{ij}]$ denotes the matrix with number α_{ij} in the ith row and jth column. The *transpose* of a matrix \mathbf{A} is denoted by \mathbf{A}^T. In matrix notation, vectors are regarded as columns, which are $m \times 1$ matrices. For a set of vectors $\mathbf{v}_1, \ldots, \mathbf{v}_n \in \mathbb{R}^m$, we denote the $m \times n$ matrix with columns \mathbf{v}_j as $[\mathbf{v}_1 \cdots \mathbf{v}_n]$.

A *square matrix* is a matrix with an equal number of columns and rows. The determinant of a square matrix \mathbf{A} is denoted by $\det(\mathbf{A})$. A matrix is called *singular* if its determinant is zero, and *nonsingular* otherwise. The set of nonsingular $n \times n$ matrices forms an algebraic group, with matrix multiplication as operator. The *identity* is the matrix $\mathbf{I} = [\delta_{ij}]$, where δ_{ij}, referred to as the *Kronecker symbol*, is defined as

$$\delta_{ij} = \begin{cases} 1 & \text{if } i = j \\ 0 & \text{otherwise.} \end{cases}$$

The inverse of a nonsingular matrix \mathbf{A} is denoted by \mathbf{A}^{-1}.

A set is defined either by enumeration, such as $\{\mathbf{x}_1, \ldots, \mathbf{x}_n\}$, or conditionally, such as $\{\mathbf{x} \in \mathbb{R}^n : P(\mathbf{x})\}$, which is the set of $\mathbf{x} \in \mathbb{R}^n$ for which predicate $P(\mathbf{x})$ holds. Closed scalar intervals are denoted as $[\alpha, \beta]$, where $[\alpha, \beta] = \{\gamma \in \mathbb{R} : \alpha \leq \gamma \leq \beta\}$. Sets are denoted by uppercase italics, such as A, B, C. The empty set is denoted by \emptyset. The union, intersection, and set difference of A and B are denoted respectively by $A \cup B$, $A \cap B$, and $A \setminus B$. The relation $A \subseteq B$ expresses that A is a subset of B, and that A and B are possibly equal. The *power-set* of a set X, denoted by $\mathcal{P}(X)$, is the set of all subsets of X. We will adopt the convention that functions $f : X \to Y$ are silently lifted to $\mathcal{P}(X) \to \mathcal{P}(Y)$ according to $f(A) = \{f(a) : a \in A\}$.

Finally, the term *iff* should be read as an abbreviation for "if and only if". We use "\equiv" as the mathematical symbol for iff.

2.1.2 Vector Spaces

A *linear combination* of n vectors $\mathbf{v}_1, \ldots, \mathbf{v}_n$ is a vector of the form

$$\mathbf{v} = \alpha_1 \mathbf{v}_1 + \cdots + \alpha_n \mathbf{v}_n.$$

The *span* of a set of vectors is the set of linear combinations of vectors in the set. A set of vectors $\{\mathbf{v}_1, \ldots, \mathbf{v}_n\}$ is said to be *linearly independent* if the equation

$$\alpha_1 \mathbf{v}_1 + \cdots + \alpha_n \mathbf{v}_n = \mathbf{0}$$

yields $\alpha_1 = \cdots = \alpha_n = 0$ as the sole solution. A *basis* of a vector space is a linearly independent set of vectors whose span is the whole space. The number of vectors in the basis is referred to as the *dimension* of the space. For a basis $\{\mathbf{b}_1, \ldots, \mathbf{b}_n\}$ the equation

$$\mathbf{v} = \alpha_1 \mathbf{b}_1 + \cdots + \alpha_n \mathbf{b}_n$$

has exactly one solution for a given vector \mathbf{v}. Hence, \mathbf{v} is uniquely identified by the n-tuple $(\alpha_1, \ldots, \alpha_n) \in \mathbb{R}^n$ with respect to the given basis. The scalars α_i are called the *vector components* of \mathbf{v} relative to $\{\mathbf{b}_i\}$. In particular, the components of the basis vectors \mathbf{b}_i are

$$\mathbf{b}_i = (\delta_{i1}, \ldots, \delta_{in}).$$

A *linear transformation* is a function \mathbf{T} that maps vectors to vectors according to

$$\mathbf{T}(\alpha \mathbf{v} + \beta \mathbf{w}) = \alpha \mathbf{T}(\mathbf{v}) + \beta \mathbf{T}(\mathbf{w}).$$

Consequently, a linear transformation is determined solely by the mappings of the basis vectors. We consider only linear transformations from a vector space onto itself. For these transformations, the image of the basis is itself a basis. Let $B' = \{\mathbf{b}_i'\}$ be the image of a basis B, where $\mathbf{b}_i' = \mathbf{T}(\mathbf{b}_i)$ are the mappings of the basis vectors given relative to B. The mapping of a vector $\mathbf{x} = (\alpha_1, \ldots, \alpha_n)$ given relative to B is

$$\mathbf{T}(\mathbf{x}) = \alpha_1 \mathbf{b}_1' + \cdots + \alpha_n \mathbf{b}_n'.$$

We introduce a matrix $\mathbf{B} = [\mathbf{b}_1' \cdots \mathbf{b}_n']$, and write this equation as

$$\mathbf{T}(\mathbf{x}) = \mathbf{Bx}.$$

Here, B' is indeed a basis iff \mathbf{B} is nonsingular. We will often use the same symbol to denote a matrix and the corresponding linear transformation.

Given a square matrix $\mathbf{A} = [\mathbf{a}_1 \cdots \mathbf{a}_n]$ and a vector \mathbf{b}, the equation $\mathbf{Ax} = \mathbf{b}$ can be solved using *Cramer's rule*. Of course, a unique solution exists

only if **A** is nonsingular. The components γ_i of the solution **x** are

$$\gamma_i = \frac{\det[\mathbf{a}_1 \cdots \mathbf{a}_{i-1} \, \mathbf{b} \, \mathbf{a}_{i+1} \cdots \mathbf{a}_n]}{\det(\mathbf{A})}.$$

Thus, the *i*th column of **A** is replaced by **b** to get the matrix that is used for computing the numerator. Determinants can be computed using the following recursively defined rule:

$$\det[\alpha] = \alpha$$

$$\det(\mathbf{A}) = \sum_{j=1}^{n}(-1)^{i+j}\alpha_{ij}\det(\mathbf{A}_{ij}), \quad \text{for any } i = 1, \ldots, n,$$

where \mathbf{A}_{ij} is the $(n-1) \times (n-1)$ matrix we get by removing the *i*th row and the *j*th column from **A**. The value $(-1)^{i+j}\det(\mathbf{A}_{ij})$ is called the *cofactor* of element α_{ij}, and the recursive method for computing the determinant is called *cofactor expansion* about the *i*th row.

The determinant function has the following properties:

1. $\det(\mathbf{A}^{\mathsf{T}}) = \det(\mathbf{A})$.

2. $\det(\mathbf{A}^{-1}) = 1/\det(\mathbf{A})$.

3. $\det(\mathbf{AB}) = \det(\mathbf{A})\det(\mathbf{B})$.

Cramer's rule can be used for computing the inverse of a matrix **A**. The inverse \mathbf{A}^{-1} is the matrix $[\alpha'_{ij}]$, where

$$\alpha'_{ij} = \frac{(-1)^{i+j}\det(\mathbf{A}_{ji})}{\det(\mathbf{A})}.$$

Since computing determinants for higher dimensions is computationally expensive, Cramer's rule is useful for low-dimensional spaces only.

2.1.3 Affine Spaces

An *affine space* consists of a set of *points*, an associated vector space, and two operations: the addition of a point and a vector, and the subtraction of two points. Points are denoted, like vectors, by lowercase boldface letters. The addition of a point and a vector yields a point according to the rules $\mathbf{p} + \mathbf{0} = \mathbf{p}$ and $(\mathbf{p} + \mathbf{v}) + \mathbf{w} = \mathbf{p} + (\mathbf{v} + \mathbf{w})$. Conversely, the subtraction of two points yields a vector according to the rule $\mathbf{p} + (\mathbf{q} - \mathbf{p}) = \mathbf{q}$. Although addition and scalar multiplication are not defined for points, we define an

affine combination of points $\mathbf{p}_0, \ldots, \mathbf{p}_n$ as

$$\mathbf{p} = \alpha_0\mathbf{p}_0 + \alpha_1\mathbf{p}_1 + \cdots + \alpha_n\mathbf{p}_n \quad \text{for } \alpha_0 + \cdots + \alpha_n = 1.$$

This expression makes sense if we are allowed to formally eliminate α_0 and write

$$\mathbf{p} = \mathbf{p}_0 + \alpha_1(\mathbf{p}_1 - \mathbf{p}_0) + \cdots + \alpha_n(\mathbf{p}_n - \mathbf{p}_0),$$

which is obviously a point. The *affine hull* of a set of points A, denoted by aff(A), is the set of affine combinations of points in A. An *affine set* is a set of points that is closed under affine combinations. Examples of affine sets are points, lines, and planes. A set of points $\{\mathbf{p}_0, \ldots, \mathbf{p}_n\}$ is called *affinely independent* if the set $\{\mathbf{p}_1 - \mathbf{p}_0, \ldots, \mathbf{p}_n - \mathbf{p}_0\}$ is linearly independent. The *dimension* of an affine set is the dimension of the associated vector space. As a result of this, the number of points in an affinely independent set is the dimension of its affine hull plus 1.

A *coordinate system* is a tuple of a point and a basis. The point is called the *origin* of the coordinate system. For a given coordinate system with origin \mathbf{c} and basis $\{\mathbf{b}_1, \ldots, \mathbf{b}_n\}$, the equation

$$\mathbf{p} = \mathbf{c} + \alpha_1\mathbf{b}_1 + \cdots + \alpha_n\mathbf{b}_n$$

has exactly one solution for a given point \mathbf{p}. The point \mathbf{p} is uniquely identified by the vector $(\alpha_1, \ldots, \alpha_n) \in \mathbb{R}^n$ with respect to the coordinate system. The components α_i are called the *coordinates* of \mathbf{p}. Thus, a coordinate system defines an affine space in which we identify each point uniquely by a vector of coordinates.

We often use multiple coordinate systems for the same space. The same point can be identified by different coordinate vectors relative to different coordinate systems. A coordinate system itself can be defined relative to a *parent coordinate system*. We transform coordinates from a coordinate system to its parent coordinate system and vice versa by means of an affine transformation.

An *affine transformation* is a function \mathbf{T} that maps coordinates to coordinates according to

$$\mathbf{T}(\alpha\mathbf{p} + \beta\mathbf{q}) = \alpha\mathbf{T}(\mathbf{p}) + \beta\mathbf{T}(\mathbf{q}) \quad \text{for } \alpha + \beta = 1.$$

Consequently, an affine transformation is determined by the images of the basis and the origin of the given coordinate system. Let \mathbf{B} represent the image of the basis, and let \mathbf{c} be the image of the origin. The corresponding

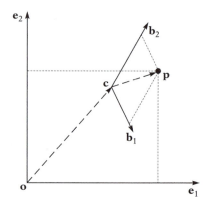

Figure 2.1 An affine transformation in \mathbb{R}^2. Point \mathbf{p} is given in coordinates relative to the coordinate system $(\mathbf{c}, \{\mathbf{b}_1, \mathbf{b}_2\})$. The coordinate vector of \mathbf{p} relative to the world coordinate system $(\mathbf{o}, \{\mathbf{e}_1, \mathbf{e}_2\})$ is $\mathbf{Bp} + \mathbf{c}$, where $\mathbf{B} = [\mathbf{b}_1, \mathbf{b}_2]$.

affine transformation \mathbf{T} is given by

$$\mathbf{T}(\mathbf{x}) = \mathbf{Bx} + \mathbf{c}.$$

A coordinate system is defined relative to a parent coordinate system by giving the coordinates of its origin in parent coordinates and its basis vectors relative to the parent basis. Let $\mathbf{B} = [\mathbf{b}_1 \cdots \mathbf{b}_n]$, where \mathbf{b}_i are the basis vectors in parent coordinates, and \mathbf{c}, the origin in parent coordinates. The affine transformation $\mathbf{T}(\mathbf{x}) = \mathbf{Bx} + \mathbf{c}$ maps child coordinates to parent coordinates, as illustrated in Figure 2.1. We can (and usually do) identify a coordinate system given relative to a parent coordinate system with the corresponding affine transformation. We refer to the primal ancestor of all coordinate systems as the *world coordinate system*. We denote the world origin by \mathbf{o}, and the world basis vectors by \mathbf{e}_i.

The set of affine transformations from \mathbb{R}^n onto \mathbb{R}^n forms an algebraic group with function composition as operator

$$\mathbf{T}_2 \circ \mathbf{T}_1(\mathbf{x}) = \mathbf{B}_2(\mathbf{B}_1\mathbf{x} + \mathbf{c}_1) + \mathbf{c}_2 = \mathbf{B}_2\mathbf{B}_1\mathbf{x} + \mathbf{B}_2\mathbf{c}_1 + \mathbf{c}_2$$

and inverse

$$\mathbf{T}^{-1}(\mathbf{x}) = \mathbf{B}^{-1}(\mathbf{x} - \mathbf{c}) = \mathbf{B}^{-1}\mathbf{x} - \mathbf{B}^{-1}\mathbf{c}.$$

The identity of the group of affine transformations is \mathbf{I}.

Composition of affine transformations can be interpreted as follows. Suppose we have three coordinate systems for which \mathbf{T}_1 represents the first coordinate system relative to the second, and \mathbf{T}_2 represents the second

coordinate system relative to the third. Then, $\mathbf{T}_2 \circ \mathbf{T}_1$ represents the first coordinate system relative to the third.

2.1.4 Euclidean Spaces

A Euclidean space is an affine space with a notion of length and distance, defined by means of the *dot product*. The dot product of vectors \mathbf{v} and \mathbf{w}, denoted by $\mathbf{v} \cdot \mathbf{w}$, yields a scalar according to the following rules:

1. Commutative: $\mathbf{v} \cdot \mathbf{w} = \mathbf{w} \cdot \mathbf{v}$.

2. Bilinear: $\mathbf{u} \cdot (\alpha\mathbf{v} + \beta\mathbf{w}) = \alpha\mathbf{u} \cdot \mathbf{v} + \beta\mathbf{u} \cdot \mathbf{w}$.

3. Positive definite: $\mathbf{v} \cdot \mathbf{v} > 0$ for $\mathbf{v} \neq \mathbf{0}$.

Note that these rules do not uniquely determine the dot product. In order to establish a unique dot product, we take $\{\mathbf{e}_i\}$ as the *standard basis* and define

$$\mathbf{e}_i \cdot \mathbf{e}_j = \delta_{ij}.$$

Within the scope of this book we choose the world basis to be the standard basis.[1]
The *length* of a vector \mathbf{v}, denoted by $\|\mathbf{v}\|$, is defined as

$$\|\mathbf{v}\| = \sqrt{\mathbf{v} \cdot \mathbf{v}}.$$

The *distance* between two points \mathbf{p} and \mathbf{q}, denoted by $d(\mathbf{p}, \mathbf{q})$ is the length of the vector $\mathbf{p} - \mathbf{q}$:

$$d(\mathbf{p}, \mathbf{q}) = \|\mathbf{p} - \mathbf{q}\|.$$

The *angle* θ between two nonzero vectors \mathbf{v} and \mathbf{w} is defined by

$$\cos(\theta) = \frac{\mathbf{v} \cdot \mathbf{w}}{\|\mathbf{v}\|\|\mathbf{w}\|} \quad 0 \leq \theta \leq \pi.$$

A pair of vectors \mathbf{v} and \mathbf{w} are said to be *orthogonal*, denoted by $\mathbf{v} \perp \mathbf{w}$, if $\mathbf{v} \cdot \mathbf{w} = 0$. It can be proven that a set of mutually orthogonal nonzero vectors is linearly independent. A basis $\{\mathbf{b}_i\}$ for which $\mathbf{b}_i \cdot \mathbf{b}_j = \delta_{ij}$, as for

1. Although it is possible to conceive of applications, for instance in crystallography, for which this is not an obvious choice.

the standard basis, is called *orthonormal*. For vectors \mathbf{v} and \mathbf{w} relative to an orthonormal basis we find that the dot product is given by

$$\mathbf{v} \cdot \mathbf{w} = \mathbf{v}^{\mathrm{T}} \mathbf{w}.$$

A *Cartesian system* is a coordinate system that has an orthonormal basis.

When we do not care about the length of a nonzero vector, we refer to the vector as a *direction*, an *axis*, or a *normal*. Since the length of such a vector \mathbf{v} does not carry any information, it is allowed and often useful to scale the vector to unit length:

$$\mathbf{u} = \frac{\mathbf{v}}{\|\mathbf{v}\|}.$$

This operation is called *normalization*.

For $\mathbf{n} \in \mathbb{R}^n \setminus \{\mathbf{0}\}$ and $\delta \in \mathbb{R}$, the *(hyper)plane* $H(\mathbf{n}, \delta)$ in \mathbb{R}^n is a set of points defined by

$$H(\mathbf{n}, \delta) = \{\mathbf{x} \in \mathbb{R}^n : \mathbf{n} \cdot \mathbf{x} + \delta = 0\}.$$

The vector \mathbf{n} is referred to as a *normal*, and the scalar δ as the corresponding *offset* of the hyperplane. For $\|\mathbf{n}\| = 1$, it can be shown that the distance from a point \mathbf{p} to $H(\mathbf{n}, \delta)$ is $|\mathbf{n} \cdot \mathbf{p} + \delta|$ so it is often useful to have a normal of unit length.

Often, the *orientation* of a hyperplane is important. The orientation of a hyperplane is determined by the direction of the normal. So, the hyperplanes $H(\mathbf{n}, \delta)$ and $H(-\mathbf{n}, -\delta)$ should be regarded as different entities, although they represent the same point set. The orientation plays a role when defining halfspaces. The positive and negative *closed halfspaces* defined by a hyperplane $H(\mathbf{n}, \delta)$ are defined as

$$H^+(\mathbf{n}, \delta) = \{\mathbf{x} \in \mathbb{R}^n : \mathbf{n} \cdot \mathbf{x} + \delta \geq 0\}$$
$$H^-(\mathbf{n}, \delta) = \{\mathbf{x} \in \mathbb{R}^n : \mathbf{n} \cdot \mathbf{x} + \delta \leq 0\}.$$

The positive and negative *open halfspaces* defined by a hyperplane $H(\mathbf{n}, \delta)$ are defined as

$$H^\oplus(\mathbf{n}, \delta) = \{\mathbf{x} \in \mathbb{R}^n : \mathbf{n} \cdot \mathbf{x} + \delta > 0\}$$
$$H^\ominus(\mathbf{n}, \delta) = \{\mathbf{x} \in \mathbb{R}^n : \mathbf{n} \cdot \mathbf{x} + \delta < 0\}.$$

For a point \mathbf{p}, the value $\mathbf{n} \cdot \mathbf{p} + \delta$ is referred to as the *signed distance* to $H(\mathbf{n}, \delta)$.

2.1.5 Affine Transformations

The group of affine transformations has a number of important sub-groups. We have already seen one of them, namely, the group of linear transformations. The group of *translations* is formed by the transformations

$$\mathbf{T}(\mathbf{x}) = \mathbf{x} + \mathbf{c}.$$

The group of *rotations* about the origin is formed by the transformations

$$\mathbf{R}(\mathbf{x}) = \mathbf{B}\mathbf{x}, \quad \text{where } \mathbf{B}^{-1} = \mathbf{B}^{\mathrm{T}} \text{ and } \det(\mathbf{B}) = 1.$$

A matrix \mathbf{B} for which $\mathbf{B}^{-1} = \mathbf{B}^{\mathrm{T}}$ is called *orthogonal*. For an orthogonal matrix \mathbf{B} we have $\det(\mathbf{B}) = \pm 1$. If the determinant of an orthogonal matrix is positive, then the matrix is called *special orthogonal*.

An orthogonal matrix maps an orthonormal basis to an orthonormal basis (note the nomenclature!), since for orthogonal \mathbf{B} and orthonormal basis $\{\mathbf{b}_i\}$ we have

$$(\mathbf{B}\mathbf{b}_i) \cdot (\mathbf{B}\mathbf{b}_j) = (\mathbf{B}\mathbf{b}_i)^{\mathrm{T}} (\mathbf{B}\mathbf{b}_j) = \mathbf{b}_i^{\mathrm{T}} \mathbf{B}^{\mathrm{T}} \mathbf{B} \mathbf{b}_j = \mathbf{b}_i^{\mathrm{T}} \mathbf{b}_j = \mathbf{b}_i \cdot \mathbf{b}_j = \delta_{ij}.$$

Furthermore, it follows that any matrix that maps an orthonormal basis to an orthonormal basis is necessarily orthogonal.

The group of *rigid motions* in \mathbb{R}^n is the supergroup of translations and rotations. The group of *length-preserving* transformations is formed by the set of affine transformations \mathbf{T} for which

$$\|\mathbf{T}(\mathbf{x}) - \mathbf{T}(\mathbf{y})\| = \|\mathbf{x} - \mathbf{y}\|$$

holds for all points \mathbf{x} and \mathbf{y}. An affine transformation $\mathbf{T}(\mathbf{x}) = \mathbf{B}\mathbf{x} + \mathbf{c}$ is length-preserving iff \mathbf{B} is orthogonal, since

$$\|\mathbf{T}(\mathbf{x}) - \mathbf{T}(\mathbf{y})\| = \|\mathbf{B}\mathbf{x} - \mathbf{B}\mathbf{y}\| = \|\mathbf{B}(\mathbf{x} - \mathbf{y})\| = \sqrt{\mathbf{B}(\mathbf{x} - \mathbf{y}) \cdot \mathbf{B}(\mathbf{x} - \mathbf{y})},$$

which is reduced to

$$\sqrt{(\mathbf{x} - \mathbf{y}) \cdot (\mathbf{x} - \mathbf{y})} = \|\mathbf{x} - \mathbf{y}\|$$

iff \mathbf{B} is orthogonal.

A *reflection* in a plane through the origin is an affine transformation of the form

$$\mathbf{W}(\mathbf{x}) = \mathbf{B}\mathbf{x}, \quad \text{where } \mathbf{B} \text{ is orthogonal and } \det(\mathbf{B}) = -1.$$

Any length-preserving transformation is either a rigid motion or a composition of a translation and a reflection [26].

The group of *uniform scalings* about the origin is the group of transformations of the form

$$\mathbf{U}(\mathbf{x}) = \alpha\mathbf{x} \quad \text{for } \alpha \neq 0.$$

Compositions of length-preserving transformations and uniform scalings constitute the group of *angle-preserving* transformations. For each angle-preserving transformation \mathbf{T}, an $\alpha > 0$ exists, such that for arbitrary points \mathbf{x} and \mathbf{y}

$$\|\mathbf{T}(\mathbf{x}) - \mathbf{T}(\mathbf{y})\| = \alpha\|\mathbf{x} - \mathbf{y}\|.$$

The group of *nonuniform scalings* about the origin is the group of transformations of the form

$$\mathbf{S}(\mathbf{x}) = [\alpha_{ij}]\mathbf{x}, \quad \text{where } \alpha_{ij} \neq 0 \text{ iff } i = j.$$

Notice that the group of uniform scalings is a subgroup of the group of nonuniform scalings. Figure 2.2 shows a visual representation of the group of affine transformations.

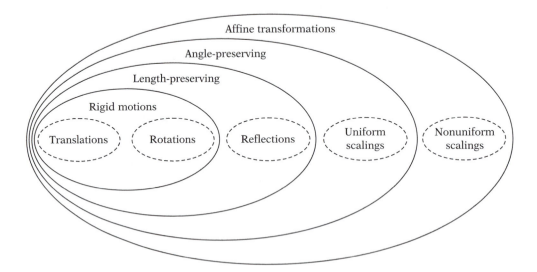

Figure 2.2 The group of affine transformations. The dashed ellipses denote classes of basic operations. Each group of transformations denoted by a solid ellipse is composed of operations from the classes inside the ellipse.

As shown in [56], any affine transformation \mathbf{A} can be constructed as a composition of a translation \mathbf{T}, two rotations \mathbf{R}_L and \mathbf{R}_R, and a nonuniform scaling \mathbf{S}, such that

$$\mathbf{A} = \mathbf{T} \circ \mathbf{R}_L \circ \mathbf{S} \circ \mathbf{R}_R.$$

So, we need only three types of basic operations for constructing any affine transformation, namely, translations, rotations, and nonuniform scalings.

Let H' be the image of a hyperplane H under affine transformation $\mathbf{T}(\mathbf{x}) = \mathbf{B}\mathbf{x} + \mathbf{c}$. A normal \mathbf{n}' and a scalar δ' such that

$$H' = \{\mathbf{x} \in \mathbb{R}^n : \mathbf{n}' \cdot \mathbf{x} + \delta' = 0\}$$

are found by expressing H' in terms of \mathbf{T}^{-1}, the inverse of \mathbf{T}. For $\mathbf{x} \in H'$ we deduce

$$\mathbf{n} \cdot \mathbf{B}^{-1}(\mathbf{x} - \mathbf{c}) + \delta = 0 \equiv \mathbf{n}^{\mathrm{T}}\mathbf{B}^{-1}(\mathbf{x} - \mathbf{c}) + \delta = 0$$
$$\equiv ((\mathbf{B}^{-1})^{\mathrm{T}}\mathbf{n})^{\mathrm{T}}(\mathbf{x} - \mathbf{c}) + \delta = 0$$
$$\equiv (\mathbf{B}^{-1})^{\mathrm{T}}\mathbf{n} \cdot (\mathbf{x} - \mathbf{c}) + \delta = 0.$$

We see that $\mathbf{n}' = (\mathbf{B}^{-1})^{\mathrm{T}}\mathbf{n}$ and $\delta' = \delta - \mathbf{n}' \cdot \mathbf{c}$ yields $\mathbf{n}' \cdot \mathbf{x} + \delta' = 0$. Iff \mathbf{T} is length-preserving, then \mathbf{B} is orthogonal, and thus $(\mathbf{B}^{-1})^{\mathrm{T}} = \mathbf{B}$, in which case we may transform a normal simply as $\mathbf{n}' = \mathbf{B}\mathbf{n}$.

2.1.6 Three-Dimensional Space

Here, we will discuss some concepts that apply to three-dimensional Euclidean space only. By convention, the world coordinate system in \mathbb{R}^3 is a right-handed Cartesian system. A coordinate system relative to the world coordinate system is called *right-handed* if the matrix $[\mathbf{b}_1 \ \mathbf{b}_2 \ \mathbf{b}_3]$ has a positive determinant, where \mathbf{b}_i are the basis vectors in world coordinates.

The *cross product* of two vectors \mathbf{v} and \mathbf{w}, denoted by $\mathbf{v} \times \mathbf{w}$, is a vector determined by the following rules:

1. Orthogonal: $(\mathbf{v} \times \mathbf{w}) \perp \mathbf{v}$ and $(\mathbf{v} \times \mathbf{w}) \perp \mathbf{w}$.

2. Positively oriented: $\det[\mathbf{v} \ \mathbf{w} \ \mathbf{v} \times \mathbf{w}] > 0$ for \mathbf{v}, \mathbf{w} linearly independent.

3. $\|\mathbf{v} \times \mathbf{w}\| = \|\mathbf{v}\|\|\mathbf{w}\| \sin(\theta)$, where θ is the angle between \mathbf{v} and \mathbf{w}.

Thus, the length of $\mathbf{v} \times \mathbf{w}$ is equal to the area of the parallelogram spanned by \mathbf{v} and \mathbf{w}. For vectors relative to an orthonormal basis, the cross product is given by

$$
\begin{bmatrix} \alpha_1 \\ \alpha_2 \\ \alpha_3 \end{bmatrix} \times \begin{bmatrix} \beta_1 \\ \beta_2 \\ \beta_3 \end{bmatrix} = \begin{bmatrix} \alpha_2\beta_3 - \alpha_3\beta_2 \\ \alpha_3\beta_1 - \alpha_1\beta_3 \\ \alpha_1\beta_2 - \alpha_2\beta_1 \end{bmatrix}.
$$

The cross product has the following properties:

1. Anticommutative: $\mathbf{v} \times \mathbf{w} = -\mathbf{w} \times \mathbf{v}$.

2. Bilinear: $\mathbf{u} \times (\alpha\mathbf{v} + \beta\mathbf{w}) = \alpha\mathbf{u} \times \mathbf{v} + \beta\mathbf{u} \times \mathbf{w}$.

The cross product is used for computing a normal to the plane through (the affine hull of) three affinely independent points. Let $\{\mathbf{p}_0, \mathbf{p}_1, \mathbf{p}_2\}$ be affinely independent. Then, $\mathbf{n} = (\mathbf{p}_1 - \mathbf{p}_0) \times (\mathbf{p}_2 - \mathbf{p}_0)$ is a normal to the plane through $\{\mathbf{p}_i\}$. It follows from rule 3 that the length of \mathbf{n} is twice the area of the triangle. If needed, \mathbf{n} can be normalized to get a normal of unit length. The plane is given by $H(\mathbf{n}, -\mathbf{n} \cdot \mathbf{p}_0)$.

The *triple product* of three vectors \mathbf{u}, \mathbf{v}, and \mathbf{w} is the scalar $\mathbf{u} \cdot (\mathbf{v} \times \mathbf{w})$. The triple product has the following useful property.

$$
\mathbf{u} \cdot (\mathbf{v} \times \mathbf{w}) = \mathbf{v} \cdot (\mathbf{w} \times \mathbf{u}) = \mathbf{w} \cdot (\mathbf{u} \times \mathbf{v}) = \det[\mathbf{u} \ \mathbf{v} \ \mathbf{w}].
$$

Notice that $\mathbf{u} \cdot (\mathbf{v} \times \mathbf{w})$ is zero iff $\{\mathbf{u}, \mathbf{v}, \mathbf{w}\}$ is linearly dependent.

2.2 Objects

In this section we define the class of objects for which collision detection algorithms are presented in this book. An *object* is a closed bounded nonempty set of points in three-dimensional Euclidean space. Here, *closed* means that the boundary is considered part of the object, and *bounded* means that there exists a sphere of finite radius that encloses the object. For instance, a plane is closed but not bounded.

An object is *convex* if it contains all the line segments connecting any pair of its points. An object that is not convex is called *concave*. Figure 2.3 shows the difference between a convex and a concave object. Convex objects often allow simpler or faster algorithms for intersection testing. In Chapter 4, we will discuss a number of algorithms that are applicable for collision detection of convex objects only.

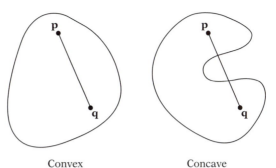

Convex Concave

Figure 2.3 An object is convex if it contains all the line segments connecting any pair of its points.

Objects may be composed of simpler objects called *primitive shapes*, or *primitives* for short. Primitives are the building blocks of the objects in the simulated environment. The primitives we consider are the common primitives for geometric modeling: spheres, cones, cylinders, boxes, points, line segments, and polygons, as described for instance in VRML97 [10]. Furthermore, we also consider polytopes as primitives for representing objects. A precise definition of the term *polytope* is presented further on. For now, let us define a polytope as a convex object whose boundary is composed of a finite number of flat facets. Figure 2.4 shows a taxonomy of the types of primitives we consider. Here, the acronym "DOP" denotes *discrete-orientation polytope*, that is, a three-dimensional polytope whose facet orientations are chosen from a fixed finite set of orientations.

Concave polyhedra are not considered primitives. For collision detection a concave polyhedron needs to be either decomposed into convex parts or represented by the set of boundary polygons. We will discuss the merits of both representations in Chapter 5. Let us have a closer look at the different primitive types now.

2.2.1 Polytopes

A (convex) *polytope* is the convex hull of a finite point set. The *convex hull* of a point set A, denoted by conv(A), is the smallest convex object containing A. The convex hull of a finite point set $A = \{\mathbf{a}_1, \ldots, \mathbf{a}_n\}$ can be expressed as the set of convex combinations of A. A *convex combination* of A is any point \mathbf{x} defined by

$$\mathbf{x} = \sum_{i=1}^{n} \lambda_i \mathbf{a}_i \quad \text{for} \quad \sum_{i=1}^{n} \lambda_i = 1, \text{ and } \lambda_i \geq 0.$$

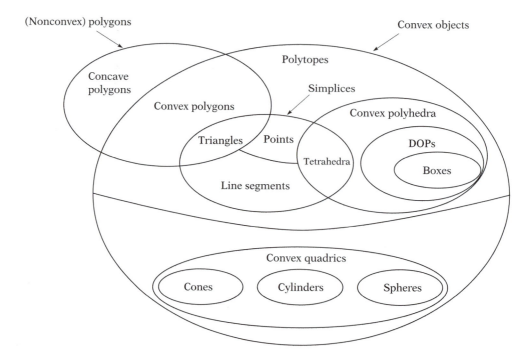

Figure 2.4 A taxonomy of primitive types.

The set of *vertices* of a polytope $P = \text{conv}(A)$, denoted by $\text{vert}(P)$, is the smallest set $X \subseteq A$, such that $\text{conv}(X) = P$. A *simplex* is the convex hull of an affinely independent set of points. Simplices of one, two, three, and four vertices are points, line segments, triangles, and tetrahedra, respectively. The dimension of a polytope is the dimension of its affine hull. The set of two- and three-dimensional polytopes are, respectively, the set of convex polygons and the set of convex polyhedra.

Boundary Representations

A *feature*[2] of a polytope is any subset of its boundary that is the intersection of the polytope with a contact plane. Features of zero, one, and two dimensions are called vertices, edges, and facets, respectively. A *boundary representation* of a polytope is the set of its features together with their incidence relation. The boundary representation of a polygon is simply the chain of its edges.

2. In the geometry literature the common term is *face*. However, we avoid using this term, since in computer graphics texts, "face" is a synonym for "polygon."

A polyhedron's boundary representation has a planar-graph topology. A graph is *planar* if it can be embedded in the plane without crossing edges. For planar graphs the numbers of the different types of features are related by *Euler's formula*. Let $v, e,$ and f denote the number of vertices, edges, and facets, respectively, in a polyhedron's boundary. Then, Euler's formula states that

$$v - e + f = 2.$$

The *degree* of a vertex \mathbf{p}, denoted by $\deg(\mathbf{p})$, is the number of edges it is incident upon. For polyhedra we know that each vertex has a degree of at least three. From this property it follows that the number of vertices, edges, and facets are pairwise proportional [104]. Phrased differently, for a polyhedron having n vertices, the number of edges and the number of facets are both $O(n)$.

We will discuss a few data structures that can be used for representing planar graphs. For a more thorough discussion of the representation of polyhedron boundaries, see [74].

The best-known data structure for representing the boundaries of polyhedra is Baumgart's *winged-edge structure* [9]. In a winged-edge structure the incidence relation of the features is stored in edge nodes. For each undirected edge in the graph, an edge node is maintained. An edge node stores references to the incident vertices and facets, as well as pointers to four adjacent edge nodes. Per incident vertex we maintain pointers to the successor and predecessor of the edge when traversing the edges incident to the vertex in counterclockwise order. Similarly, the pointers can also be used for traversing the edges that bound one of the incident facets in clockwise order. The edge, together with the four linked edges, resembles a butterfly, hence the name "winged-edge." Figure 2.5 illustrates the linkage of edge nodes in the winged-edge structure.

A similar data structure, called a *doubly connected edge list* (DCEL), was proposed by Muller and Preparata [92, 104]. The DCEL is a winged-edge structure in which pointers to the predecessor edge nodes are omitted. Thus, with a DCEL, the edges that bound a facet cannot be traversed in a simple way. Often, we do not require a complete representation of the boundary, but are interested only in the adjacency graph of the polytope's vertices. In these cases, we may use a simplified variant of the DCEL, in which the references to the incident facets are also omitted.

In winged-edge-type structures, each edge node represents an undirected edge in the vertex adjacency graph. When traversing all incident edges of a vertex in counterclockwise order, we need to determine for each visited edge node which of its two vertices is the vertex for which all edges are traversed. This leads to an inefficient case distinction in graph traversals, since it is necessary to determine the direction of each edge node traversed in order to find the proper successor edge node.

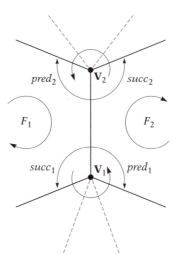

Figure 2.5 The linkage of edge nodes in a winged-edge structure. Each edge node contains references to the incident vertices \mathbf{v}_1 and \mathbf{v}_2 and incident facets F_1 and F_2, as well as four pointers to adjacent edge nodes. Per vertex \mathbf{v}_i, the pointers $succ_i$ and $pred_i$ point to the next and previous edge nodes, respectively, when traversing the edges incident to \mathbf{v}_i in counterclockwise order.

This problem is solved in the *halfedge structure*, in which each undirected edge is represented by a pair of directed edge nodes [74]. For vertex adjacency graphs, each halfedge node stores a reference to a vertex, a pointer to the successor halfedge node of the vertex, and a pointer to the oppositely directed halfedge node that stores the other vertex of the edge.

Winged-edge-type boundary representations are useful for applications where polyhedra are subjected to topological changes. Features can be added and removed in a flexible way. However, in most applications that require collision detection, the boundaries of polyhedra are topologically invariant. Hence, we do not rely on efficient operations for modifying boundary representations. In these cases, we represent the vertex adjacency graph by simply storing for each vertex a set of (pointers to its) adjacent vertices. We denote the set of adjacent vertices of a vertex \mathbf{p} by $\mathrm{adj}(\mathbf{p})$. Thus, for each directed edge from \mathbf{p} to \mathbf{q}, we have $\mathbf{q} \in \mathrm{adj}(\mathbf{p})$.

Both the winged-edge-type structures and the vertex adjacency graph require storage that is linear in the number of edges. The winged-edge structure and the vertex adjacency graph of a polytope can be obtained by using the Quickhull algorithm for convex hulls [7, 101, 104]. A C implementation of this algorithm, Qhull, has been released as open source by the Geometry Center of the University of Minnesota [8], and is included on the accompanying CD-ROM.

The Dobkin-Kirkpatrick Hierarchical Representation

A boundary representation can be used for closest and extreme point queries. However, these type of queries would still take linear time in the worst-case number of vertices of the polytope. In order to speed up such queries, Dobkin and Kirkpatrick devised a hierarchical representation for two- and three-dimensional polytopes that allows these queries to be performed in worst-case logarithmic time [30, 31].

A hierarchical representation of a polytope P is a sequence of polytopes P_1, \ldots, P_k of decreasing complexity, such that $P_1 = P$ and P_h is a simplex. Each polytope P_{i+1} is obtained from its predecessor P_i by removing some vertices from P_i. The set of vertices $S = \text{vert}(P_i) \setminus \text{vert}(P_{i+1})$ is chosen such that S forms an independent set; that is, no two vertices in S are adjacent. Furthermore, all vertices in S have a degree that is at most b, for some constant b, and $|\text{vert}(P_{i+1})|$, the number of vertices in P_{i+1}, is at most $c|\text{vert}(P_i)|$, for some constant $c < 1$. Edelsbrunner has shown that for $b = 8$ and $c = \frac{17}{18}$ such a set S can be constructed using Algorithm 2.1 [38]. Obviously, S can be computed in time linear in the number of vertices. Since in each next polytope P_{i+1} a constant fraction of the vertices is removed, the height h of the hierarchy (i.e., the number of polytopes in the sequence) is $O(\log n)$. Figure 2.6 shows the construction of the hierarchical representation for a convex polygon.

Algorithm 2.1

Computing an independent set S of vertices of polytope P. All vertices in S have a degree that is at most eight.

```
S := ∅;
for p ∈ vert(P) do
begin
    if deg(p) ≤ 8 and "p is not marked" then
    begin
        S := S ∪ {p};
        for q ∈ adj(p) do "mark q"
    end
end
```

Halfspace Representation

In most cases, we will use a representation for polytopes based on vertex data. However, a polytope may also be represented as the intersection of a finite number of closed halfspaces. In fact, any object that is a bounded intersection of a finite number of closed halfspaces is a polytope [61]. We saw that the number of facets of a polytope is linear in its number of

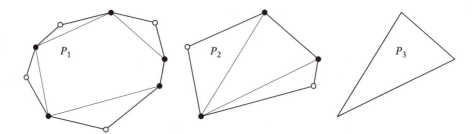

Figure 2.6 The Dobkin-Kirkpatrick hierarchical representation of a polytope. The vertices marked by an open circle are the independent vertices that are removed in the next polytope.

vertices. Since each facet corresponds with a halfspace in the halfspace representation, the minimum number of halfspaces that are required for representing a given polytope is linear in the number of vertices of the polytope.

In some applications, representing a polytope by a collection of halfspaces is more convenient than using a vertex representation. For instance, polytope types that are applied as bounding volumes, such as discrete-orientation polytopes, rely on a halfspace representation. A *discrete-orientation polytope* (DOP) is the intersection of a fixed number of slabs. A *slab* is the intersection of a pair of oppositely oriented half-spaces, that is, a region of space bounded by a pair of parallel planes. Each slab is oriented according to a fixed axis relative to the object's coordinate system. For each DOP we use the same set of axes; hence, the description of the axes is not part of a DOP's representation.

A k-DOP is the intersection of k slabs.[3] For $\mathbf{d}_1, \ldots, \mathbf{d}_k$, a set of axes, we define the k-DOP represented by offsets β_i and η_i, as the point set

$$\{\mathbf{x} \in \mathbb{R}^3 : \beta_i \leq \mathbf{d}_i \cdot \mathbf{x} \leq \eta_i, \text{ for } i = 1, \ldots, k\}.$$

Due to their small storage requirements ($2k$ scalars), k-DOPs are well-suited for use as a bounding volume.

A 3-DOP is better known as a *parallelepiped*, or simply *box*. We commonly use coordinate axes for aligning the three slabs, since this greatly simplifies the dot product computation. For a coordinate axis \mathbf{e}_i, the dot product $\mathbf{e}_i \cdot \mathbf{x}$ is simply the ith component of \mathbf{x}. For notational convenience, we lift the relational operator \leq to three-dimensional space:

$$(\alpha_1, \alpha_2, \alpha_3) \leq (\beta_1, \beta_2, \beta_3) \quad \equiv \quad \alpha_1 \leq \beta_1 \quad \text{and} \quad \alpha_2 \leq \beta_2 \quad \text{and} \quad \alpha_3 \leq \beta_3.$$

3. In contrast with [76], we count the number of slabs rather than the number of halfspaces.

Then, an *axis-aligned box* with minimum **p** and maximum **q** can be described as the point set

$$[\mathbf{p}, \mathbf{q}] = \{\mathbf{x} \in \mathbb{R}^3 : \mathbf{p} \leq \mathbf{x} \leq \mathbf{q}\}.$$

Boxes may alternatively be represented by a center point **c** and extent vector **h**. Again for notational convenience, we lift the absolute value operator to three-dimensional space:

$$|(\alpha_1, \alpha_2, \alpha_3)| = (|\alpha_1|, |\alpha_2|, |\alpha_3|).$$

Then, the box represented by center point **c** and extent vector **h** is the point set

$$\{\mathbf{x} \in \mathbb{R}^3 : |\mathbf{x} - \mathbf{c}| \leq \mathbf{h}\} = [\mathbf{c} - \mathbf{h}, \mathbf{c} + \mathbf{h}].$$

Both representations have their uses in collision detection, as we shall discover further on. To get from min-max to center-extent representation, simply take $\mathbf{h} = \frac{1}{2}(\mathbf{q} - \mathbf{p})$ and $\mathbf{c} = \mathbf{p} + \mathbf{h}$.

2.2.2 **Polygons**

Polygons are currently the most commonly used modeling primitives in 3D graphics. A *polygon* is the region of a plane bounded by a closed chain of line segments that lie in the plane. Let $\mathbf{p}_0, \ldots, \mathbf{p}_{n-1}$ be coplanar points. For $i = 0, \ldots, n - 1$, the $(i + 1)$th line segment in the boundary of the polygon defined by this sequence of points is the segment connecting \mathbf{p}_i and $\mathbf{p}_{i \oplus 1}$, where \oplus denotes addition modulo n. The points are referred to as *vertices* and the segments as *edges*. A polygon is called *simple* if no two edges intersect, other than the edges that share a vertex.

According to this definition, a simple polygon cannot have holes. However, if we allow pairs of identical but oppositely directed edges in the boundary of a polygon, we can represent polygons with holes. For a polygon with a hole, let $\mathbf{p}_0, \ldots, \mathbf{p}_{m-1}$ be a simple polygon in counterclockwise orientation that represents the polygon's outer boundary, and let $\mathbf{q}_0, \ldots, \mathbf{q}_{n-1}$ be a simple polygon in clockwise orientation that represents the hole. By connecting a vertex \mathbf{p}_i on the outer boundary and a vertex \mathbf{q}_j on the inner boundary by a pair of oppositely directed edges, we can represent the polygon with a hole as a single chain of edges.

Special care must be taken in choosing the vertices \mathbf{p}_i and \mathbf{q}_j in order to avoid constructing a nonsimple polygon. First, choose for \mathbf{q}_j a vertex

on the inner boundary that is also a vertex of the convex hull of the inner boundary. It is not necessary to compute the convex hull, since, for a coordinate axis that is not orthogonal to the polygon, a vertex that has the greatest (or least) coordinate value on this axis must be a vertex of the convex hull. Choose the coordinate axis for which the polygon's normal has the least absolute component value, since this axis cannot be a normal. Simply choose as \mathbf{q}_j the vertex with the greatest coordinate value for this axis. We choose \mathbf{p}_i by traversing the outer boundary and checking whether the edge $\mathbf{p}_i\mathbf{q}_j$ does not cross any of the edges of the inner and outer boundaries. It can be seen that at least one such \mathbf{p}_i must exist, since the "view" of the outer boundary from a vertex on the convex hull of the inner boundary is unobstructed for an angle that is larger than π, so at least one vertex on the outer boundary must be "visible." For polygons having multiple holes, this operation is performed repeatedly until all holes have been attached to the outer boundary. In each step, the vertex with the greatest coordinate value of all remaining hole vertices needs to be chosen as \mathbf{q}_j. Note that the order in which the holes are attached to the outer boundary is important. By choosing a vertex on the convex hull of all remaining holes, we make sure that the corresponding hole can be connected to the outer boundary without crossing any of the remaining holes. Figure 2.7 illustrates this construction.

For many applications, a representation of a polygon as a list of vertices suffices. However, sometimes a representation of the supporting plane of a polygon is convenient. We saw earlier how the supporting plane of a triangle is computed. For polygons with more than three vertices, we may compute a supporting plane by selecting three vertices and computing the

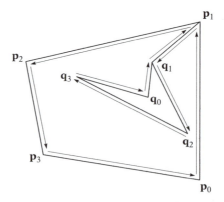

Figure 2.7 Fixing a hole in a polygon. Edges are added between \mathbf{q}_1 and \mathbf{p}_1, since \mathbf{q}_1 is the hole vertex with the greatest y-coordinate and \mathbf{p}_1 is the first vertex "visible" from \mathbf{q}_1.

plane through these vertices. However, there are a number of issues with this approach that might give unwanted results:

- The selected vertices should not be (close to) collinear. Otherwise, the computed normal's length will be (close to) zero. For almost collinear vertices the computation of the normal is numerically unstable, as we will see in Section 2.7.

- The orientation of the triangle formed by the selected vertices may be opposite to the orientation of the polygon.

- The vertices of the polygon are often not exactly coplanar, so different selections of vertices may result in slightly different planes.

A better alternative is Newell's method [122, 123], which produces a plane that approximates the best-fit plane more closely. It can be seen that the components of the normal are proportional to the areas of the projections of the polygon on the planes orthogonal to the corresponding coordinate axes. Newell's method computes the signed areas of these projections in the following way. Let, for $i = 0, \ldots, n-1$, $\mathbf{p}_i = (\alpha_1^{(i)}, \alpha_2^{(i)}, \alpha_3^{(i)})$ be the polygon's vertices. The normal to the plane $\mathbf{n} = (\nu_1, \nu_2, \nu_3)$ is given by

$$\nu_1 = \sum_{i=0}^{n-1} (\alpha_2^{(i)} - \alpha_2^{(i\oplus 1)})(\alpha_3^{(i)} + \alpha_3^{(i\oplus 1)}),$$

$$\nu_2 = \sum_{i=0}^{n-1} (\alpha_3^{(i)} - \alpha_3^{(i\oplus 1)})(\alpha_1^{(i)} + \alpha_1^{(i\oplus 1)}),$$

$$\nu_3 = \sum_{i=0}^{n-1} (\alpha_1^{(i)} - \alpha_1^{(i\oplus 1)})(\alpha_2^{(i)} + \alpha_2^{(i\oplus 1)}).$$

Again, we may need to normalize \mathbf{n} if the application requires it. As offset for the plane equation we take $\delta = -\mathbf{n} \cdot \mathbf{p}$, where \mathbf{p} is the average of the vertices,

$$\mathbf{p} = \frac{1}{n} \sum_{i=0}^{n-1} \mathbf{p}_i.$$

The majority of polygonal models that are used in 3D graphics applications are composed of convex polygons. Popular graphics libraries such as OpenGL [133] support convex polygons only. The reason for this limitation lies in the fact that for convex polygons we can use simpler and faster clipping and rasterization algorithms [43]. In order to use models

composed of nonconvex polygons in such a graphics library, it is necessary to decompose concave polygons into convex subparts, for instance by triangulation. Algorithms for triangulating nonconvex polygons can be found in [101].

Conveniently, convex polygons also allow for faster intersection testing and computation algorithms, as we will see in Chapters 3 and 4. So why bother considering intersection algorithms for nonconvex polygons? Well, some file formats, such as VRML97 [10], as well as some CAD-oriented applications support nonconvex polygons. Since collision detection requires potentially $O(n^2)$ intersection tests for n primitives, we want to keep the number of primitives as small as possible. One way to achieve this is to use algorithms that can handle nonconvex polygons, since then we do not have to decompose concave polygons into multiple convex polygons. Also, keeping concave polygons in one piece saves storage. Nevertheless, we acknowledge that the use of models composed of nonconvex polygons is not widespread, so our main focus will be on convex polygons.

2.2.3 Quadrics

A *quadric* is an object that has quadratic surface elements. Quadrics are considered solids rather than surfaces; that is, the interior is part of the object. We consider convex quadrics, such as spheres, capped cones, and capped cylinders, as primitives. Although for interactive visualization, these shapes are often represented by convex polyhedra, it is possible—and usually more efficient and accurate—to use their exact quadric representation for intersection testing, as we will discover in Chapter 4.

A *sphere* is represented by a center point \mathbf{c} and a radius ρ. A *cone* is represented by a center point \mathbf{c} (halfway between the apex and the base), a unit vector \mathbf{u} that spans its central axis and is directed from the center to the apex, and two positive scalars η (its halfheight) and ρ (its radius at the base). A *cylinder* is represented by a center point \mathbf{c}, a unit vector \mathbf{u} that spans its central axis, and two positive scalars η (its halfheight) and ρ (its radius). See Figure 2.8 for a visual description of these primitives.

In VRML97, the center point and central axis of the quadric and box primitives are fixed and cannot be used as a shape parameter [10]. The local origin and y-axis are taken to be, respectively, the center point and central axis of the primitives. This convention does not restrict the set of objects that can be specified using the language, since the primitives may be placed at arbitrary positions and orientations by applying affine transformations.

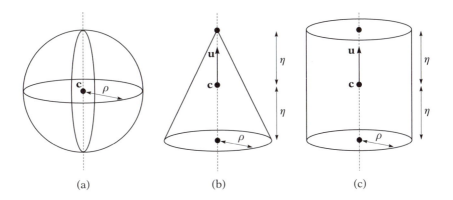

Figure 2.8 The three quadric primitives: (a) sphere, (b) cone, and (c) cylinder.

2.2.4 Minkowski Addition

From the primitives we have seen so far, we can derive more complex shapes by applying Minkowski addition. The *Minkowski sum* of objects A and B is defined as

$$A + B = \{\mathbf{x} + \mathbf{y} : \mathbf{x} \in A, \mathbf{y} \in B\}.$$

At first sight, this definition does not make much sense since we know that addition of points is not allowed. However, we are not exactly adding points here. A point is regarded as a vector from the origin of the given coordinate system to the point. The sum of two such vectors is again regarded as a point by adding it to the origin of the coordinate system. The object $A + B$ is the set of points that is covered by sweeping B's origin over all points of A. As can be seen, Minkowski sums are useful for representing swept volumes. Most commonly used are sphere-swept volumes. A sphere-swept volume is the result of adding a sphere centered at the origin to an arbitrary object. Figure 2.9 shows the sphere-swept volume that results from adding a sphere to a box.

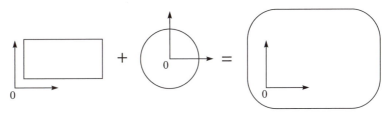

Figure 2.9 The Minkowski sum of a box and a sphere.

A useful property of Minkowski addition is the fact that the sum of two convex objects is convex as well, as shown in Theorem 2.1. Minkowski sums of general convex objects usually have shapes that are difficult to represent explicitly, so algorithms for Minkowski sums generally use an implicit representation.

The sum of two polytopes, however, is itself a polytope, as shown in Theorem 2.2, and can thus be represented using any of the given polytope representations. Theorem 2.2 presents us with a method for computing an explicit representation of the Minkowski sum of a pair of polytopes. Simply construct the set of all combinations $\mathbf{a} + \mathbf{b}$ of vertices of A and B, and compute the convex hull of this set to get a boundary representation of the Minkowski sum. For polytopes A and B that have n vertices each, there are n^2 combinations of vertices of A and B. Computing the convex hull of n^2 points takes $O(n^2 \log n)$ time [7, 104]. The resulting boundary representation of $A + B$ has $O(n^2)$ features.

Theorem 2.1

Let A and B be convex objects. Then, $A + B$ is also convex.

Proof

Let \mathbf{w}_1 and \mathbf{w}_2 be points in $A + B$, and let $\mathbf{x}_1, \mathbf{x}_2 \in A$ and $\mathbf{y}_1, \mathbf{y}_2 \in B$ such that $\mathbf{w}_1 = \mathbf{x}_1 + \mathbf{y}_1$ and $\mathbf{w}_2 = \mathbf{x}_2 + \mathbf{y}_2$. We have to show that any convex combination of \mathbf{w}_1 and \mathbf{w}_2 is a point in $A+B$. A convex combination of \mathbf{w}_1 and \mathbf{w}_2 is described by $\mathbf{w} = \lambda_1\mathbf{w}_1+\lambda_2\mathbf{w}_2$, for $\lambda_1+\lambda_2 = 1$ and $\lambda_1, \lambda_2 \geq 0$. We derive $\mathbf{w} = \lambda_1(\mathbf{x}_1+\mathbf{y}_1)+\lambda_2(\mathbf{x}_2+\mathbf{y}_2) = \lambda_1\mathbf{x}_1+\lambda_2\mathbf{x}_2+\lambda_1\mathbf{y}_1+\lambda_2\mathbf{y}_2 = \mathbf{x}+\mathbf{y}$, where $\mathbf{x} = \lambda_1\mathbf{x}_1 + \lambda_2\mathbf{x}_2$ and $\mathbf{y} = \lambda_1\mathbf{y}_1 + \lambda_2\mathbf{y}_2$; that is, \mathbf{x} is a convex combination of \mathbf{x}_1 and \mathbf{x}_2, and \mathbf{y} is a convex combination of \mathbf{y}_1 and \mathbf{y}_2. Since A and B are both convex, we have $\mathbf{x} \in A$ and $\mathbf{y} \in B$, and thus $\mathbf{w} = \mathbf{x} + \mathbf{y} \in A + B$.

Theorem 2.2

Let A and B be polytopes. Then, $A + B$ is the polytope $\mathrm{conv}(\mathrm{vert}(A) + \mathrm{vert}(B))$, the convex hull of the set of all combinations $\mathbf{a} + \mathbf{b}$, where \mathbf{a} is a vertex of A and \mathbf{b} is a vertex of B.

Proof

This proof is a slightly modified version of the proof presented in [80]. First, we show that $\mathrm{conv}(\mathrm{vert}(A) + \mathrm{vert}(B))$ is a subset of $A + B$, and next (the hard part), we show that $A + B$ is a subset of $\mathrm{conv}(\mathrm{vert}(A)+\mathrm{vert}(B))$.

1. $\mathrm{conv}(\mathrm{vert}(A) + \mathrm{vert}(B)) \subseteq A + B$:
 Since A and B are convex, it follows from Theorem 2.1 that $A+B$ is also convex. Obviously, $\mathrm{vert}(A) + \mathrm{vert}(B) \subseteq A+B$. Since $A+B$ is convex and $\mathrm{conv}(\mathrm{vert}(A)+\mathrm{vert}(B))$ is the smallest convex object containing $\mathrm{vert}(A)+\mathrm{vert}(B)$, it follows that $\mathrm{conv}(\mathrm{vert}(A) + \mathrm{vert}(B))$ is a subset of $A + B$.

2. $A + B \subseteq \text{conv}(\text{vert}(A) + \text{vert}(B))$:

Let \mathbf{w} be a point in $A + B$, and let $\mathbf{x} \in A$ and $\mathbf{y} \in B$ such that $\mathbf{w} = \mathbf{x} + \mathbf{y}$. Furthermore, let $\text{vert}(A) = \{\mathbf{a}_1, \ldots, \mathbf{a}_m\}$ and $\text{vert}(B) = \{\mathbf{b}_1, \ldots, \mathbf{b}_n\}$. Then, there exist $\lambda_i, \sum_{i=1}^{m} \lambda_i = 1, \lambda_i \geq 0$, and $\mu_j, \sum_{j=1}^{n} \mu_j = 1, \mu_j \geq 0$, such that

$$\mathbf{x} = \sum_{i=1}^{m} \lambda_i \mathbf{a}_i \quad \text{and} \quad \mathbf{y} = \sum_{j=1}^{n} \mu_j \mathbf{b}_j.$$

We derive

$$\mathbf{w} = \mathbf{x} + \mathbf{y} = \left(\sum_{i=1}^{m} \lambda_i \mathbf{a}_i \right) + \mathbf{y} = \sum_{i=1}^{m} \lambda_i (\mathbf{a}_i + \mathbf{y})$$

$$= \sum_{i=1}^{m} \lambda_i \left(\mathbf{a}_i + \sum_{j=1}^{n} \mu_j \mathbf{b}_j \right)$$

$$= \sum_{i=1}^{m} \lambda_i \left(\sum_{j=1}^{n} \mu_j \mathbf{a}_i + \sum_{j=1}^{n} \mu_j \mathbf{b}_j \right)$$

$$= \sum_{i=1}^{m} \sum_{j=1}^{n} \lambda_i \mu_j (\mathbf{a}_i + \mathbf{b}_j).$$

Since $\sum_{i=1}^{m} \sum_{j=1}^{n} \lambda_i \mu_j = 1$ and $\lambda_i \mu_j \geq 0$, we find that \mathbf{w} is a convex combination of $\text{vert}(A) + \text{vert}(B)$, and thus must be contained by $\text{conv}(\text{vert}(A) + \text{vert}(B))$.

From step 1 and step 2 it follows that $A + B = \text{conv}(\text{vert}(A) + \text{vert}(B))$.

As mentioned earlier, Minkowski sums are useful for representing swept volumes. However, there is deeper reason why we introduce Minkowski addition. Minkowski sums give us a means to express a number of queries on pairs of objects in terms of their configuration space obstacle. For this purpose we introduce a negation operation on objects:

$$-B = \{-\mathbf{y} : \mathbf{y} \in B\}.$$

The *configuration space obstacle* (CSO) of objects A and B is the object $A + (-B)$, which is abbreviated to $A - B$. The object $A - B$ is the set of all

vectors from a point of B to a point of A, as can be verified by working out the expression. Note that in order for this definition to make sense, the objects must be defined relative to the same coordinate system.

The CSO contains all the information needed to answer a number of queries on pairs of objects in the context of collision detection. First of all, an intersection test can be expressed in terms of the CSO of the query objects, since a pair of objects intersect iff their CSO contains the origin:

$$A \cap B \neq \emptyset \equiv \mathbf{0} \in A - B.$$

This is obvious, since only if the objects intersect, do they have a common point, and thus the vector from this point to itself, which is the zero vector or origin, is contained in the CSO.

The *distance* between two objects A and B, denoted by $d(A, B)$, is defined as

$$d(A, B) = \min\{\|\mathbf{x} - \mathbf{y}\| : \mathbf{x} \in A, \mathbf{y} \in B\}.$$

The distance can be expressed in terms of the CSO as follows:

$$d(A, B) = \min\{\|\mathbf{x}\| : \mathbf{x} \in A - B\}.$$

For any pair of convex objects there exists a unique point in $A - B$ that is closest to the origin. This can be seen by the fact that if there were two such points, then there exists a convex combination of these points that is closer to the origin than $d(A, B)$. But since $A - B$ is convex, the convex combination is contained in $A - B$, and thus its distance to the origin is at least $d(A, B)$, which results in a contradiction. Note that the uniqueness of the point of $A - B$ closest to the origin does not imply that the distance between two convex objects is realized by a unique pair of points. There may exist multiple pairs $\mathbf{a} \in A$ and $\mathbf{b} \in B$, such that $\|\mathbf{a} - \mathbf{b}\| = d(A, B)$. However, all closest pairs map to the same point $\mathbf{a} - \mathbf{b}$ in configuration space.

Similarly, the penetration depth of a pair of objects can be expressed in terms of their CSO. The *penetration depth* of a pair of intersecting objects is the length of the shortest vector over which one of the objects needs to be translated in order to bring the pair in touching contact. The penetration depth $p(A, B)$ of A and B can be expressed as

$$p(A, B) = \inf\{\|\mathbf{x}\| : \mathbf{x} \notin A - B\}.$$

Note that we must use *infimum* (i.e., greatest lower bound) rather than *minimum* since $A - B$ is a closed set. For a pair of intersecting objects, the

penetration depth is realized by a point on the boundary of $A - B$ that is closest to the origin. Such a point is not necessarily unique. Consider the case where A and B are a pair of concentric spheres. For such a pair of objects, all points on the boundary of $A - B$ realize the penetration depth. It can be seen that by translating object B over a vector from the origin to a point on the boundary of $A - B$, the pair is brought in touching contact. Clearly, for a point on the boundary of $A - B$ closest to the origin, the translational distance is the shortest. Figure 2.10 illustrates the relation between a pair of objects and its CSO.

The following property of Minkowski addition is useful when bounding volumes are applied. Let $A \subseteq C$ and $B \subseteq D$. Then,

$$A + B \subseteq C + D.$$

Thus, the Minkowski sum of the bounding volumes of objects A and B is a bounding volume of $A + B$. In the same manner, we find that

$$A - B \subseteq C - D.$$

Thus, the CSO of the bounding volumes of A and B is a bounding volume of $A - B$.

Minkowski sums can be represented explicitly for a number of bounding-volume types. The Minkowski sum $A - B$ of two spheres A and B given by center points \mathbf{c}_A and \mathbf{c}_B and radii ρ_A and ρ_B is itself a sphere with center $\mathbf{c}_A + \mathbf{c}_B$ and radius $\rho_A + \rho_B$. The CSO $A - B$ of these spheres has the same radius, but is centered at $\mathbf{c}_A - \mathbf{c}_B$.

The Minkowski sum of a pair of axis-aligned boxes is itself an axis-aligned box:

$$[\mathbf{p}_1, \mathbf{q}_1] + [\mathbf{p}_2, \mathbf{q}_2] = [\mathbf{p}_1 + \mathbf{p}_2, \mathbf{q}_1 + \mathbf{q}_2].$$

And, for the CSO of two axis-aligned bounding boxes, we find

$$[\mathbf{p}_1, \mathbf{q}_1] - [\mathbf{p}_2, \mathbf{q}_2] = [\mathbf{p}_1 - \mathbf{q}_2, \mathbf{q}_1 - \mathbf{p}_2].$$

Readers familiar with interval arithmetics [117] will recognize these equations as the addition and subtraction of intervals. The plus and minus operations on intervals are, in fact, by definition equivalent to the Minkowski plus and minus.

For a pair of boxes that are represented by centers \mathbf{c}_1 and \mathbf{c}_2 and extents \mathbf{h}_1 and \mathbf{h}_2, the Minkowski sum is the box centered at $\mathbf{c}_1 + \mathbf{c}_2$ and with extent $\mathbf{h}_1 + \mathbf{h}_2$. The CSO is a box of equal extent, centered at $\mathbf{c}_1 - \mathbf{c}_2$.

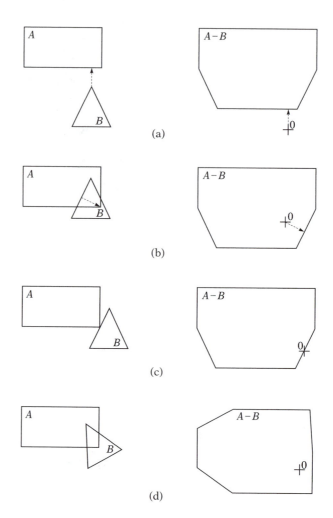

Figure 2.10 A pair of convex objects and the corresponding CSO. (a) Nonintersecting: The origin is outside the CSO. The arrow denotes the distance. (b) Intersecting: The origin is inside the CSO. The arrow denotes the penetration depth. (c) After a translation of B over the penetration depth vector, the objects are in contact. The origin lies on the boundary of the CSO. (d) After a rotation of B, the shape of the CSO changes.

2.2.5 Complex Shapes and Scenes

So far, we have discussed the different types of primitives that are commonly used for building models. Here, we will examine how these shapes are combined to create complex shapes and scenes.

Complex shapes are constructed by grouping primitives. The object represented by a grouping of primitives is the set of points defined by the union of the primitives. We do not consider objects defined by the intersection or set difference of primitives. Such types of object representations are common in constructive solid geometry (CSG), but are not easily dealt with for performing collision detection. We restrict ourselves to unions of objects, since only for unions can we reduce an intersection test involving a complex object to a number of intersection tests for the object's primitives. Let $A \cup B$ be a grouping of two objects A and B, and C an arbitrary object. Then, an intersection test between $A \cup B$ and C,

$$(A \cup B) \cap C \neq \emptyset,$$

can be reduced to

$$A \cap C \neq \emptyset \text{ and } B \cap C \neq \emptyset.$$

Such a reduction is not possible for objects defined by the intersection or set difference of primitives.

The most commonly used complex shape types are triangle and quadrilateral meshes. Meshes are often used for approximating curved surfaces. For storing the incidence relation of the polygons in a mesh we can use the boundary representations discussed on page 24. However, for collision detection of objects represented by meshes we usually do not need the incidence relation of the polygons. Meshes are treated simply as sets of polygons, commonly referred to as *polygon soups*. See Chapter 5 for a discussion of collision detection methods for complex shapes.

It is common practice to define a shape relative to a *local coordinate system*. An object is created by placing the shape's local coordinate system relative to the object's parent coordinate system. In this way, the position, orientation, and scaling of an object within the parent coordinate system can be changed without changing the shape description. Furthermore, multiple objects can be instanced using the same shape, each object being the result of a different placement of the shape's local coordinate system.

Objects can again be grouped together to form even more complex objects, and groups of objects can be given their own local coordinate systems, which are placed in yet another parent coordinate system, and so on. The hierarchical structure we get by using this construction method is commonly known as a *scene graph*. A scene graph is a directed acyclic graph (DAG), that is, a treelike structure in which a single node may have multiple parents. The structure has two types of internal nodes: grouping nodes and transform nodes.

- A *grouping node* simply combines a number of subgraphs. The object represented by a grouping node is the union of the objects represented by its children.

- A *transform node* defines a local coordinate system for its child relative to the parent coordinate system. The object represented by a transform node is the image of the child object under the corresponding affine transformation.

The terminating nodes are the basic shapes in local coordinates. Each root path in a scene graph corresponds with an instance of its terminating shape. The placement of this shape relative to the root coordinate system is given by the composition of all transformations along the root path. Let $\mathbf{T}_1, \ldots, \mathbf{T}_n$ be the affine transformations corresponding with the transform nodes on the root path of the shape. Then, the local coordinate system of the shape relative to the root coordinate system is given by

$$\mathbf{T} = \mathbf{T}_1 \circ \cdots \circ \mathbf{T}_n.$$

Geometric queries on pairs of objects can be answered only if we have representations of the objects relative to the same reference coordinate system. For queries that depend on a metric, such as distance and penetration depth computation, the reference coordinate system should be a Cartesian system. The world coordinate system is an obvious choice for such a reference coordinate system. The world coordinate system is the coordinate system associated with the root of the world scene graph and is by definition Cartesian.

For queries that do not depend on a metric, such as testing for intersections, we may use any coordinate system as the reference system. Usually, it is faster to use one of the objects' local coordinate systems as a reference system, since this saves us coordinate transformations for the object's shape description. In that case, we compute the second object's local coordinate system relative to the first object's. Let \mathbf{T}_A and \mathbf{T}_B be the local coordinate systems of objects A and B, respectively, relative to the world coordinate system. Then, B's local coordinate system relative to A's is simply

$$\mathbf{T}_{BA} = \mathbf{T}_A^{-1} \circ \mathbf{T}_B.$$

A popular file format for describing 3D objects and environments is VRML97 [10]. VRML97 uses a scene graph structure that is similar to what is described above.[4] In VRML97 it is possible to describe dynamic environments in which 3D objects can be animated. In the next section

4. In VRML97 a *Transform* node can have multiple children, so it is in fact the combination of a transform node and a grouping node.

we will have a look at the different types of animation that are commonly used.

2.3 **Animation**

Animation adds a time parameter to the object representation; that is, the set of points that comprises an object is a function of time. Animation is created by changing attributes of a scene graph over time. For collision detection we are interested only in model changes that affect the geometric attributes. We discern two types of motion corresponding with different attributes in a scene graph:

- The most common way to animate a model is by altering the transformations in the transform nodes of the scene graph. We will refer to this type of motion as *placement change*. The placement changes are the result of translations, rotations, and nonuniform scalings on (part of) the model.

- Animation may also be created by changing the geometries of the primitive shapes. This type of motion is called *deformation*. This is most commonly done for objects represented by polygon meshes. Here, the positions of the vertices of the polygons are time-dependent. Deformations may be applied to simulate, for instance, fluids, cloths, or skin.

The majority of placement changes we see in interactive 3D environments are rigid motions, so let's have a closer look at this important group of motions.

Rigid motion is the motion of a *rigid body*—an object that is not subjected to deformation or change of scaling. The placement of a rigid body is given by the position of its local origin and orientation of its local basis. In three-dimensional space, position and orientation have three degrees of freedom (DOFs) each, so a rigid body has a total of six DOFs. For positions, the three DOFs correspond with the three coordinate axes. For orientations, the three DOFs are less obvious. The three angular DOFs become clear from the observation that any orientation of the local basis can be created by a single rotation around an arbitrary axis. The angle of rotation gives us one DOF and the direction of the axis gives us the other two DOFs.

Each orientation of a rigid body corresponds with a special orthogonal matrix (all columns mutually orthogonal and of length 1, and the determinant positive). However, for representing orientations, special orthogonal matrices are not an ideal choice. A 3×3 matrix has nine DOFs corresponding with the nine scalars. The requirement that it has to be special orthogonal constrains six DOFs. The surplus of DOFs in

orientation matrices for rigid bodies tends to become a nuisance when doing motion simulation. Numerical operations such as integration and computing derivatives are performed on nine scalars although only three DOFs are used. Apparently, computations are complicated by the inefficient representation. Moreover, since numerical integration introduces some drift (i.e., an error in the returned value due to discretization of time), the orientation matrix needs to be reorthogonalized after each integration step. All this suggests that we could benefit from a more economical representation for orientations.

Since an orientation has three DOFs, any representation should use at least three scalars. We can represent an orientation using only three scalars. The three scalars represent the angles of rotation around three well-chosen axes. The common name for such a triple of angles is *Euler angles*. Another representation that is often better suited for doing motion simulation are quaternions. Quaternions use four scalars. However, for the purpose of representing orientations, it suffices to store only three of the four scalars, since one of the components can be deduced from the other three, as we shall see further on.

Euler angles exist in different formats depending on the choice of axes. The three angles are commonly referred to as the *roll*, *pitch*, and *yaw*, corresponding with the x-, y-, and z-axis, respectively, as shown in Figure 2.11. Note that the order in which each rotation is applied is important. A roll rotation over $\frac{1}{2}\pi$ followed by a pitch rotation over $\frac{1}{2}\pi$ will give a different orientation than a pitch rotation over $\frac{1}{2}\pi$ followed by a roll rotation over $\frac{1}{2}\pi$. Conventionally, the roll is applied first, then the pitch rotation, and finally the change of heading.

Although rotations have three DOFs, the rotation space does not really map nicely to a three-dimensional vector space. Since Euler angles are actually a forced mapping of rotation space to a linear space, certain artifacts exist that make the use of Euler angles for motion simulation somewhat awkward. This forced mapping of the rotation space is comparable to the mapping of a global map to the plane. There is not really a nice way to represent a global map in the plane. For a Mercator projection we see that the poles are stretched to lines. The poles are the *singularities* of the projection—a point on the globe corresponds with multiple points on the map. Also, the shortest line segment between two points on the planar map does not generally correspond with the shortest arc between the points on the globe.

For Euler angles we have similar artifacts. A single orientation can be represented using many different triples of Euler angles. For instance, a roll rotation over $\frac{1}{2}\pi$ followed by a pitch rotation over $\frac{1}{2}\pi$ results in the same orientation as a pitch rotation over $\frac{1}{2}\pi$ followed by a yaw rotation over $-\frac{1}{2}\pi$. The same orientation can be achieved by performing a roll rotation over $-\frac{1}{2}\pi$ followed by a pitch rotation over $\frac{1}{2}\pi$ followed by a yaw

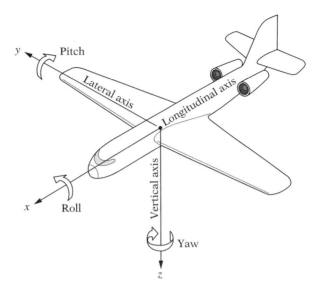

Figure 2.11 The conventional use of yaw, pitch, and roll.

rotation over π. In fact, there is an infinite number of Euler triples that result in the same orientation, since any roll rotation can be canceled out by a yaw rotation after a pitch rotation over $\frac{1}{2}\pi$.

As with the poles on a Mercator projection, Euler angles suffer from singularities, since there exist orientations that correspond with an infinite number of Euler angles. It is possible to prove that any mapping of rotation space to a three-dimensional linear space will contain singularities. Also, linear interpolation of two triples of Euler angles does not generally give you the smoothest interpolation in rotation space. Moreover, the conversion from a triple of Euler angles to a 3×3 orientation matrix involves evaluating the sine and cosine for each angle. For an orientation given by the triple (ϕ, θ, ψ), where ϕ is yaw, θ is pitch, and ψ is roll, we find the matrix

$$\begin{bmatrix} \cos\phi\cos\theta & -\sin\phi\cos\psi+\cos\phi\sin\theta\sin\psi & \sin\phi\sin\psi+\cos\phi\sin\theta\cos\psi \\ \sin\phi\cos\theta & \cos\phi\cos\psi+\sin\phi\sin\theta\sin\psi & -\cos\phi\sin\psi+\sin\phi\sin\theta\cos\psi \\ -\sin\theta & \cos\theta\sin\psi & \cos\theta\cos\psi \end{bmatrix}.$$

This conversion is computationally more expensive than performing the conversion from quaternions to orientation matrices, which we discuss further on. Notably, computations of the sines and cosines of each of the three angles take a considerable amount of processing.

Although they have some limitations, Euler angles do have their use in animation. They are quite useful in configurations where some of the angular DOFs are constrained. For instance, the knees of a walking figure have only one angular DOF, and the shoulder joints usually have only two DOFs. For these types of joints, one or more angles are fixed and the remaining angles can be constrained to a "safe" range, so there is no risk of running into a singularity. Usually it is easier to manipulate the free Euler angles directly rather than impose additional constraints on the relative orientations.

For rigid bodies that have all three angular DOFs, *quaternions* are better suited for representing orientations. The quaternion algebra is a generalization of complex numbers. A quaternion is a quadruple of the form

$$\mathbf{q} = \alpha_0 + i\alpha_1 + j\alpha_2 + k\alpha_3,$$

where $i^2 = j^2 = k^2 = -1$, $ij = -ji = k$, $jk = -kj = i$, and $ki = -ik = j$. The *conjugate* of \mathbf{q}, denoted by \mathbf{q}^*, is the quaternion

$$\mathbf{q}^* = \alpha_0 - i\alpha_1 - j\alpha_2 - k\alpha_3.$$

The quaternion space behaves as a four-dimensional vector space with respect to addition and scalar multiplication. The *norm* of a quaternion \mathbf{q} is the squared length of this four-dimensional vector:

$$N(\mathbf{q}) = \alpha_0^2 + \alpha_1^2 + \alpha_2^2 + \alpha_3^2 = \mathbf{q}\mathbf{q}^* = \mathbf{q}^*\mathbf{q}.$$

The noncommutative product rule gives quaternions their special properties that make them useful for representing orientations. Quaternion multiplication has the property

$$N(\mathbf{q}_1\mathbf{q}_2) = N(\mathbf{q}_1)N(\mathbf{q}_2).$$

As a result of this, the set of unit quaternions, that is, $N(\mathbf{q}) = 1$, forms a subgroup with unit 1 $(= 1 + i0 + j0 + k0)$ and inverse $\mathbf{q}^{-1} = \mathbf{q}^*$.

Quaternions can be used for rotating points about the origin. For this purpose we regard a point $\mathbf{x} = (\alpha_1, \alpha_2, \alpha_3)$ as a quaternion $\hat{\mathbf{x}} = i\alpha_1 + j\alpha_2 + k\alpha_3$. The rotation defined by a unit quaternion \mathbf{q} is given by

$$\hat{\mathbf{x}}' = \mathbf{q}\hat{\mathbf{x}}\mathbf{q}^*.$$

Given an axis \mathbf{v}, $\|\mathbf{v}\| = 1$, and an angle θ, the rotation around \mathbf{v} over θ is represented by the unit quaternion

$$\mathbf{q} = \cos(\theta/2) + \hat{\mathbf{v}}\sin(\theta/2),$$

where $\hat{\mathbf{v}}$ is the quaternion representation of vector \mathbf{v}. In the context of rotations, the four components of a unit quaternion are often referred to as *Euler parameters*. Note that Euler angles and Euler parameters are different concepts!

As with Euler angles, unit quaternions do not have a one-on-one relation with orientations in three-dimensional space either; however, quaternions are far less problematic for representing orientations. As can be seen, each orientation corresponds with exactly two unit quaternions. For \mathbf{q}, a unit quaternion, \mathbf{q} and $-\mathbf{q}$ represent the same orientation. In fact, we can represent an orientation by the vector part of a unit quaternion only, since its scalar part α_0 can be determined from the other three components. Note that, since \mathbf{q} and $-\mathbf{q}$ represent the same orientation, we can choose, for each orientation, a unit quaternion that represents this orientation and for which α_0 is nonnegative. For this unit quaternion $\alpha_0 + i\alpha_1 + j\alpha_2 + k\alpha_3$, we know that

$$\alpha_0 = \sqrt{1 - \alpha_1^2 - \alpha_2^2 - \alpha_3^2}.$$

So, for representing orientations in this way, we need to store only three of the four Euler parameters.

Of course, the reduction in storage space does not always justify the added cost of computing α_0 from the other three parameters. Furthermore, constraining all results of quaternion operations to a four-dimensional hemisphere complicates matters to some extent, so intermediate results are better allowed the full quaternion unit sphere as range. Nevertheless, it is good to know that converting the vector part of a unit quaternion to an orientation matrix is still a lot cheaper than converting a triple of Euler angles to an orientation matrix. So, if you have to store an orientation using only three scalars, then the quaternion format is preferable.

The conversion from unit quaternions to special orthogonal matrices follows directly from the rotation operation. Since quaternion multiplication uses only scalar addition and scalar multiplication, the matrix can be found by working out the expression $\mathbf{q}\hat{\mathbf{x}}\mathbf{q}^*$. For a unit quaternion $\mathbf{q} = \alpha_0 + i\alpha_1 + j\alpha_2 + k\alpha_3$, we find the matrix

$$\begin{bmatrix} 1 - 2(\alpha_2^2 + \alpha_3^2) & 2(\alpha_1\alpha_2 - \alpha_0\alpha_3) & 2(\alpha_1\alpha_3 + \alpha_0\alpha_2) \\ 2(\alpha_1\alpha_2 + \alpha_0\alpha_3) & 1 - 2(\alpha_1^2 + \alpha_3^2) & 2(\alpha_2\alpha_3 - \alpha_0\alpha_1) \\ 2(\alpha_1\alpha_3 - \alpha_0\alpha_2) & 2(\alpha_2\alpha_3 + \alpha_0\alpha_1) & 1 - 2(\alpha_1^2 + \alpha_2^2) \end{bmatrix}.$$

Notice that in each element of the matrix, quaternion components occur only in second-degree terms—terms that are the product of two quaternion components. Thus, indeed we find the same matrix for \mathbf{q} and $-\mathbf{q}$.

Quaternions behave a lot better than Euler angles in animation. Interpolation of a sequence of orientations can be done smoothly by following curves over the four-dimensional unit sphere, without the necessity of handling singularities [112]. Also, for motion simulation, it pays to use quaternions for representing the orientation of the rigid bodies. The derivative $\dot{\mathbf{q}}$ of a quaternion \mathbf{q} can be determined directly from the angular velocity vector ω:

$$\dot{\mathbf{q}} = \frac{1}{2}\hat{\omega}\mathbf{q}.$$

Again, $\hat{\omega}$ is the quaternion representation of the vector ω. There are some advantages of using quaternions over special orthogonal matrices for rigid body simulations. Since a quaternion representation uses fewer scalars, we have to carry out fewer operations for numerical integration. Also, in order to cancel out numerical drift, matrices need to be reorthogonalized, whereas quaternions merely need to be renormalized, which is a much simpler operation.

2.4 **Time**

In the real world, time is assumed to be continuous—the time interval between two instances of time can be arbitrarily short. The placement of an object is given for each instance of time. In computer simulation, time is discrete. Object placements are given at discretely sampled instances of time only. By making the interval between two samples small enough, we can suggest continuously moving objects. The observer of the simulation is not aware that the object placements between two consecutive samples are not actually there.

However, if we would perform collision detection for these discretely sampled instances of time only, we might end up detecting collisions too late or not at all, as illustrated in Figure 2.12. Missing collisions may result in behavior that will be observed as incorrect. For instance, a high-speed object, such as a bullet fired from a gun, may pass through an obstacle, such as a wall, without resulting in a collision for any of the sampled times. We can reduce the possibility of this happening by increasing the sampling rate. However, if the speed of an object is unbounded, there always remains the possibility that a collision is not detected. Moreover, using a higher sampling rate is not always an option in real-time applications, since it increases the computational load of a simulation.

This suggests that we need to solve the collision detection problem as an intersection test in continuous four-dimensional space (space-time). The object placements between two sampled instances of time are

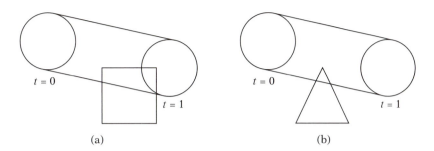

Figure 2.12 Problems when detecting collisions at discrete time steps: (a) too late; (b) missed.

obtained by interpolating the sampled placements. The four-dimensional objects that we test for intersection are the result of extruding the three-dimensional objects along their interpolated placements over the time interval. Solutions to the four-dimensional intersection detection problem have been presented for a restricted class of objects and motions [13, 14, 17, 37, 71, 105, 108]. However, in many common cases, the four-dimensional object that is the extrusion of a three-dimensional object in motion is often geometrically too complex to make a four-dimensional intersection test at interactive rates computationally feasible. For instance, it is hard to test the space-time extrusion of a spinning object, such as a propellor or a fan, for intersection with the extrusion of another moving object.

For objects that have fixed orientations or are invariant under rotations, the swept volume is simply the Minkowski sum of the object in local coordinates and the line segment connecting the sampled positions of the object at the start and end of the time interval.[5] Let A and B be fixed-orientation objects given in local coordinates, and \mathbf{p}_t and \mathbf{q}_t the positions of their respective local origins at time $t \in [0, 1]$. For the times $t = 0$ and $t = 1$, the positions are given by the sampled placements. The in-between positions are the result of linear interpolation; thus $\mathbf{p}_t = (1 - t)\mathbf{p}_0 + t\mathbf{p}_1$. Then, the configuration of the objects at time t is $A + \{\mathbf{p}_t\}$ and $B + \{\mathbf{q}_t\}$. For a collision between the objects at time t, we derive

$$(A + \{\mathbf{p}_t\}) \cap (B + \{\mathbf{q}_t\}) \neq \emptyset \equiv \mathbf{0} \in A + \{\mathbf{p}_t\} - (B + \{\mathbf{q}_t\})$$
$$\equiv \mathbf{0} \in A - B - (\{\mathbf{q}_t\} - \{\mathbf{p}_t\})$$

5. Strictly speaking, the Minkowski sum is not a four-dimensional object. In order to make it four-dimensional, we should assign to each point of the line segment the corresponding time as time component, and zero as time component of the object.

$$\equiv \mathbf{0} \in A - B - \{\mathbf{q}_t - \mathbf{p}_t\}$$
$$\equiv A - B \cap \{\mathbf{q}_t - \mathbf{p}_t\} \neq \emptyset$$
$$\equiv \mathbf{q}_t - \mathbf{p}_t \in A - B.$$

Thus, the objects collide at time t iff $\mathbf{q}_t - \mathbf{p}_t$ is contained in their CSO given in local coordinates. A collision occurred on the time interval $[0, 1]$ iff the line segment $\mathbf{q}_t - \mathbf{p}_t = (1 - t)(\mathbf{q}_0 - \mathbf{p}_0) + t(\mathbf{q}_1 - \mathbf{p}_1)$, $t \in [0, 1]$, intersects with the CSO. The time of the collision is the earliest t for which $\mathbf{q}_t - \mathbf{p}_t$ is contained by $A - B$. Such a query that returns the first point of intersection of a line segment (ray) and an arbitrary query object is called a *ray cast*. In the case where we do not need to know the time or points of collision, but only require to know whether the objects intersect at some point in the given time frame, simply testing the intersection of the line segment and the CSO suffices. We will talk some more about ray casts and line segment intersection tests in the following chapters.

What to do with rotating objects? We may deal with objects that have angular DOFs by encapsulating them by a bounding sphere. For objects that have only one angular DOF, a line-symmetrical volume, such as a cylinder or a cone, may in some cases be a more sensible choice. The four-dimensional intersection test is performed for the bounding volumes rather than for the actual objects. This approach will detect high-speed objects passing through obstacles; however, the time of collision returned for a bounding volume may not be the actual time of collision for the encapsulated object. It is even possible that a collision is detected for the bounding volume, whereas the encapsulated object does not collide at all. The best that we can get from a four-dimensional intersection test on bounding volumes is a subinterval of time where the encapsulated object potentially collided. If accuracy is an issue, exact intersection tests for placements on the returned subinterval are necessary to establish whether the encapsulated object did indeed collide.

In some cases you may get away with the following simplified four-dimensional intersection test of objects with angular DOFs. When the maximum angular velocity is rather low, orientations do not change a lot between frames. Thus, a good approximation of the trajectory of such objects can be obtained by changing the orientations instantaneous at fixed time steps, and only interpolating the positions of the objects in between frames. In this way, we can use the discussed ray-cast technique for fixed-orientation objects, since orientations are assumed to be invariant in between frames. Of course, this simplification results in rather poor accuracy for fast spinning objects. However, if the center of rotation is contained in the object, then the collision test is guaranteed not to suffer from the bullet-wall problem. See Figure 2.13 for an illustration of these solutions.

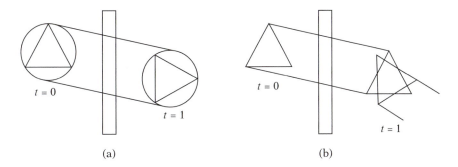

Figure 2.13 Solutions for simplified four-dimensional intersection tests on rotating objects. (a) Encapsulation: The rotating object is encapsulated by a sphere. Since spheres are invariant under rotations, a four-dimensional intersection test is easier on spheres. (b) Instantaneous orientation changes: Orientations are assumed to be invariant between frames.

2.5 **Response**

Obviously, the reason for performing collision detection is to have some form of response to a collision. For some forms of collision response, no additional data pertaining to the geometry of the colliding objects are needed. For instance, in a game, the response to a collision of two objects is often the deletion of one or both objects, and an update of the game statistics. However, for most forms of collision response, additional data are used for response computations. For instance, in VR applications the exact spot where the simulated hand of the operator touches an object is often required for collision response. Here, a common point of the object and the hand is the collision data.

In the application of collision detection to physics-based simulations, it is necessary to have (an approximation of) the time of collision, a contact normal, and a contact point for a colliding pair of objects in order to compute the reaction forces or impulses that resolve the collision. A *contact point* is a point where the objects first touch, and a *contact normal* is a normal to a plane that passes through the contact point and is oriented such that it separates the objects near the contact point. More formally, the intersections of the objects with an ε-neighborhood of the contact point (i.e., a small sphere with radius ε and the contact point as center) lie on different sides of the plane, as depicted in Figure 2.14. It is assumed that by choosing ε small enough, each object's intersection with the ε-neighborhood can be regarded as a convex set; hence, a contact plane always exists. Note that neither a contact point nor a contact normal is necessarily unique.

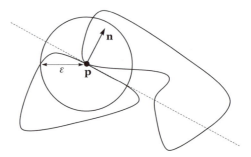

Figure 2.14 The contact region described by a contact point **p** and a contact normal **n**.

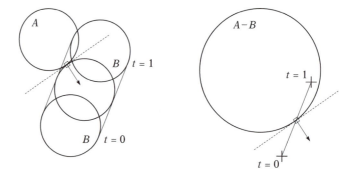

Figure 2.15 Computing a contact point (open dot) and contact normal (arrow) of fixed-orientation objects by performing a ray test on the CSO of the objects.

As we saw earlier, we can compute the exact time of collision for a restricted set of objects and motions. For fixed-orientation objects, the time of collision, a contact plane, and a contact normal can be computed by performing a ray test on the CSO of the objects, as described in Section 2.4. The contact point is the point where the ray enters the CSO, and the contact normal is the normal to the boundary of the CSO at this point. Figure 2.15 shows an example of the ray test for spheres. Note that for the contact point we find a point on the boundary of the CSO that does not necessarily map uniquely to a contact point on either object. For instance, multiple contact points exist for objects that collide face-to-face or edge-to-face. It is usually not hard to find a contact point on the objects given a contact point on the CSO, as we will see further on.

For arbitrary objects and motions, computing the exact time of collision is not always feasible. For these cases, we may approximate the time of collision by bisection. Suppose we have for $t = 0$ a nonintersecting configuration and for $t = 1$ an intersecting configuration of two objects.

By repeatedly bisecting the time interval and performing an intersection test for the configuration at the bisection time, we can find an arbitrary short interval $[t_0, t_1]$ for which the configuration at t_0 is nonintersecting and the configuration at t_1 is intersecting. It goes without saying that such an approach is computationally expensive, since each bisection step requires an intersection test. Furthermore, it is not guaranteed that bisection gives us the earliest collision time if the objects' status changes multiple times from nonintersecting to intersecting during the time interval. For interactive applications, we often do not bother to approximate the collision time in this way and simply take $t = 0$ or $t = 1$ as the collision time.

For computing a contact point and a contact normal we have several options. Suppose we found a pair of intersecting objects at $t = 1$. In general, this means that at $t = 1$ the objects overlap to some extent. Given a configuration of intersecting objects, we have to estimate a contact normal and contact point that best describe the contact region at the time of collision.

Good estimations for the contact point and contact normal are achieved by using the configuration at $t = 0$, the time step prior to the collision. For this purpose, a pair of closest points of the objects at $t = 0$ are determined. A *pair of closest points* is a pair of points, one from each object, such that their distance is the shortest of all point pairs. We use the difference of the closest points as the contact normal, which is a fairly good approximation of the actual contact normal, as depicted in Figure 2.16. The closest points are used as contact points.

The accuracy of the contact points and contact normal derived from a pair of closest points depends on the velocities of the objects.

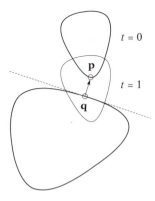

Figure 2.16 For a pair of closest points **p** and **q** at $t = 0$, the difference $\mathbf{p} - \mathbf{q}$ is a good approximation of a contact normal.

For fast-moving or spinning objects, the closest point pair at $t = 0$ may differ considerably from the actual contact data. Again, we can use bisection to find a nonintersecting configuration of the objects at a time closer to the time of collision. For such a configuration the closest points describe the contact data more accurately.

Another way to get more accurate contact data from the closest points is by applying a skin-bone technique. For intersection testing, we use slightly enlarged objects. The enlarged objects are defined by the Minkowski sums of the original objects and a tiny sphere. Such a Minkowski sum thus represents the set of points that lie at a distance of at most the sphere's radius from the original object. When a collision between the sphere-swept objects is detected, we check whether the original objects intersect as well. If so, then we use bisection to find a configuration in which the sphere-swept objects (the skins) intersect, but the plain objects (the bones) do not. For such a configuration, the closest-points pair of the plain objects can be used as a better approximation of the contact points and contact normal. By tweaking the size of the sphere, accuracy can be traded for performance and vice versa. A large sphere needs fewer bisection steps to find a proper configuration, but results in poorer accuracy, than a small sphere.

The skin-bone technique takes a lot of processing time and is therefore less suited for interactive applications. Also, in order for the closest-points approach to be usable, the configuration of (bone) objects at $t = 0$ must be nonintersecting. This requirement can be quite hard to establish when there are lots of interactions between objects in a scene. Therefore, it might be better to rely solely on the collision configuration at $t = 1$ for computing the contact data.

An approximation of the contact normal can also be found by computing the penetration depth vector. The penetration depth vector is computed for the collision configuration at $t = 1$. As contact points, we take the points on the boundaries of the intersecting objects that are the witness points of the penetration depth vector. As for closest points, the penetration depth vector results in fairly accurate contact data for most intersecting configurations of objects. However, for some configurations we may get undesired results, as shown in Figure 2.17. We see that for the rectangle example, the penetration depth vector is orthogonal to the actual contact normal. Nevertheless, computing the penetration depth is quite useful for interactive applications, since it does not require bisection of the time interval and does not fail because of earlier intersecting configurations.

There exist a number of techniques for physics-based collision resolution. In impulse-based methods, the impulse that (partially) reverses the relative velocity of the contact points is pointed along the contact normal. In penalty-based methods, a spring is attached to the contact points

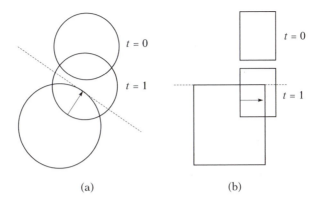

(a) (b)

Figure 2.17 Using the penetration depth vector for approximating a contact normal: (a) fairly accurate and (b) inaccurate.

that pushes the objects out of each other. A discussion of methods used for physics-based simulations falls outside the scope of this book. The reader is referred to [36] for a thorough treatment of techniques used for interactive dynamics simulations.

2.6 **Performance**

In interactive computer animation, the available computational time per frame for collision detection is bound by the desired frame rate. In order to experience real-time response, the frame rate needs to be around 30 to 60 frames per second. We see that this real-time constraint imposes quite strict demands upon the performance of the used collision detection methods.

Often, performance can be gained at the cost of higher memory usage. For instance, faster algorithms often require special shape representations or reuse cached data from earlier computations. Although in many cases memory usage is less critical than performance, the amount of available memory nevertheless imposes a hard constraint on the used methods and shape representations. On the other hand, memory access is slow on current computer platforms. So, a reduction in the amount of memory processed by an algorithm may have a positive effect on the performance. Thus, we also have to take the amount of memory used into account in choosing a collision detection method. In this section, we discuss a number of efficiency considerations that may govern the choice of algorithm for collision detection.

2.6.1 **Frame Coherence**

Under the assumption that the changes per frame are small (i.e., the motion is smooth), the computations for detecting collisions are repeated for mostly the same input values. By caching and reuse of earlier computations the computation time per frame may be greatly reduced. The measure of reusability of computations from earlier frames is called *frame coherence*.

Witnesses play an important role in the exploitation of frame coherence. A *witness* is some piece of data pertaining to the current configuration of a pair of objects that can be used for quickly answering future intersection queries on the objects, provided that the configuration does not change much. A witness may be either positive (i.e., the objects intersect) or negative (i.e., the objects are disjoint). An example of a positive witness is a common point of both objects. For convex objects, we may use a *separating plane* or a *separating axis* (i.e., an axis orthogonal to a separating plane) as a negative witness. A closest-points pair may be used both as a positive and a negative witness. We will discuss the computation of these witnesses for convex objects in Chapter 4.

The use of cached witnesses is based on the idea that testing whether a witness from a previous frame is still valid in the current frame is cheaper than repeating the witness computation from scratch for the current frame. For instance, a point containment test is cheaper than an object intersection test for many object types. Therefore, if a witness from a previous frame is likely to be a witness in the current frame, as a result of a high degree of frame coherence, we may save ourselves some time by first testing the validity of the cached witness in the current frame. Only if the witness test fails does an expensive collision test need to be performed, which may result in a new witness being computed.

Besides the cost of testing their validity, some additional overhead costs are involved when using witnesses. The witnesses need to be cached in a data structure and retrieved in the following frames, which obviously takes some time. Therefore, it is wise to cache witnesses only if they have a high probability of being valid witnesses in the following frames. In computer animation, collisions are usually resolved rather than maintained. Hence, in this context, negative witnesses are more useful than positive witnesses, since most object pairs will be disjoint most of the time.

2.6.2 **Geometric Coherence**

Another type of coherence, which we will refer to as *geometric coherence*, may also be exploited for improving the performance of collision

(a) (b)

Figure 2.18 The amount of geometric coherence in a collection of triangles: (a) little coherence and (b) much coherence.

detection. Geometric coherence is the quality of a complex model that expresses the degree in which the objects in the model can be ordered geometrically. It is hard to give a formal definition of the notion of geometric coherence, since the notion is strongly related to the method of ordering that is applied. However, we shall try to give a formal definition that is more or less independent of a specific ordering method.

Geometric coherence of a complex model is best described as the degree of *separability* of the set of objects in the model. Two objects are separable if the regions defined by the convex hulls of the objects are disjoint. The degree of separability decreases if the degree of overlap among the convex hulls increases. Figure 2.18 shows two sets of triangles: one has very little geometric coherence, and the other a lot.

It may sound awkward that a model that has more space between the components has more geometric coherence than a model in which all the objects are interlinked. We should keep in mind that geometric coherence has to do with the degree to which a location in space can be associated with one designated object, rather than the degree to which objects cohere.

A *bounding volume* is a simple primitive that encloses a more complex shape and for which a cheap intersection test exists. If the probability that the bounding volumes of the objects intersect is low (i.e., there is a lot of geometric coherence among the objects in a model), we may save ourselves some time by first testing the bounding volumes for intersection. Only for the objects whose bounding volumes intersect do we need to perform an exact and expensive intersection test. Again, the use of bounding volumes requires some additional storage and computational cost, so performance is gained only if the bounding volumes have a high probability of being disjoint.

2.6.3 **Average Time**

In order to attain the best average performance by exploiting coherence, collision detection is typically done as a sequence of intersection tests of increasing computational cost. Except for the last test, each test establishes an answer to the intersection query only for a portion of all possible configurations of objects. The last test must return an answer for all the remaining configurations. Here, an answer may be either positive or negative. A test in the sequence needs to be performed only if the previous test failed; that is, it did not establish an answer to the query.

For instance, an intersection test of two geometric objects may consist of a bounding-volume test and an exact intersection test. The common terms for these steps in a collision detection framework are *broad phase* and *narrow phase*, respectively [72]. If the bounding volumes of the two objects do not intersect, then a negative answer is returned; thus, the bounding-volume test is successful. Otherwise, we need to do an exact intersection test.

Let S_1, \ldots, S_n be a sequence of intersection tests that is used for answering an intersection query, and let f_i represent the event that test S_i fails, and C_i, the average time necessary for performing S_i. We can define the average time of an intersection query as

$$T_{\mathrm{avg}} = \sum_{i=1}^{n} P[f_1 \cdots f_{i-1}]C_i,$$

where $P[f_1 \cdots f_{i-1}]$ is the probability of failure of tests S_1, \ldots, S_{i-1} for a given input domain. Often, C_i depends on the size of the input. For instance, testing whether two polygons intersect takes an amount of time that is linear in the total number of vertices of the two polygons (see Chapter 3). Hence, the average time for performing an intersection query is often a function of the input size.

It is our goal to design collision queries as a sequence of tests for which, given a realistic input domain, the worst-case time never exceeds a given time constraint. However, since collision query times vary a lot between best and worst cases, and since absolute worst cases are rare, we often abandon the hard real-time requirement and shoot for optimal average timings. Since we will be performing a lot of these collision queries per frame, it is considered unlikely that the total time per frame spent on collision detection will stray far from the average query time. It can be seen that the best times are gained by using tests S_i for which both $P[f_i|f_1 \cdots f_{i-1}]$ (i.e., the probability of the test failing under the condition that the former tests failed) and C_i are small.

The next question to answer is how the values for the probabilities and cost are determined. The cost values may be found by counting the

number of primitive operations in a single intersection test. Primitive operations are, for instance, arithmetic operations (additions, subtractions, multiplications, and divisions), branch instructions, and memory accesses. We often express the cost of a test routine by the number of arithmetic operations only.

For more complex intersection tests that depend on the input size, expressing the cost in primitive operations is often not feasible. In these cases, we determine the cost empirically. For a given implementation and input size, the cost is measured by running a large number of tests for a representative input domain using a profiling tool, such as gprof [42]. Of course, the measured values are only valid for the given implementation, input size, and testing platform, and thus, we need to apply our findings with some restrictions.

The probability values are also best found empirically by running a large number of tests. Although a field of probability theory called *stochastic geometry* [119] can be applied for determining these values for some configurations of objects, the majority of object types and input domains are too complex for an analytic approach to be feasible. The probability values can be found simply by counting the number of times each intersection test is called. For this purpose, we may also use a profiling tool.

2.7 Robustness

Geometry is the theoretical basis for deriving collision detection algorithms. In these theoretical algorithms, scalars are assumed to be real numbers, and scalar operations are assumed to be exact. However, for implementations of these algorithms that run on a computer, infinite-precision number representations and arithmetics are either not possible or computationally very expensive.

Generally, we represent the scalars in collision detection algorithms by floating-point numbers. Floating-point arithmetic is not exact. Since floating-point numbers have a finite precision, the result of a floating-point operation may deviate from the theoretical result due to rounding of the result to the given precision. The error introduced by rounding the result of an arithmetic operation may cause all sorts of problems in our algorithms. This section explains what sort of problems you can expect and how to cope with them.

2.7.1 Floating-Point Numbers

A floating-point number format is given by a base β, a mantissa size p (precision), and an exponent size q. The floating-point numbers that can

be represented using this format are of the form

$$\pm m \times \beta^e,$$

where m, the *mantissa*, is a number represented by p base-β digits such that

$$1 \le m < \beta,$$

and e, the *exponent*, is an integer represented by q base-β digits. Usually, the range of the exponent is defined by an exponent bias b such that the exponent is taken to be the unsigned integer represented by the q base-β digits minus the bias,

$$-b < e < \beta^q - b.$$

Notice that it is not possible to represent the number zero using this format. For this purpose, the value $e = -b$ is reserved. The number zero is represented by the floating-point number $\pm 1.0 \times \beta^{-b}$. In base-2 floating point formats such as the popular IEEE Standard 754, the most significant digit of the mantissa is always one and can thus be left out of the mantissa representation.

Floating-point numbers have a certain range. The largest number that can be represented is

$$\alpha_{\max} = (1 - \beta^{-p})\beta^{\beta^q - b},$$

and the smallest positive number is[6]

$$\alpha_{\min} = \beta^{1-b}.$$

The result of an arithmetic operation may fall outside the range of floating-point numbers. If the absolute value of the result is greater than α_{\max}, we speak of *overflow*. If the absolute value of the result is less than α_{\min} but greater than zero, we speak of *underflow*. Problems due to numbers that are out of range are less common and are not discussed here. The reader is referred to [55] for a more thorough discussion of out-of-range problems in floating-point arithmetic.

The main source of headache is the fact that the results of arithmetic operations are rounded to the nearest representable floating-point number. The distance between two consecutive floating-point numbers in the

6. In the IEEE Standard 754 it is possible to represent smaller numbers by allowing denormalized mantissas ($m < 1$) for $e = 1 - b$.

interval $[\beta^{e-1}, \beta^e]$ is β^{e-p}. For each real number $\alpha \in [\beta^{e-1}, \beta^e]$, there exists a floating-point number $\tilde{\alpha} \in [\beta^{e-1}, \beta^e]$, such that $|\alpha - \tilde{\alpha}| \leq \frac{1}{2}\beta^{e-p}$. Under the assumption that floating-point operations return the floating-point number closest to the actual result, the greatest relative error introduced by a floating-point operation is $\frac{1}{2}\beta^{1-p}$. Thus, for α, the result of an arithmetic operation, and $\tilde{\alpha}$, the floating-point number after rounding, there exists an η, such that

$$\tilde{\alpha} = \alpha(1 + \eta), \quad |\eta| \leq \frac{1}{2}\beta^{1-p}.$$

The number $\epsilon = \frac{1}{2}\beta^{1-p}$ is called the *machine epsilon*.

A relative error of ϵ in the result of an arithmetic operation seems pretty harmless; however, problems may occur when further operations are performed on the already contaminated floating-point values. Notably, subtracting two almost equal floating-point values introduces a large relative error. Let floating-point numbers $\tilde{\alpha}_1$ and $\tilde{\alpha}_2$ be the result of arithmetic operations, and let η_1 and η_2 be their respective relative errors with respect to their theoretical values α_1 and α_2. Thus, $\tilde{\alpha}_1 = \alpha_1(1 + \eta_1)$ and $\tilde{\alpha}_2 = \alpha_2(1 + \eta_2)$. For $\gamma = \alpha_1 - \alpha_2$, we find the computed value

$$\tilde{\gamma} = (\tilde{\alpha}_1 - \tilde{\alpha}_2)(1 + \eta_\ominus),$$

where η_\ominus is the rounding error introduced by the floating-point subtraction. The relative error in $\tilde{\gamma}$ is found as follows:

$$\tilde{\gamma} = (\alpha_1(1 + \eta_1) - \alpha_2(1 + \eta_2))(1 + \eta_\ominus)$$
$$= (\alpha_1 - \alpha_2 + \alpha_1\eta_1 - \alpha_2\eta_2)(1 + \eta_\ominus)$$
$$= (\alpha_1 - \alpha_2)\left(1 + \frac{\alpha_1\eta_1 - \alpha_2\eta_2}{\alpha_1 - \alpha_2}\right)(1 + \eta_\ominus).$$

Assume that the earlier computations for α_1 and α_2 were fairly accurate; thus $\eta_i = O(\epsilon)$, for $i = 1, 2$. For small relative errors we ignore higher-order terms in η_i, which are terms that contain products of relative errors η_i. We then find as an upper bound for the relative error in $\tilde{\gamma}$,

$$\frac{|\tilde{\gamma} - \gamma|}{|\gamma|} \leq \frac{|\alpha_1\eta_1| + |\alpha_2\eta_2|}{|\alpha_1 - \alpha_2|} + \epsilon.$$

Now, suppose that α_1 and α_2 are almost equal ($\alpha_1 \approx \alpha_2$). Then, we see that the relative error in $\tilde{\gamma}$ can be huge. The relative error can be orders of magnitude larger than ϵ, in which case the least-significant digits in the

Table 2.1 Arithmetic operations and their upper bounds for the relative error in the computed floating-point value. η denotes the relative error in the floating-point representation of the corresponding parameter α.

γ	Upper bound for $\frac{	\tilde{\gamma} - \gamma	}{	\gamma	}$		
$\alpha_1 + \alpha_2$	$\frac{	\alpha_1 \eta_1	+	\alpha_2 \eta_2	}{	\alpha_1 + \alpha_2	} + \epsilon$
$\alpha_1 - \alpha_2$	$\frac{	\alpha_1 \eta_1	+	\alpha_2 \eta_2	}{	\alpha_1 - \alpha_2	} + \epsilon$
$\alpha_1 \alpha_2$	$	\eta_1	+	\eta_2	+ \epsilon$		
α_1 / α_2	$	\eta_1	+	\eta_2	+ \epsilon$		
α^2	$2	\eta	+ \epsilon$				
$\sqrt{\alpha}$	$\frac{1}{2}	\eta	+ \epsilon$				
$\alpha_1^{\alpha_2}$	$	\alpha_2 \eta_1	+	\alpha_1^{\alpha_2} \ln(\alpha_1)\eta_2	+ \epsilon$		

mantissa are meaningless. This loss of significant digits in the mantissa due to subtraction is called *cancellation* and is the source of all sorts of numerical problems in geometric algorithms. Table 2.1 shows the upper bound in the relative error for a number of arithmetic operations. As can be seen, addition and subtraction are the most problematic.

The number of contaminated digits in the mantissa of a floating-point number $\tilde{\gamma}$ that represents the real number γ is

$$c = \left\lceil \log_\beta \frac{|\tilde{\gamma} - \gamma|}{|\gamma|\epsilon} \right\rceil.$$

So, the number of significant digits in the mantissa of $\tilde{\gamma}$ is $p - c$. In the IEEE Standard 754, the floating-point formats are base 2, and thus, $\epsilon = 2^{-p}$. The single-precision (32-bit) floating-point format has $p = 24$, and the double-precision (64-bit) format has $p = 53$.

2.7.2 Stability

Huge relative errors in computed values are bad enough as it is. They can be levered to dramatic proportions by the algorithm that uses the values as input parameters. In some algorithms, a small change in the input parameters can give rise to a huge change in the returned value. Such algorithms are called *unstable*.

For example, let us examine the computation of the signed distance of a point \mathbf{x} to the plane given by a normal \mathbf{n} and a point \mathbf{p}. For $\|\mathbf{n}\| = 1$, the signed distance is $\delta = \mathbf{n} \cdot (\mathbf{x} - \mathbf{p})$. Suppose the computed normal $\tilde{\mathbf{n}}$ has a direction that is slightly different from the direction of the theoretical normal \mathbf{n}. Then, the absolute error in the computed signed distance for \mathbf{x} is

$$|\tilde{\delta} - \delta| = |(\tilde{\mathbf{n}} - \mathbf{n}) \cdot (\mathbf{x} - \mathbf{p})|.$$

We see that the error is larger for points \mathbf{x} that lie further from \mathbf{p}. If the distance between \mathbf{x} and \mathbf{p} is orders of magnitude larger than the distance of \mathbf{x} to the plane, then a slight relative error in $\tilde{\mathbf{n}}$ can give rise to a huge relative error in $\tilde{\delta}$.

Let's illustrate this example by performing the computations for floating-point numbers represented using $\beta = 10$ and $p = 4$. Note that this number format serves purely as illustration. The single-precision IEEE 754 format holds roughly twice as many base-10 digits in the mantissa and should therefore generate much smaller errors.

Suppose we computed \mathbf{n} as the normal to the triangle given by the points

$$\mathbf{p}_0 = (3.856 \times 10^0, 4.074 \times 10^0, 8.278 \times 10^0),$$

$$\mathbf{p}_1 = (1.000 \times 10^0, 1.000 \times 10^0, 1.000 \times 10^0), \quad \text{and}$$

$$\mathbf{p}_2 = (1.001 \times 10^0, 9.996 \times 10^{-1}, 9.992 \times 10^{-1}).$$

Thus, \mathbf{n} is the normalized cross product $\mathbf{v}_1 \times \mathbf{v}_2$, where $\mathbf{v}_1 = \mathbf{p}_1 - \mathbf{p}_0$ and $\mathbf{v}_2 = \mathbf{p}_2 - \mathbf{p}_0$. We see that that \mathbf{p}_1 and \mathbf{p}_2 lie close to each other and that \mathbf{p}_0 lies at some distance from these points. Thus, the vectors \mathbf{v}_1 and \mathbf{v}_2 are relatively close to each other, in which case $\mathbf{v}_1 \times \mathbf{v}_2$ is close to being zero. For the computed values of the vectors \mathbf{v}_1 and \mathbf{v}_2, we find

$$\tilde{\mathbf{v}}_1 = (-2.856 \times 10^0, -3.074 \times 10^0, -7.278 \times 10^0) \quad \text{and}$$

$$\tilde{\mathbf{v}}_2 = (-2.855 \times 10^0, -3.074 \times 10^0, -7.279 \times 10^0).$$

The computation of the cross product returns

$$\tilde{\mathbf{v}}_1 \times \tilde{\mathbf{v}}_2 = \begin{bmatrix} 2.238 \times 10^1 - 2.237 \times 10^1 \\ 2.078 \times 10^1 - 2.079 \times 10^1 \\ 8.779 \times 10^0 - 8.776 \times 10^0 \end{bmatrix}.$$

This is where cancellation shows its devastating effect. The computed value for $\tilde{\mathbf{v}}_1 \times \tilde{\mathbf{v}}_2$ is $(1.0 \times 10^{-2}, -1.0 \times 10^{-2}, 3.0 \times 10^{-3})$, whereas the precise value for $\mathbf{v}_1 \times \mathbf{v}_2$ would be $(-4.52 \times 10^{-4}, -9.563 \times 10^{-3}, 4.216 \times 10^{-3})$. After normalization, we find

$$\tilde{\mathbf{n}} = (6.916 \times 10^{-1}, -6.916 \times 10^{-1}, 2.075 \times 10^{-1}),$$

which differs substantially from what we would find given a higher precision:

$$\mathbf{n} = (-4.321 \times 10^{-2}, -9.142 \times 10^{-1}, 4.031 \times 10^{-1}).$$

We see that the relative error introduced by rounding is large enough to enable a change of sign in the first component of the computed normal.

If we take $\mathbf{p} = \mathbf{p}_0$ as a point in the plane, then we find for the computed signed distance of \mathbf{p}_2 to the plane,

$$\tilde{\delta} = \tilde{\mathbf{n}} \cdot (\mathbf{p}_2 - \mathbf{p}_0) = \tilde{\mathbf{n}} \cdot \tilde{\mathbf{v}}_2 = -1.359 \times 10^0.$$

Whereas, if we take $\mathbf{p} = \mathbf{p}_1$ as a point in the plane, we find for the computed signed distance of \mathbf{p}_2 to the plane,

$$\tilde{\delta} = \tilde{\mathbf{n}} \cdot (\mathbf{p}_2 - \mathbf{p}_1) = 8.022 \times 10^{-4}.$$

The exact signed distance of \mathbf{p}_2 to the plane of course is zero. The relative error in $\tilde{\mathbf{n}}$ resulted in a much larger error in the computed signed distance of \mathbf{p}_2 for $\mathbf{p} = \mathbf{p}_0$ than for $\mathbf{p} = \mathbf{p}_1$, since \mathbf{p}_2 lies much further away from \mathbf{p}_0 than from \mathbf{p}_1.

This type of behavior occurs in many different forms in geometric algorithms. We have to keep an eye open for values that can have huge relative errors due to rounding. If used in unstable algorithms, large relative errors can create all sorts of numerical havoc. Understanding the source of a numerical problem is the first step. The next step is fixing it.

2.7.3 Coping with Numerical Problems

Obviously, the easiest way to solve a numerical problem is increasing the precision. Changing from single-precision to double-precision or even quadruple-precision (128-bit) floating-point numbers may in some cases get you out of the mud. If this does not help, then switching to a software library for arbitrary precision arithmetic, such as the GNU Multiple Precision Arithmetic Library (GMP), will give you the necessary precision.

However, switching to a higher-precision floating-point format is not always desirable from a storage and performance point of view. Increasing the precision results in a larger storage usage for storing the scalar values. Of course, we can use higher-precision floating-point numbers for intermediate results only and store the final results in single precision. So, the increase in storage usage should not be that dramatic.

The increase in computation time for higher-precision floating-point arithmetic can, however, become a problem for interactive applications. In geometric algorithms, floating-point operations take up the larger part of the computations. So, an increase in computation time for floating-point operations invariably results in a substantial drop in performance for geometric algorithms.

Modern platforms for interactive 3D media can perform single-precision floating-point arithmetic parallel in hardware. At best, a switch to double-precision arithmetic results in fewer floating-point operations per second, since the hardware cannot perform as many double-precision operations in parallel as single-precision operations. At worst, the hardware is not capable of handling higher-precision numbers, and thus, the floating-point operations have to be performed in software, using up valuable CPU time. So, in order to warrant a sufficient performance, the decision to use single-precision floating-point numbers is often made out of necessity rather than choice.

Single-precision numbers generally have ample precision for geometric computations as performed in interactive 3D applications. However, certain degeneracies in the input, such as the case described in the previous section where the normal of an oblong triangle is computed, result in huge errors that cause our algorithms not to perform as expected. The general trick to solving or at least coping with these numerical problems is modifying the algorithm such that degeneracies in the input do not trigger bad behavior. There are several strategies to modifying problematic algorithms:

- If an algorithm is unstable for a certain input, then use a more stable algorithm for this input. For instance, in the case of computing the signed distance of a query point to a plane given by a normal and a point in the plane, store multiple points in the plane and pick the one closest to the query point for doing the signed-distance computation.

- Detect degeneracies in the input and either pass on them or process them in a simplified manner. For instance, if the input is a triangle having almost collinear vertices, then regard it as a line segment. Since it is not possible to compute a normal to a line segment, the signed-distance algorithm has to pass on the input. In some queries, a sensible answer exists even for triangles with collinear vertices. For instance, the query

whether or not a pair of triangles intersect can be answered for triangles that have collinear vertices. However, the algorithm for answering the query may require the triangles to have a nonzero normal. In such a case, we drop the superfluous vertex of a degenerate input triangle and use an algorithm for testing the intersection of a line segment and a triangle.

■ We can use assertions in the theoretical algorithm to detect misbehavior in the finite-precision algorithm. For instance, after computing the plane of a triangle, we can check whether the vertices of the triangle are sufficiently close to the plane. In theory, the vertices should lie in the plane, so if they are at some distance from the computed plane, we know the algorithm suffered from numerical errors. Usually, there is not a lot we can do to return an accurate result after detecting misbehavior of the algorithm. However, we can prevent the algorithm from making an even bigger mess by not allowing it to continue on values that are contaminated by numerical errors.

Numerical problems are the toughest to tackle in geometric algorithms. Algorithms that behave perfectly on test input may run into numerical problems as soon as you apply them to real-life input. Real-life input is full of cases you never thought about when designing the algorithm. Real-life objects can differ by orders of magnitude in size, they can be composed of many more primitives than your test input, they have a higher probability of having degeneracies, and last but not least, real-life simulations have a tendency to generate configurations of objects that are problematic. For instance, in real life, objects are never overlapping; however, a lot of objects are in resting contact. So, a real-life simulation will often generate configurations of barely touching objects, which are the hard cases for collision detection, as we shall see.

As long as we are using finite-precision arithmetic, it is impossible to safeguard ourselves from running into numerical problems. However, we can take some actions to find out as soon as possible where numerical problems might occur.

■ First of all, use real-life input as early as possible in the development of the algorithms. By using the input domain of the real-life application that is going to use the algorithm, you are not only confronted with numerical problems early in the development of your algorithm, but you also get an idea of the performance of the algorithm.

■ It is a good idea to develop an algorithm using double- or higher-precision floating-point numbers in order to make sure that the theoretical algorithm is doing what it should. However, when you are confident that the algorithm is correct, try running it using single-precision

floating-point numbers, even if you plan to use double-precision numbers in the final version. The single-precision algorithm will help you track down numerical problems much faster.

■ "Measure" the relative error in the computed values by simultaneously performing the same computations using both single- and higher-precision arithmetic. By comparing the results for the different precisions, you should get an idea of the relative error in the single-precision numbers. Alternatively, estimate an upper bound for the accumulated relative error using the formulas given in Table 2.1. This can be done automatically in the code while running the algorithm.

The companion CD-ROM contains a C++ header of a tracer class for floating-point numbers. By replacing the scalars in our programs by instances of this tracer class, an estimated upper bound for the accumulated relative error is computed at run time for all arithmetic operations. In this way, potentially unstable expressions can be tracked down quickly, simply by executing the programs compiled using the tracer class.

3

Basic Primitives

Elementary, my dear Watson.
—Sherlock Holmes

In this chapter we discuss intersection tests for a number of basic primitives. The primitives we consider are spheres, boxes, line segments (rays), triangles, and general polygons. These are the most commonly used primitives in interactive 3D applications. Spheres and boxes are popular bounding-volume types, whereas triangles and polygons are in general the components from which complex models are built. This chapter provides intersection tests for any combination of these primitives.

3.1 Spheres

Spheres are probably the simplest type of primitives for geometric modeling. A sphere can be represented using only four scalars (three for the center point and one for the radius), so they are quite cheap to store. Furthermore, spheres are invariant under rotations, which makes them a good candidate as a bounding volume for rigid bodies. In many applications, spheres are also used as active areas in which events are triggered. For instance, a sliding door that opens when an avatar approaches the door can be simulated by detecting whether the avatar intersects a sphere that represents the active area of the door. An *avatar* is an object in a 3D world that represents the user who is viewing the world from the location of the object. Both the avatar itself as well as the area of the world that is visible/audible by the user are often represented as spheres.

3.1.1 Sphere–Sphere Test

Due to their simplicity, collision detection of spheres is not that hard. Two spheres A and B intersect iff the distance between their centers \mathbf{c}_A and \mathbf{c}_B

is at most the sum of their radii ρ_A and ρ_B:

$$A \cap B \neq \emptyset \equiv \|\mathbf{c}_A - \mathbf{c}_B\| \leq \rho_A + \rho_B.$$

We want to avoid the evaluation of square roots as much as possible, since square roots take more time to compute than primitive arithmetic operations such as additions and multiplications. So, for our implementations we rewrite the expression as

$$A \cap B \neq \emptyset \equiv \|\mathbf{c}_A - \mathbf{c}_B\|^2 \leq (\rho_A + \rho_B)^2,$$

which uses only primitive arithmetic operations. The distance between a pair of spheres is the distance between their centers minus the sum of their radii—that is, if the spheres do not intersect, because then the distance is of course zero:

$$d(A, B) = \max(\|\mathbf{c}_A - \mathbf{c}_B\| - (\rho_A + \rho_B), 0).$$

We find a similar expression for the penetration depth, which is zero for nonintersecting objects:

$$p(A, B) = \max(\rho_A + \rho_B - \|\mathbf{c}_A - \mathbf{c}_B\|, 0).$$

The witness points for both a nonzero distance and a nonzero penetration depth are computed in the same way. Let $\mathbf{v} = \mathbf{c}_A - \mathbf{c}_B$, the vector from B's center to A's center. Then, the points

$$\mathbf{p}_A = \mathbf{c}_A - \rho_A \frac{\mathbf{v}}{\|\mathbf{v}\|} \quad \text{and} \quad \mathbf{p}_B = \mathbf{c}_B + \rho_B \frac{\mathbf{v}}{\|\mathbf{v}\|}$$

are the witness points for either the distance or the penetration depth, as can be verified by computing the distance between these points. Note that these expressions are valid only for nonconcentric spheres. For a pair of concentric spheres, \mathbf{v} is the zero vector, and thus the expressions result in division by zero. For concentric spheres, choose an arbitrary nonzero vector \mathbf{v}, preferably one of unit length, since this saves normalization, and compute the witness points for the penetration depth using this vector.

3.1.2 Ray-Sphere Test

In Section 2.4, we saw that a four-dimensional space-time collision test on a pair of spheres can be done by performing a ray cast on the CSO of the spheres in local coordinates. A ray is a line segment connecting a source point \mathbf{s} and a target point \mathbf{t}. For the four-dimensional intersection test, the points \mathbf{s} and \mathbf{t} are the differences $\mathbf{c}_B - \mathbf{c}_A$ of the centers at $t = 0$

and $t = 1$, respectively. If the ray intersects the CSO, then the *ray cast* returns the smallest $\lambda \in [0, 1]$ for which the point $\mathbf{x} = \mathbf{s} + \lambda(\mathbf{t} - \mathbf{s})$ is contained in the CSO. The CSO of a pair of spheres is itself a sphere centered at $\mathbf{c}_A - \mathbf{c}_B$ and with a radius ρ equal to $\rho_A + \rho_B$, the sum of the radii of the spheres. For the ray cast we use the CSO of the spheres in local coordinates (i.e., centered at the origin); thus the CSO is centered at the origin as well. The ray cast is performed in the following way.

Let the direction of the ray be given by the vector $\mathbf{r} = \mathbf{t} - \mathbf{s}$. First, we compute the intersection of the unbounded line $\mathbf{x} = \mathbf{s} + \lambda \mathbf{r}$ and the sphere. The points of intersection of the line and the sphere's boundary are given by

$$\mathbf{x} = \mathbf{s} + \lambda \mathbf{r} \quad \text{and} \quad \|\mathbf{x}\| = \rho.$$

We substitute the first expression in the second and square out the square root,

$$\|\mathbf{s} + \lambda \mathbf{r}\|^2 = \rho^2.$$

This quadratic equation needs some rewriting in order to find the roots:

$$
\begin{aligned}
\|\mathbf{s} + \lambda \mathbf{r}\|^2 = \rho^2 &\equiv \|\mathbf{s} + \lambda \mathbf{r}\|^2 - \rho^2 = 0 \\
&\equiv \|\mathbf{s}\|^2 + 2\lambda(\mathbf{s} \cdot \mathbf{r}) + \lambda^2 \|\mathbf{r}\|^2 - \rho^2 = 0 \\
&\equiv \|\mathbf{r}\|^2 \lambda^2 + 2(\mathbf{s} \cdot \mathbf{r})\lambda + \|\mathbf{s}\|^2 - \rho^2 = 0.
\end{aligned}
$$

Thus,

$$\lambda_{1,2} = \frac{-\mathbf{s} \cdot \mathbf{r} \pm \sqrt{(\mathbf{s} \cdot \mathbf{r})^2 - \|\mathbf{r}\|^2(\|\mathbf{s}\|^2 - \rho^2)}}{\|\mathbf{r}\|^2}.$$

A solution exists only if

$$(\mathbf{s} \cdot \mathbf{r})^2 - \|\mathbf{r}\|^2(\|\mathbf{s}\|^2 - \rho^2) \geq 0.$$

This should not be too much of a surprise, since after rewriting this expression as

$$\|\mathbf{s}\|^2 - \left(\frac{\mathbf{s} \cdot \mathbf{r}}{\|\mathbf{r}\|}\right)^2 \leq \rho^2,$$

we see that the left-hand side is the squared distance of the origin to the line, as can be verified in Figure 3.1. The line intersects the sphere iff the distance between the origin and the line is at most the sphere's radius.

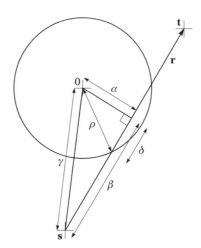

Figure 3.1 The distance α of the origin to the line $\overline{\mathbf{st}}$ is found using the Pythagorean theorem, $\alpha^2 + \beta^2 = \gamma^2$. Here, $\beta = -\mathbf{s} \cdot \mathbf{r}/\|\mathbf{r}\|$ and $\gamma = \|\mathbf{s}\|$. Thus, we find $\alpha^2 = \|\mathbf{s}\|^2 - (\mathbf{s} \cdot \mathbf{r}/\|\mathbf{r}\|)^2$. The line intersects the sphere only if $\alpha^2 \leq \rho^2$, in which case the closest common point of the ray and the sphere lies at a distance of $\beta - \delta$ from \mathbf{s}, where $\delta^2 = \rho^2 - \alpha^2$.

The ray itself intersects the sphere iff $[\lambda_1, \lambda_2] \cap [0, 1] \neq \emptyset$. This is the case iff $\lambda_1 \leq 1$ and $\lambda_2 \geq 0$. If $\lambda_1 > 1$, then the ray did not reach far enough to hit the sphere. If $\lambda_2 < 0$, then the ray is pointing away from the sphere. In the case where the ray intersects the sphere, the parameter for the point where the ray enters the sphere is $\lambda_{enter} = \max(\lambda_1, 0)$. The value λ_{enter} can be used as the time of collision of the spheres in the four-dimensional intersection test. The interval of time where the spheres are intersecting is $[\lambda_{enter}, \lambda_{exit}]$, where $\lambda_{exit} = \min(\lambda_2, 1)$. Note that if λ_{exit} does not need to be returned, the value λ_2 is used only for testing whether it is at least zero. In that case, we can leave out the division by $\|\mathbf{r}\|^2$ in the computation of λ_2.

If $0 \leq \lambda_1 \leq 1$, then the point $\mathbf{x} = \mathbf{s} + \lambda_1\mathbf{r}$ is the point where the ray enters the sphere. The normal to the boundary at this point is \mathbf{x}, regarded as the vector from the origin to \mathbf{x}. If $\lambda_1 < 0 < \lambda_2$, then the point \mathbf{s} is an internal point of the sphere, and thus the ray does not enter the sphere. Algorithm 3.1 summarizes the operations that are performed for a ray cast.

Algorithm 3.1 A ray cast for a ray $\overline{\mathbf{st}}$ and a sphere centered at the origin having radius ρ. The intersection of the ray and the sphere is represented by the interval $[\lambda_{enter}, \lambda_{exit}]$. The point where the ray enters the sphere is returned as \mathbf{x}.

$$\mathbf{r} := \mathbf{t} - \mathbf{s};$$
$$\sigma := (\mathbf{s} \cdot \mathbf{r})^2 - \|\mathbf{r}\|^2(\|\mathbf{s}\|^2 - \rho^2);$$

```
if σ ≥ 0 then
    {{Line x = s + λr intersects the sphere. }}
    begin
        λ₁ := (−s · r − √σ)/‖r‖²;
        λ₂ := (−s · r + √σ)/‖r‖²;
        if λ₁ ≤ 1 and λ₂ ≥ 0 then
            {{The ray intersects the sphere, since [λ₁, λ₂] ∩ [0, 1] ≠ ∅. }}
            begin
                λₑₙₜₑᵣ := max(λ₁, 0);
                λₑₓᵢₜ := min(λ₂, 1);
                x := s + λₑₙₜₑᵣr;
                return true
            end
    end;
return false
```

For a ray of infinite length, we can use almost the same computation. An infinite ray is represented by a source point \mathbf{s} and a unit vector \mathbf{r}. The ray is the set of points $\mathbf{x} = \mathbf{s} + \lambda\mathbf{r}$, where $\lambda \geq 0$. Algorithm 3.1 is greatly simplified for infinite rays, since the condition $\lambda_1 \leq 1$ does not have to be checked and all occurrences of $\|\mathbf{r}\|^2$ can be removed.

Let us explore the potential numerical problems in Algorithm 3.1. Suppose that the length of \mathbf{s} is orders of magnitude greater that ρ, $\|\mathbf{s}\| \gg \rho$, and that the ray is pointing at the sphere. Then, $(\mathbf{s} \cdot \mathbf{r})^2 \approx \|\mathbf{r}\|^2\|\mathbf{s}\|^2$, and thus, the relative error in $\tilde{\sigma}$, the computed value of σ, can become quite large. So, the computed value $\tilde{\sigma}$ may be negative when the theoretical value σ is nonnegative or vice versa. Furthermore, suppose that $\tilde{\sigma} \geq 0$ and that the ray is long enough to hit the sphere, $\tilde{\lambda}_1 \leq 1$. Then, the computed value $\tilde{\mathbf{x}}$ for the point where the ray enters the sphere may not lie exactly on the sphere's boundary. We see that the long-range accuracy of the ray cast is limited. Using an infinite ray, $\|\mathbf{r}\| = 1$, for long-range ray casts does not make a dramatic difference, since this will reduce the relative error in $\tilde{\sigma}$ only by a small factor. So, in practical applications of the ray cast, it is best to use relatively short rays, or, for infinite rays, ignore hits with distant spheres.

3.1.3 Line Segment–Sphere Test

For cases where the points of intersection of the ray with the sphere's boundary are of no interest, a simpler test can be used. A line segment intersects a sphere iff the point on the segment closest to the sphere's center is contained by the sphere. A point on the line segment is a point $\mathbf{x} = \mathbf{s} + \lambda\mathbf{r}$, for some $\lambda \in [0, 1]$. We first solve this problem without the

constraint $\lambda \in [0, 1]$ and compute the parameter λ for the closest point on the unbounded line through the segment. This is the point $\mathbf{x} = \mathbf{s} + \lambda\mathbf{r}$ for which the vector from the sphere's center to \mathbf{x} is orthogonal to the direction of the line. Thus, for the closest point we have $\mathbf{x} \cdot \mathbf{r} = 0$. We substitute $\mathbf{x} = \mathbf{s} + \lambda\mathbf{r}$ in the latter equation and find

$$(\mathbf{s} + \lambda\mathbf{r}) \cdot \mathbf{r} = 0.$$

This equation gives us the parameter $\lambda = -\mathbf{s} \cdot \mathbf{r}/\|\mathbf{r}\|^2$. If $\lambda \leq 0$, then \mathbf{s} is the closest point of the line segment. If $\lambda \geq 1$, then \mathbf{t} is the closest point. Otherwise, if $0 < \lambda < 1$, then the closest point is an internal point of the line segment. Algorithm 3.2 describes this intersection test.

Algorithm 3.2

An intersection test for a line segment $\overline{\mathbf{st}}$ and a sphere centered at the origin having radius ρ. The point \mathbf{x} is the point of the line segment closest to the sphere's center.

```
r := t − s;
δ := −s · r;
if δ ≤ 0 then x := s
else if δ ≥ ‖r‖² then x := t
else
begin
   λ := δ / ‖r‖²;
   {{0 < λ < 1}}
   x := s + λr
end;
return ‖x‖² ≤ ρ²
```

The closest point \mathbf{x} is also the witness point on the line segment for the distance and the penetration depth. The distance is $\max(\|\mathbf{x}\| - \rho, 0)$, and the penetration depth is $\max(\rho - \|\mathbf{x}\|, 0)$. As witness on the sphere we can use the point $\rho\mathbf{x}/\|\mathbf{x}\|$—that is, if \mathbf{x} is not the zero vector. In the degenerate case where the line segment contains the origin, we may use any point $\rho\mathbf{y}/\|\mathbf{y}\|$, for which $\mathbf{y} \perp \mathbf{r}$, as the witness point on the sphere. A good choice is $\mathbf{y} = \mathbf{r} \times \mathbf{e}_i$, where \mathbf{e}_i is the coordinate axis on which \mathbf{r} has the smallest absolute coordinate ($|\mathbf{v} \cdot \mathbf{e}_i|$ is the smallest). In this way, \mathbf{y} can never be zero.

3.2 Axis-Aligned Boxes

Axis-aligned boxes are the most widely used type of bounding volumes because they are easy to compute, cheap to store, and fast to test for

intersection. For axis-aligned boxes represented using min-max representation, testing the intersection is simply done by comparing the extrema:

$$[\mathbf{p}_1, \mathbf{q}_1] \cap [\mathbf{p}_2, \mathbf{q}_2] \neq \emptyset \quad \equiv \quad \mathbf{p}_1 \leq \mathbf{q}_2 \text{ and } \mathbf{p}_2 \leq \mathbf{q}_1.$$

Testing the intersection of a pair of boxes in center-extent representation is not much harder:

$$[\mathbf{c}_1 - \mathbf{h}_1, \mathbf{c}_1 + \mathbf{h}_1] \cap [\mathbf{c}_2 - \mathbf{h}_2, \mathbf{c}_2 + \mathbf{h}_2] \neq \emptyset \quad \equiv \quad |\mathbf{c}_1 - \mathbf{c}_2| \leq \mathbf{h}_1 + \mathbf{h}_2.$$

The center-extent test uses a few arithmetic operations but performs three scalar comparisons and branch instructions fewer than the min-max test. On a platform that has parallel hardware for performing arithmetic operations, the difference in performance is negligible.

3.2.1 Ray-Box Test

For performing a ray cast on an axis-aligned box we enter the realm of line segment clipping. If we merely need to test a line segment for intersection with an axis-aligned box, then the separating-axes test, discussed in Section 3.3, is likely to be faster. There is a considerable amount of literature available on line segments [11, 32, 33, 43, 78]. We borrow techniques from two popular line clippers, Cohen-Sutherland (CS) [43] and Liang-Barsky (LB) [78]. Originally, CS and LB were presented for clipping in 2D; however, both algorithms can be readily generalized to 3D. We will give brief descriptions of the algorithms.

CS uses a classification of points with respect to the six planes supporting the facets of the box. The classification is represented by a 6-bit *outcode*, in which each bit corresponds with a plane. A bit in the outcode is 1 iff the point lies "outside" the corresponding plane—in the positive open halfspace of the plane for plane normals pointing outward. We see that a point that is contained by the box is classified as 000000. If the outcodes of the ray's endpoints contain the same bit (i.e., their bitwise AND is nonzero), then the ray does not hit the box, since the corresponding plane separates the ray from the box. If the bitwise AND of the outcodes of the ray's endpoints is zero, the ray may still miss the box, as illustrated in Figure 3.2 for the 2D case.

We need to compute the parameters of the intersection points of the ray and the planes, and, for this purpose, we use a technique from the LB parametric line clipping algorithm. Let \mathbf{s} be the source point and \mathbf{t} be the target point of the ray. Then, an intersection point can be expressed as $\mathbf{s} + \lambda(\mathbf{t} - \mathbf{s})$, where $\lambda \in [0, 1]$ is its parameter. By classifying the intersection

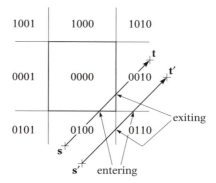

Figure 3.2 A ray cast for axis-aligned boxes using techniques from Cohen-Sutherland and Liang-Barsky line clipping. The ray intersects the box iff the largest parameter of an entering intersection point is at most the smallest parameter of an exiting intersection point.

point as *entering* or *exiting*, we can decide whether the ray hits the box. An intersection point is classified as *entering* if moving from **s** to **t** we go from the positive to the negative halfspace of the corresponding plane, and *exiting* otherwise. It can be seen that a ray intersects the box iff the largest parameter of an entering intersection point is at most the smallest parameter of an exiting intersection point.

We will now explain why CS and LB make such a good team. First of all, under the assumption that the bitwise AND of the outcodes of the end-points is zero, the 1 bits in either of the two outcodes correspond with the planes for which intersection points need to be computed, since the ray crosses only the planes that correspond with these bits. Moreover, each intersection point corresponding with a 1 bit in the outcode of **s** is entering, and each intersection point corresponding with a 1 bit in **t**'s outcode is exiting. Hence, the ray intersects the box iff the largest parameter corresponding with a 1 bit in **s**'s outcode is at most the smallest parameter corresponding with a 1 bit in **t**'s outcode. We see how neatly LB benefits from the outcodes computed by CS. Considering the long history of line clipping, it is remarkable that a hybrid of CS and LB got published only recently [11].

For a box centered at the origin the parameters are computed in the following way. Let σ_i and τ_i be the ith components of the ray's source **s** and target **t**, respectively, and let η_i be the ith component of the box's extent **h**. Then, the parameters of the intersection points on the lower and upper plane orthogonal to the ith coordinate axis are, respectively,

$$\lambda_- = \frac{-\sigma_i - \eta_i}{\tau_i - \sigma_i} \quad \text{and} \quad \lambda_+ = \frac{-\sigma_i + \eta_i}{\tau_i - \sigma_i}.$$

Since we compute these parameters only for planes for which \mathbf{s} and \mathbf{t} lie on different sides, each computed parameter lies in the interval $[0, 1]$, and thus represents an intersection point of the ray and the plane. Pseudocode for the ray cast on boxes is presented in Algorithm 3.3.

Algorithm 3.3

A ray cast for a ray $\overline{\mathbf{st}}$, where $\mathbf{s} = (\sigma_1, \sigma_2, \sigma_3)$ and $\mathbf{t} = (\tau_1, \tau_2, \tau_3)$, and a box centered at the origin having extent (η_1, η_2, η_3). The intersection of the ray and the box is represented by the interval $[\lambda_{enter}, \lambda_{exit}]$. The point where the ray enters the box is returned as \mathbf{x}.

$bits_\mathbf{s} := outcode(\mathbf{s});$
$bits_\mathbf{t} := outcode(\mathbf{t});$
if $bits_\mathbf{s}$ & $bits_\mathbf{t} = 0$ then
 {{*None of the side planes separate the ray from the box.*}}
begin
 $\lambda_{enter} := 0;$
 $\lambda_{exit} := 1;$
 $bit := 1;$
 for $i := 1, 2, 3$ do
 begin
 if $bits_\mathbf{s}$ & $bit \neq 0$ then
 {{*Point of intersection is entering.*}}
 $\lambda_{enter} := \max(\lambda_{enter}, (-\sigma_i - \eta_i)/(\tau_i - \sigma_i));$
 else if $bits_\mathbf{t}$ & $bit \neq 0$ then
 {{*Point of intersection is exiting.*}}
 $\lambda_{exit} := \min(\lambda_{exit}, (-\sigma_i - \eta_i)/(\tau_i - \sigma_i));$
 $bit := bit \ll 1;$
 if $bits_\mathbf{s}$ & $bit \neq 0$ then
 {{*Point of intersection is entering.*}}
 $\lambda_{enter} := \max(\lambda_{enter}, (-\sigma_i + \eta_i)/(\tau_i - \sigma_i));$
 else if $bits_\mathbf{t}$ & $bit \neq 0$ then
 {{*Point of intersection is exiting.*}}
 $\lambda_{exit} := \min(\lambda_{exit}, (-\sigma_i + \eta_i)/(\tau_i - \sigma_i));$
 $bit := bit \ll 1$
 end;
 if $\lambda_{enter} \leq \lambda_{exit}$ then
 {{*The ray intersects the box, since* $[\lambda_{enter}, \lambda_{exit}] \neq \emptyset.$}}
 begin
 $\mathbf{x} := \mathbf{s} + \lambda_{enter}(\mathbf{t} - \mathbf{s});$
 return true
 end
end;
return false

3.2.2 Sphere-Box Test

We conclude this section with a discussion of how a sphere and an axis-aligned box are tested for intersection. This is done by computing the point in the box closest to the sphere's center, and testing whether this point is contained in the sphere. Let the box be centered at the origin with extent $\mathbf{h} = (\eta_1, \eta_2, \eta_3)$, and let the sphere's center be given by $\mathbf{c} = (\gamma_1, \gamma_2, \gamma_3)$. Then, the point in the box closest to \mathbf{c} is the point $\mathbf{x} = (\text{clamp}(\gamma_1, -\eta_1, \eta_1), \text{clamp}(\gamma_2, -\eta_2, \eta_2), \text{clamp}(\gamma_3, -\eta_3, \eta_3))$, where

$$\text{clamp}(\gamma, \alpha, \beta) = \begin{cases} \alpha & \text{if } \gamma < \alpha \\ \beta & \text{if } \gamma > \beta \\ \gamma & \text{otherwise.} \end{cases}$$

The sphere intersects the box iff the point \mathbf{x} is contained in the sphere; that is, the squared distance $\|\mathbf{x} - \mathbf{c}\|^2$ is at most the squared radius ρ^2.

The witness points for a nonzero distance are found in the following way. We take the point \mathbf{x} closest to the sphere's center as the witness point on the boundary of the box. The witness point on the sphere's boundary is the point

$$\mathbf{r} = \mathbf{c} + \rho \frac{\mathbf{v}}{\|\mathbf{v}\|},$$

where $\mathbf{v} = \mathbf{x} - \mathbf{c}$. The distance between the sphere and the box is $\|\mathbf{x} - \mathbf{r}\| = \|\mathbf{v}\| - \rho$—that is, if the sphere and the box do not intersect ($\|\mathbf{v}\| > \rho$), since otherwise the distance is zero.

If the sphere and the box intersect and the center of the sphere is not contained by the box, then the points \mathbf{r} and \mathbf{x} are witness points of a nonzero penetration depth as well. In that case, the penetration depth is $\rho - \|\mathbf{v}\|$. However, if the center is contained by the box, then the points \mathbf{c} and \mathbf{x} coincide. In that case, the witness point for the box is given by the point \mathbf{y} on the boundary of the box closest to the sphere's center. The point \mathbf{y} is found in the following way. First, we select the coordinate axis on which \mathbf{c}'s component lies closest to the boundary, as illustrated in Figure 3.3. This is the axis \mathbf{e}_i for which $\delta_i = \eta_i - |\gamma_i|$ has the smallest value. If multiple axes result in a smallest value δ_i, then simply choose one of these axes. Given such an axis \mathbf{e}_i, the point on the boundary of the box closest to the sphere's center is

$$\mathbf{y} = \mathbf{c} + \delta_i \, \text{sign}(\gamma_i)\mathbf{e}_i,$$

where

$$\text{sign}(\alpha) = \begin{cases} -1 & \text{if } \alpha < 0 \\ 1 & \text{otherwise.} \end{cases}$$

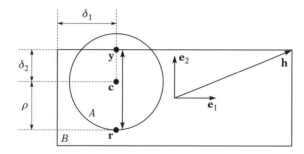

Figure 3.3 Computing the penetration depth of a sphere A and a box B for the case where the sphere's center \mathbf{c} is contained by the box. The point \mathbf{y} is the point on the boundary of B closest to \mathbf{c}. The penetration depth vector $\mathbf{y} - \mathbf{r}$ is aligned along \mathbf{e}_2, the coordinate axis on which \mathbf{c}'s component lies closest to the boundary.

The witness point on the sphere is the point $\mathbf{r} = \mathbf{c} - \rho\,\mathrm{sign}(\gamma_i)\mathbf{e}_i$, and the penetration depth is $\|\mathbf{y} - \mathbf{r}\| = \delta_i + \rho$.

3.3 Separating Axes

For simple polytopes, such as line segments, triangles, and boxes, there exists an easy and fast method for intersection testing. Two objects A and B are disjoint if for some vector \mathbf{v} the projections $\mathbf{v} \cdot A$ and $\mathbf{v} \cdot B$ of the objects onto the vector do not overlap. Such a vector \mathbf{v} is called a *separating axis*. This property is illustrated in Figure 3.4. For nonintersecting convex objects a separating axis always exists. A general proof for this claim is presented in Chapter 4. For now, let's restrict ourselves to separating axes for polytopes.

Theorem 3.1 gives us a straightforward method for finding a separating axis for a pair of polytopes that can successfully be used if the number of

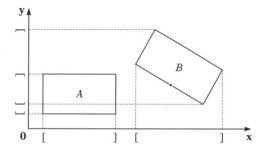

Figure 3.4 The vector \mathbf{x} is a separating axis of A and B, whereas \mathbf{y} is not a separating axis.

facet orientations and edge directions is small. From Theorem 3.1, it follows that we can decide whether or not a pair of polytopes intersect simply by testing all facet orientations and all cross products of edge directions to see if one of these is a separating axis. If none of these axes is a separating axis, then the polytopes must intersect. For a pair of polytopes with, respectively, f_1 and f_2 facet orientations and e_1 and e_2 edge directions, we need to test at most $f_1 + f_2 + e_1 e_2$ axes. We refer to this method for intersection testing of polytopes as the *separating-axes test* (SAT).

Theorem 3.1

For a pair of nonintersecting polytopes, there exists a separating axis that is orthogonal to a facet of either polytope, or orthogonal to an edge from each polytope.

Proof

Let A and B be a pair of nonintersecting polytopes. Then, their CSO $A - B$ is itself a polytope, as shown in Theorem 2.2. Therefore, the CSO can be represented as the intersection of a finite number of halfspaces [61]. Each halfspace in this representation corresponds with a facet of the CSO; that is, the boundary plane of a halfspace is the supporting plane (affine hull) of a facet. Since for nonintersecting objects, the origin is not contained in the CSO, there is at least one halfspace that does not contain the origin. Let $H^+(\mathbf{v}, \delta)$ be such a halfspace that does not contain the origin. Since $\mathbf{0} \notin H^+(\mathbf{v}, \delta)$, we see that $\delta < 0$. For all $\mathbf{x} \in A - B$, we have $\mathbf{v} \cdot \mathbf{x} + \delta \geq 0$, and thus $\mathbf{v} \cdot \mathbf{x} > 0$, which in turn yields that \mathbf{v} is a separating axis of A and B. Hence, a separating axis exists that is normal to a facet of $A - B$. Each facet of $A - B$ is (the union of subfacets, being) either the CSO of a facet from one polytope and a vertex from the other, or the CSO of a pair of edges from each polytope.[1] A normal to a facet of $A - B$ is therefore either orthogonal to a face of one of the polytopes, or orthogonal to a pair of edges, one from each polytope.

The SAT works well for simple polytopes, such as line segments (rays), triangles, and boxes. A line segment has no facets and one edge direction. A triangle has one facet orientation and three edge directions. A box has three facet orientations and three edge directions. Table 3.1 presents an overview of the maximum number of axes tests in a SAT for these polytope types.

A single separating-axis test in the SAT involves projecting both polytopes onto the axis, and testing whether the projection intervals of the polytopes overlap. The projection interval of a polytope A onto an axis \mathbf{v}

1. Two or more facet-vertex or edge-edge pairs may have coplanar CSOs. The union of these coplanar CSOs is a single facet in $A - B$.

Table 3.1 The maximum number of axes that need to be tested in a separating-axes test for different types of polytopes.

Polytope	Polytope	Number of axes
line segment	triangle	$0 + 1 + (1 \times 3) = 4$
line segment	box	$0 + 3 + (1 \times 3) = 6$
triangle	triangle	$1 + 1 + (3 \times 3) = 11$
triangle	box	$1 + 3 + (3 \times 3) = 13$
box	box	$3 + 3 + (3 \times 3) = 15$

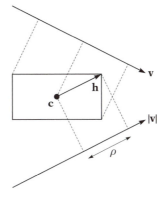

Figure 3.5 The projection of a box with center \mathbf{c} and extent \mathbf{h} onto an axis \mathbf{v} is the interval $[\mathbf{v} \cdot \mathbf{c} - \rho, \mathbf{v} \cdot \mathbf{c} + \rho]$, where $\rho = |\mathbf{v}| \cdot \mathbf{h}$.

is the interval $[\delta_{\min}, \delta_{\max}]$, where

$$\delta_{\min} = \min\{\mathbf{v} \cdot \mathbf{p} : \mathbf{p} \in \text{vert}(A)\} \quad \text{and} \quad \delta_{\max} = \max\{\mathbf{v} \cdot \mathbf{p} : \mathbf{p} \in \text{vert}(A)\}.$$

Since we are not dealing with arbitrary axes, there is often room for optimizations in the computation of the projection interval. For instance, the axis that is the result of a cross product of a line segment's direction and another edge direction is orthogonal to the line segment, and thus, the projection of the line segment onto this axis is a single point. The same is true for the projection of a triangle onto an axis that is normal to the triangle.

For computing the projection interval of a box, it is not necessary to project all the vertices of the box onto the axis. Let \mathbf{c} be the center, and $\mathbf{h} = (\eta_1, \eta_2, \eta_3)$, the extent vector of the box. Then, the vertices of the box are the points $\mathbf{c} + (\pm\eta_1, \pm\eta_2, \pm\eta_3)$. The projection of the box onto an axis \mathbf{v} is the interval $[\mathbf{v} \cdot \mathbf{c} - \rho, \mathbf{v} \cdot \mathbf{c} + \rho]$, where $\rho = \max\{\mathbf{v} \cdot (\pm\eta_1, \pm\eta_2, \pm\eta_3)\}$. We see that for $\mathbf{v} = (v_1, v_2, v_3)$, the value of ρ is $|v_1\eta_1| + |v_2\eta_2| + |v_3\eta_3| = |\mathbf{v}| \cdot \mathbf{h}$. See Figure 3.5 for an illustration of this projection.

Next, we discuss three examples of the SAT. A line segment–triangle test and a triangle-triangle test are not discussed here. For these two types, the SAT is in many cases not the fastest test. Better alternatives are discussed in Section 3.4.

3.3.1 Line Segment–Box Test

For testing the intersection of a line segment \overline{st} and an axis-aligned box, the axes that are tested in the SAT are the three coordinate axes e_i and the cross products $e_i \times r$ of the coordinate axes and the direction $r = t - s$ of the line segment. Let σ_i and τ_i be the components of, respectively, s and t corresponding with coordinate axis e_i. Then, the projection of the line segment \overline{st} onto e_i is the interval $[\min(\sigma_i, \tau_i), \max(\sigma_i, \tau_i)]$. Assume the box is centered at the origin. For boxes that have an arbitrary center c, simply replace s by $s - c$ and t by $t - c$. The axis e_i is a separating axis iff

$$\min(\sigma_i, \tau_i) > \eta_i \quad \text{or} \quad \max(\sigma_i, \tau_i) < -\eta_i.$$

The projection of the line segment \overline{st} onto e_i can also be represented as the interval $[\gamma - \delta, \gamma + \delta]$, where $\gamma = \frac{1}{2}(\sigma_i + \tau_i)$ and $\delta = \frac{1}{2}|\sigma_i - \tau_i|$. Using this representation, it can be seen that e_i is a separating axis iff

$$|\tfrac{1}{2}(\sigma_i + \tau_i)| > \tfrac{1}{2}|\sigma_i - \tau_i| + \eta_i.$$

This expression is optimized a little further by multiplying it by two:

$$|\sigma_i + \tau_i| > |\sigma_i - \tau_i| + 2\eta_i.$$

In this way, the expression has one multiplication fewer. The latter expression is generally cheaper to evaluate than the one that uses the minimum and maximum of σ_i and τ_i, since it requires fewer scalar comparisons and branch instructions.

For the three axes $v = e_i \times r$, the projection of the line segment is a single point $v \cdot s$. The axis v is a separating axis iff

$$|v \cdot s| > |v| \cdot h.$$

Note that in each vector $e_i \times r$, the ith component is zero, so by writing out the dot products and removing all multiplications by zero, this expression can be further optimized.

The SAT is likely to be faster than the ray cast discussed in Section 3.2, since for the SAT there are more possibilities for early exit and there are no divisions necessary, whereas in the clipping method divisions are necessary for computing the line parameters. So, if we merely need to test a ray and a box for intersection, then the SAT is the preferred method.

Also, if we need to do a lot of ray casts on boxes, then the SAT can be used as a first phase for culling the boxes that are not intersected by the ray, after which the intersection point or interval is computed only for the intersected boxes using the clipping method.

The SAT for testing the intersection of a line segment and a box is used in a method by Green and Hatch for testing the intersection of a polygon and a box [60]. However, in their explanation of the method, Green and Hatch do not refer to the separating-axis theorem, but explain it as a test for containment of the origin in the CSO of the line segment and the box. The CSO is a rhombic dodecahedron or 6-DOP, according to the definition on page 28. The six facet orientations of the dodecahedron correspond with the six axis tests in the SAT. The resulting test is similar to the SAT described above.

3.3.2 **Triangle-Box Test**

For testing the intersection of a triangle and an axis-aligned box, the SAT again shows its usefulness. The 13 axes that are tested in the SAT are the three coordinate axes \mathbf{e}_i, the triangle's normal, and the nine cross products of coordinate axes and edge directions of the triangle. Let $\mathbf{p}_j, j = 0, 1, 2$ be the triangle's vertices, and $\alpha_i^{(j)}$ the component of \mathbf{p}_j corresponding with coordinate axis \mathbf{e}_i. Then, the projection of the triangle onto coordinate axis \mathbf{e}_i is the interval $[\alpha_i^{\min}, \alpha_i^{\max}]$, where $\alpha_i^{\min} = \min\{\alpha_i^{(j)} : j = 0, 1, 2\}$, and $\alpha_i^{\max} = \max\{\alpha_i^{(j)} : j = 0, 1, 2\}$. Again, assume the box is centered at the origin. For boxes that have an arbitrary center \mathbf{c}, simply replace \mathbf{p}_j by $\mathbf{p}_j - \mathbf{c}$. The axis \mathbf{e}_i is a separating axis iff

$$\alpha_i^{\min} > \eta_i \quad \text{or} \quad \alpha_i^{\max} < -\eta_i.$$

Notice that performing these three coordinate-axis tests is equivalent to computing an axis-aligned bounding box for the triangle and testing it for overlap with the box.

For the remaining axes let the vectors $\mathbf{d}_1 = \mathbf{p}_1 - \mathbf{p}_0$, $\mathbf{d}_2 = \mathbf{p}_2 - \mathbf{p}_0$, and $\mathbf{d}_3 = \mathbf{p}_2 - \mathbf{p}_1$ be the edge directions of the triangle. The triangle's normal is the vector $\mathbf{n} = \mathbf{d}_1 \times \mathbf{d}_2$. The projection of the triangle onto \mathbf{n} is a single point $\mathbf{n} \cdot \mathbf{p}_0$. The axis \mathbf{n} is a separating axis iff

$$|\mathbf{n} \cdot \mathbf{p}_0| > |\mathbf{n}| \cdot \mathbf{h}.$$

Finally, the axis tests for the nine cross products of coordinate axes and edge directions are optimized as follows. Let's consider the axis $\mathbf{v} = \mathbf{e}_1 \times \mathbf{d}_2$. Since \mathbf{v} is orthogonal to the edge $\overline{\mathbf{p}_0 \mathbf{p}_2}$, the vertices \mathbf{p}_0 and \mathbf{p}_2 are projected onto the same point. So, we only have to take the vertices \mathbf{p}_0 and \mathbf{p}_1 into consideration. Let $\delta_0 = \mathbf{v} \cdot \mathbf{p}_0$ and $\delta_1 = \mathbf{v} \cdot \mathbf{p}_1$ be the projections of

\mathbf{p}_0 and \mathbf{p}_1 onto \mathbf{v}. Then, we find the following expression for a separating axis \mathbf{v}, which is similar to the coordinate axis test in the SAT for testing the intersection of a line segment and a box:

$$|\delta_0 + \delta_1| > |\delta_0 - \delta_1| + 2(|\mathbf{v}| \cdot \mathbf{h}).$$

For each vector $\mathbf{e}_i \times \mathbf{d}_j$, the ith component is zero, so again this expression can be further optimized by writing out the dot products and removing all multiplications by zero.

3.3.3 Box-Box Test

The SAT is particularly useful for testing the intersection of two relatively oriented rectangular boxes, as demonstrated by Gottschalk in the RAPID collision detection package [58]. Here, the relative orientation is given by an orthogonal 3×3 matrix \mathbf{B} that represents the local basis of box B relative to box A's local basis. The center of box B is given by a point \mathbf{c} relative to box A's local coordinate system as shown in Figure 3.6. Note that since \mathbf{B} is orthogonal, the result of the dot product operation on two vectors is the same for vectors given relative to either A's or B's basis. So, we are free to choose either A's or B's basis for computing the dot products as long as both operands of the dot products are given relative to the same basis. Let \mathbf{h}_A and \mathbf{h}_B be the extent vectors of boxes A and B, respectively, given relative to their respective bases. For a vector \mathbf{v} given relative to A's

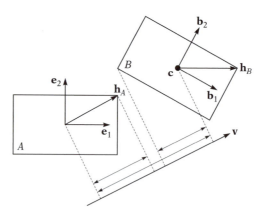

Figure 3.6 A separating-axis test for two relatively oriented boxes A and B on an axis \mathbf{v}. Box B is given relative to A by a 3×3 matrix $\mathbf{B} = [\mathbf{b}_i]$ and center point \mathbf{c}. Note that all vectors are given relative to A's coordinate system except for \mathbf{h}_B, which is given relative to B's coordinate system.

basis, we find that this vector relative to B's basis is $\mathbf{B}^{\mathrm{T}}\mathbf{v}$. Thus, an axis \mathbf{v} is a separating axis iff

$$|\mathbf{v} \cdot \mathbf{c}| > |\mathbf{v}| \cdot \mathbf{h}_A + |\mathbf{B}^{\mathrm{T}}\mathbf{v}| \cdot \mathbf{h}_B.$$

The 15 axes that are tested in the SAT are the three coordinate axes of A's local basis, the three coordinate axes of B's local basis, and all nine cross products of a coordinate axis of A's local basis and a coordinate axis of B's local basis. The coordinate axes of B's local basis relative to A's local basis are the columns of \mathbf{B}.

The expression $\mathbf{B}^{\mathrm{T}}\mathbf{v}$ can be simplified for any of the 15 axes. For example, let us consider the case where \mathbf{v} is the cross product of A's first coordinate axis and B's second coordinate axis. Let $\mathbf{B} = [\mathbf{b}_1\ \mathbf{b}_2\ \mathbf{b}_3] = [\beta_{ij}]$. Then, for $\mathbf{v} = \mathbf{e}_1 \times \mathbf{b}_2 = (0, -\beta_{32}, \beta_{22})$ given relative to A's basis, we find the following components relative to B's basis:

$$\mathbf{B}^{\mathrm{T}}(\mathbf{e}_1 \times \mathbf{b}_2) = \begin{bmatrix} \mathbf{b}_1 \cdot (\mathbf{e}_1 \times \mathbf{b}_2) \\ \mathbf{b}_2 \cdot (\mathbf{e}_1 \times \mathbf{b}_2) \\ \mathbf{b}_3 \cdot (\mathbf{e}_1 \times \mathbf{b}_2) \end{bmatrix} \overset{(*)}{=} \begin{bmatrix} \mathbf{e}_1 \cdot (\mathbf{b}_2 \times \mathbf{b}_1) \\ \mathbf{e}_1 \cdot (\mathbf{b}_2 \times \mathbf{b}_2) \\ \mathbf{e}_1 \cdot (\mathbf{b}_2 \times \mathbf{b}_3) \end{bmatrix} = \begin{bmatrix} \mathbf{e}_1 \cdot (-\mathbf{b}_3) \\ \mathbf{e}_1 \cdot 0 \\ \mathbf{e}_1 \cdot \mathbf{b}_1 \end{bmatrix}$$

$$= (-\beta_{13}, 0, \beta_{11}).$$

The equation step marked by $(*)$ is the result of the triple product property discussed on page 22.

Since the axis tests frequently use the absolute values of elements of \mathbf{B}, it is a good idea to compute $|\mathbf{B}| = [|\beta_{ij}|]$, the matrix of absolute values of \mathbf{B}'s elements, before doing the axis tests. In this way, the SAT for oriented boxes takes fewer than 200 primitive operations, given a relative orientation matrix and a relative center position [59]. The SAT is currently the fastest method for testing the intersection of oriented boxes.

For relatively oriented k-DOPs with higher complexity, $k > 3$, the number of axis tests in the SAT will rapidly become too large in order for this method to be of any practical use. The number of facet orientations of a k-DOP is k by definition. From Euler's formula it follows that the number of edge directions is at most $3k - 6$ (see page 25). Therefore, the number of axes that need to be tested for determining whether a pair of k-DOPs intersect is $2k + (3k - 6)^2$. Zachmann shows in [135] that the projection of a DOP onto an axis can be found in $O(k)$ time. Hence, a SAT for relatively oriented DOPs has $O(k^3)$ time complexity.

We see that for more complex polytopes, the number of axis tests is too large, and the cost of an axis test is too high, for this approach to be useful. In Chapter 4, we discuss cheaper methods for finding a separating axis for polytopes of arbitrary complexity.

3.4 **Polygons**

Polygons are currently the most commonly used modeling primitives in interactive 3D media. Complex shapes are usually modeled using triangle meshes, although quadrilaterals and other polygon types are used as well [10]. In this section, we discuss intersection tests for both triangles and general polygons.

3.4.1 **Ray-Triangle Test**

For testing the intersection of a line segment and a triangle we can use the SAT, as we saw in the previous section. However, there exists a faster method by Möller and Trumbore that requires only two cross product computations and also gives us the point of intersection [90].

Let \mathbf{s} be the source point and \mathbf{t} be the target point of the ray, and let \mathbf{p}_0, \mathbf{p}_1, and \mathbf{p}_2 be the vertices of the triangle. A point \mathbf{x} on the triangle can be represented as a convex combination of the triangle's vertices,

$$\mathbf{x} = \mu_0 \mathbf{p}_0 + \mu_1 \mathbf{p}_1 + \mu_2 \mathbf{p}_2, \text{ where } \mu_0 + \mu_1 + \mu_2 = 1, \mu_i \geq 0.$$

The three values μ_0, μ_1, and μ_2 are called the *barycentric coordinates* of point \mathbf{x} relative to the triangle. We immediately eliminate μ_0 by substituting $\mu_0 = 1 - \mu_1 - \mu_2$ and get

$$\mathbf{x} = \mathbf{p}_0 + \mu_1(\mathbf{p}_1 - \mathbf{p}_0) + \mu_2(\mathbf{p}_2 - \mathbf{p}_0), \text{ where } \mu_1 + \mu_2 \leq 1, \mu_i \geq 0.$$

A point \mathbf{x} on the ray is given by

$$\mathbf{x} = \mathbf{s} + \lambda(\mathbf{t} - \mathbf{s}), \text{ where } 0 \leq \lambda \leq 1.$$

Let $\mathbf{r} = \mathbf{t} - \mathbf{s}$, $\mathbf{d}_1 = \mathbf{p}_1 - \mathbf{p}_0$, and $\mathbf{d}_2 = \mathbf{p}_2 - \mathbf{p}_0$. Then, for the point of intersection, we have

$$\mathbf{s} + \lambda\mathbf{r} = \mathbf{p}_0 + \mu_1\mathbf{d}_1 + \mu_2\mathbf{d}_2.$$

We rearrange this equation to an expression in matrix notation:

$$[-\mathbf{r} \ \mathbf{d}_1 \ \mathbf{d}_2] \begin{bmatrix} \lambda \\ \mu_1 \\ \mu_2 \end{bmatrix} = \mathbf{s} - \mathbf{p}_0.$$

Now, let $\mathbf{b} = \mathbf{s} - \mathbf{p}_0$. With Cramer's rule (see page 13), we find the following solution.

$$\begin{bmatrix} \lambda \\ \mu_1 \\ \mu_2 \end{bmatrix} = \frac{1}{\det[-\mathbf{r} \ \mathbf{d}_1 \ \mathbf{d}_2]} \begin{bmatrix} \det[\ \mathbf{b} \ \mathbf{d}_1 \ \mathbf{d}_2] \\ \det[-\mathbf{r} \ \mathbf{b} \ \mathbf{d}_2] \\ \det[-\mathbf{r} \ \mathbf{d}_1 \ \mathbf{b}] \end{bmatrix}.$$

The determinants are computed using triple products. By permuting the vectors in the triple products, we derive an expression that uses only two distinct cross products,

$$\begin{bmatrix} \lambda \\ \mu_1 \\ \mu_2 \end{bmatrix} = \frac{1}{-\mathbf{r} \cdot (\mathbf{d}_1 \times \mathbf{d}_2)} \begin{bmatrix} \mathbf{b} \cdot (\mathbf{d}_1 \times \mathbf{d}_2) \\ \mathbf{d}_2 \cdot (\mathbf{b} \times \mathbf{r}) \\ -\mathbf{d}_1 \cdot (\mathbf{b} \times \mathbf{r}) \end{bmatrix}.$$

A solution exists only if the determinant $\delta = -\mathbf{r} \cdot (\mathbf{d}_1 \times \mathbf{d}_2)$ is not zero. If the determinant is zero, then the ray is parallel to the plane, in which case we return a nonintersection. The case where a ray that lies in the triangle's plane intersects the triangle is ignored. Note that for back-facing triangles, the δ is negative, so in applications where only front-facing triangles should be tested, we return a nonintersection for negative δ.

The ray intersects the triangle iff $0 \le \lambda \le 1$, $\mu_1 + \mu_2 \le 1$, and $\mu_1, \mu_2 \ge 0$. The point of intersection is $\mathbf{x} = \mathbf{s} + \lambda \mathbf{r}$. The computations for the ray-triangle test are summarized in Algorithm 3.4. If performance is an issue, then it pays to store the vectors \mathbf{d}_1 and \mathbf{d}_2 and the normal $\mathbf{n} = \mathbf{d}_1 \times \mathbf{d}_2$ with the triangle rather than to compute them in the test.

Algorithm 3.4

A ray cast for a ray $\overline{\mathbf{st}}$ and a triangle with vertices \mathbf{p}_0, \mathbf{p}_1, and \mathbf{p}_2. The point of intersection is \mathbf{x}.

$\mathbf{d}_1 := \mathbf{p}_1 - \mathbf{p}_0$;
$\mathbf{d}_2 := \mathbf{p}_2 - \mathbf{p}_0$;
$\mathbf{n} := \mathbf{d}_1 \times \mathbf{d}_2$;
$\mathbf{r} := \mathbf{t} - \mathbf{s}$;
$\delta := -\mathbf{r} \cdot \mathbf{n}$;
if $\delta \ne 0$ then
 {{*The ray is not parallel to the triangle's plane. (Coplanar rays are ignored.)*}}
begin
 $\mathbf{b} := \mathbf{s} - \mathbf{p}_0$;
 $\lambda := (\mathbf{b} \cdot \mathbf{n})/\delta$;

```
if 0 ≤ λ ≤ 1 then
  {{The ray intersects the triangle's plane.}}
  begin
    u := b × r;
    μ₁ := (d₂ · u)/δ;
    μ₂ := (−d₁ · u)/δ;
    if μ₁ + μ₂ ≤ 1 and μ₁ ≥ 0 and μ₂ ≥ 0 then
      {{The ray intersects the triangle.}}
      begin
        x := s + λr;
        return true
      end
  end
end;
return false
```

Numerical problems may arise due to cancellation in the computation of the determinants. If the determinant δ is small in comparison to the lengths of the vectors \mathbf{r}, \mathbf{d}_1, and \mathbf{d}_2, then the computed value of δ may have a huge relative error. This error is propagated to the computed values of λ, μ_1, and μ_2. So, to be on the safe side, we may want to replace the guard $\delta \neq 0$ by $|\delta| > \varepsilon$, where ε is a small tolerance value. Thus, intersections are returned only for cases where the absolute value of δ is greater than a given tolerance value.

However, keep in mind that the size of the determinant is proportional to the area of the triangle. For huge triangles the tolerance may be too strict, whereas for tiny triangles the tolerance may be too lenient. So, when there is a huge difference in triangle sizes, it is better to use a tolerance value that is relative to the triangle's area. For instance, we can use the tolerance value $\varepsilon\|\mathbf{n}\|$, since the length of \mathbf{n} is twice the triangle's area. It is computationally a little bit cheaper to use $\varepsilon\|\mathbf{n}\|_\infty$, where

$$\|(v_1, v_2, v_3)\|_\infty = \max\{|v_1|, |v_2|, |v_3|\},$$

since this expression does not require the evaluation of a square root.

Loss of precision occurs also for long-range ray casts. If the source of the ray lies at a great distance from the triangle and the ray is pointing at the triangle, then the computation of $\mathbf{b} \times \mathbf{r}$ suffers from cancellation, in which case the computed values of λ, μ_1, and μ_2 may have a large relative error. If, in this case, the ray hits the triangle, then the computed value for the intersection point may have a considerable error. So again, accurate results are achieved only for relatively short rays.

3.4.2 Line Segment–Triangle Test

If no point of intersection is required, then the following line segment–triangle test may be a better alternative than the ray-triangle test discussed in Section 3.4.1. Since this test uses only multiplications, additions, and subtractions of scalars, it is very fast and robust [66, 110].

Let $\mathbf{r} = \mathbf{t} - \mathbf{s}$ be the direction of the line segment, and let $\mathbf{v}_i = \mathbf{p}_i - \mathbf{s}$ be the vectors from the source of the line segment to each of the three vertices. Furthermore, let $\delta_i = \det[\mathbf{v}_i \mathbf{v}_{i\oplus1} \mathbf{r}]$ be the signed volumes of the parallelepipeds spanned by the vectors \mathbf{v}_i, $\mathbf{v}_{i\oplus1}$, and \mathbf{r}, where $i = 1, 2, 3$ and \oplus is addition modulo 3. Then, the line segment $\overline{\mathbf{st}}$ intersects the triangle if the determinants δ_i all have the same sign, and the endpoints \mathbf{s} and \mathbf{t} of the line segment are located on different sides of the triangle's supporting plane. As discussed on page 21, a positive δ_i indicates that the vectors \mathbf{v}_i, $\mathbf{v}_{i\oplus1}$, and \mathbf{r} form a right-handed basis, and a negative δ_i indicates a left-handed basis. Figure 3.7 describes this test in terms of the handedness of the vector triples.

Computing a determinant takes one cross product and one dot product (two additions, three subtractions, and nine multiplications). Furthermore, we need an extra cross product for computing the triangle's normal, and three dot products for determining whether the line segment crosses the triangle's plane. This results in a total of four cross products and six dot products. In this respect, the ray-triangle test from Section 3.4.1, which requires only two cross products and four dot products, seems to be the fastest alternative. In practice, however, the two tests appear to be roughly as fast [110].

An interesting variation of this approach is the line segment–triangle test described in [1]. This test computes the signs of the determinants based on Plücker coordinates. Plücker coordinates are an alternate way

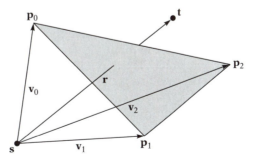

Figure 3.7 The line segment $\overline{\mathbf{st}}$ intersects the triangle if the bases $\{\mathbf{v}_i, \mathbf{v}_{i\oplus1}, \mathbf{r}\}$ are either all right-handed or are all left-handed, and the endpoints \mathbf{s} and \mathbf{t} of the line segment are located on different sides of the triangle's supporting plane.

of describing directed lines in three-dimensional space using vectors of six scalars [118]. A discussion of the geometric properties of Plücker coordinates falls outside the scope of this book. However, we would like to note that, using Plücker coordinates, computing the signs of the determinants requires only five additions and six multiplications. Sadly, there is no free lunch here as well, since the coordinates have to be computed and stored with the triangles. Thus, if you can spare the storage space, then you may benefit from a faster line segment–triangle test using Plücker coordinates.

3.4.3 Ray-Polygon Test

In this section we discuss a ray cast for nonconvex polygons. This test uses the plane equation $H(\mathbf{n}, \delta)$ of the polygon's supporting plane. The plane equation is best computed using Newell's method described on page 31. If a lot of ray casts need to be performed on the polygon, we may want to store the plane equation with the polygon. When transforming a polygon to another coordinate system, it is usually faster to transform its plane equation, rather than recompute it for the new coordinates. A plane equation can be transformed using the method described on page 21.

A ray-polygon intersection test involves the following steps. First, the point of intersection of the ray with the polygon's supporting plane is computed, after which this point is tested for containment in the polygon. Finding the point of intersection of a ray and a plane involves computing the signed distances of the ray's endpoints. For a plane

$$H(\mathbf{n}, \delta) = \{\mathbf{x} \in \mathbb{R}^3 : \mathbf{n} \cdot \mathbf{x} + \delta = 0\},$$

the signed distance of a point \mathbf{p} to this plane is $\mathbf{n} \cdot \mathbf{p} + \delta$. Note that for the correctness of the following computations, it is not necessary that $\|\mathbf{n}\| = 1$.

Let α and β be the signed distances of the endpoints \mathbf{s} and \mathbf{t} of the ray, respectively. If α and β have the same sign (i.e., the endpoints lie on the same side of the plane), then the ray does not intersect the polygon and can be rejected. If α and β have opposite signs, then the intersection point of the ray and the plane is the point $\mathbf{x} = \mathbf{s} + \lambda(\mathbf{t} - \mathbf{s})$, where $\lambda = \alpha/(\alpha - \beta)$. Figure 3.8 illustrates this operation.

After computing the point of intersection of the ray and the supporting plane of the polygon, we test whether this point is contained in the polygon. Since this is actually a 2D problem, we project all points onto a coordinate plane; that is, we drop (ignore) a coordinate in the 3D coordinates of the intersection point and the vertices of the polygon. The safest coordinate axis to drop is the one whose angle with the normal of the polygon's supporting plane is the smallest. Since the projection of the

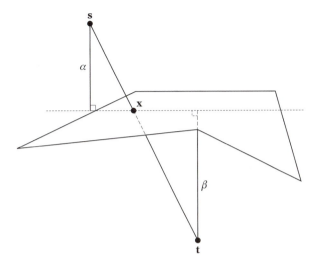

Figure 3.8 Computing the point of intersection of a ray and a polygon's supporting plane. The point of intersection is $\mathbf{x} = \mathbf{s} + \lambda(\mathbf{t} - \mathbf{s})$, where $\lambda = \alpha/(\alpha - \beta)$.

polygon onto the plane orthogonal to this axis has the largest area of all coordinate axes, we avoid the problem of the projection of the polygon being a line segment (area is zero). The coordinate axis whose angle with the normal of the polygon's supporting plane is the smallest corresponds with the component of the plane's normal that has the largest absolute value of the three component values [53]. The axis is referred to as the *closest axis* to the plane normal.

There are quite a number of methods for testing the containment of a point in a polygon. Haines presents an excellent discussion of a number of methods for point-in-polygon testing in [64]. When preprocessing of the polygons is not done, the best choice for a point-in-polygon test for general polygons is the crossings test. The crossings test counts the number of times a ray, originating from the query point and targeted in the direction of the positive x-axis, crosses the boundary of the polygon. If the number of crossings is odd, then the query point lies inside the polygon; otherwise, it lies outside the polygon.

Let, for $i = 0, \ldots, n - 1$, $\mathbf{p}_i = (\alpha_x^{(i)}, \alpha_y^{(i)})$ be the 2D coordinates of the vertices, and $\mathbf{x} = (\beta_x, \beta_y)$ the query point. The ray intersects an edge $\overline{\mathbf{p}_i \mathbf{p}_{i \oplus 1}}$ iff the y-coordinates of the endpoints lie on opposite sides of \mathbf{x}, and the point of intersection of the edge and the line through \mathbf{x} parallel to the x-axis lies to the right of \mathbf{x}. Trivially, the point of intersection lies to the right of \mathbf{x} if the x-coordinates of the edge's endpoints both lie to the right of \mathbf{x}. The opposite is true if both endpoints lie to the left of \mathbf{x}. Only if the x-coordinates of the endpoints lie on opposite sides of \mathbf{x} do we need to

compute the actual x-coordinate of the intersection point. Pseudocode for the crossings test is given in Algorithm 3.5.

Algorithm
3.5

The crossings test for testing the containment of a point (β_x, β_y) in a polygon with vertices $(\alpha_x^{(i)}, \alpha_y^{(i)})$, where $i = 0, \ldots, n - 1$. Here, \oplus denotes addition modulo n.

```
inside := false;
for i := 0, ..., n − 1  do
begin
    if αy⁽ⁱ⁾ ≥ βy ≠ αy⁽ⁱ⊕¹⁾ ≥ βy  then
        {{Edge i crosses the horizontal line y = βy. }}
    begin
        if αx⁽ⁱ⁾ ≥ βx ≠ αx⁽ⁱ⊕¹⁾ ≥ βx  then
            {{Edge i crosses the vertical line x = βx. }}
        begin
            if αx⁽ⁱ⁾ + (βy − αy⁽ⁱ⁾)(αx⁽ⁱ⊕¹⁾ − αx⁽ⁱ⁾)/(αy⁽ⁱ⊕¹⁾ − αy⁽ⁱ⁾) ≥ βx  then
                {{Edge i crosses the ray y = βy, x ≥ βx. }}
                inside := not inside
        end
        else if αx⁽ⁱ⁾ ≥ βx  then
            {{Edge i crosses the ray y = βy, x ≥ βx. }}
            inside := not inside
    end
end;
return  inside
```

Note that a convex polygon can have at most two edges for which the y-coordinates lie on opposite sides of the query point **x**. We can use this property to speed up the crossings tests for convex polygons. After the second time the algorithm encounters an edge for which the endpoints lie on opposite sides of **x** with respect to the y-axis, we can exit, since the remaining edges all lie either completely below or above **x**.

3.4.4 Triangle-Triangle Test

As we saw in Section 3.3, the intersection of a pair of triangles can be tested using a separating-axes test. The SAT requires a maximum of 11 axes to be tested, which are the normals of the triangles plus the nine cross products of edge directions. The SAT works well if the triangles have low probability of intersecting, since then the test is likely to exit early after only a few axis tests.

However, triangle-triangle tests are commonly performed only after extensive culling using bounding-volume tests, so in practice the tested triangles have a high probability of intersecting. So, in that case, we might want to use a different approach. A common way of detecting an intersection of two polygons is testing each edge of the first polygon against the second polygon for intersection and vice versa [12]. Clearly, this suffices to find an intersection, since for a pair of intersecting polygons at least one polygon has an edge that intersects the other.

For testing the intersection of an edge and a triangle, we use the ray-triangle test from page 84. As soon as we find an intersecting edge, we may exit. Note that we can use the same vectors $\mathbf{d}_1 = \mathbf{p}_1 - \mathbf{p}_0$ and $\mathbf{d}_2 = \mathbf{p}_2 - \mathbf{p}_0$ and normal $\mathbf{n} = \mathbf{d}_1 \times \mathbf{d}_2$ for all three edge-triangle tests on each triangle. Thus, the maximum number of cross products that need to be computed is eight (two normals plus one for each of the six edge-triangle tests). In comparison, the SAT requires 11 cross-product computations in the worst case, which occurs when the triangles are intersecting.

Intersecting edges come in pairs. If the triangles intersect, there must be two intersecting edges. So, in theory, we do not have to test all six edges, since if five edges are found to be nonintersecting, the sixth edge must also be nonintersecting. However, keep in mind that, in the finite-precision ray-triangle test, edges that are almost parallel to the triangle's plane are regarded as nonintersecting. So, for degenerate cases, we may find only one intersecting edge, as illustrated in Figure 3.9.

Yet another method for testing the intersection of a pair of triangles is presented by Möller in [89]. This method can be tailored to return the line segment of intersection of a pair of triangles. Since it can be readily generalized to convex polygons, we discuss this method in the next section.

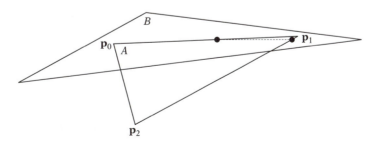

Figure 3.9 The edge $\overline{\mathbf{p}_0\mathbf{p}_1}$ is almost parallel to triangle B's plane, and thus is regarded as nonintersecting by the finite-precision ray-triangle test. The only intersecting edge we find is $\overline{\mathbf{p}_1\mathbf{p}_2}$.

3.4.5 **Polygon–Polygon Test**

Similar to the the triangle-triangle test, two general polygons can be tested for intersection by testing edges of one polygon against the other polygon using the ray-polygon test described on page 88. Using this approach, a polygon-polygon intersection test takes a worst-case time of $O(n)$ for convex polygons, and $O(n^2)$ for nonconvex polygons, where n is the number of vertices in each polygon. The worst case for nonconvex polygons occurs when all edges of both polygons intersect the other polygon's supporting plane, but none of them intersect the polygon itself, since then we need to perform n point-in-polygon tests. For convex polygons, there are at most two edges that intersect the other polygon's supporting plane, so the worst case still takes linear time.

There exists, however, an approach for polygon-polygon intersection testing that has also a worst-case linear time complexity for nonconvex polygons. This method is presented by Möller for triangle-triangle intersection testing [89], but can be readily generalized to convex polygons. We demonstrate that with a little bit more effort this method can be generalized to nonconvex polygons as well.

The approach is based on the following idea. A pair of polygons intersect iff the intersections of each polygon and the other polygon's supporting plane overlap. The intersection of a convex polygon and a plane is a line segment. The intersection of a nonconvex polygon and a plane is a collection of collinear line segments. If both polygons intersect with the other polygon's plane, then the line segments of intersection are collinear, since they are segments of the line of intersection of the polygon's planes, as depicted in Figure 3.10. We see that for a pair of intersecting polygons, one or more pairs of line segments overlap.

Let n_1 and n_2 be the normals of the polygons. Note that for the correctness of what follows it is not necessary that the normals are of unit length. The direction of the line of intersection of the polygon's planes is the vector $d = n_1 \times n_2$. If d is the zero vector, then the planes are parallel and a nonintersection is returned. We simply ignore intersections of coplanar polygons. Ignoring this case is usually not harmful for detecting collisions between polygonal objects, since the polygons are commonly pieces of a mesh. So, at least one of the coplanar polygons has an adjacent polygon that intersects the other polygon and is not coplanar with this polygon.

The intersection of a polygon and a plane is computed using a polygon clipping technique [54, 121]. We use the ray-plane intersection method described on page 88 to compute all intersection points of one polygon's edges with the other polygon's plane. These intersection points are the endpoints of the line segments. The endpoints are computed in the order in which they appear along the boundary, as can be seen in Figure 3.11.

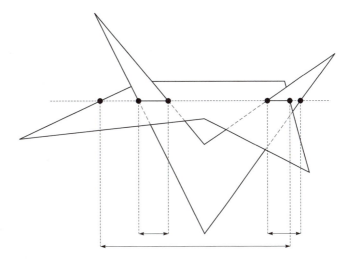

Figure 3.10 A pair of nonconvex polygons intersect iff the intersections of each polygon with the other polygon's supporting plane overlap.

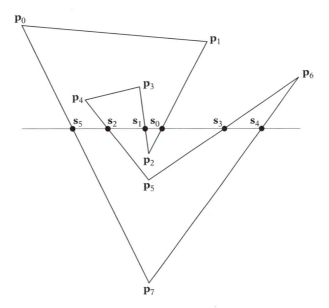

Figure 3.11 When computing the intersection of a nonconvex polygon and a plane, the intersection points of the edges are found in the order in which they appear along the boundary of the polygon.

In order to find the line segments of intersection we need to sort the endpoints along the line of intersection.

In order to sort the endpoints along the line of intersection it is not necessary to project the endpoints onto the line. We may choose any axis that is not orthogonal to the line for projecting the endpoints. It is easiest to project the points onto a coordinate axis, since for a coordinate axis the projection of a point is simply the coordinate of the point corresponding with the coordinate axis. In order to eliminate the risk of having coinciding finite-precision values for the projections of distinct endpoints, we choose the coordinate axis that is closest to the direction of the line of intersection. The closest axis is the coordinate axis for which the direction **d** has the largest absolute value.

Next, the endpoints are sorted according to their coordinate values for the closest axis. For convex polygons, sorting the endpoints is trivial, since a convex polygon has at most two edges that intersect with a plane. For nonconvex polygons, we can apply a general sorting algorithm, such as Quicksort, which has $O(n \log n)$ average time complexity. However, for this particular sorting problem, which is referred to as *Jordan sorting*, there exists a sorting algorithm that has a better time complexity. Jordan sorting is the problem of sorting a sequence of intersection points of a Jordan curve with an axis, given in the order in which they occur along the curve. Clearly, this is the case here, since the boundary of a simple polygon is a Jordan curve. It has been shown that Jordan sorting can be done in linear time [47, 67]. However, these algorithms require rather sophisticated data structures. Therefore, we regard it unlikely that Jordan sorting outperforms the Quicksort routine for the input sizes that we are interested in.

After sorting the endpoints, we have a representation of the intersection line segments in the order in which they occur along the closest axis. For convex polygons it is now simply a matter of testing the projections of the line segments onto the closest axis for overlap. Nonconvex polygons may have multiple line segments of intersection. So, we need to check for overlap among these line segments.

Let $\overline{\mathbf{s}_{2i}, \mathbf{s}_{2i+1}}$ and $\overline{\mathbf{t}_{2j}, \mathbf{t}_{2j+1}}$ be the sorted sequences of, respectively, l and m intersection line segments of the two polygons, and let $[\sigma_{2i}, \sigma_{2i+1}]$ and $[\tau_{2j}, \tau_{2j+1}]$ be their respective projections onto the closest axis, for $i = 0, \ldots, l-1$ and $j = 0, \ldots, m-1$. Overlap among the segments is found by simultaneously scanning the sorted sequences of endpoints for both polygons. Two segments overlap iff their projections onto the closest axis overlap. More precisely, the ith segment of **s** overlaps the jth segment of **t** iff $[\sigma_{2i}, \sigma_{2i+1}] \cap [\tau_{2j}, \tau_{2j+1}] \neq \emptyset$; that is, $\sigma_{2i} \leq \tau_{2j+1}$ and $\tau_{2j} \leq \sigma_{2i+1}$. Assume without loss of generality that $\sigma_{2i+1} < \tau_{2j}$. Then, the ith segment of **s** does not overlap the kth segment of **t**, where $k \geq j$. This property is exploited in Algorithm 3.6 for detecting whether two sequences of line

segments overlap in $O(l + m)$ time. For a pair of polygons, each having n vertices, we have $l \leq n$ and $m \leq n$, since each edge contributes at most one endpoint. Hence, Algorithm 3.6 runs in $O(n)$ time.

Algorithm
3.6

Detecting overlap in two sorted sequences of intervals. The intervals are, respectively, $[\sigma_{2i}, \sigma_{2i+1}]$ and $[\tau_{2j}, \tau_{2j+1}]$, for $i = 0, \ldots, l - 1$ and $j = 0, \ldots, m - 1$.

```
i := 0;
j := 0;
while i < l and j < m do begin
    if σ₂ᵢ₊₁ < τ₂ⱼ then i := i + 1
    else if τ₂ⱼ₊₁ < σ₂ᵢ then j := j + 1
    else return true
end;
return false
```

Let's summarize the complete algorithm for testing the intersection of a pair of nonconvex polygons, each having n vertices:

1. The direction of the line of intersection of the polygon's supporting planes is computed, $\mathbf{d} = \mathbf{n}_1 \times \mathbf{n}_2$. If $\mathbf{d} = \mathbf{0}$ (i.e., the planes are parallel), then false is returned. We simply ignore the case where the polygons are coplanar.

2. For each polygon, the intersection points of its edges with the other polygon's supporting plane are computed and stored in a list. This takes $O(n)$ time. If the list is empty for one of the polygons then false is returned.

3. The lists of intersection points are sorted along the coordinate axis that is closest to the direction of the line of intersection. This takes $O(n)$ time using Jordan sorting, and $O(n \log n)$ average time using the more common Quicksort algorithm.

4. The lists are checked for overlapping segments using Algorithm 3.6. This operation takes $O(n)$ time.

We see that the complete algorithm has a worst-case time complexity of $O(n)$ using Jordan sorting. At this level, though, asymptotic worst-case performance bounds are mainly of theoretical interest.

In practice, we will in most cases perform a bounding-box test before testing the polygons for intersection, in which case the performance of this method differs only slightly from the method that tests edges using a ray-polygon test. In our experiments, we found that the sorting approach

Figure 3.12 The intersection of two line segment sequences.

that uses Quicksort is only 10% faster than the ray-polygon approach in the cases where the bounding boxes of the polygons intersect.

As a conclusion, we show how to tailor the sorting approach such that it returns the intersection of a pair of polygons. The main difference with intersection detection is that for intersection computation we need to have all intersecting pairs of line segments. Note that a single segment from one polygon may overlap multiple segments of the other polygon, as can be seen in Figure 3.12. As soon as a pair of overlapping segments is found, the segment of intersection of these segments is reported. After reporting an overlapping pair of segments, we examine the next pair of segments by progressing in one of the segment sequences. Assume without loss of generality that $\sigma_{2i+1} < \tau_{2j+1}$. Since the sequences are sorted, we know that the ith segment in \mathbf{s} does not overlap any of the kth segments of \mathbf{t} for $k > j$. Hence, we discard the ith segment of \mathbf{s} from consideration, and progress to the next segment in \mathbf{s}. See Algorithm 3.7 for a description of the intersection computation algorithm in pseudocode. As the detection algorithm, the intersection computation algorithm runs also in $O(l + m)$ time.

Algorithm 3.7

Computing the intersection of two sequences of collinear line segments. The line segments are $\overline{\mathbf{s}_{2i}, \mathbf{s}_{2i+1}}$ and $\overline{\mathbf{t}_{2j}, \mathbf{t}_{2j+1}}$, and their respective projections are $[\sigma_{2i}, \sigma_{2i+1}]$ and $[\tau_{2j}, \tau_{2j+1}]$, for $i = 0, \ldots, l-1$ and $j = 0, \ldots, m-1$.

```
i := 0;
j := 0;
while i < l and j < m do begin
    if σ2i+1 < τ2j then i := i + 1
    else if τ2j+1 < σ2i then j := j + 1
    else begin
        if σ2i > τ2j then a := s2i
        else a := t2j;
        if σ2i+1 < τ2j+1 then b := s2i+1
        else b := t2j+1;
```

> *"Report the line segment* $\overline{\mathbf{ab}}$*"*;
> if $\sigma_{2i+1} < \tau_{2j+1}$ then $i := i + 1$
> else $j := j + 1$
> end
> end

The algorithms we have seen so far use a representation of the supporting plane. Since a plane equation is represented using only four scalars, the additional storage that is needed for representing the plane equation is in most cases acceptable. However, transformations on polygons, which are needed for getting the coordinates of the polygons relative to the coordinate system of reference, require some additional overhead if plane equations are involved. Hence, using an intersection testing algorithm that does not require a representation of the plane equation might be a valid option in some applications. In [126] Thomas and Torras present an intersection test for nonconvex polygons that does not require a plane representation. In their algorithm, the point of intersection of an edge and a plane is not computed. Similar to the line segment–triangle test discussed in Section 3.4.2, an edge-polygon test is performed using only dot and cross products and sign comparisons.

3.4.6 Triangle-Sphere Test

For testing the intersection of a triangle and a sphere, we compute the point of the triangle closest to the sphere's center. The triangle and the sphere intersect iff the closest point is contained by the sphere; that is, the (squared) distance of the closest point to the sphere's center is at most the (squared) radius of the sphere.

In Chapter 4, we will discuss Johnson's distance algorithm in the context of the Gilbert-Johnson-Keerthi algorithm for computing the distance between arbitrary convex objects. Johnson's distance algorithm is a general solution for computing the closest point of a simplex. The solution presented here is basically a written-out version of Johnson's distance algorithm, in which some further optimizations are incorporated.

Let \mathbf{p}_0, \mathbf{p}_1, and \mathbf{p}_2 be the vertices of the triangle. Then, the barycentric coordinates of a point \mathbf{x} on the triangle are the parameters λ_0, λ_1, λ_2, given by

$$\mathbf{x} = \lambda_0 \mathbf{p}_0 + \lambda_1 \mathbf{p}_1 + \lambda_2 \mathbf{p}_2, \text{ where } \lambda_0 + \lambda_1 + \lambda_2 = 1, \text{ and } \lambda_i \geq 0.$$

Assume that the sphere is centered at the origin. For spheres that have an arbitrary center \mathbf{c}, simply replace \mathbf{p}_i by $\mathbf{p}_i - \mathbf{c}$.

Let's first look at the problem of computing the point on the triangle's plane (affine hull) closest to the origin. For this problem, we simply drop the constraints $\lambda_i \geq 0$. The point \mathbf{x} is the closest point iff the vector from the origin to \mathbf{x} is orthogonal to the plane. This is the case iff the vector \mathbf{x} is orthogonal to two of the triangle's edges. The choice of the two edges is arbitrary. Let's pick $\overline{\mathbf{p}_0\mathbf{p}_1}$ and $\overline{\mathbf{p}_0\mathbf{p}_2}$. The vector \mathbf{x} is orthogonal to edge $\overline{\mathbf{p}_0\mathbf{p}_1}$ iff $(\mathbf{p}_1 - \mathbf{p}_0) \cdot \mathbf{x} = 0$. We substitute $\mathbf{x} = \lambda_0\mathbf{p}_0 + \lambda_1\mathbf{p}_1 + \lambda_2\mathbf{p}_2$, and do this also for edge $\overline{\mathbf{p}_0\mathbf{p}_2}$, to find the following linear system of equations:

$$
\begin{bmatrix}
1 & 1 & 1 \\
(\mathbf{p}_1 - \mathbf{p}_0) \cdot \mathbf{p}_0 & (\mathbf{p}_1 - \mathbf{p}_0) \cdot \mathbf{p}_1 & (\mathbf{p}_1 - \mathbf{p}_0) \cdot \mathbf{p}_2 \\
(\mathbf{p}_2 - \mathbf{p}_0) \cdot \mathbf{p}_0 & (\mathbf{p}_2 - \mathbf{p}_0) \cdot \mathbf{p}_1 & (\mathbf{p}_2 - \mathbf{p}_0) \cdot \mathbf{p}_2
\end{bmatrix}
\begin{bmatrix}
\lambda_0 \\
\lambda_1 \\
\lambda_2
\end{bmatrix}
=
\begin{bmatrix}
1 \\
0 \\
0
\end{bmatrix}.
$$

Notice that the choice of edges is indeed arbitrary, since by subtracting the second row from the third row we get the orthogonality of $\overline{\mathbf{p}_1\mathbf{p}_2}$.

Before we solve this system of equations, let's take a look at the possible solutions. If $\lambda_i > 0$ for $i = 0, 1, 2$, then the point \mathbf{x} is an internal point of the triangle. Otherwise, the closest point lies on the triangle's boundary. The closest point may be one of the vertices, or it may be an internal point of one of the edges. For computing the closest point on an edge, we use the same strategy. The problem is simpler, however, because we have only one edge to take into account. For edge $\overline{\mathbf{p}_0\mathbf{p}_1}$, we solve the system of equations

$$
\begin{bmatrix}
1 & 1 \\
(\mathbf{p}_1 - \mathbf{p}_0) \cdot \mathbf{p}_0 & (\mathbf{p}_1 - \mathbf{p}_0) \cdot \mathbf{p}_1
\end{bmatrix}
\begin{bmatrix}
\mu_0 \\
\mu_1
\end{bmatrix}
=
\begin{bmatrix}
1 \\
0
\end{bmatrix}.
$$

Again, if $\mu_i > 0$, for $i = 0, 1$, then the closest point is an internal point of the edge. If $\mu_0 \leq 0$, then \mathbf{p}_1 is the closest point, else if $\mu_1 \leq 0$, then \mathbf{p}_0 is the closest point. Furthermore, if \mathbf{p}_0 is the closest point of both edge $\overline{\mathbf{p}_0\mathbf{p}_1}$ and edge $\overline{\mathbf{p}_0\mathbf{p}_2}$, then \mathbf{p}_0 is the closest point of the triangle.

The basic outline of our approach is as follows. We first compute the parameters μ_i for the edges of the triangle. If we find a vertex \mathbf{p}_i that is the closest point of its adjacent edges, we return this vertex as the closest point of the triangle. If such a vertex does not exist, then the closest point of at least one of the edges is an internal point of that edge. In that case, we compute the parameters λ_i for the triangle. If for any $i = 0, 1, 2$, we have $\lambda_i \leq 0$, then the closest point of the triangle is the closest point of the edge connecting the vertices \mathbf{p}_j, for $j \neq i$. Otherwise, the closest point is an internal point of the triangle and has λ_i as barycentric coordinates.

We find the parameters μ_i for the edges by solving the linear systems of equations using Cramer's rule. For edge $\overline{\mathbf{p}_0\mathbf{p}_1}$, this is done as follows. Let

$$\mathbf{A} = [\mathbf{a}_0\ \mathbf{a}_1] = \begin{bmatrix} 1 & 1 \\ (\mathbf{p}_1 - \mathbf{p}_0) \cdot \mathbf{p}_0 & (\mathbf{p}_1 - \mathbf{p}_0) \cdot \mathbf{p}_1 \end{bmatrix} \quad \text{and} \quad \mathbf{b} = \begin{bmatrix} 1 \\ 0 \end{bmatrix}.$$

Then, we have as solution,

$$\mu_0 = \frac{\det[\mathbf{b}\ \mathbf{a}_1]}{\det(\mathbf{A})} \quad \text{and} \quad \mu_1 = \frac{\det[\mathbf{a}_0\ \mathbf{b}]}{\det(\mathbf{A})}.$$

It can be shown that $\det(\mathbf{A})$ is positive for affinely independent triangles [52]. Note that in the first step we only need the signs of the parameters. Since the denominator of μ_i is positive, it suffices to compute only the numerator in order to determine the sign of each parameter. We define $\Delta_i^{\{\mathbf{p}_0,\mathbf{p}_1\}}$ as the numerator of μ_i, that is, the determinant of the matrix we get by replacing the column in \mathbf{A} corresponding with \mathbf{p}_i by \mathbf{b}. Thus,

$$\Delta_0^{\{\mathbf{p}_0,\mathbf{p}_1\}} = \det[\mathbf{b}\ \mathbf{a}_1] = (\mathbf{p}_1 - \mathbf{p}_0) \cdot \mathbf{p}_1 \quad \text{and}$$
$$\Delta_1^{\{\mathbf{p}_0,\mathbf{p}_1\}} = \det[\mathbf{a}_0\ \mathbf{b}] = -(\mathbf{p}_1 - \mathbf{p}_0) \cdot \mathbf{p}_0.$$

Since $\mu_0 + \mu_1 = 1$, we have $\det(A) = \det[\mathbf{b}\ \mathbf{a}_1] + \det[\mathbf{a}_0\ \mathbf{b}]$, so let's also define $\Delta^{\{\mathbf{p}_0,\mathbf{p}_1\}} = \det(\mathbf{A}) = \Delta_0^{\{\mathbf{p}_0,\mathbf{p}_1\}} + \Delta_1^{\{\mathbf{p}_0,\mathbf{p}_1\}}$. Then, for edge $\overline{\mathbf{p}_0\mathbf{p}_1}$, we have $\mu_i = \Delta_i^{\{\mathbf{p}_0,\mathbf{p}_1\}} / \Delta^{\{\mathbf{p}_0,\mathbf{p}_1\}}$. In the same way, we find for edge $\overline{\mathbf{p}_0\mathbf{p}_2}$,

$$\Delta_0^{\{\mathbf{p}_0,\mathbf{p}_2\}} = (\mathbf{p}_2 - \mathbf{p}_0) \cdot \mathbf{p}_2 \quad \text{and}$$
$$\Delta_2^{\{\mathbf{p}_0,\mathbf{p}_2\}} = -(\mathbf{p}_2 - \mathbf{p}_0) \cdot \mathbf{p}_0,$$

and for edge $\overline{\mathbf{p}_1\mathbf{p}_2}$,

$$\Delta_1^{\{\mathbf{p}_1,\mathbf{p}_2\}} = (\mathbf{p}_2 - \mathbf{p}_1) \cdot \mathbf{p}_2 \quad \text{and}$$
$$\Delta_2^{\{\mathbf{p}_1,\mathbf{p}_2\}} = -(\mathbf{p}_2 - \mathbf{p}_1) \cdot \mathbf{p}_1.$$

For the triangle itself, we solve the system of equations in a similar way. The solution is given by $\lambda_i = \Delta_i^{\{p_0,p_1,p_2\}}/\Delta(\{p_0,p_1,p_2\})$, where $\Delta(\{p_0,p_1,p_2\}) = \Delta_0^{\{p_0,p_1,p_2\}} + \Delta_1^{\{p_0,p_1,p_2\}} + \Delta_2^{\{p_0,p_1,p_2\}}$, and

$$\Delta_0^{\{p_0,p_1,p_2\}} = \det \begin{bmatrix} (p_1 - p_0) \cdot p_1 & (p_1 - p_0) \cdot p_2 \\ (p_2 - p_0) \cdot p_1 & (p_2 - p_0) \cdot p_2 \end{bmatrix}$$

$$\Delta_1^{\{p_0,p_1,p_2\}} = -\det \begin{bmatrix} (p_1 - p_0) \cdot p_0 & (p_1 - p_0) \cdot p_2 \\ (p_2 - p_0) \cdot p_0 & (p_2 - p_0) \cdot p_2 \end{bmatrix}$$

$$\Delta_2^{\{p_0,p_1,p_2\}} = \det \begin{bmatrix} (p_1 - p_0) \cdot p_0 & (p_1 - p_0) \cdot p_1 \\ (p_2 - p_0) \cdot p_0 & (p_2 - p_0) \cdot p_1 \end{bmatrix}.$$

Notice that the determinants that have been computed for the edges can be reused in the computation of the determinants $\Delta_i^{\{p_0,p_1,p_2\}}$. To make even more reuse of earlier computed determinants possible, we subtract the first row from the second in the submatrix for $\Delta_0^{\{p_0,p_1,p_2\}}$:

$$\Delta_0^{\{p_0,p_1,p_2\}} = \det \begin{bmatrix} (p_1 - p_0) \cdot p_1 & (p_1 - p_0) \cdot p_2 \\ (p_2 - p_1) \cdot p_1 & (p_2 - p_1) \cdot p_2 \end{bmatrix}.$$

By substituting the edge determinants where appropriate, we find

$$\Delta_0^{\{p_0,p_1,p_2\}} = \Delta_0^{\{p_0,p_1\}} \Delta_1^{\{p_1,p_2\}} + \Delta_2^{\{p_1,p_2\}}((p_1 - p_0) \cdot p_2)$$

$$\Delta_1^{\{p_0,p_1,p_2\}} = \Delta_1^{\{p_0,p_1\}} \Delta_0^{\{p_0,p_2\}} - \Delta_2^{\{p_0,p_2\}}((p_1 - p_0) \cdot p_2)$$

$$\Delta_2^{\{p_0,p_1,p_2\}} = \Delta_2^{\{p_0,p_2\}} \Delta_0^{\{p_0,p_1\}} - \Delta_1^{\{p_0,p_1\}}((p_2 - p_0) \cdot p_1).$$

We will now summarize the operations needed for testing the intersection of a triangle and a sphere centered at the origin:

1. Compute the determinants for the three edges of the triangle. If for any $i = 0, 1, 2$, we have $\Delta_j^{\{p_i,p_j\}} \leq 0$ and $\Delta_k^{\{p_i,p_k\}} \leq 0$, for $j, k \neq i$, then return the closest point $\mathbf{x} = p_i$.

2. Otherwise, compute the determinants for the triangle. If for any $i = 0, 1, 2$, we have $\Delta_i^{\{p_0,p_1,p_2\}} \leq 0$, then return the closest point $\mathbf{x} = \mu_j p_j + \mu_k p_k$, where $j, k \neq i$ and $\mu_j = \Delta_j^{\{p_j,p_k\}}/\Delta^{\{p_j,p_k\}}$ and $\mu_k = \Delta_k^{\{p_j,p_k\}}/\Delta^{\{p_j,p_k\}}$.

3. Otherwise, return the closest point $\mathbf{x} = \lambda_0 p_0 + \lambda_1 p_1 + \lambda_2 p_2$, where $\lambda_i = \Delta_i^{\{p_0,p_1,p_2\}}/\Delta^{\{p_0,p_1,p_2\}}$.

4. The triangle intersects the sphere iff the squared distance $\|\mathbf{x}\|^2$ to the closest point \mathbf{x} is at most the squared radius ρ^2 of the sphere.

Testing a point for containment in a sphere is quite cheap. So, if we do not require witnesses for either the distance or the penetration depth, we can speed up the triangle-sphere test by first testing the triangle's vertices for containment in the sphere. If one of the vertices is contained in the sphere, then we can exit early, returning an intersection.

The distance between the triangle and the sphere is $\max(\|\mathbf{x}\| - \rho, 0)$. The penetration depth is $\max(\rho - \|\mathbf{x}\|, 0)$. The witness point on the triangle for both the distance and the penetration depth is the closest point \mathbf{x}. The witness point on the sphere is the point $\rho\mathbf{x}/\|\mathbf{x}\|$. However, this is only the case if \mathbf{x} is nonzero. In the case where the center of the sphere is contained by the triangle, \mathbf{x} is the zero vector. In that case we return the point $\rho\mathbf{n}/\|\mathbf{n}\|$ as the witness point on the sphere, where \mathbf{n} is a normal to the triangle. Note that in all of these cases the penetration depth vector is not unique, and therefore multiple choices for the witness point on the sphere are possible. However, the given choice for the witness point is by far the simplest.

Recall that for spheres that are centered at an arbitrary point \mathbf{c}, we translate both triangle and sphere over $-\mathbf{c}$ to construct an equivalent configuration in which the sphere is centered at the origin. When returning the witness points, we of course have to translate them back over \mathbf{c} in order to place these points in the reference coordinate system of the original objects.

We conclude with a note on numerical issues. From a performance point of view, it is tempting to rewrite expressions of the form $(\mathbf{p}_1 - \mathbf{p}_0) \cdot \mathbf{p}_2$ to $\mathbf{p}_1 \cdot \mathbf{p}_2 - \mathbf{p}_0 \cdot \mathbf{p}_2$, since this eliminates the need for an intermediate vector $\mathbf{p}_1 - \mathbf{p}_0$. However, note that subtractions may suffer from cancellation; that is, subtracting two values that are almost equal introduces a huge relative error. Therefore, it is better to perform subtractions as early as possible in the computation, since then the values are less contaminated by rounding errors. So in this case, the expression $(\mathbf{p}_1 - \mathbf{p}_0) \cdot \mathbf{p}_2$ is preferred over $\mathbf{p}_1 \cdot \mathbf{p}_2 - \mathbf{p}_0 \cdot \mathbf{p}_2$.

3.4.7 Polygon–Volume Tests

We wrap up this chapter with a discussion of intersection testing of general polygons with primitive volumes. Again, we use the plane equation $H(\mathbf{n}, \delta)$ of the polygon's supporting plane. The basic strategy for polygon-volume intersection testing is as follows:

1. If the polygon's supporting plane and the volume do not intersect, then return false.

2. Otherwise, if a vertex of the polygon is contained in the volume, then return true.

3. Otherwise, if an edge of the polygon intersects the volume, then return true.

4. Otherwise, if a point common to both the volume and the polygon's supporting plane is contained in the polygon, then return true. Otherwise, return false.

This strategy can be used for testing the intersection of a polygon with any object type and is most useful for intersection tests of a polygon with a primitive volume, such as a sphere or a box, since for these types of objects the individual tests in the strategy are quite elementary. For polygon-polygon intersection testing we found strategies that exploit the symmetry of this problem to be more effective. Note that the first two tests in this algorithm are not necessary for the correctness of the operation; however, they contribute to a large extent to the performance of the test. Recall that it is our aim to come up with algorithms that have good average performance. In this light, the two tests are quite useful, since they give us a quick answer for the majority of intersection tests and are relatively cheap.

We will show how to apply this basic strategy to polygon-sphere and polygon-box intersection testing. For other primitives, such as cylinders and cones, similar algorithms can be used.

Polygon-Sphere Test

Deciding whether a sphere intersects a plane is quite simple. The sphere intersects the plane if the distance from its center to the plane is at most its radius. Let \mathbf{c} be the center of the sphere and $H(\mathbf{n}, \delta)$ the polygon's supporting plane. Then, the distance of \mathbf{c} to the plane is $|\mathbf{n} \cdot \mathbf{c} + \delta|/\|\mathbf{n}\|$. We see that in this case it is useful to have a normal of unit length, since this saves us the division by the normal's length. For normals that do not have unit length, we may want to eliminate the square root in the computation of the normal's length by comparing the squared distance $(\mathbf{n} \cdot \mathbf{c} + \delta)^2/\|\mathbf{n}\|^2$ with the squared radius ρ^2.

For the vertex containment test, we simply compare the (squared) distance between the vertex and the sphere's center with the sphere's (squared) radius. The edge-sphere intersection test is done by computing the closest point of the edge to the sphere's center and testing this point for containment. We saw how to compute the closest point of an edge on page 71. Alternatively, we can use the ray-sphere test described on page 68 for testing the intersection of an edge and a sphere. However, this method is likely to be slower, since it involves a square root evaluation.

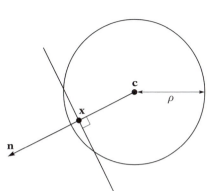

Figure 3.13 Computing a point \mathbf{x} common to a sphere and a plane $H(\mathbf{n}, \delta)$. The point $\mathbf{x} = \mathbf{c} + \lambda \mathbf{n}$, where $\lambda = -(\mathbf{n} \cdot \mathbf{c} + \delta)/\|\mathbf{n}\|^2$.

For the final test a common point to both the plane and the sphere needs to be found. As a common point we take the center of the sphere projected onto the plane, that is, the intersection point of the plane and the line orthogonal to the plane passing through the center, as depicted in Figure 3.13. This is the point $\mathbf{x} = \mathbf{c} + \lambda \cdot \mathbf{n}$ such that $\mathbf{n} \cdot \mathbf{x} + \delta = 0$. We substitute \mathbf{x} in the plane equation

$$\mathbf{n} \cdot (\mathbf{c} + \lambda \mathbf{n}) + \delta = 0$$

and find that

$$\lambda = -\frac{\mathbf{n} \cdot \mathbf{c} + \delta}{\|\mathbf{n}\|^2}.$$

It can be seen that under the assumption that the plane intersects the sphere, this point is indeed contained in both the plane and the sphere. Finally, the intersection point is tested for containment in the polygon, for which we use the point-in-polygon test described on page 89. Note that in all cases where the polygon-sphere test returns an intersection, we have a common point as witness of the intersection.

Polygon-Box Test

For testing the intersection of a general polygon and an axis-aligned box, we follow the same basic strategy. The plane $H(\mathbf{n}, \delta)$ does not intersect the box iff the normal \mathbf{n} is a separating axis. Clearly, for all points \mathbf{x} in the plane, the projection $\mathbf{n} \cdot \mathbf{x}$ is simply $-\delta$. Recall that, for a box centered at point \mathbf{c} and with extent \mathbf{h}, the projection of the box onto \mathbf{n} is the interval

$[\mathbf{n} \cdot \mathbf{c} - \rho, \mathbf{n} \cdot \mathbf{c} + \rho]$, where $\rho = |\mathbf{n}| \cdot \mathbf{h}$. Thus, the plane does not intersect the box (i.e., \mathbf{n} is a separating axis) iff

$$|\mathbf{n} \cdot \mathbf{c} + \delta| > |\mathbf{n}| \cdot \mathbf{h}.$$

A vertex \mathbf{p} is contained in the box iff $|\mathbf{x} - \mathbf{c}| \leq \mathbf{h}$. For the edge-box intersection test, we use the SAT described on page 80 if we merely want to test the polygon for intersection and do not require any further data. If we need to compute a common point or the actual intersection of the polygon and the box, then we should use the clipping method described on page 73.

Finally, if none of these tests results in an answer, there is still a possibility that the box intersects the interior of the polygon. This case is tested by the fourth test in the basic strategy. In order to test this case, we compute the intersection point of the polygon's plane and the box diagonal that is closest to (i.e., has the smallest angle with) the plane's normal, and check whether this point lies inside the polygon. This method for testing the intersection of the box and the polygon's interior has been proposed by Green and Hatch in [60] as an improvement over the method presented by Voorhies in [129].

Let $\mathbf{n} = (\nu_1, \nu_2, \nu_3)$ and $\mathbf{h} = (\eta_1, \eta_2, \eta_3)$. Then, the closest diagonal is the line segment $\mathbf{c} + \lambda \mathbf{d}$, for $\lambda \in [-1, 1]$, where

$$\mathbf{d} = (\text{sign}(\nu_1)\eta_1, \text{sign}(\nu_2)\eta_2, \text{sign}(\nu_3)\eta_3).$$

This diagonal is indeed closest to \mathbf{n}, since $\mathbf{n} \cdot \mathbf{d} = |\mathbf{n}| \cdot \mathbf{h}$ is the maximum over all diagonal directions $(\pm\eta_1, \pm\eta_2, \pm\eta_3)$. The point of intersection of the diagonal and the plane is the point $\mathbf{x} = \mathbf{c} + \lambda \mathbf{d}$, where

$$\lambda = -\frac{\mathbf{n} \cdot \mathbf{c} + \delta}{\mathbf{n} \cdot \mathbf{d}}.$$

Clearly, we have $\lambda \in [-1, 1]$ iff the plane intersects the box, since then $|\mathbf{n} \cdot \mathbf{c} + \delta| \leq \mathbf{n} \cdot \mathbf{d}$. Thus, the point \mathbf{x} is indeed a common point of the box and the plane. The box intersects the interior of the polygon iff the point \mathbf{x} is contained in the polygon.

Convex Objects

Just ask the axis.
—Jimi Hendrix

In this chapter, we look at algorithms for convex objects. We consider algorithms for polytopes (convex polyhedra) and general convex objects, such as ellipsoids, cones, and cylinders. We present an overview of algorithms for performing several types of proximity queries on pairs of polytopes. The major part of this chapter discusses the Gilbert-Johnson-Keerthi algorithm (GJK) in detail. GJK is an iterative method for computing the distance between a pair of general convex objects. We will show how to tailor GJK for performing the other proximity queries as well. GJK receives our special attention here, since it not only excels in versatility, being applicable to general convex objects, but it is also one of the fastest methods for intersection testing of polytopes. We conclude this chapter with an explanation of the expanding-polytope algorithm (EPA) for computing the penetration depth of a pair of intersecting convex objects. GJK and EPA are closely related and are applicable to the same class of convex objects.

4.1 Proximity Queries

A *proximity query* is a query on a pair of objects that provides us with a clue about their relative geometric configuration. The proximity query types that we consider for convex objects are

- finding a common point
- finding a separating plane or a separating axis
- computing the distance and a pair of closest points
- computing the penetration depth and a pair of witness points for the penetration depth.

We will look at single-shot algorithms and incremental algorithms for solving these queries. In animated 3D worlds, there usually is a lot of frame coherence. Incremental algorithms that exploit frame coherence are likely to result in a better performance than single-shot algorithms.

Algorithms for finding a common point are usually single-shot algorithms. Exploiting coherence by using common points from previous frames for speeding up intersection tests does not appear to be useful, since in most applications of collision detection, collisions are resolved rather than maintained. A separating plane or axis is a witness of the disjointness of a pair of objects. This type of witness is better suited for exploiting frame coherence than common points, since it is the objective in most applications to keep objects disjoint. So, a witness of the disjointness of a pair of objects is likely to persist over several frames.

A *separating plane* of two objects is a plane for which one object lies in the positive open halfspace and the other in the negative. The axis orthogonal to a separating plane is a *separating axis*. Let the plane $H(\mathbf{v}, \delta)$ be a separating plane of objects A and B, and assume without loss of generality that $A \subset H^{\oplus}(\mathbf{v}, \delta)$ and $B \subset H^{\ominus}(\mathbf{v}, \delta)$. We see that for separating axis \mathbf{v} we have

$$\mathbf{v} \cdot \mathbf{x} > \mathbf{v} \cdot \mathbf{y} \quad \text{for all } \mathbf{x} \in A \text{ and } \mathbf{y} \in B.$$

Conversely, for an axis \mathbf{v} for which the above inequality holds, we find that each plane $H(\mathbf{v}, \delta)$ with $\max\{\mathbf{v} \cdot \mathbf{y} : \mathbf{y} \in B\} < \delta < \min\{\mathbf{v} \cdot \mathbf{x} : \mathbf{x} \in A\}$ is a separating plane.

Frame coherence can be exploited by testing whether a separating plane or axis from a previous frame also separates the objects in the current frame. This operation is usually a lot cheaper than performing a single-shot intersection test. Since animated objects usually move relatively little between frames, a separating plane from a previous frame is likely to be a separating plane in the current frame, in which case we immediately have an answer.

Theorem 4.1 shows that for nonintersecting convex objects a separating axis always exists. We already saw this to be true for convex polytopes in Theorem 3.1 on page 78; however, the theorem presented here is more general. For proving Theorem 4.1 we use Lemma 4.1. We will use this lemma a few more times in proofs in this chapter.

We see that closest points of $\mathbf{a} \in A$ and $\mathbf{b} \in B$ coincide if objects A and B are intersecting, and form a separating axis $\mathbf{a} - \mathbf{b}$ if A and B are disjoint. Apparently, an algorithm for computing a pair of closest points of two convex objects can be used to solve three types of proximity queries: the

common point query, the separating-axis query, and of course, the closest point query.

Theorem 4.1

Let A and B be convex objects and $\mathbf{a} \in A$ and $\mathbf{b} \in B$, a pair of closest points. Then, either A and B intersect ($A \cap B \neq \emptyset$), or $\mathbf{a} - \mathbf{b}$ is a separating axis.

Proof

Suppose that $A \cap B = \emptyset$. Then, $\mathbf{v} = \mathbf{a} - \mathbf{b} \neq \mathbf{0}$. Since \mathbf{a} and \mathbf{b} are closest points, \mathbf{v} is the point closest to the origin of $A - B$, the CSO of A and B. Let $\mathbf{x} \in A$ and $\mathbf{y} \in B$. Then, $\mathbf{w} = \mathbf{x} - \mathbf{y} \in A - B$. Since $A - B$ is convex, any \mathbf{u} on the line segment $\overline{\mathbf{vw}}$ is contained in $A - B$, and thus $\|\mathbf{u}\| \geq \|\mathbf{v}\|$. It follows from Lemma 4.1 that $\|\mathbf{v}\|^2 - \mathbf{v} \cdot \mathbf{w} \leq 0$. Hence, $\mathbf{v} \cdot \mathbf{w} \geq \|\mathbf{v}\|^2 > 0$. We find that $\mathbf{v} \cdot \mathbf{x} > \mathbf{v} \cdot \mathbf{y}$ for all $\mathbf{x} \in A$ and $\mathbf{y} \in B$. Thus, \mathbf{v} is a separating axis. ∎

Lemma 4.1

Let \mathbf{v} and \mathbf{w} be vectors. The line segment connecting \mathbf{v} and \mathbf{w} contains a vector \mathbf{u} for which $\|\mathbf{u}\| < \|\mathbf{v}\|$ only if $\|\mathbf{v}\|^2 - \mathbf{v} \cdot \mathbf{w} > 0$. (See Figure 4.1.)

Proof

Let $\mathbf{u} = \mathbf{v} + \lambda(\mathbf{w} - \mathbf{v})$. Then, for $0 \leq \lambda \leq 1$, \mathbf{u} is contained by the line segment $\overline{\mathbf{vw}}$. We see that $\|\mathbf{u}\|^2 - \|\mathbf{v}\|^2 = 2\lambda \mathbf{v} \cdot (\mathbf{w} - \mathbf{v}) + \lambda^2 \|\mathbf{w} - \mathbf{v}\|^2$. For $\|\mathbf{u}\|^2 - \|\mathbf{v}\|^2 = 0$, we find the roots $\lambda_1 = 0$ and $\lambda_2 = -2\mathbf{v} \cdot (\mathbf{w} - \mathbf{v})/\|\mathbf{w} - \mathbf{v}\|^2$. Since $\|\mathbf{w} - \mathbf{v}\|^2 > 0$, we find that $\|\mathbf{u}\|^2 - \|\mathbf{v}\|^2$ is positive for $\lambda \to \infty$. It follows that $\lambda_2 > 0$ only if $\|\mathbf{v}\|^2 - \mathbf{v} \cdot \mathbf{w} > 0$. If $\|\mathbf{v}\|^2 - \mathbf{v} \cdot \mathbf{w} \leq 0$, then $\lambda_2 \leq 0$, and thus $\|\mathbf{u}\|^2 - \|\mathbf{v}\|^2$ is positive for all $0 \leq \lambda \leq 1$. Otherwise, $\|\mathbf{u}\|^2 - \|\mathbf{v}\|^2 < 0$ for $\lambda_1 < \lambda < \lambda_2$. Since $[\lambda_1, \lambda_2] \cap [0, 1] \neq \emptyset$, there must be a point \mathbf{u} on the line segment $\overline{\mathbf{vw}}$ for which $\|\mathbf{u}\| < \|\mathbf{v}\|$. ∎

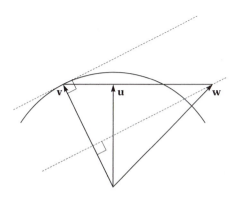

Figure 4.1 The line segment $\overline{\mathbf{vw}}$ contains a vector \mathbf{u} for which $\|\mathbf{u}\| < \|\mathbf{v}\|$ only if $\|\mathbf{v}\|^2 - \mathbf{v} \cdot \mathbf{w} > 0$.

4.2 Overview of Algorithms for Polytopes

Proximity queries on polytopes are a popular topic in computational geometry literature. The algorithms presented in computational geometry texts are usually single-shot algorithms that are aimed at finding the worst-case time bounds for the different query types. Research in this area was mainly driven by theoretical interest, and thus implementations are often lacking.

For our purpose, incremental algorithms are more interesting than single-shot algorithms, since they allow us to exploit temporal coherence. This section presents an overview of both single-shot and incremental algorithms for performing different types of proximity queries on polytopes.

4.2.1 Finding a Common Point

The first algorithm that improved upon the trivial $O(n^2)$ bound for finding a common point of a pair of convex polyhedra was presented by Muller and Preparata [92]. Their paper presents an algorithm for constructing the intersection of two convex polyhedra. The common point returned by the detection algorithm is a prerequisite for the construction algorithm. The algorithms use doubly connected edge lists (DCELs) as boundary representations for the polyhedra. A DCEL is basically a winged-edge structure in which some information is omitted. Winged-edge type structures are discussed on page 25. Both the detection and construction algorithms have a time complexity of $O(n \log n)$, where n is the total number of vertices of both polyhedra.

In fact, it has been shown by Chazelle and Dobkin that detecting intersections between polyhedra can be done in sublinear time if the proper preprocessing on the polyhedra is allowed, whereas constructing the intersection of polyhedra has a linear lower bound [22]. The best upper bound for the common point detection problem was given by Dobkin and Kirkpatrick [29]. Their algorithm has an upper bound of $O(\log^2 n)$ and requires a representation of each polyhedron decomposed into drums, which are the convex subparts that are formed by slicing the polyhedron at each vertex by a horizontal plane. The drum representation requires $O(n^2)$ space. Little is known of how well these algorithms perform on current computer platforms, since implementations are not currently available and are probably nonexistent.

An interesting way to view the intersection detection problem for polytopes is by regarding it as a linear programming (LP) problem. An LP

problem is an optimization problem of the form

$$\text{maximize } \mathbf{c} \cdot \mathbf{x}$$
$$\text{subject to } \mathbf{n}_i \cdot \mathbf{x} + \delta_i \leq 0 \quad \text{for } i = 1, \ldots, n,$$

where the vector \mathbf{c} and the constraints $\mathbf{n}_i \cdot \mathbf{x} + \delta_i \leq 0$ are given, and \mathbf{x} is the variable for which an optimal solution is sought. The feasible set is the intersection of all halfspaces $H^-(\mathbf{n}_i, \delta_i)$. A feasibility test returns, if possible, a member of the feasible set. For a feasibility test, the objective vector \mathbf{c} may be taken to be any vector, including the zero vector.

The problem of finding a common point of a pair of polytopes can be expressed as an LP feasibility test in the following way. We take the halfspaces of the two polytopes as the constraints of our LP problem; thus, the intersection of the polytopes is the feasible set. Recall that the number of halfspaces in a halfspace representation of a polytope is linear in its number of vertices. Hence, for a pair of polytopes of n vertices each, we have $O(n)$ constraints. A common point of a pair of polytopes is returned by a feasibility test on the set of halfspaces of both polyhedra.

Both Megiddo [84] and Dyer [34] showed independently that low-dimension LP problems can be solved in linear time with respect to the number of constraints. Their solutions, however, are rather complex and have a large constant for problems in three or higher dimensions. Low-dimensional LPs can be implemented in a surprisingly simple manner, by applying a randomized algorithm, as shown by Seidel in [111]. The basic outline for performing a feasibility test using this randomized algorithm is as follows.

First, the halfspaces are put is some random order H_1, \ldots, H_n. We compute an arbitrary point \mathbf{x}_d in $P_d = H_1 \cap \cdots \cap H_d$, where d is the dimension of the space. If, for $i = 1, \ldots, d$, the normals \mathbf{n}_i are linearly independent, then the intersection point of the hyperplanes $\mathbf{n}_i \cdot \mathbf{x} + \delta_i = 0$ is a proper point \mathbf{x}_d in P_d. Otherwise, swap one or more of the d halfspaces with a halfspace $H_i, i = d+1, \ldots, n$, until the first d normals are linearly independent. If no d linearly independent normals can be found, then reduce the problem to a lower-dimensional LP problem by replacing the halfspaces by their intersection with the subspace spanned by the normals.

Next, we iterate over all remaining halfspaces $H_i, i = d + 1, \ldots, n$, and compute, if possible, in each step a point \mathbf{x}_i in $P_i = P_{i-1} \cap H_i$. If we are lucky, and $\mathbf{x}_{i-1} \in H_i$, then we simply take $\mathbf{x}_i = \mathbf{x}_{i-1}$. Otherwise, \mathbf{x}_i is taken to be a point in $P_{i-1} \cap H(\mathbf{n}_i, \delta_i)$, that is, a point on the current hyperplane in the previous feasible set. This is actually a feasibility test in $(d - 1)$–dimensional space on the halfspaces $H'_j = H_j \cap H(\mathbf{n}_i, \delta_i)$, for $j = 1, \ldots, i-1$. We recursively reduce the dimension of the problem space and solve the feasibility test in the lower-dimensional space. For $d = 1$, either finding a feasible point or detecting that the feasible set is empty is trivial. As shown

Table 4.1 Common point search algorithms for convex polyhedra.

	MP [92]	DK [29]	LP problem [111]
Representation	DCEL	drum decomp.	halfspaces
Space bound	$O(n)$	$O(n^2)$	$O(n)$
Time bound	$O(n \log n)$	$O(\log^2 n)$	expected $O(n)$
Implementation	unknown	unknown	Hohmeyer [68]

by Seidel in [111], this algorithm has an expected time complexity of $O(d!n)$.

Table 4.1 shows an overview of the discussed common point detection algorithms. These algorithms seem less suitable for collision detection in animated worlds, since they are single-shot algorithms and probably perform worse than the incremental algorithms that we discuss in the following sections.

4.2.2 Finding a Separating Plane

Contrary to the problem of finding a common point, the problem of finding a separating plane for polytopes cannot be expressed as a linear programming problem. However, there is a less strict definition of a separating plane, referred to as a weakly separating plane, for which the separating plane search problem *can* be expressed as an LP feasibility test. A *weakly separating plane* is a plane for which the objects are contained in the positive and negative *closed* halfspaces. The existence of a weakly separating plane does not guarantee the disjointness of the objects, but it does warrant the disjointness of the interiors of the objects. In practice, not counting touching contacts as collisions hardly makes a difference, since in general touching contacts are extremely rare and are hard to distinguish from near contacts.

The problem of finding a weakly separating plane for a pair of polytopes can be expressed as an LP problem in the following way. It can be seen that a plane that weakly separates the vertices of two polytopes also weakly separates the polytopes themselves. For a pair of polytopes A and B, we need to find a plane $H(\mathbf{v}, \delta)$ such that for all vertices $\mathbf{a} \in \text{vert}(A)$, we have $\mathbf{v} \cdot \mathbf{a} + \delta \geq 0$, and for all vertices $\mathbf{b} \in \text{vert}(B)$, we have $\mathbf{v} \cdot \mathbf{b} + \delta \leq 0$. We see that our search space is four-dimensional. This problem can be expressed as the problem of finding a "point" $\mathbf{x} = (\mathbf{v}, \delta)$ subject to the constraints $(\mathbf{a}, 1) \cdot \mathbf{x} \geq 0$ for $\mathbf{a} \in \text{vert}(A)$, and $(\mathbf{b}, 1) \cdot \mathbf{x} \leq 0$ for $\mathbf{b} \in \text{vert}(B)$, which is clearly an LP problem. As we saw earlier, low-dimensional LP problems can be solved in expected linear time using Seidel's randomized algorithm.

An original approach to finding a weakly separating axis of a pair of polytopes is presented by Chung and Wang in [23]. A *weakly separating axis* of polytopes A and B is a nonzero vector \mathbf{v} such that

$$\mathbf{v} \cdot \mathbf{a} \geq \mathbf{v} \cdot \mathbf{b} \quad \text{for all} \quad \mathbf{a} \in \text{vert}(A) \text{ and } \mathbf{b} \in \text{vert } B.$$

The Chung-Wang (CW) algorithm is an iterative method for approximating a weakly separating axis. The algorithm uses support mappings of the polytopes for computing approximations of the weakly separating axis. A *support mapping* of a polytope A is a function s_A that maps a vector \mathbf{v} to a vertex of A, according to

$$s_A(\mathbf{v}) \in \text{vert}(A) \quad \text{such that} \quad \mathbf{v} \cdot s_A(\mathbf{v}) = \max\{\mathbf{v} \cdot \mathbf{a} : \mathbf{a} \in \text{vert}(A)\}.$$

The result of a support mapping is called a *support point*. Support mappings are used also in the GJK algorithm. We will discuss the computation of support points for polytopes and other shapes in Section 4.3.4.

Expressed in terms of support points, a weakly separating axis of A and B is a nonzero vector \mathbf{v} for which

$$\mathbf{v} \cdot s_A(-\mathbf{v}) \geq \mathbf{v} \cdot s_B(\mathbf{v}),$$

as illustrated in Figure 4.2. Suppose that in the kth iteration, the axis \mathbf{v}_k failed to be a weakly separating axis. Then, the following axis is taken as a better approximation of a possibly existing weakly separating axis:

$$\mathbf{v}_{k+1} = \mathbf{v}_k - 2(\mathbf{r}_k \cdot \mathbf{v}_k)\mathbf{r}_k,$$

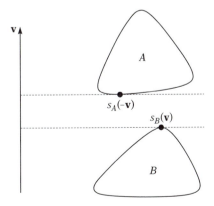

Figure 4.2 For a weakly separating axis \mathbf{v}, we have $\mathbf{v} \cdot s_A(-\mathbf{v}) \geq \mathbf{v} \cdot s_B(\mathbf{v})$.

where

$$\mathbf{r}_k = \mathbf{w}_k/\|\mathbf{w}_k\| \quad \text{and} \quad \mathbf{w}_k = s_A(-\mathbf{v}_k) - s_B(\mathbf{v}_k).$$

This choice is motivated by the observation that for a nonintersecting pair of spheres, for which \mathbf{v}_k is not a weakly separating axis, the axis \mathbf{v}_{k+1} is a weakly separating axis [23]. As initial axis \mathbf{v}_0 we may take an arbitrary unit vector. Each \mathbf{v}_k has length 1, since each new \mathbf{v}_{k+1} is the reflection of \mathbf{v}_k in the plane $H(\mathbf{r}_k, 0)$.

The CW algorithm terminates as soon as either \mathbf{v}_k is a weakly separating axis (i.e., $\mathbf{v}_k \cdot \mathbf{w}_k \geq 0$) or there is evidence that the objects' interiors intersect. Note that \mathbf{r}_k is not defined for $\mathbf{w}_k = \mathbf{0}$. However, this case does not yield a problem, since for $\mathbf{w}_k = \mathbf{0}$, we have $\mathbf{v}_k \cdot \mathbf{w}_k = 0$, and thus, \mathbf{v}_k is a weakly separating axis, in which case the algorithm terminates. Figure 4.3 illustrates a sequence of iterations that results in \mathbf{v}_3 being a separating axis.

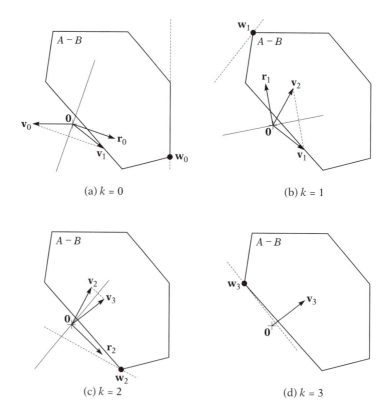

(a) $k = 0$

(b) $k = 1$

(c) $k = 2$

(d) $k = 3$

Figure 4.3 Four iterations of the CW algorithm. The dashed line segments represent the support planes $H(\mathbf{v}_k, -\mathbf{v}_k \cdot \mathbf{w}_k)$. The plane in which \mathbf{v}_k is reflected is represented as a continuous line segment.

In the case where a weakly separating axis does not exist, the algorithm terminates as soon as there is evidence that the interiors of the objects intersect. For this purpose, the CW algorithm uses a subalgorithm that tries to compute a vector \mathbf{n}_k such that $\mathbf{n}_k \cdot \mathbf{w}_i \geq 0$ for all $i = 0, \ldots, k$. If such a vector does not exist, then $\mathbf{0}$ must lie in the interior of $A - B$, and thus, the interiors of A and B intersect. Chung and Wang present an $O(k)$ time algorithm for computing such an \mathbf{n}_k. Hence, for a pair of polytopes of n and m vertices, it takes $O(k^2)$ time to perform k iterations, assuming that the support points are computed in constant time. It shows that for an acceptable performance of the algorithm the number of iterations needs to be kept small.

The problem with the basic iteration step is the fact that for a weakly separable pair of objects, \mathbf{v}_k may not converge to a weakly separating axis. Theorem 4.2 expresses the strongest point that can be made.[1] Since both \mathbf{v}_k and \mathbf{v}_{k+1} are unit vectors, it follows from Theorem 4.2 that the angle between \mathbf{v}_{k+1} and \mathbf{u} is at most as large as the angle between \mathbf{v}_k and \mathbf{u}. However, this is not sufficient to conclude that $\mathbf{v}_k \cdot \mathbf{w}_k \geq 0$, for some $k \geq 0$; that is, it does not prove that eventually a weakly separating axis is found. Further on, we will discuss how termination can be achieved.

Theorem 4.2

Suppose that unit vector \mathbf{u} is a weakly separating axis of A and B, and that \mathbf{v}_k is not a weakly separating axis. Then, $\mathbf{v}_{k+1} \cdot \mathbf{u} \geq \mathbf{v}_k \cdot \mathbf{u}$.

Proof

We deduce, $\mathbf{v}_{k+1} \cdot \mathbf{u} = \mathbf{v}_k \cdot \mathbf{u} - 2(\mathbf{r}_k \cdot \mathbf{v}_k)(\mathbf{r}_k \cdot \mathbf{u})$. Since \mathbf{u} is a weakly separating axis, and \mathbf{v}_k is not, we have $\mathbf{r}_k \cdot \mathbf{u} \geq 0$ and $\mathbf{r}_k \cdot \mathbf{v}_k < 0$. Hence, $\mathbf{v}_k \cdot \mathbf{u} - 2(\mathbf{r}_k \cdot \mathbf{v}_k)(\mathbf{r}_k \cdot \mathbf{u}) \geq \mathbf{v}_k \cdot \mathbf{u}$.

Let's explore how large the number of iterations of the CW algorithm can grow. Clearly, if \mathbf{v}_k is close to being a separating axis (i.e., $\mathbf{v}_k \cdot \mathbf{w}_k \approx 0$), then $\mathbf{r}_k \cdot \mathbf{v}_k \approx 0$, and thus $\mathbf{v}_{k+1} \approx \mathbf{v}_k$, which suggests that convergence is slow. This problem will occur most prominently if the objects are (almost) touching. In our experiments, we computed a convergence factor ρ using the formula

$$\rho = \frac{\mathbf{r}_k \cdot \mathbf{v}_k}{\mathbf{r}_{k-1} \cdot \mathbf{v}_{k-1}}.$$

Here, $\mathbf{r}_k \cdot \mathbf{v}_k$ is half the length of $\mathbf{v}_{k+1} - \mathbf{v}_k$ (half the length of the dotted line in Figure 4.3). For the cases where objects were touching, we often found $\rho \approx 1$, which shows that the algorithm's convergence is extremely slow.

1. Chung and Wang claim $\mathbf{v}_{k+1} \cdot \mathbf{u} > \mathbf{v}_k \cdot \mathbf{u}$ in [23]; however, the proof they give is incorrect.

In general, the number of iterations can grow arbitrarily large. However, Chung and Wang exploit a property that enables the algorithm to terminate in a finite number of iterations. After a certain number of iterations (Chung and Wang suggest the first time a vector \mathbf{w}_k is returned that appeared before), the algorithm continues iterating using $\mathbf{v}_{k+1} = \mathbf{n}_k$ as a new axis. If for this axis a vector \mathbf{w}_{k+1} is returned that appeared before, then the axis is a weakly separating axis, since $\mathbf{n}_k \cdot \mathbf{w}_i \geq 0$ for all $i = 0, \ldots, k$. Thus, in each iteration the algorithm either terminates, or the new vector \mathbf{w}_{k+1} is different from all \mathbf{w}_i, for $i = 0, \ldots, k$. Since for polytopes of m and n vertices there exist mn combinations of support points, the number of different vectors $\mathbf{w}_k = s_A(-\mathbf{v}_k) - s_B(\mathbf{v}_k)$ is at most mn. Thus, the algorithm will perform mn iterations in the worst case, before establishing a termination condition. In practice, the algorithm will often need fewer iterations, since only a small number of all the possible vertex combinations will be returned. However, for polytopes that have a lot of vertices, the number of iterations can still be quite large, which is harmful for performance, considering the algorithm's $O(k^2)$ time complexity.

Further iterations can be saved by exploiting frame coherence. We saw that the initial axis \mathbf{v}_0 may be chosen arbitrarily. In cases where there is a lot of frame coherence, an existing separating axis of the object pair from a previous frame is likely to be a separating axis in the current frame. If we take this axis as the initial axis, the algorithm will often need only one iteration.

At first glance, the CW algorithm seems a good candidate for generalization to other convex objects besides polytopes, since we can also provide support mappings for nonpolytopes. However, since the number of support points of a nonpolytope is unbounded, we cannot guarantee that the algorithm terminates. Due to extremely slow convergence for cases where the objects are almost touching, this termination condition is of crucial importance.

Table 4.2 shows an overview of the discussed separating-plane algorithms. Although Seidel's randomized LP algorithm runs in linear time, we have to be aware of the fact that for higher dimensions the constant factor is quite large ($O(d!)$). Since finding a weakly separating axis is a four-dimensional problem, the LP approach may turn out to be too expensive in practice. In this respect, the Chung-Wang approach seems more attractive, since it runs in near constant time when used incrementally. However, keep in mind that the differences in performance between the average and the worst case can be huge for CW. The Gilbert-Johnson-Keerthi algorithm, which we will discuss in Section 4.3, results in a similar iterative method for finding (strongly) separating axes. GJK may not perform as well as CW on average; however, its worst-case performance has a tighter bound, which is often more desirable. Moreover, GJK can be generalized more successfully to arbitrary convex objects.

Table 4.2 Weakly separating plane algorithms for convex polyhedra.

	LP problem [111]	CW [23]
Representation	vertices only	vertex adjacency graph
Space bound	$O(n)$	$O(n)$
Time bound	expected $O(n)$	incremental: near $O(1)$
		single shot: roughly $O(n^2)$
Implementation	Hohmeyer [68]	no longer publicly available

4.2.3 Distance and Penetration Depth Computation

One of the first significant solutions to the polytope distance computation problem was presented by Dobkin and Kirkpatrick in [30]. They devised an algorithm for computing the distance between two convex polyhedra in time that is linear in the total number of vertices. This algorithm utilizes a hierarchical representation for two- and three-dimensional polytopes, discussed on page 27. They later showed that the distance between a pair of polytopes with m and n vertices can be found in $O(\log m \log n)$ time using the same hierarchical representation [31]. Although these algorithms are mainly of theoretical interest, the hierarchical polytope representation on which they rely has been applied successfully in practice, as we shall see further on.

In Chapter 2 we saw that the distance between a pair of convex objects A and B is realized by the point in their CSO $A - B$ closest to the origin. If the objects intersect, then the penetration depth is realized by the point on the boundary of the CSO closest to the origin. The distance as well as the penetration depth of a pair of convex polyhedra can be computed using the following approach by Cameron and Culley [16].

First, an explicit representation of $A - B$ is constructed, which is then used for solving the queries. We showed in Theorem 2.2 on page 34 that the Minkowski sum of two convex polyhedra is itself a convex polyhedron and can thus be represented using any of the discussed polyhedron representations. Cameron and Culley represent $A - B$ as the intersection of a set of halfspaces $H_i = H^-(\mathbf{n}_i, \delta_i)$, where $\|\mathbf{n}_i\| = 1$ and $i = 1, \ldots, m$. From Theorem 2.2 it follows that, for a pair of polytopes A and B having n vertices each, the number of halfspaces m is $O(n^2)$. The theoretical worst-case bound for the construction time of the set of halfspaces is $O(n^2 \log n)$ by applying a convex hull algorithm [104]. However, Cameron and Culley claim for their worst-case $O(n^3)$ time construction method a better expected performance.

From the halfspace representation, the distance and penetration depth are computed in the following way. Let $\delta_{max} = \max\{\delta_i\}$. If $\delta_{max} \leq 0$, then the origin is contained in the CSO, and thus, the distance is zero. The penetration depth is simply $-\delta_{max}$, the distance from the origin to $H(\mathbf{n}_{max}, \delta_{max})$, the closest boundary plane of any of the halfspaces. If $\delta_{max} > 0$, then the origin is not contained in the CSO, since \mathbf{n}_{max} is a separating axis. The point of the CSO closest to the origin lies on the plane $H(\mathbf{n}_{max}, \delta_{max})$. Similar to the LP feasibility test described on page 109, this point is found by reducing the dimension of the problem space. The closest point is the point in the convex polygon that is the region of the plane $H(\mathbf{n}_{max}, \delta_{max})$ bounded by the halfspaces $H'_i = H_i \cap H(\mathbf{n}_{max}, \delta_{max})$, for $i = 1, \ldots, m$. This algorithm does not return witness points for either the distance or the penetration depth since all computations are performed in configuration space.

The approach presented by Cameron and Culley is useful for objects that have a fixed orientation, since then the CSO is computed only once and only needs to be translated if one of the objects is translated. For objects with angular degrees of freedom, the CSO needs to be recomputed each time the orientation of one of the objects changes. In that case, computing the distance or the penetration depth using an explicit representation of the CSO may turn out to be too expensive. It would be better if we compute the closest point of $A - B$ without using an explicit representation of $A - B$. In Section 4.3 we will describe the GJK distance algorithm, which takes this approach for computing the point in $A - B$ closest to the origin, for convex objects A and B.

The Lin-Canny algorithm (LC) is an incremental algorithm for computing a pair of closest features of convex polyhedra [79]. A feature is a vertex, an edge, or a facet of the boundary of a polyhedron. LC forms the heart of I-COLLIDE, a publicly available software library for interactive collision detection [24]. LC's utility for interactive collision detection follows from its ability to compute a pair of closest features in near constant time if the closest features are approximately known. This is useful when there is a lot of frame coherence, as commonly is the case in computer animation, since then the closest features from a previous frame are likely to be approximate to the closest features in the current frame.

LC finds the closest features by iteratively "walking" across the boundaries of the polyhedra toward the features of the boundary that lie closest to each other. The algorithm starts at an arbitrary pair of features, preferably features that lie near to the closest features. In each iteration, the algorithm proceeds to a neighboring pair of features that either lie closer to each other or have lower dimensionality than the previous pair.

In order to quickly traverse the boundary toward the closest features, LC applies the concept of Voronoi regions. A *Voronoi region* of a feature is the set of points that are closer to this feature than to any other feature.

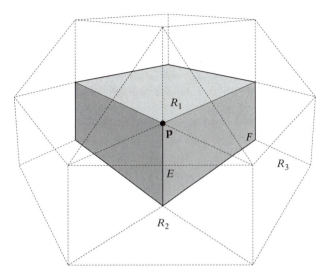

Figure 4.4 Voronoi regions of the features of a box. Vertex **p** has Voronoi region R_1, edge E has region R_2, and facet F has region R_3.

The Voronoi regions of the features of a convex polyhedron form a partitioning of the space outside the polyhedron, as illustrated in Figure 4.4. The Voronoi regions are separated by constraint planes and are unbounded. The constraint plane that separates the Voronoi region of a vertex from the region of an adjacent edge contains the vertex and is orthogonal to the edge. Similarly, the constraint plane that separates the Voronoi region of an edge from the region of an adjacent facet contains the edge and is orthogonal to the facet.

The basic data structure used for feature walking is the winged-edge structure, discussed on page 25. The constraint planes are stored as additional data in the edge nodes. Each edge node maintains four constraint planes: two corresponding with the adjacent vertices and two corresponding with the adjacent facets.

The Lin-Canny algorithm relies on Theorem 4.3 for its correctness. LC performs a local search of pairs of features until it finds a pair that satisfies the conditions of this theorem. In each iteration step the closest points of the current feature pair are computed and tested for containment in the other feature's Voronoi region. Should both points be contained by the Voronoi regions, then the closest points of the current feature pair are the closest points of the polyhedra, and we are done. Otherwise, one or both points violate some of the constraint planes that bound the Voronoi region of its counterpart. In that case, we replace the counterpart feature by an adjacent feature corresponding to a violated constraint plane. In the

case where multiple constraint planes are violated, we simply pick one of them.

Theorem 4.3

Let X and Y be features of disjoint convex polyhedra A and B, and let $\mathbf{x} \in X$ and $\mathbf{y} \in Y$ be the closest points of X and Y. If \mathbf{x} is contained by the Voronoi region of Y and \mathbf{y} is contained by the Voronoi region of X, then \mathbf{x} and \mathbf{y} are the closest points of A and B.

Proof

Let $\mathbf{v} = \mathbf{x} - \mathbf{y}$. Since \mathbf{x} is the point of X closest to \mathbf{y}, and \mathbf{y} is contained by X's Voronoi region, it follows from Lemma 4.1 that for all $\mathbf{x}' \in A$, we have $\mathbf{v} \cdot (\mathbf{x} - \mathbf{x}') = \|\mathbf{v}\|^2 - \mathbf{v} \cdot (\mathbf{x}' - \mathbf{y}) \leq 0$. Similarly, we find that for all $\mathbf{y}' \in B$, we have $\mathbf{v} \cdot (\mathbf{y}' - \mathbf{y}) \leq 0$. Let $\mathbf{x}' \in A$ and $\mathbf{y}' \in B$. We deduce

$$0 \geq \mathbf{v} \cdot (\mathbf{x} - \mathbf{x}') + \mathbf{v} \cdot (\mathbf{y}' - \mathbf{y})$$
$$= \mathbf{v} \cdot (\mathbf{x} - \mathbf{y} - (\mathbf{x}' - \mathbf{y}'))$$
$$= \|\mathbf{v}\|^2 - \mathbf{v} \cdot \mathbf{w},$$

where $\mathbf{w} = \mathbf{x}' - \mathbf{y}'$. Again, it follows from Lemma 4.1 that $\|\mathbf{w}\| \geq \|\mathbf{v}\|$. Therefore, \mathbf{x} and \mathbf{y} must be the closest points of A and B.

In each iteration step, either the distance between the current features or the dimension of one or both features decreases. In the case of a switch to a lower-dimensional feature, the distance between the features remains the same. Thus, the distance between the feature pairs in a sequence of iterations is monotonically nonincreasing. Furthermore, the algorithm cannot iterate infinitely using only switches to lower-dimensional features. Since a polyhedron has a finite number of features, any sequence of iteration steps must be finite.

This does not mean, however, that the sequence always converges to a feature pair that meets the conditions of Theorem 4.3. Special care should be taken in handling local minima—feature pairs that are not closest, and for which no closer neighboring feature pair exists. A local minimum occurs if one of the features is a facet and the closest point of the other feature (usually a vertex) is enclosed by the constraint planes of the facet's Voronoi region and lies on the negative side of the facet, as illustrated in Figure 4.5. We see that in this case all features adjacent to the facet lie further from the closest point than the facet.

The existence of a local minimum may be the result of the polyhedra interpenetrating; however, this is not guaranteed to be the case. Additional computations are necessary in order to determine if the polyhedra truly intersect. We escape a local-minimum condition for a disjoint

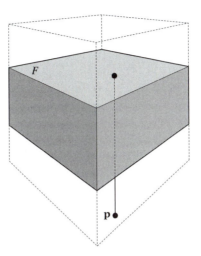

Figure 4.5 A local minimum condition. Facet *F* is not closest to point **p**. However, since **p** is enclosed by the constraint planes of *F*'s Voronoi region, all features adjacent to *F* are further from **p** than *F*.

pair of polyhedra by replacing the locally minimal facet with the closest facet. Testing a point for containment inside a polyhedron and finding the closest facet to a point can be done in a single operation [88]. Simply find the facet for which the point has the largest signed distance to the facet's supporting plane. If the maximum signed distance is negative, then the point is contained in the polyhedron. Otherwise, the corresponding facet is closest to the point. This operation takes linear time in the number of features. Note that for detecting intersections of the polyhedra we also need to check edges for intersection with the facets, since two polyhedra may intersect without the need for either polyhedron to contain a vertex of the other polyhedron. Checking edge-facet intersections can be done while computing the closest points for the feature pair, and thus takes little additional processing.

In theory, the running time of the LC algorithm has a worst-case upper bound of $O(n^2)$ for a pair of polyhedra of n vertices each, since there are $O(n^2)$ feature pairs. However, Lin and Canny claim that empirically their algorithm has a time bound that is linear in the number of vertices if no special initialization is done, and constant when the algorithm is initialized by a pair of features that lie close to the closest features. Local-minimum conditions for disjoint polyhedra should only occur in the initialization phase if the degree of frame coherence is high, since then at most one feature switch per frame is necessary. If there is not a lot of frame coherence—for instance, if objects are moving or spinning fast—then local minima may still occur in the simulation phase.

Although in theory the algorithm is guaranteed to reach a termination condition, finite-precision implementations of LC tend to suffer from cycling (i.e., infinite alternating of pairs of features) for degenerate configurations of objects. In I-COLLIDE the closest-feature test recovers from cycling by setting a maximum on the number of iterations. If the maximum is reached, then the LC approach is abandoned, and the results of the test are computed using Seidel's randomized linear-programming algorithm for finding a separating plane. Mirtich presented a variant of LC, called V-Clip, which is claimed to solve the cycling problem and has better performance than the original algorithm [88]. An implementation by Mirtich of the V-Clip algorithm is made publicly available as the V-Clip collision detection library.

Recently, two new variants of the LC feature-walking algorithm that employ multiple-level-of-detail polyhedron representations have been proposed [40, 62]. Both variants are offered as faster solutions for cases where the degree of coherence is low. The solution presented by Guibas et al. [62] is based on the Dobkin-Kirkpatrick hierarchical representation, discussed on page 27. By following shortcuts via coarser layers, their algorithm reduces the worst-case time for finding the closest features to $O(\log n)$.

The solution presented by Ehmann and Lin [40] is similar to the Dobkin-Kirkpatrick structure in the sense that each coarser level of detail reduces the number of features by a fixed factor. However, unlike DK, each level is a bounding volume of the original polyhedron. During feature tracking, the algorithm may skip to a coarser or finer level depending on the current distance between the features. In this way, considerable speedups can be attained in applications where accurate distances are not required. An implementation of this algorithm is publicly available as the SWIFT library [39].

Table 4.3 shows an overview of the discussed distance computation algorithms, of which the algorithm by Cameron and Culley also computes the penetration depth. Although the Dobkin-Kirkpatrick algorithm has

Table 4.3 Distance computation algorithms for convex polyhedra.

	DK [31]	CC [16]	LC [79]
Representation	hierarchical	winged-edge	winged-edge
Space bound	$O(n)$	$O(n^2)$	$O(n)$
Time bound	$O(\log^2 n)$	$O(n^3)$ $(O(n^2)$ orientations)	incremental: near $O(1)$ single shot: roughly $O(n)$
Implementation	unknown	exists [16]	I-COLLIDE [24], V-Clip [88]

the best worst-case time bound, we cannot draw conclusions regarding its actual performance, since there is no reference to an implementation of this algorithm. Of the mentioned distance algorithms, the LC-based algorithms are best suited for computer animation applications, where there is usually a lot of frame coherence. In the following section we will discuss the Gilbert-Johnson-Keerthi distance algorithm, which is competitive in performance with the LC-based algorithms.

4.3 The Gilbert-Johnson-Keerthi Algorithm

We devote the rest of this chapter to the Gilbert-Johnson-Keerthi algorithm (GJK). GJK is an iterative method for computing the distance between convex objects; however, it can be tailored to solve all the mentioned proximity queries. GJK is our method of choice for proximity queries on convex objects for the following reasons:

- GJK is extremely versatile. It can be applied to convex objects in general. We will show how to use GJK for polytopes, quadrics, Minkowski sums of convex objects, and images of convex objects under affine transformation.

- GJK is a one of the fastest methods currently available for performing the mentioned proximity queries. Incremental versions of GJK that exploit frame coherence achieve a performance that is competitive with other incremental methods.

- Despite the fact that GJK can be difficult to grasp, since the algorithm requires quite a lot of nonintuitive mathematics to describe, implementing GJK is not so hard. The algorithm needs to handle hardly any special cases.

The difficulty in understanding—or rather, getting an intuitive notion of—how GJK works can be a problem for implementors. Moreover, since it is an iterative method, GJK is very susceptible to numerical errors that may cause all sorts of bad behavior. So, we will take extra care in explaining all the mathematical and numerical details of the algorithm and pay special attention to how bad behavior due to numerical problems can be met. We start off with an overview of GJK and fill in the details in subsequent sections.

4.3.1 Overview

The original GJK distance algorithm is applicable to polytopes only [52]. Later, Gilbert and Foo presented a generalized GJK algorithm to be

used for convex objects in general [51]. We describe the generalized GJK algorithm here.

GJK is essentially a descent method for approximating the point closest to the origin of $A - B$, the CSO of A and B, where A and B are general convex objects. We denote this point as $v(A - B)$, where

$$v(C) \in C \quad \text{and} \quad \|v(C)\| = \min\{\|\mathbf{x}\| : \mathbf{x} \in C\}.$$

It follows that the distance between A and B can be expressed as

$$d(A, B) = \|v(A - B)\|.$$

GJK approximates the point $v(A - B)$ in the following way. In each iteration a simplex is constructed that is contained in $A - B$ and lies nearer to the origin than the simplex constructed in the previous iteration. A simplex is the convex hull of an affinely independent set of vertices. The simplices can have one to four vertices, so a simplex can be a single point, a line segment, a triangle, or a tetrahedron. We define W_k as the set of vertices of the simplex constructed in the kth iteration ($k \geq 1$), and \mathbf{v}_k as $v(\text{conv}(W_k))$, the point of the simplex closest to the origin. Initially, we take $W_0 = \emptyset$, and \mathbf{v}_0, an arbitrary point in $A - B$. Since $A - B$ is convex and $W_k \subseteq A - B$, we see that $\mathbf{v}_k \in A - B$, and thus $\|\mathbf{v}_k\| \geq \|v(A - B)\|$ for all $k \geq 0$. So, the length of \mathbf{v}_k is an upper bound for the distance between A and B.

GJK constructs each new simplex using a support mapping of $A - B$. A *support mapping* of a convex object A is a function s_A that maps a vector \mathbf{v} to a point of A, according to

$$s_A(\mathbf{v}) \in A \quad \text{such that} \quad \mathbf{v} \cdot s_A(\mathbf{v}) = \max\{\mathbf{v} \cdot \mathbf{x} : \mathbf{x} \in A\}.$$

The result of a support mapping for a given vector is called a *support point*. We already saw the use of support mappings for polytopes in the Chung-Wang algorithm on page 111. Note that a support mapping of a given object may not be unique. The choice of support mapping does not matter in the applications that we will encounter. We discuss the computation of support mappings for the different types of convex shapes in Section 4.3.4. For now, let's assume we have a support mapping s_{A-B} of $A - B$.

In each iteration we add a new support point $\mathbf{w}_k = s_{A-B}(-\mathbf{v}_k)$ as a vertex to the current simplex W_k. We take $\mathbf{v}_{k+1} = v(\text{conv}(W_k \cup \{\mathbf{w}_k\}))$, the point closest to the origin of the new simplex. As W_{k+1}, we take the smallest set $X \subseteq W_k \cup \{\mathbf{w}_k\}$, such that \mathbf{v}_{k+1} is contained in $\text{conv}(X)$. It can be seen that exactly one such X exists and that it must be affinely independent. So, what happens is that while we are adding vertices to the simplex, earlier vertices that are no longer necessary for supporting \mathbf{v}_{k+1} are discarded.

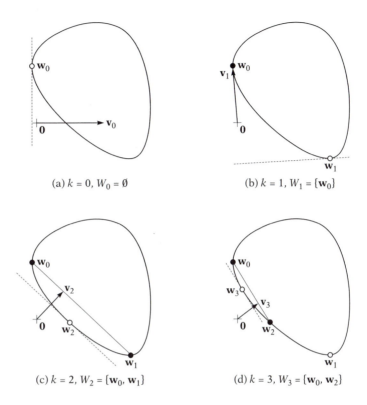

(a) $k = 0$, $W_0 = \emptyset$

(b) $k = 1$, $W_1 = \{\mathbf{w}_0\}$

(c) $k = 2$, $W_2 = \{\mathbf{w}_0, \mathbf{w}_1\}$

(d) $k = 3$, $W_3 = \{\mathbf{w}_0, \mathbf{w}_2\}$

Figure 4.6 Four iterations of the GJK algorithm. The dashed lines represent the support planes $H(-\mathbf{v}_k, \mathbf{v}_k \cdot \mathbf{w}_k)$. The points of W_k are drawn in black.

Figure 4.6 illustrates a sequence of iterations of the GJK algorithm in two-dimensional space.

4.3.2 Convergence and Termination

The theorems presented here prove that the sequence $\{\mathbf{v}_k\}$ converges to $v(A - B)$ and provide an upper bound for the error in \mathbf{v}_k. The proofs of these theorems are rather elaborate and presented only for the interested. They are not essential for understanding the GJK algorithm and can be safely skipped.

Theorem 4.4 shows that in each iteration step the new \mathbf{v}_{k+1} must be closer to the origin than the previous one, except if the previous \mathbf{v}_k was already the closest point. The proof of this theorem uses Lemma 4.1 from page 107 as well as Lemma 4.2. Lemma 4.2 offers a criterion for deciding whether \mathbf{v}_k is the closest point of $A - B$.

Theorem 4.4

$\|\mathbf{v}_{k+1}\| \leq \|\mathbf{v}_k\|$, with equality only if $\mathbf{v}_k = v(A - B)$.

Proof

First of all, $\|\mathbf{v}_{k+1}\| = \min\{\|\mathbf{x}\| : \mathbf{x} \in \text{conv}(W_k \cup \{\mathbf{w}_k\})\} \leq \|\mathbf{v}_k\|$, since $\mathbf{v}_k \in \text{conv}(W_k)$ and $\text{conv}(W_k) \subseteq \text{conv}(W_k \cup \{\mathbf{w}_k\})$. Suppose $\|\mathbf{v}_{k+1}\| = \|\mathbf{v}_k\|$. Then, $\|\mathbf{v}_k\| \leq \|\mathbf{x}\|$ for any $\mathbf{x} \in \text{conv}(W_k \cup \{\mathbf{w}_k\})$. Since $\mathbf{v}_k \in \text{conv}(W_k)$, and thus, the line segment $\overline{\mathbf{v}_k \mathbf{w}_k}$ is contained in $\text{conv}(W_k \cup \{\mathbf{w}_k\})$, we have $\|\mathbf{u}\| \geq \|\mathbf{v}_k\|$ for any point \mathbf{u} on the line segment $\overline{\mathbf{v}_k \mathbf{w}_k}$. Thus, according to Lemma 4.1, it follows that $\|\mathbf{v}\|^2 - \mathbf{v}_k \cdot \mathbf{w}_k \leq 0$. From Lemma 4.2 we know that $\|\mathbf{v}_k\|^2 - \mathbf{v}_k \cdot \mathbf{w}_k \geq 0$, and thus, $\|\mathbf{v}_k\|^2 - \mathbf{v}_k \cdot \mathbf{w}_k = 0$, which can only be the case if $\mathbf{v}_k = v(A - B)$.

Lemma 4.2

$\|\mathbf{v}\|^2 - \mathbf{v}_k \cdot \mathbf{w}_k \geq 0$, with equality only if $\mathbf{v}_k = v(A - B)$.

Proof

Since $-\mathbf{v}_k \cdot \mathbf{w}_k = -\mathbf{v}_k \cdot s_{A-B}(-\mathbf{v}_k) \geq -\mathbf{v}_k \cdot \mathbf{x}$ for all $\mathbf{x} \in A - B$, we have $\mathbf{v}_k \cdot \mathbf{x} - \mathbf{v}_k \cdot \mathbf{w}_k \geq 0$ for $\mathbf{x} \in A - B$. In particular, $\|\mathbf{v}_k\|^2 - \mathbf{v}_k \cdot \mathbf{w}_k \geq 0$. Suppose $\|\mathbf{v}_k\|^2 - \mathbf{v}_k \cdot \mathbf{w}_k = 0$. Then, for any $\mathbf{x} \in A - B$,

$$
\begin{aligned}
\|\mathbf{v}_k\|^2 &\leq \|\mathbf{v}_k\|^2 + \|\mathbf{x} - \mathbf{v}_k\|^2 \\
&= \|\mathbf{x}\|^2 - 2(\mathbf{v}_k \cdot \mathbf{x} - \|\mathbf{v}_k\|^2) \\
&= \|\mathbf{x}\|^2 - 2(\mathbf{v}_k \cdot \mathbf{x} - \mathbf{v}_k \cdot \mathbf{w}_k) \\
&\leq \|\mathbf{x}\|^2,
\end{aligned}
$$

and thus, $\mathbf{v}_k = v(A - B)$.

Theorem 4.4 provides a necessary, yet not sufficient, condition for global convergence [81]. It falls outside the scope of this book to get into the details of proving global convergence; however, an argument that can be made is the following. Gilbert has shown that for $\mathbf{v}_{k+1} = v(\overline{\mathbf{v}_k \mathbf{w}_k})$, the sequence $\{\mathbf{v}_k\}$ converges to $v(A - B)$ [50]. Since $\overline{\mathbf{v}_k \mathbf{w}_k} \subseteq \text{conv}(W_k \cup \{\mathbf{w}_k\})$, the GJK algorithm must do at least as well as the simpler iterative method. Thus, indeed $\mathbf{v}_k \rightarrow v(A - B)$ for $k \rightarrow \infty$.

For polytopes, GJK arrives at $\mathbf{v}_k = v(A - B)$ in a finite number of iterations, as shown in [52]. For nonpolytopes this may not be the case. For these types of objects, it is necessary that the algorithm terminates as soon as \mathbf{v}_k lies within a given tolerance from $v(A - B)$. Theorem 4.5 provides us with a means to estimate the error in \mathbf{v}_k. This theorem states that the squared distance between \mathbf{v}_k and $v(A - B)$ is bounded by $\|\mathbf{v}_k\|^2 - \mathbf{v}_k \cdot \mathbf{w}_k$. We recognize this term as the stop criterion from Lemma 4.2.

Theorem 4.5

$$\|\mathbf{v}_k - v(A - B)\|^2 \leq \|\mathbf{v}_k\|^2 - \mathbf{v}_k \cdot \mathbf{w}_k.$$

Proof

From Lemma 4.2 it follows that $\|\mathbf{v}\|^2 - \mathbf{v} \cdot s_{A-B}(-\mathbf{v}) = 0$, for $\mathbf{v} = v(A - B)$. Since, for any $\mathbf{x} \in A - B$, we have $-\mathbf{v} \cdot s_{A-B}(-\mathbf{v}) \geq -\mathbf{v} \cdot \mathbf{x}$, and thus, $\|\mathbf{v}\|^2 - \mathbf{v} \cdot \mathbf{x} \leq 0$, we find that $\|v(A - B)\|^2 - v(A - B) \cdot \mathbf{v}_k \leq 0$. We derive

$$\begin{aligned}
\|\mathbf{v}_k - v(A - B)\|^2 &= \|\mathbf{v}_k\|^2 - 2\mathbf{v}_k \cdot v(A - B) + \|v(A - B)\|^2 \\
&\leq \|\mathbf{v}_k\|^2 - \mathbf{v}_k \cdot v(A - B).
\end{aligned}$$

Furthermore, $-\mathbf{v}_k \cdot \mathbf{w}_k = -\mathbf{v}_k \cdot s_{A-B}(-\mathbf{v}_k) \geq -\mathbf{v}_k \cdot \mathbf{x}$ for any $\mathbf{x} \in A - B$. In particular, $-\mathbf{v}_k \cdot \mathbf{w}_k \geq -\mathbf{v}_k \cdot v(A-B)$. Hence, $\|\mathbf{v}_k - v(A-B)\|^2 \leq \|\mathbf{v}_k\|^2 - \mathbf{v}_k \cdot \mathbf{w}_k$.

Let $\gamma_k = \|\mathbf{v}_k\|^2 - \mathbf{v}_k \cdot \mathbf{w}_k$ be the upper bound for the squared distance between \mathbf{v}_k and $v(A - B)$. Note that, although $\mathbf{w}_k = s_{A-B}(-\mathbf{v}_k)$ may not be uniquely defined for \mathbf{v}_k, the error bound γ_k is uniquely defined for each \mathbf{v}_k. It follows from the well-known triangle inequality $\|x\| - \|y\| \leq \|x - y\|$ that

$$\|\mathbf{v}_k\| - \|v(A - B)\| \leq \|\mathbf{v}_k - v(A - B)\| \leq \sqrt{\gamma_k}.$$

So, $\sqrt{\gamma_k}$ is an upper bound for the absolute error in $\|\mathbf{v}_k\|$, the approximated value for $d(A, B)$. Furthermore, it follows from Lemma 4.3.2 that $\gamma_k = 0$ for $\mathbf{v}_k = v(A - B)$. Since γ_k is continuous in \mathbf{v}_k, we find that $\gamma_k \to 0$ for $\mathbf{v}_k \to v(A - B)$. For any positive absolute error tolerance ε_{abs}, there exists a k such that $\sqrt{\gamma_k} \leq \varepsilon_{\text{abs}}$. Phrased differently, γ_k drops below $\varepsilon_{\text{abs}}^2$ within a finite number of iterations, for any positive ε_{abs}. As a stop criterion for general convex objects we may choose $\|\mathbf{v}_k\|^2 - \mathbf{v}_k \cdot \mathbf{w}_k \leq \varepsilon_{\text{abs}}^2$. Algorithm 4.1 describes the GJK distance algorithm in pseudocode.

Algorithm 4.1

The theoretical GJK distance algorithm.

```
v := "arbitrary point in A − B";
W := ∅;
w := s_{A−B}(−v);
while ‖v‖² − v · w > ε²_abs do
   {{v is not close enough to v(A − B). }}
begin
   v := v(conv(W ∪ {w}));
   W := "smallest X ⊆ W ∪ {w} such that v ∈ conv(X)";
   w := s_{A−B}(−v);
end;
return ‖v‖
```

Note that Algorithm 4.1 describes the theoretical algorithm, in which arithmetic operations are assumed to have infinite precision. In a finite-precision implementation of the GJK algorithm, numerical problems may cause all sorts of bad behavior. We address these problems further on. First, let's fill in the remaining details.

4.3.3 Johnson's Distance Algorithm

Johnson's distance algorithm is an algorithm for computing the point \mathbf{v} of a simplex closest to the origin. Let Y be the affinely independent set of vertices of the simplex. Then, $\mathbf{v} = v(\text{conv}(Y))$. Furthermore, with Johnson's distance algorithm we determine the smallest $X \subseteq Y$ such that $\mathbf{v} \in \text{conv}(X)$. The algorithm is used in GJK for computing \mathbf{v}_{k+1} and W_{k+1} from $Y = W_k \cup \{\mathbf{w}_k\}$.

For $Y = \{\mathbf{y}_1, \ldots, \mathbf{y}_n\}$, the point \mathbf{v} is described as a convex combination of Y in the following way:

$$\mathbf{v} = \sum_{i=1}^{n} \lambda_i \mathbf{y}_i, \quad \text{where} \quad \sum_{i=1}^{n} \lambda_i = 1 \quad \text{and} \quad \lambda_i \geq 0.$$

The smallest $X \subseteq Y$ such that $\mathbf{v} \in \text{conv}(X)$ is the set $X = \{\mathbf{y}_i : \lambda_i > 0\}$. In other words, the set X is found by discarding all the points \mathbf{y}_i from Y for which $\lambda_i = 0$.

Since $\mathbf{v} = v(\text{conv}(X))$ and $X = \{\mathbf{y}_i : \lambda_i > 0\}$, it must also be that $\mathbf{v} = v(\text{aff}(X))$, that is, the point closest to the origin of the affine hull of X. This can be seen from the fact that if $v(\text{aff}(X))$ is closer to the origin than $v(\text{conv}(X))$, then for at least one $\mathbf{y}_i \in X$, the parameter λ_i would have to be zero. Moreover, for any $\mathbf{y}_j \in Y \setminus X$, the parameter λ_j for the point $v(\text{aff}(X \cup \{\mathbf{y}_j\}))$ is at most zero, because otherwise $v(\text{conv}(X)) \neq v(\text{conv}(Y))$.

So, we are looking for set $X = \{\mathbf{y}_i : i \in I_X\}$, where $I_X \subseteq \{1, \ldots, n\}$, for which (i) for all $i \in I_X$, we have $\lambda_i > 0$ in

$$v(\text{aff}(X)) = \sum_{i \in I_X} \lambda_i \mathbf{y}_i \quad \text{and} \quad \sum_{i \in I_X} \lambda_i = 1,$$

and (ii) for all $j \notin I_X$, we have $\lambda_j \leq 0$ in

$$v(\text{aff}(X \cup \{\mathbf{y}_j\})) = \sum_{i \in I_X \cup \{j\}} \lambda_i \mathbf{y}_i \quad \text{and} \quad \sum_{i \in I_X \cup \{j\}} \lambda_i = 1.$$

For such a set X, we have $v(\text{aff}(X)) = v(\text{conv}(Y))$. In Johnson's algorithm, this subset X is found simply by iterating over all nonempty $X \subseteq Y$ and

checking whether X complies with rules (i) and (ii). Thus, it is necessary to compute the signs of the parameters λ_i that represent $v(\mathrm{aff}(X))$ for each nonempty $X \subseteq Y$. The parameters λ_i of $v(\mathrm{aff}(X))$ are computed as follows.

Let $X = \{\mathbf{y}_i : i \in I_X\} = \{\mathbf{x}_1, \ldots, \mathbf{x}_m\}$ be a subset of Y. We observe that a point $\mathbf{v} \in \mathrm{aff}(X)$ is closest to the origin iff the vector \mathbf{v} is perpendicular to $\mathrm{aff}(X)$, that is, $(\mathbf{x}_i - \mathbf{x}_1) \cdot \mathbf{v} = 0$ for $i = 2, \ldots, m$. Thus, the parameters λ_i of $v(\mathrm{aff}(X))$, expressed as an affine combination of X,

$$v(\mathrm{aff}(X)) = \sum_{i=1}^{m} \lambda_i \mathbf{x}_i \quad \text{and} \quad \sum_{i=1}^{m} \lambda_i = 1,$$

are found by solving the system of linear equations $\mathbf{A}[\lambda_1, \ldots, \lambda_m]^{\mathsf{T}} = \mathbf{b}$, where

$$\mathbf{A} = \begin{bmatrix} 1 & \cdots & 1 \\ (\mathbf{x}_2 - \mathbf{x}_1) \cdot \mathbf{x}_1 & \cdots & (\mathbf{x}_2 - \mathbf{x}_1) \cdot \mathbf{x}_m \\ \vdots & & \vdots \\ (\mathbf{x}_m - \mathbf{x}_1) \cdot \mathbf{x}_1 & \cdots & (\mathbf{x}_m - \mathbf{x}_1) \cdot \mathbf{x}_m \end{bmatrix} \quad \text{and} \quad \mathbf{b} = \begin{bmatrix} 1 \\ 0 \\ \vdots \\ 0 \end{bmatrix}.$$

We apply Cramer's rule to solve this system of equations. For $\mathbf{A} = [\mathbf{a}_1 \cdots \mathbf{a}_m]$, we find the solution

$$\lambda_j = \frac{\det[\mathbf{a}_1 \cdots \mathbf{a}_{j-1} \, \mathbf{b} \, \mathbf{a}_{j+1} \cdots \mathbf{a}_m]}{\det(\mathbf{A})}.$$

By performing a cofactor expansion about the first row, we find that

$$\lambda_j = \frac{(-1)^{1+j} \det(\mathbf{A}_{1j})}{\det(\mathbf{A})}.$$

For $\mathbf{x}_j = \mathbf{y}_i, i \in I_X$ we define

$$\Delta_i^X = (-1)^{1+j} \det(\mathbf{A}_{1j}).$$

This expression makes sense since the order in which the \mathbf{y}_i appear in X is irrelevant. This can be seen by the fact that for any permutation of assignments of points \mathbf{y}_i to \mathbf{x}_j, the vectors $\mathbf{x}_j - \mathbf{x}_1$ for $j = 2, \ldots, m$ are linearly independent and contained in $\mathrm{aff}(X)$. Thus, the value of Δ_i^X will be the same for all of these permutations.

We will derive a recursive definition for Δ_i^X. First of all, for singleton X, we trivially have $\Delta_i^X = 1$; thus,

$$\Delta_i^{\{y_i\}} = 1.$$

Suppose we have computed Δ_i^X for all $i \in I_X$. Take $j \notin I_X$, and assign \mathbf{y}_j to \mathbf{x}_{m+1}. Then,

$$\Delta_j^{X \cup \{\mathbf{y}_j\}} = (-1)^{1+(m+1)} \det(\mathbf{M}),$$

where the submatrix \mathbf{M} is defined as

$$\mathbf{M} = \begin{bmatrix} (\mathbf{x}_2 - \mathbf{x}_1) \cdot \mathbf{x}_1 & \cdots & (\mathbf{x}_2 - \mathbf{x}_1) \cdot \mathbf{x}_m \\ \vdots & & \vdots \\ (\mathbf{x}_m - \mathbf{x}_1) \cdot \mathbf{x}_1 & \cdots & (\mathbf{x}_m - \mathbf{x}_1) \cdot \mathbf{x}_m \\ (\mathbf{x}_{m+1} - \mathbf{x}_1) \cdot \mathbf{x}_1 & \cdots & (\mathbf{x}_{m+1} - \mathbf{x}_1) \cdot \mathbf{x}_m \end{bmatrix}.$$

The determinant $\det(\mathbf{M})$ is computed by cofactor expansion about the last (mth) row of \mathbf{M}. We find

$$\det(\mathbf{M}) = \sum_{j=1}^{m} (-1)^{m+j} ((\mathbf{x}_{m+1} - \mathbf{x}_1) \cdot \mathbf{x}_j) \det(\mathbf{A}_{1j}).$$

We derive

$$\Delta_j^{X \cup \{\mathbf{y}_j\}} = (-1)^{1+(m+1)} \sum_{j=1}^{m} (-1)^{m+j} ((\mathbf{x}_{m+1} - \mathbf{x}_1) \cdot \mathbf{x}_j) \det(\mathbf{A}_{1j})$$

$$= \sum_{j=1}^{m} (-1)^{2m+2+j} ((\mathbf{x}_{m+1} - \mathbf{x}_1) \cdot \mathbf{x}_j) \det(\mathbf{A}_{1j})$$

$$= \sum_{j=1}^{m} (-1)^{1+j} ((\mathbf{x}_1 - \mathbf{x}_{m+1}) \cdot \mathbf{x}_j) \det(\mathbf{A}_{1j})$$

$$= \sum_{i \in I_X} \Delta_i^X ((\mathbf{y}_k - \mathbf{y}_j) \cdot \mathbf{y}_i),$$

where $\mathbf{y}_k = \mathbf{x}_1$. Since the order in which \mathbf{y}_i appear in X is irrelevant, we may take any \mathbf{y}_k for which $k \in I_X$, as long as we use the same \mathbf{y}_k for all

terms in the summation. Let's summarize the recursive definition we just found:

$$\Delta_i^{\{\mathbf{y}_i\}} = 1$$

$$\Delta_j^{X \cup \{\mathbf{y}_j\}} = \sum_{i \in I_X} \Delta_i^X((\mathbf{y}_k - \mathbf{y}_j) \cdot \mathbf{y}_i) \quad \text{for } j \notin I_X \text{ and any } k \in I_X.$$

In the same way, we define $\Delta^X = \det(\mathbf{A})$ and express $v(\text{aff}(X))$ as

$$v(\text{aff}(X)) = \sum_{i \in I_X} \lambda_i \mathbf{y}_i \quad \text{where} \quad \lambda_i = \frac{\Delta_i^X}{\Delta^X}.$$

Since $v(\text{aff}(X))$ is expressed as an affine combination of X, and thus, $\sum_{i \in I_X} \lambda_i = 1$, we have

$$\Delta^X = \sum_{i \in I_X} \Delta_i^X.$$

Furthermore, it can be shown that $\det(\mathbf{A})$ is positive for affinely independent sets X [52]; thus the signs of the parameters λ_i are equal to the signs of the values Δ_i^X. Thus, the smallest $X \subseteq Y$ such that $\mathbf{v} \in \text{conv}(X)$ can now be characterized as the subset X for which (i) $\Delta_i^X > 0$ for each $i \in I_X$, and (ii) $\Delta_j^{X \cup \{\mathbf{y}_j\}} \leq 0$, for all $j \notin I_X$. Johnson's algorithm successively tests each nonempty subset X of Y until it finds one for which (i) and (ii) hold.

Let's take a look at the numerical aspects of Johnson's algorithm. As mentioned on page 101, it may seem tempting from a performance viewpoint to rewrite $(\mathbf{y}_k - \mathbf{y}_j) \cdot \mathbf{y}_i$ as $\mathbf{y}_k \cdot \mathbf{y}_i - \mathbf{y}_j \cdot \mathbf{y}_i$, since then we avoid the computation of an intermediate vector $\mathbf{y}_k - \mathbf{y}_j$. However, if the result is close to zero, then the expression $\mathbf{y}_k \cdot \mathbf{y}_i - \mathbf{y}_j \cdot \mathbf{y}_i$ may result in a much larger relative error than the expression $(\mathbf{y}_k - \mathbf{y}_j) \cdot \mathbf{y}_i$. This is due to the fact that for the first expression the relative round-off errors in the computations of the dot products are amplified by the subtraction, whereas in the second expression the subtractions are performed before the dot product computation. So, for numerical stability, it is preferred to compute the determinants Δ_i^X using the expression $(\mathbf{y}_k - \mathbf{y}_j) \cdot \mathbf{y}_i$.

An aspect of Johnson's algorithm that can be exploited for improving the precision is the choice of the arbitrary \mathbf{y}_k. Since we are free to pick any \mathbf{y}_k for which $k \in I_X$, we would like to choose the one that introduces the smallest numerical error. The choice of \mathbf{y}_k affects the amount of cancellation in the summation of the terms $\Delta_i^X((\mathbf{y}_k - \mathbf{y}_j) \cdot \mathbf{y}_i)$ in the computation of $\Delta_j^{X \cup \{\mathbf{y}_j\}}$. We should choose \mathbf{y}_k such that the terms $\Delta_i^X((\mathbf{y}_k - \mathbf{y}_j) \cdot \mathbf{y}_i)$ have the smallest absolute value, since then the loss of precision in the computation

of $\Delta_j^{X \cup \{\mathbf{y}_j\}}$ will be the least. So, an obvious choice for \mathbf{y}_k is the point in X closest to \mathbf{y}_j, since if the length of $\mathbf{y}_k - \mathbf{y}_j$ is short, then the absolute value of $(\mathbf{y}_k - \mathbf{y}_j) \cdot \mathbf{y}_i$ is likely to be small as well.

Experiments show that this choice for \mathbf{y}_k indeed results in a relative error in the computed values of the determinants that is at most as large, and often smaller, than the relative error for an arbitrary chosen \mathbf{y}_k. However, the gain in precision in comparison with an arbitrarily chosen \mathbf{y}_k is only marginal. Considering the high cost of determining the point in X closest to \mathbf{y}_j, it may therefore be a reasonable choice to simply pick \mathbf{y}_k arbitrarily if performance is an issue.

Despite these measures to preserve precision in the computation of the determinants Δ_i^X, numerical errors cannot be avoided when using finite-precision arithmetics. Numerical errors manifest themselves most prominently when X is close to being affinely dependent, since then Δ^X is close to zero. Large relative errors in the computed parameters λ_i cause a number of irregularities in the GJK algorithm. We address these irregularities further on. But first, let's fill in the remaining issue of how to compute the support mappings for the different types of convex objects.

4.3.4 Support Mappings

The versatility of GJK is a result of the fact that it relies solely on support mappings for reading the geometry of an object. A support mapping fully describes the geometry of a convex object and can thus be viewed as an implicit representation of the object. In this section we discuss the computation of the support points for a large class of convex objects. The class of objects we consider is recursively constructed from

1. convex primitives, such as

 (a) polytopes (e.g., line segments, triangles, boxes, and other convex polyhedra)

 (b) quadrics (e.g., spheres, cones, and cylinders)

2. images of convex objects under affine transformation

3. Minkowski sums of two convex objects

4. convex hulls of a collection of convex objects.

For each primitive type we need to supply a support mapping. The support mappings for affine transformations, Minkowski sums, and convex hulls are derived from the support mappings of their child objects.

Earlier, we defined a support mapping of a convex object A as a function s_A that maps a vector \mathbf{v} to a point of A, according to

$$s_A(\mathbf{v}) \in A \quad \text{such that} \quad \mathbf{v} \cdot s_A(\mathbf{v}) = \max\{\mathbf{v} \cdot \mathbf{x} : \mathbf{x} \in A\}.$$

We see that for $\mathbf{v} = \mathbf{0}$ any point in A may be returned as a support point. However, we will impose that the support mappings we use should always return a point on the boundary of the object. The reason for this constraint will become apparent in Section 4.3.8.

Polytope

For a polytope P, we may take $s_P(\mathbf{v}) = s_{\text{vert}(P)}(\mathbf{v})$; that is,

$$s_P(\mathbf{v}) \in \text{vert}(P), \quad \text{where} \quad \mathbf{v} \cdot s_P(\mathbf{v}) = \max\{\mathbf{v} \cdot \mathbf{p} : \mathbf{p} \in \text{vert}(P)\}.$$

Obviously, a support point of a polytope can be determined in time that is linear in the number of vertices of the polytope. Simply search the list of vertices for a vertex \mathbf{p} for which $\mathbf{v} \cdot \mathbf{p}$ is maximum. For simple polytopes, such as simplices, this is the fastest way to determine a support point. However, for more complex polytopes we can do a lot better.

It is shown in [23] that a support point can be found in $O(\log n)$ time for two- and three-dimensional polytopes represented by the Dobkin-Kirkpatrick hierarchical representation, as discussed on page 27. For our purpose, the Dobkin-Kirkpatrick hierarchy is best represented as a *multilayered vertex adjacency graph*. Let P_1, \ldots, P_h be the sequence of polytopes in the hierarchical representation, where $P_1 = P$ and P_h is a simplex. With each vertex \mathbf{p} we associate a sequence of successor sets $\text{adj}_i(\mathbf{p})$, which contain the adjacent vertices of \mathbf{p} in polytope P_i. The successor sets are defined only for polytopes P_i that have \mathbf{p} as a vertex. For each ith layer, the vertex adjacency graph is obtained by performing a convex hull computation on the vertices of P_i. It can be seen that the shortest path between two vertices using edges from multiple layers has $O(\log n)$ length.

Using a multilayered vertex adjacency graph, a support point $s_P(\mathbf{v})$ is determined efficiently in the following way. Let $\mathbf{p}_i = s_{P_i}(\mathbf{v})$, the support point for \mathbf{v} of P_i. First, we determine the vertex \mathbf{p}_h, simply by testing all the vertices of P_h. Since P_h is a simplex, this takes constant time. We determine a support point \mathbf{p}_i from \mathbf{p}_{i+1} by testing the vertices in $\text{adj}_i(\mathbf{p}_{i+1})$ only. Since $\text{vert}(P_i) \setminus \text{vert}(P_{i+1})$ is an independent set, the support point \mathbf{p}_i must be either \mathbf{p}_{i+1} or a member of $\text{adj}_i(\mathbf{p}_{i+1})$. If for any $\mathbf{q} \in \text{adj}_i(\mathbf{p}_{i+1})$, we have $\mathbf{v} \cdot \mathbf{q} > \mathbf{v} \cdot \mathbf{p}_{i+1}$, then $\mathbf{p}_i = \mathbf{q}$. Otherwise, $\mathbf{p}_i = \mathbf{p}_{i+1}$.

Note that for a vertex \mathbf{p} we do not necessarily have $\text{adj}_i(\mathbf{p}) \cap \text{adj}_{i+1}(\mathbf{p}) = \emptyset$; that is, P_i and P_{i+1} may have edges in common. For the correctness of

the given method it is not harmful to remove from $\text{adj}_i(\mathbf{p})$ the vertices it has in common with $\text{adj}_{i+1}(\mathbf{p})$. By doing this for all vertices on all layers, we can attain a considerable speedup. It can be shown that for a slimmed-down multilayered vertex adjacency graph, $\text{adj}_i(\mathbf{p}_{i+1})$ has at most eight vertices, and thus the amount of work that needs to be done on each layer is constant. Since there are $O(\log n)$ layers, a support point $s_P(\mathbf{v})$ can be determined in $O(\log n)$ time.

In GJK, especially in the incremental version we discuss further on, there is usually a lot of coherence between consecutive calls of the support mappings. It has been mentioned in a number of publications [15, 16, 23, 98] that by exploiting this coherence, the cost of computing a support point of a convex polytope can be reduced to almost constant time. For this purpose, an adjacency graph of the vertices is maintained with each polytope. Using a vertex adjacency graph, a support point that lies close to the previously returned support point can be found much faster using local search. This technique, commonly referred to as *hill climbing*, is described in Algorithm 4.2.

| **Algorithm 4.2** | Computing a support point $\mathbf{p} = s_P(\mathbf{v})$ using hill climbing on the polytope's vertex adjacency graph. |

```
p := "cached support vertex";
repeat
    optimal := true;
    for q ∈ adj(p) do
    begin
        if v · q > v · p then
        begin
            p := q;
            optimal := false
        end
    end
until optimal
```

Notice that for vertices that have a large number of adjacent edges, such as the apex of the polyhedral cone in Figure 4.7, a single iteration of the hill-climbing method may still take a large amount of time. Moreover, these complex vertices are likely to be visited more frequently than other vertices and therefore slow down hill climbing considerably. This problem can be solved by leaving out the complex vertices from the vertex adjacency graph and handling them separately [99]. Thus, for W, the set of vertices minus the vertices that have a degree of, say, eight or more, we compute a vertex adjacency graph of $\text{conv}(W)$, and use this graph

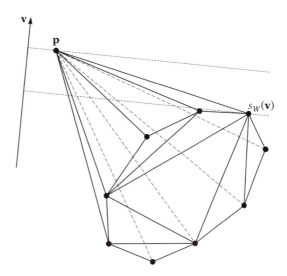

Figure 4.7 Vertex **p** has a very high degree and slows down hill climbing on this polytope. Hill climbing is performed on the vertex adjacency graph of the reduced polytope conv(W), where W is the set of vertices minus **p**. The result $s_W(\mathbf{v})$ is compared with **p** afterwards.

in Algorithm 4.2. We compare the returned support point of the reduced polytope with the complex vertices and return the point **p** for which $\mathbf{v} \cdot \mathbf{p}$ is maximum. Usually a polytope has only a few complex vertices, so handling them separately is much faster.

In addition, it is important to use fully triangulated vertex adjacency graphs. Otherwise, complex facets, such as the base of the polyhedral cone in Figure 4.7, slow down hill climbing when the support point moves to a vertex on the opposite side of the facet [99]. Qhull, a software library for convex-hull computation, supports fully triangulated boundary representations as output [8].

On page 120 we mentioned a feature-walking variant by Guibas et al. [62] that attains a worst-case $O(\log n)$ time bound by employing the Dobkin-Kirkpatrick hierarchical polyhedron representations, while still maintaining a near constant computation cost per frame when there is a lot of frame coherence. A similar technique can be applied for determining a support point using a multilayered vertex adjacency graph. We use the full multilayered vertex adjacency graph rather than the slimmed-down variant in this scheme. Think of a multilayered vertex adjacency graph as a road network in which the coarser layers correspond with freeways and the finer layers correspond with local roads. We use the coarser layers only if the new support point lies further away from the previously returned support point.

In this scheme, a support point is determined in a two-phase procedure. The first phase is similar to the hill-climbing technique, only, for the multilayered graph, we attempt to descend to the next coarser layer in each step. We descend from layer i to layer $i + 1$ if the current vertex is also a vertex of P_{i+1}. If this is not the case, then we continue to search the current layer. The *depth* of a vertex \mathbf{p}, denoted by depth(\mathbf{p}), is the coarsest layer i for which \mathbf{p} is a vertex of P_i. Thus, if $i <$ depth(\mathbf{p}), then we may descend to a coarser layer.

As with the hill-climbing technique, we repeat these steps until we have found a vertex that is a support point on the current layer. The second phase, in which we ascend back to the finest layer, is similar to the single-shot operation that starts on the coarsest level. Algorithm 4.3 describes this two-phase scheme in pseudocode.

Algorithm 4.3

Computing a support point $\mathbf{p} = s_P(\mathbf{v})$ using hill climbing on a multilayered vertex adjacency graph.

```
p := "cached support vertex";
i := 1;
repeat
    optimal := true;
    for q ∈ adj_i(p') do
    begin
        if v · q > v · p then
        begin
            p := q;
            optimal := false
        end
    end;
    if not optimal and i < depth(p) then
        i := i + 1;   {{Switch to a coarser layer.}}
until optimal;
{{p is support point of the current layer.}}
while i ≠ 1 do
begin
    i := i − 1;   {{Switch to a finer layer.}}
    for q ∈ adj_i(p) do
    begin
        if v · q > v · p then p := q
    end
end
```

The advantage of this multilayered hill-climbing technique over the single-shot method is the fact that if the current support point is close to

the previously returned support point, then we only need to descend a few layers to find the support point, whereas for the single-shot method we would always have to start on the coarsest level and step through all layers. Thus, if there is a lot of coherence between consecutive calls for support points, then determining a support point can be done in almost constant time, whereas, in the worst case, when the current support point lies further away from the previously returned support point, the time bound is $O(\log n)$ (if the vertex degree is bounded by a constant).

Note that the full multilayered vertex adjacency graph is needed only in the first phase, while descending the hierarchy. For the second phase, we may use the slimmed-down variant. So, in order to speed up the second phase, we mark, per layer, the adjacent vertices of each vertex \mathbf{p} with a Boolean flag denoting whether or not this vertex is also an adjacent vertex of \mathbf{p} on a coarser layer. In this way, we can skip the flagged vertices when iterating over the adjacent vertices of \mathbf{p} in the second phase.

Box

Let A be an axis-aligned box centered at point \mathbf{c} and with extent vector $\mathbf{h} = (\eta_1, \eta_2, \eta_3)$. Then, we take as a support mapping for A,

$$s_A((v_1, v_2, v_3)) = \mathbf{c} + (\text{sign}(v_1)\eta_1, \text{sign}(v_2)\eta_2, \text{sign}(v_3)\eta_3),$$

where $\text{sign}(\alpha) = -1$ if $\alpha < 0$ and 1 otherwise.

Sphere

The support mapping of a sphere A centered at the point \mathbf{c} and with radius ρ is

$$s_A(\mathbf{v}) = \mathbf{c} + \begin{cases} \rho\frac{\mathbf{v}}{\|\mathbf{v}\|} & \text{if } \mathbf{v} \neq \mathbf{0} \\ \rho\mathbf{e}_1 & \text{otherwise.} \end{cases}$$

Notice that for all vectors \mathbf{v}, including $\mathbf{v} = \mathbf{0}$, a point on the boundary of A is returned.

Cone

Let A be a cone that is centered at the point \mathbf{c} and whose central axis is spanned by the unit vector \mathbf{u}. Furthermore, let the cone A have a radius of ρ at its base and a halfheight of η. Then, for the top angle θ we have

$$\sin(\theta) = \frac{\rho}{\sqrt{\rho^2 + (2\eta)^2}}.$$

Figure 4.8 Computing a support point for a cone. For the top angle θ, we have $\sin(\theta) = \rho/\sqrt{\rho^2 + (2\eta)^2}$. The apex is a support point only if ϕ, the angle between \mathbf{v} and \mathbf{w}, is at least θ. We have $\sin(\phi) = \delta/\|\mathbf{v}\|$, where $\delta = \mathbf{u} \cdot \mathbf{v}$.

Figure 4.8 explains how this value is used to determine whether or not the apex is the support point. Let $\mathbf{w} = \mathbf{v} - (\mathbf{u} \cdot \mathbf{v})\mathbf{u}$ be the component of \mathbf{v} orthogonal to \mathbf{u}. We choose as a support mapping for A, the mapping

$$
s_A(\mathbf{v}) = \mathbf{c} + \begin{cases} \eta\mathbf{u} & \text{if } (\mathbf{u} \cdot \mathbf{v})/\|\mathbf{v}\| \geq \sin(\theta) \\ -\eta\mathbf{u} + \rho\frac{\mathbf{w}}{\|\mathbf{w}\|} & \text{if } (\mathbf{u} \cdot \mathbf{v})/\|\mathbf{v}\| < \sin(\theta) \text{ and } \mathbf{w} \neq \mathbf{0} \\ -\eta\mathbf{u} & \text{otherwise.} \end{cases}
$$

Cylinder

Let A be a cylinder that is centered at the point \mathbf{c} and whose central axis is spanned by the unit vector \mathbf{u}. Furthermore, let cylinder A have a radius of ρ and a halfheight of η. Again, let $\mathbf{w} = \mathbf{v} - (\mathbf{u} \cdot \mathbf{v})\mathbf{u}$ be the component of \mathbf{v} orthogonal to \mathbf{u}. We find as a support mapping for A, the mapping

$$
s_A(\mathbf{v}) = \mathbf{c} + \begin{cases} \text{sign}(\mathbf{u} \cdot \mathbf{v})\eta\mathbf{u} + \rho\frac{\mathbf{w}}{\|\mathbf{w}\|} & \text{if } \mathbf{w} \neq \mathbf{0} \\ \text{sign}(\mathbf{u} \cdot \mathbf{v})\eta\mathbf{u} & \text{otherwise.} \end{cases}
$$

Note that for both the cone and the cylinder the computations can be greatly simplified if one of the coordinate axes is chosen for \mathbf{u}. For instance, for $\mathbf{u} = \mathbf{e}_2$, the dot product $\mathbf{u} \cdot \mathbf{v}$ is simply the second component of \mathbf{v}, and the vector \mathbf{w} is the vector \mathbf{v} with the second component set to zero.

Affine Transformation

As discussed in Section 2.3, an object is most commonly animated by changing the placement (position, orientation, and scaling) of its local coordinate system. The placement of an object is represented by an affine transformation. Theorem 4.6 shows that for any object A that has a proper support mapping s_A, the following mapping can be used as a support mapping for $\mathbf{T}(A)$, the image of A under affine transformation $\mathbf{T}(\mathbf{x}) = \mathbf{B}\mathbf{x} + \mathbf{c}$:

$$s_{\mathbf{T}(A)}(\mathbf{v}) = \mathbf{T}(s_A(\mathbf{B}^{\mathrm{T}}\mathbf{v})).$$

Note that $\mathbf{B}^{\mathrm{T}}\mathbf{v} = (\mathbf{v}^{\mathrm{T}}\mathbf{B})^{\mathrm{T}}$, which is simply the vector result of \mathbf{B} left-multiplied by \mathbf{v}. We see that we do not need to compute the inverse of \mathbf{B} for computing a support point for $\mathbf{T}(A)$. This is true even if the transformation involves nonuniform scalings. We do not need an inverse in order to transform \mathbf{v} to local coordinates, since vector \mathbf{v} behaves as a normal in support point computation.

Theorem 4.6

Let s_A be a support mapping of object A, and $\mathbf{T}(\mathbf{x}) = \mathbf{B}\mathbf{x} + \mathbf{c}$ an affine transformation. Then a support mapping for $\mathbf{T}(A)$, the image of A under \mathbf{T}, is $s_{\mathbf{T}(A)}(\mathbf{v}) = \mathbf{T}(s_A(\mathbf{B}^{\mathrm{T}}\mathbf{v}))$.

Proof

A support mapping $s_{\mathbf{T}(A)}$ is characterized by

$$\mathbf{v} \cdot s_{\mathbf{T}(A)}(\mathbf{v}) = \max\{\mathbf{v} \cdot \mathbf{T}(\mathbf{x}) : \mathbf{x} \in A\}.$$

We rewrite the right member of this equation using the following deduction:

$$\begin{aligned}
\mathbf{v} \cdot \mathbf{T}(\mathbf{x}) &= \mathbf{v} \cdot \mathbf{B}\mathbf{x} + \mathbf{v} \cdot \mathbf{c} \\
&= \mathbf{v}^{\mathrm{T}}\mathbf{B}\mathbf{x} + \mathbf{v} \cdot \mathbf{c} \\
&= (\mathbf{B}^{\mathrm{T}}\mathbf{v})^{\mathrm{T}}\mathbf{x} + \mathbf{v} \cdot \mathbf{c} \\
&= (\mathbf{B}^{\mathrm{T}}\mathbf{v}) \cdot \mathbf{x} + \mathbf{v} \cdot \mathbf{c}.
\end{aligned}$$

This equation is used in the steps marked by $(*)$ in the following deduction:

$$\begin{aligned}
\max\{\mathbf{v} \cdot \mathbf{T}(\mathbf{x}) : \mathbf{x} \in A\} &\stackrel{(*)}{=} \max\{(\mathbf{B}^{\mathrm{T}}\mathbf{v}) \cdot \mathbf{x} + \mathbf{v} \cdot \mathbf{c} : \mathbf{x} \in A\} \\
&= \max\{(\mathbf{B}^{\mathrm{T}}\mathbf{v}) \cdot \mathbf{x} : \mathbf{x} \in A\} + \mathbf{v} \cdot \mathbf{c}
\end{aligned}$$

$$= (\mathbf{B}^T\mathbf{v}) \cdot s_A(\mathbf{B}^T\mathbf{v}) + \mathbf{v} \cdot \mathbf{c}$$

$$\stackrel{(*)}{=} \mathbf{v} \cdot \mathbf{T}(s_A(\mathbf{B}^T\mathbf{v}))$$

Hence, $s_{\mathbf{T}(A)}(\mathbf{v}) = \mathbf{T}(s_A(\mathbf{B}^T\mathbf{v}))$ is a support mapping of $\mathbf{T}(A)$.

Minkowski Sum

Given two convex objects A and B, for which we have support mappings s_A and s_B, the support mapping

$$s_{A+B}(\mathbf{v}) = s_A(\mathbf{v}) + s_B(\mathbf{v})$$

is a proper support mapping for $A + B$, the Minkowski sum of A and B, as can be verified quite easily. We see that it is not necessary to construct an explicit representation of $A + B$ in order to determine support points for $A + B$.

For $-B$, the Minkowski negation of convex object B, we find the support mapping

$$s_{-B}(\mathbf{v}) = -s_B(-\mathbf{v}).$$

Thus, a proper support mapping for $A - B$, the CSO of A and B, is

$$s_{A-B}(\mathbf{v}) = s_A(\mathbf{v}) - s_B(-\mathbf{v}).$$

The versatility of GJK lies in the fact that it uses a support mapping for reading the geometry of the CSO. Since it is easy to compute support points for CSOs of different types of convex objects, we can combine any two types of convex primitives in the GJK algorithm.

Convex Hull

We saw that for polytopes we may choose a vertex \mathbf{p}, for which the dot product $\mathbf{v} \cdot \mathbf{p}$ is maximum, as the support point for \mathbf{v}. This idea can be generalized to collections of arbitrary convex objects. Let X be a collection of convex objects. Then, a support mapping for $\text{conv}(X)$, the convex hull of X, is

$$s_{\text{conv}(X)}(\mathbf{v}) = s_A(\mathbf{v}), \text{ where } A \in X \text{ and } \mathbf{v} \cdot s_A(\mathbf{v}) = \max\{\mathbf{v} \cdot s_B(\mathbf{v}) : B \in X\}.$$

In other words, simply compute support points $s_A(\mathbf{v})$ for all $A \in X$, and select the point \mathbf{p} for which $\mathbf{v} \cdot \mathbf{p}$ is maximum.

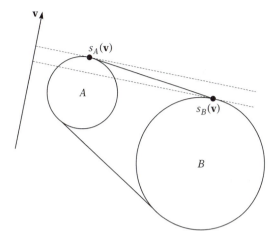

Figure 4.9 A support mapping for the convex hull of spheres A and B. Compute the support points for each sphere, and select the point \mathbf{p} for which $\mathbf{v} \cdot \mathbf{p}$ is maximum.

Convex hulls are useful for constructing complex objects from primitives. For instance, a conical shape with rounded caps can be constructed by taking the convex hull of two spheres of different sizes, as illustrated in Figure 4.9. Such shapes can be used, for instance, for representing limbs of an animated character.

4.3.5 Implementing the GJK Algorithm

In this section, we discuss a fast implementation of the GJK distance algorithm. Recall that Johnson's algorithm computes, for each nonempty $X \subseteq Y$, the parameters λ_i of the point closest to the origin of $\text{aff}(X)$ using the recursive definition

$$\Delta_i^{\{\mathbf{y}_i\}} = 1$$

$$\Delta_j^{X \cup \{\mathbf{y}_j\}} = \sum_{i \in I_X} \Delta_i^X ((\mathbf{y}_k - \mathbf{y}_j) \cdot \mathbf{y}_i) \quad \text{for } j \notin I_X \text{ and any } k \in I_X.$$

In the kth iteration, this set Y is the set $W_k \cup \{\mathbf{w}_k\}$. Since some or all vertices in W_k reappear in W_{k+1}, many vectors $\mathbf{y}_k - \mathbf{y}_j$ from the kth iteration are also needed in the $(k+1)$th iteration. So, it makes sense to cache these vectors for future iterations. We will show how this caching of vectors is implemented efficiently.

In order to minimize the caching overhead, we assign an index to each new support point, which is invariant for the duration that the support point is a member of $W_k \cup \{\mathbf{w}_k\}$. Since $W_k \cup \{\mathbf{w}_k\}$ has at most four points,

and each point that is discarded will not reappear, we need to cache data for only four points. The support points are stored in an array **y** of length four. The index of each support point is its array index. The set W_k is identified by a subset of $\{0, 1, 2, 3\}$, which is implemented as a bit-array b; that is, $W_k = \{\mathbf{y}[i] : b[i] = 1, i = 0, 1, 2, 3\}$. The index number of the new support point \mathbf{w}_k is the smallest i for which $b[i] = 0$. Note that during iterations, a free "slot" for \mathbf{w}_k is always available, as long as \mathbf{v}_k is not the closest point. This follows from the fact that if W_k has four elements, then the point $\mathbf{v}_k = v(\mathrm{aff}(W_k))$ must be the origin, since W_k is affinely independent. We see that if \mathbf{v}_k is the origin, Algorithm 4.1 terminates immediately without computing a new support point.

The vector differences of all pairs $\mathbf{y}[i], \mathbf{y}[j] \in W_k \cup \{\mathbf{w}_k\}$ are stored in a 4×4 array **d**; thus, $\mathbf{d}[i, j] = \mathbf{y}[i] - \mathbf{y}[j]$. Note that the elements of the diagonal of **d**, the vectors $\mathbf{d}[i, i]$, are not used. However, a tighter representation of the cache space, for instance as a 3×4 array, complicates indexing the cached vectors, so we prefer the 4×4 array. In each iteration, we need to compute the vector differences of the pairs containing \mathbf{w}_k only. The other vector differences are already computed in previous iterations. For a W_k containing n points, this takes $2n$ vector difference computations.

Earlier we explained that some precision improvements can be achieved by choosing \mathbf{y}_k such that $\|\mathbf{y}_k - \mathbf{y}_j\|^2$ is minimal. In the same way as we do for the vector differences, we cache the squared lengths of the vectors $\mathbf{d}[i, j]$ in a 4×4 array, rather than recompute them when needed. Since the squared length of $\mathbf{d}[i, j]$ is equal to the squared length of $\mathbf{d}[j, i]$, we need to compute n squared lengths in each iteration.

We further improve the performance by caching also the values of the determinants Δ_i^X. Let $Y = W_k \cup \{\mathbf{w}_k\}$. For many of the subsets $X \subseteq Y$, the determinants Δ_i^X are needed in several iterations and are therefore better cached and reused instead of recomputed. For this purpose, each subset X is identified by the integer value of the corresponding bit-array. For instance, for $X = \{\mathbf{y}[0], \mathbf{y}[3]\}$, we find bit-array 1001, corresponding to integer value $2^0 + 2^3 = 9$. The values of Δ_i^X for each subset X are stored in a 16×4 array. The element $\Delta[x, i]$ stores the value of Δ_i^X, where x is the integer value corresponding with subset X. Only the elements $\Delta[x, i]$ for which bit i of bit-array x is set are used. Again, we do not choose to use a tighter cache space for the determinants, since that would complicate the indexing of cached determinants. Similar to the vector difference computations, we only need to compute, in each kth iteration, the values of Δ_i^X for the subsets X containing the new support point \mathbf{w}_k, since the other values are computed in previous iterations.

Another performance improvement is based on Theorem 4.7. This theorem states that in each iteration, the new support point has to be one of the vertices of the new simplex. Consequently, only the subsets of $W_k \cup \{\mathbf{w}_k\}$ that contain \mathbf{w}_k need to be tested in Johnson's algorithm. This

reduces the number of subsets to be tested from $2^{n+1} - 1$ to 2^n, where n is the number of elements in W_k.

Theorem
4·7

For each kth iteration, if $\mathbf{v}_k \neq v(A - B)$, then $\mathbf{w}_k \in W_{k+1}$.

Proof

Suppose $\mathbf{v}_k \neq v(A - B)$ and $\mathbf{w}_k \notin W_{k+1}$. Then, $v(W_{k+1}) = v(W_k)$, and thus $\mathbf{v}_{k+1} = \mathbf{v}_k$. But according to Theorem 4.4, $\|\mathbf{v}_{k+1}\| = \|\mathbf{v}_k\|$ only if $\mathbf{v}_k = v(A - B)$, so this yields a contradiction.

We test all subsets $X \cup \{\mathbf{w}_k\}$, where $X \subseteq W_k$ and is possibly empty, in the following way. Let y be the integer value that represents I_{W_k}. Then, for the integer value x of a subset $X \subseteq W_k$, we have $0 \leq x \leq y$, and $x \& y$, the bitwise AND of x and y, is equal to x. Thus, in order to generate the integer values corresponding with the subsets $X \subseteq W_k$, we iterate over $x = 0, \ldots, y$ and skip all integers x for which $x \& y \neq x$. Let w be the integer value corresponding with $\{\mathbf{w}_k\}$. Thus, $w = 2^i$, where i is the index of \mathbf{w}_k. Then, the subsets $X \cup \{\mathbf{w}_k\}$ are represented by the integers $x + w$.

Finally, a pair of closest points is computed as follows. At termination, we have a representation of $\mathbf{v} \approx v(A - B)$ as

$$\mathbf{v} = \sum_{i \in I_X} \lambda_i \mathbf{y}_i, \quad \text{where} \quad \sum_{i \in I_X} \lambda_i = 1 \quad \text{and} \quad \lambda_i > 0.$$

Each vertex \mathbf{y}_i is a support point of $A - B$ and is therefore equal to $\mathbf{a}_i - \mathbf{b}_i$, where \mathbf{a}_i and \mathbf{b}_i are support points of A and B, respectively. These support points of A and B are stored in two arrays of length four and are indexed in the same way as the array \mathbf{y}. Let $\mathbf{p} = \sum_{i \in I_X} \lambda_i \mathbf{a}_i$ and $\mathbf{q} = \sum_{i \in I_X} \lambda_i \mathbf{b}_i$. Since A and B are convex, it is clear that $\mathbf{p} \in A$ and $\mathbf{q} \in B$. Furthermore, it can be seen that $\mathbf{p} - \mathbf{q} = \mathbf{v}$. Hence, \mathbf{p} and \mathbf{q} are the closest points of A and B.

4.3.6 Numerical Aspects of the GJK Algorithm

Arithmetic operations on finite-precision numbers will introduce rounding errors. In this section we discuss the implications of rounding errors for the GJK algorithm and present solutions to problems that might occur as a result of these.

Johnson's Algorithm

Johnson's algorithm is the main source of precision loss due to rounding. If the set $W_k \cup \{\mathbf{w}_k\}$ is close to being affinely dependent, then the

determinants Δ_i^X are close to zero. Thus, the computed values of the determinants may have a huge relative error.

The point $v(\text{conv}(W_k \cup \{\mathbf{w}_k\})$ is computed as the point

$$\mathbf{v} = \sum_{i \in I_X} \lambda_i \mathbf{y}_i, \quad \text{where} \quad \lambda_i = \frac{\Delta_i^X}{\Delta^X} > 0 \quad \text{and} \quad \Delta^X = \sum_{i \in I_X} \Delta_i^X,$$

for a subset $X \subset W_k \cup \{\mathbf{w}_k\}$. We see that the computed values for the parameters λ_i add up to 1 (within machine precision) even if they have large relative errors due to rounding. Thus, the computed point $\tilde{\mathbf{v}} = v(\text{conv}(W_k \cup \{\mathbf{w}_k\}))$ lies in $\text{conv}(X)$. However, large relative errors in the computed parameters λ_i result in a vector $\tilde{\mathbf{v}}$ that may not be quite orthogonal to $\text{aff}(X)$. A small deviation in the direction of $\tilde{\mathbf{v}}$ may cause termination problems, as we discover further on.

More dramatic problems occur when a large error in a computed determinant Δ_i^X causes its sign to change. As a result of this, Johnson's algorithm may select a wrong subset X or, even worse, may not be able to find a subset X that satisfies the stated criteria. The case where Johnson's algorithm is unable to find a proper subset X is addressed in the original GJK paper [52]. The original GJK uses a backup procedure to compute the best subset. Here, the best subset is the subset X for which all determinants Δ_i^X are positive and $v(\text{aff}(X))$ is closest to the origin.

In our experiments, we observed that in the degenerate case where the backup procedure needs to be called, the difference between the best vector returned by the backup procedure and the vector \mathbf{v}_k from the previous iteration is negligible. Hence, considering the high computational cost of executing the backup procedure, we choose to leave it out and return the vector from the previous iteration, after which GJK is forced to terminate. Should the algorithm continue iterating after this event, then it will infinitely loop, since each iteration will result in the same vector being computed.

Termination

Let us review the termination condition $\|\mathbf{v}\|^2 - \mathbf{v} \cdot \mathbf{w} \leq \varepsilon_{\text{abs}}^2$ of the GJK distance algorithm. We see that for large $\|\mathbf{v}\|$ the absolute rounding error in the computed error bound $\|\mathbf{v}\|^2 - \mathbf{v} \cdot \mathbf{w}$ can be of the same magnitude as $\varepsilon_{\text{abs}}^2$. This may cause termination problems. We solve this problem by terminating as soon as the relative error, rather than the absolute error, in the computed value of $\|\mathbf{v}\|^2$ drops below a tolerance value $\varepsilon_{\text{rel}} > 0$. Thus, as a termination condition we take $\|\mathbf{v}\|^2 - \mathbf{v} \cdot \mathbf{w} \leq \varepsilon_{\text{rel}}^2 \|\mathbf{v}\|^2$.

We would like to add that our experiments have shown that for quadric objects, such as spheres and cones, the average number of iterations used

for computing the distance is $O(-\log(\varepsilon_{\mathrm{rel}}))$; that is, the average number of iterations is roughly linear in the number of accurate digits in the computed distance. For polytopes, the average number of iterations is smaller than for quadrics, regardless of the complexity of the polytopes, and is not a function of $\varepsilon_{\mathrm{rel}}$ (for small values of $\varepsilon_{\mathrm{rel}}$).

Let's examine the other end of the spectrum. If $\mathbf{v} \approx \mathbf{0}$, then the rounding error in the computed $\tilde{\mathbf{v}}$ may render the direction of $\tilde{\mathbf{v}}$ totally unreliable. Experiments show that, for $\mathbf{v} = v(\mathrm{aff}(W))$, the absolute rounding error in $\|\tilde{\mathbf{v}}\|^2$ is proportional to $\|\mathbf{y}_{\max}\|^2 = \max\{\|\mathbf{y}\|^2 : \mathbf{y} \in W\}$. Thus, for some well-chosen error tolerance $\varepsilon_{\mathrm{tol}}$, we trust only $\tilde{\mathbf{v}}$ for which $\|\tilde{\mathbf{v}}\|^2 > \varepsilon_{\mathrm{tol}}\|\mathbf{y}_{\max}\|^2$. We found that for $\varepsilon_{\mathrm{tol}} = 100\epsilon$, the accuracy of the direction of $\tilde{\mathbf{v}}$ to be sufficient. Here, ϵ is the machine epsilon of the floating-point format, which is 2^{-24} for the single-precision format, and 2^{-53} for the double-precision format of the IEEE Standard 754. If $\|\tilde{\mathbf{v}}\|^2 \leq \varepsilon_{\mathrm{tol}}\|\mathbf{y}_{\max}\|^2$, then we regard $\tilde{\mathbf{v}}$ as the zero vector, in which case GJK terminates.

Often, we can establish more easily that the actual $\mathbf{v} = v(\mathrm{aff}(W))$ is zero. We know that W is affinely independent. If $|W|$, the number of points in W, is equal to four, then $\mathrm{aff}(W)$ is the whole space, and thus, \mathbf{v} must be the zero vector. Note that \mathbf{v} can be equal to the zero vector for $|W| < 4$; however, these cases are rare for general objects and occur most frequently for configurations of symmetrical objects such as spheres and cylinders.

Ill-Conditioned Error Bounds

For certain configurations of objects, in particular objects that have flat boundary elements, the error bound $\|\mathbf{v}\|^2 - \mathbf{v} \cdot \mathbf{w}$ is *ill-conditioned*—a small change in \mathbf{v} may result in a large change in $\|\mathbf{v}\|^2 - \mathbf{v} \cdot s_{A-B}(-\mathbf{v})$. The relative error in $\tilde{\mathbf{v}} = v(\mathrm{aff}(W))$ is larger for sets W that are close to being affinely dependent. GJK has a tendency to generate simplices that are progressively more oblong (i.e., closer to being affinely dependent) as the number of iterations increases. Since for certain configurations of objects, a slight deviation in the direction of $\tilde{\mathbf{v}}$ is amplified to a huge error in the error bound, termination problems may arise.

Termination problems may occur when two polytopes that differ a few orders of magnitude in size are in close proximity of each other. Due to the difference in size, the CSO of the objects has extremely oblong-shaped facets. Let's examine a scenario in which the current simplex $\mathrm{conv}(W)$ is an oblong-shaped triangle, and $\mathbf{v} = v(A - B)$ is an internal point of the triangle.

First we note that two of the triangle's vertices lie close to each other in comparison to the third vertex. This may cause a large relative rounding error in the computation of the determinants Δ_i^W. Hence, the computed $\tilde{\mathbf{v}}$ may be contaminated by these errors. As mentioned earlier, Johnson's

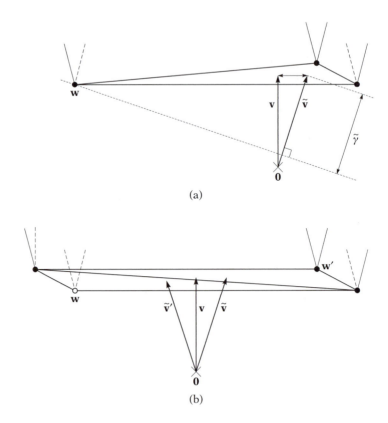

(a)

(b)

Figure 4.10 Two types of oscillations in GJK when the termination conditions are not met due to an ill-conditioned error bound. (a) A slight error in $\tilde{\mathbf{v}}$ causes a huge error in the error bound $\tilde{\gamma} = \|\mathbf{v}\|^2 - \mathbf{v} \cdot \mathbf{w}$ and prevents GJK from terminating. The same support point \mathbf{w} is found in each following iteration. (b) If \mathbf{v} lies close to the diagonal of a quadrilateral, then failure to meet the termination condition may cause GJK to alternate between two support points.

algorithm computes parameters λ_i that are positive and add up to 1. Thus, $\tilde{\mathbf{v}}$ is an interior point of the triangle, yet located at some distance from the actual \mathbf{v}. Figure 4.10(a) depicts the effect of an error in $\tilde{\mathbf{v}}$. We see that a small error in $\tilde{\mathbf{v}}$ may result in a large error in $\|\mathbf{v}\|^2 - \mathbf{v} \cdot \mathbf{w}$, the computed error bound of $\|\mathbf{v}\|^2$. The algorithm should terminate at this point since the actual error bound is zero. However, the computed error bound is too large for the termination condition to be met. Since the support point $\mathbf{w} = s_{A-B}(\tilde{\mathbf{v}})$ is already a vertex of the current simplex, the algorithm will find the same $\tilde{\mathbf{v}}$ in each following iteration and thus will never terminate.

Failure to meet the termination condition can result in a different type of behavior when $v(A - B)$ lies close to the diagonal of an oblong

quadrilateral facet in $A - B$, as depicted in Figure 4.10(b). Again, the large error in the error bound causes the algorithm to continue iterating, only this time GJK alternately returns the diagonal's opposing vertices \mathbf{w} and \mathbf{w}' as support points. In each iteration, one of the vertices is added to the current simplex and the other is discarded, and vice versa. The remaining two vertices of the current simplex are the vertices of the facet lying on the diagonal. We see that for the simplex containing \mathbf{w}, the value $\tilde{\mathbf{v}}'$ is computed, which results in the vertex \mathbf{w}' being added to the current simplex. For the simplex containing \mathbf{w}', the value $\tilde{\mathbf{v}}$ is computed, which again will cause \mathbf{w} to be added to the current simplex.

Both degenerate cases are tackled in the following way. In each iteration, we test whether the support point \mathbf{w}_{k+1} is a member of $W_k \cup \{\mathbf{w}_k\}$. This can only be true as a result of one of the discussed cases. If a degenerate case is detected, then the algorithm terminates and returns $\tilde{\mathbf{v}}$ as the best approximation of $v(A-B)$ within the precision bounds of the floating-point format. Algorithm 4.4 summarizes all the modifications that are needed in the GJK algorithm, in order to have it behave robustly without running into termination problems.

Algorithm 4.4

The numerical GJK distance algorithm.

$\mathbf{v} :=$ "arbitrary point in $A - B$";
$W := \emptyset$;
$Y := \emptyset$;
repeat
 $\mathbf{w} := s_{A-B}(-\mathbf{v})$;
 if $\mathbf{w} \in Y$ or $\|\mathbf{v}\|^2 - \mathbf{v} \cdot \mathbf{w} \leq \varepsilon_{\text{rel}}^2 \|\mathbf{v}\|^2$ then
 {{\mathbf{v} is close enough to $v(A - B)$. }}
 return $\|\mathbf{v}\|$;
 $Y := W \cup \{\mathbf{w}\}$;
 $\mathbf{v} := v(\text{conv}(Y))$;
 $W :=$ "smallest $X \subseteq Y$ such that $\mathbf{v} \in \text{conv}(X)$"
until $|W| = 4$ or $\|\mathbf{v}\|^2 \leq \varepsilon_{\text{tol}} \max\{\|\mathbf{y}\|^2 : \mathbf{y} \in W\}$;
{{\mathbf{v} is considered zero. }}
return 0

4.3.7 Testing for Intersections

For determining whether two objects intersect, we do not need to know the distance. We merely need to know whether the distance is equal to zero or not. As a lower bound for the distance we have the signed distance from the origin to the support plane $H(-\mathbf{v}_k, \mathbf{v}_k \cdot \mathbf{w}_k)$. We see that for a

positive signed distance (i.e., $\mathbf{v}_k \cdot \mathbf{w}_k > 0$) the origin lies in the positive open halfspace of the support plane, whereas $A - B$ is contained in the negative closed halfspace. Thus, if $\mathbf{v}_k \cdot \mathbf{w}_k > 0$, then \mathbf{v}_k is a *separating axis* of A and B, in which case we return a nonintersection for the objects.

In general, GJK needs fewer iterations for finding a separating axis of a pair of nonintersecting objects than for computing an accurate approximation of $v(A - B)$. For instance in Figure 4.6, the vector \mathbf{v}_k is a separating axis for the first time when $k = 2$. For intersecting objects, the GJK separating-axis algorithm terminates on $\mathbf{v}_k = \mathbf{0}$. We test whether \mathbf{v}_k is (almost) the zero vector in the same robust way as we did for the GJK distance algorithm, such that potential rounding errors do not cause termination problems. Algorithm 4.5 describes the GJK separating-axis algorithm, which is, as can be seen, quite similar to the GJK distance algorithm. Note that in the collision detection algorithm, \mathbf{v} does not have to be initialized by a point in $A - B$, since there is no reference to the length of \mathbf{v}. This feature is convenient for exploiting frame coherence.

Algorithm 4.5

The GJK separating-axis algorithm.

$\mathbf{v} :=$ *"arbitrary vector"*;
$W := \emptyset$;
$Y := \emptyset$;
repeat
 $\mathbf{w} := s_{A-B}(-\mathbf{v})$;
 if $\mathbf{w} \in Y$ or $\mathbf{v} \cdot \mathbf{w} > 0$ then
 {{\mathbf{v} is (*considered*) a *separating axis*. }}
 return false;
 $Y := W \cup \{\mathbf{w}\}$;
 $\mathbf{v} := v(\text{conv}(Y))$;
 $W :=$ *"smallest $X \subseteq Y$ such that $\mathbf{v} \in \text{conv}(X)$"*
until $|W| = 4$ or $\|\mathbf{v}\|^2 \leq \varepsilon_{\text{tol}} \max\{\|\mathbf{y}\|^2 : \mathbf{y} \in W\}$;
{{\mathbf{v} *is considered zero*. }}
return true

The separating-axis GJK is particularly useful when there is a lot of frame coherence. Similar to the Lin-Canny closest-feature tracking algorithms [79], an incremental version of the GJK separating-axis algorithm shows almost constant time complexity per frame for convex objects of arbitrary complexity when frame coherence is high. The incremental separating-axis GJK algorithm (ISA-GJK) exploits frame coherence by using the separating axis from the previous frame as the initial vector. When the degree of coherence between frames is high, then the separating axis from the previous frame is likely to be a separating axis in the current

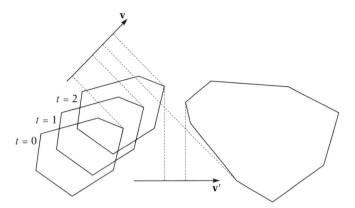

Figure 4.11 Incremental separating-axis computation using ISA-GJK. The separating axis **v** from $t = 0$ is also a separating axis for $t = 1$. However, **v** fails to be a separating axis for $t = 2$. A new separating axis **v**′ is computed using **v** as the initial axis.

frame, in which case ISA-GJK terminates in the first iteration. Figure 4.11 shows the behavior of ISA-GJK for a smoothly moving object. We saw in Section 4.3.4 that a support point can be computed in constant time for quadrics and, when coherence is high, in nearly constant time for arbitrary polytopes. Hence, in these cases, ISA-GJK takes nearly constant time per frame.

4.3.8 Penetration Depth

In this section, we present an iterative method for computing the penetration depth of a pair of intersecting objects. This method is closely related to GJK. Like GJK, it uses only support mappings for reading the geometry of the objects and is therefore applicable to the same class of objects as GJK. Moreover, the method requires, as the initial state, a polytope that contains the origin and has vertices that lie on the boundary of the CSO of the objects. For intersecting objects, GJK terminates when a simplex is generated that contains the origin. In most cases, this simplex is a tetrahedron. Recall that all support mappings discussed in Section 4.3.4 return support points on the boundary of the object. So, a tetrahedron generated by GJK is a proper initial polytope for the penetration depth method.

The method presented here is similar to an earlier method by Cameron for estimating the penetration depth [15], in the sense that it uses the simplex returned by GJK for determining the penetration depth.

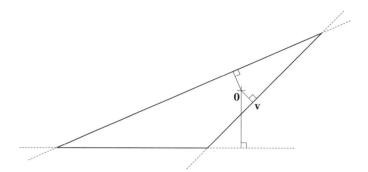

Figure 4.12 For a convex polytope that contains the origin, a point **v** on the affine hull of an edge closest to the origin is an internal point of the edge.

However, unlike Cameron's method, our algorithm returns the exact penetration depth of an intersecting pair of polytopes. For nonpolytopes, we compute the penetration depth within a given numerical tolerance.

We saw that the penetration depth of a pair of intersecting objects A and B is a point on the boundary of $A - B$ closest to the origin. We say "a point" since the penetration depth is not necessarily unique. Our algorithm for finding such a point starts with a polytope that contains the origin and "expands" it by adding vertices that lie on the boundary. The added vertices are generated by the support mapping of $A - B$. The basic strategy is to iteratively pick the facet of the polytope closest to the origin and subdivide it using support points as additional vertices.

For reasons of clarity, we will first explain the algorithm in 2D and then generalize it to 3D. In the 2D version, we blow up a convex polygon by splitting the edges. We start off with a simple polygon, such as a triangle, that contains the origin and has vertices on the boundary of the CSO. For each edge X of the polygon, we compute $v(\mathrm{aff}(X))$, the point on the affine hull of the edge (i.e., the line through the edge's vertices) that lies closest to the origin. Let $\mathbf{v} = v(\mathrm{aff}(X))$ be a point on the affine hull of an edge X closest to the origin. Since the polygon is convex, the point **v** must be an internal point of edge X, as illustrated in Figure 4.12. Theorem 4.8 shows the general form of this property.

The length of the vector **v** is a lower bound for the penetration depth, since the polygon is contained in the CSO. In each iteration step, the closest edge is split by inserting the support point $s_{A-B}(\mathbf{v})$ as a new vertex. For the two new edges we again compute the points closest to the origin on the affine hulls of the edges and repeat this procedure until **v** lies sufficiently close to the penetration depth. Figure 4.13 shows a sequence of iterations of this algorithm, which we will refer to as the *expanding-polytope algorithm* (EPA).

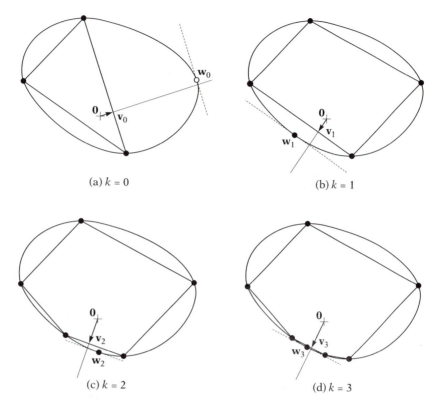

(a) $k = 0$

(b) $k = 1$

(c) $k = 2$

(d) $k = 3$

Figure 4.13 A sequence of iterations of the expanding-polytope algorithm. An arrow denotes a point **v** on the polygon's boundary closest to the origin. The dashed lines represent the support planes $H(\mathbf{v}_k, -\mathbf{v}_k \cdot \mathbf{w}_k)$.

Theorem 4.8

Let P be a d-dimensional polytope that contains the origin, and, for each $(d-1)$-dimensional boundary feature X of P, let $\mathbf{v}_X = v(\mathrm{aff}(X))$, the point closest to the origin on the affine hull of X. Furthermore, let \mathbf{v} be a point of $\{\mathbf{v}_X\}$ closest to the origin. Then, (i) $\mathbf{v} \in P$, (ii) \mathbf{v} is a point on the boundary of P closest to the origin, and (iii) \mathbf{v} is an internal point of the corresponding $(d-1)$-dimensional boundary feature.

Proof

A d-dimensional polytope P can be represented as the intersection of a set of halfspaces. For a minimal set, each halfspace corresponds to exactly one $(d-1)$-dimensional boundary feature, and vice versa. As a representation for P, we choose a minimal set of halfspaces $H^-(\mathbf{n}_i, \delta_i)$ such that $\|\mathbf{n}_i\| = 1$. Suppose the origin is contained in P. Then, $\delta_i \leq 0$ for all i. The affine hulls of the $(d-1)$-dimensional boundary features are the

hyperplanes $H(\mathbf{n}_i, \delta_i)$ and the points closest to the origin on the affine hulls are the points $-\delta_i\mathbf{n}_i$. Since the distance from $H(\mathbf{n}_i, \delta_i)$ to the origin is $-\delta_i$, a point $\mathbf{v} = -\delta_{max}\mathbf{n}_{max}$, for which $\delta_{max} = \max\{\delta_i\}$, is closest to the origin of all points $-\delta_i\mathbf{n}_i$. The point \mathbf{v} is contained in all halfspaces, since

$$\mathbf{n}_i\mathbf{v} + \delta_i = -\delta_{max}(\mathbf{n}_i \cdot \mathbf{n}_{max}) + \delta_i \leq -\delta_{max} + \delta_i \leq 0,$$

and thus $\mathbf{v} \in P$. Obviously, \mathbf{v} is a point on the boundary, and since all points on the boundary of P are contained in one of the hyperplanes, \mathbf{v} is a point on the boundary of P closest to the origin. Only points on boundary features with dimensions lower than $d - 1$ are contained in multiple hyperplanes. If a point is contained in only one hyperplane, then it can only be an internal point of a $(d-1)$-dimensional boundary feature. It can be seen that the point \mathbf{v} is contained in $H(\mathbf{n}_{max}, \delta_{max})$ only and, thus, must be an internal point of a $(d-1)$-dimensional boundary feature.

The EPA has some similarities with Dijkstra's shortest path algorithm, which computes the lowest-cost path from a source to a destination on a weighted graph [28]. Dijkstra's algorithm constructs a shortest path by maintaining a list of candidate nodes and iteratively expanding the lowest-cost candidate. Here, "expanding a candidate" means replacing the candidate by its successors in the graph. In our case, the best candidate is the edge closest to the origin. As in Dijkstra's algorithm, we store the candidates in a priority queue, using the distance to the origin as the key value. In the EPA, an "expansion" can be taken literally, as the area of the polygon is expanded by splitting the closest edge. Note that according to Theorem 4.8, an edge, for which the point on its affine hull closest to the origin is not an internal point of the edge, can never be a closest edge of any convex polygon containing the origin, and thus need not be inserted in the priority queue.

A candidate entry *entry* stores

- *entry*.\mathbf{y}_i, for $i = 0, 1$, the endpoints of the edge

- *entry*.\mathbf{v}, the point closest to the origin on the affine hull of the edge

- *entry*.λ_i, for $i = 0, 1$, the parameters of \mathbf{v}, such that $\mathbf{v} = \lambda_0\mathbf{y}_0 + \lambda_1\mathbf{y}_1$ and $\lambda_0 + \lambda_1 = 1$

- *entry*.*key*, the distance of \mathbf{v} to the origin.

Given an edge $X = \{\mathbf{y}_0, \mathbf{y}_1\}$, the corresponding entry is constructed by the function *construct_entry*(X). For the computation of the closest point *entry*.\mathbf{v} and the parameters *entry*.λ_i, we refer to page 98. Recall that the point *entry*.\mathbf{v} is an internal point of the edge iff *entry*.$\lambda_i > 0$ for $i = 0, 1$.

The priority queue Q supports the following operations:

- *push(Q, entry)*: push *entry* in priority queue Q
- *best(Q)*: return the entry with the smallest key value *entry.key* in Q
- *pop_best(Q)*: remove the entry with smallest key value *entry.key* from Q.

Priority queues can be implemented efficiently using binary heaps. A binary heap implementation allows the *best* operation to be performed in constant time, and the *push* and *pop_best* operations to be performed in $O(\log n)$ time, where n is the number of entries [109]. For C++ developers, a useful implementation of the binary-heap operations is available in the Standard Template Library (STL) [93].

The penetration depth vector is the vector *entry.v* at termination. The penetration depth vector can be used as an approximation of the contact plane's normal. The expanding-polytope algorithm can be tailored to return the witness points of the penetration depth vector also, which are proper contact points for contact resolution. At termination, we have a description of the penetration depth vector *entry.v* as a convex combination of the vertices *entry.y_i*. Each vertex is computed as $\mathbf{y}_i = \mathbf{p}_i - \mathbf{q}_i$, where \mathbf{p}_i and \mathbf{q}_i are support points of A and B, respectively. If we store, besides \mathbf{y}_i, also the points \mathbf{p}_i and \mathbf{q}_i in *entry*, we are able to compute the witness points. From the final *entry*, we compute the witness points as $\mathbf{a} = \lambda_0 \mathbf{p}_0 + \lambda_1 \mathbf{p}_1$ and $\mathbf{b} = \lambda_0 \mathbf{q}_0 + \lambda_1 \mathbf{q}_1$. These are proper witness points, since $\mathbf{a} \in A$ and $\mathbf{b} \in B$ and $\mathbf{a} - \mathbf{b} = \mathbf{v}$.

Termination

For pairs of polytopes, the EPA finds the point closest to the origin on the boundary of their CSO in a finite number of iterations. For quadric types, the algorithm terminates as soon as the error in \mathbf{v} drops below a given tolerance. Since \mathbf{v} is the closest point on the boundary of a polytope that is contained in the CSO, $\|\mathbf{v}\|$ is a lower bound for the penetration depth. As an upper bound for the penetration depth we take the distance from the support plane $H(\mathbf{v}, -\mathbf{v} \cdot \mathbf{w})$ through \mathbf{w} to the origin. The distance from this support plane to the origin is $\mathbf{v} \cdot \mathbf{w}/\|\mathbf{v}\|$. Algorithm 4.6 describes the theoretical expanding-polytope algorithm in pseudocode.

Algorithm 4.6

The theoretical expanding-polytope algorithm in 2D.

$P := $ *"a convex polygon containing the origin"*;
$Q := \emptyset$;
for *"each edge X of P"*

```
begin
    entry := construct_entry(X);
    if closest_is_internal(entry) then push(Q, entry)
end;
repeat
    entry := best(Q);
    pop_best(Q);
    v := entry.v;
    w := s_{A-B}(v);
    close_enough := v · w/‖v‖ − ‖v‖ ≤ ε_abs;
    if not close_enough then
        {{ Split edge "entry" by adding w as vertex. }}
    begin
        entry_1 := construct_entry({entry.y_0, w});
        if closest_is_internal(entry_1) then push(Q, entry_1);
        entry_2 := construct_entry({entry.y_1, w});
        if closest_is_internal(entry_2) then push(Q, entry_2)
    end
until close_enough;
return ‖v‖
```

We observe that when the origin lies close to the center of the CSO, the algorithm "pokes around" wildly before converging to the penetration depth. This is due to the fact that the early splits result in edges that are further away from the origin than the current best candidate. So, the priority queue behaves more like a FIFO (first-in-first-out) queue. Gradually the queue will have a more stacklike, or LIFO (last-in-first-out), behavior; that is, a split results in a new best candidate, and convergence will go faster. When the origin is already close to the boundary of the CSO, we observe an immediate stacklike behavior of the priority queue, in which case convergence is very fast.

In the extreme case where the CSO is circular and centered at the origin, the priority queue will keep a FIFO behavior throughout the iterative process, since the penetration depth has an infinite number of solutions. This results in the EPA converging extremely slowly. These cases are better avoided or dealt with in a different way. Examples of such cases are pairs of concentric spheres or cylinders.

Expanding a Polytope in 3D

We are now ready to tackle penetration depth computation in 3D. The main difference with the 2D algorithm is that we need to inflate a convex

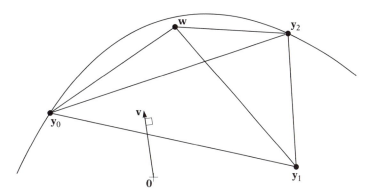

Figure 4.14 A naive split of the triangle $\{\mathbf{y}_0, \mathbf{y}_1, \mathbf{y}_2\}$ by adding the support point $\mathbf{w} = s_{A-B}(\mathbf{v})$ as a vertex. Notice that by splitting triangles in this way, the edges of the triangle remain edges of the polytope.

polyhedron in 3D and thus have to subdivide triangles rather than line segments. The naive way of splitting a triangle would be to add the last-found support point as depicted in Figure 4.14. This is not a very good solution for two reasons. First, as we proceed in splitting the triangles, the resulting triangles will become gradually more oblong. For oblong triangles, the computation of the closest point suffers more from numerical problems due to round-off errors in floating-point arithmetic. Second, since the edges of the split triangle remain edges of the polytope, the algorithm will have a hard time approaching the surface when the penetration depth vector is located near an edge of the initial polytope.

In fact, unlike the two-dimensional case, the three-dimensional polytope can become concave if a triangle is split in this way, as illustrated in Figure 4.15. An edge of the split triangle becomes a reflex edge if the new vertex \mathbf{w} lies above the supporting plane of the adjacent triangle, that is, if the adjacent triangle is visible from \mathbf{w}.

It is important to keep the expanding polytope convex, since otherwise it may happen that certain areas of the boundary of the CSO are not approached properly. This can be established by taking the convex hull of \mathbf{w} and the current polytope as the new polytope. Rather than inspect only the best candidate, we also need to check the adjoining triangles of the polytope's boundary to see if they are part of the boundary of the new polytope. All triangles that are visible from \mathbf{w} are removed from the polytope, and a cone-shaped set of triangles, whose apex is \mathbf{w} and whose base is the silhouette of the current polytope as seen from \mathbf{w}, is added. The silhouette is the set of edges that bound the visible part of the boundary. See Figure 4.16 for an illustration of this operation.

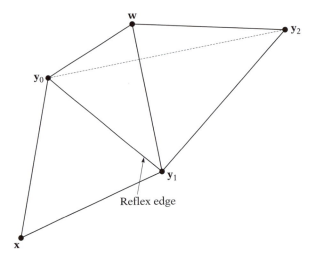

Figure 4.15 Splitting triangle $\{\mathbf{y}_0, \mathbf{y}_1, \mathbf{y}_2\}$ by adding support point \mathbf{w} causes the polytope to become concave. Edge $\overline{\mathbf{y}_0\mathbf{y}_1}$ becomes a reflex edge.

Figure 4.16 The silhouette of the polytope as seen from support point \mathbf{w} is marked by thick lines. The visible triangles (shaded gray) are removed from the polytope and replaced by triangles connecting the silhouette to \mathbf{w}.

Computing the convex hull of a polytope and a point outside the polytope normally takes linear time in the number of boundary features [104]. The basic difficulty is finding the chain of edges that form the silhouette of the polytope as seen from the new point. However, in our case we know that the silhouette is located near the current best triangle and often is simply the set of edges of the best triangle. So, we can find the silhouette a lot faster by local search.

The local search algorithm for finding the silhouette performs a flood fill over the boundary of the current polytope, starting from the current best triangle, and marks all triangles that are visible from the new vertex "obsolete." In order to be able to perform a flood fill, we need to maintain adjacency information with the triangles, so that the adjoining triangles can be retrieved quickly. We could use a winged-edge structure for retrieving adjoining triangles; however, since the boundary is composed of triangles only, we can use a simpler structure for our purpose.

Rather than maintaining different storage classes for the different boundary features, we maintain all adjacency information in a single entry structure. Similar to the 2D case, a triangle entry *entry* stores

- *entry*.\mathbf{y}_i, for $i = 0, 1, 2$, the vertices of the triangle

- *entry*.\mathbf{v}, the point closest to the origin on the affine hull of the triangle

- *entry*.λ_i, for $i = 0, 1, 2$, the parameters of \mathbf{v}, such that $\mathbf{v} = \lambda_0 \mathbf{y}_0 + \lambda_1 \mathbf{y}_1 + \lambda_2 \mathbf{y}_1$ and $\lambda_0 + \lambda_1 + \lambda_2 = 1$

- *entry*.*key*, the distance of \mathbf{v} to the origin.

Furthermore, in order to perform a flood fill on the boundary, *entry* also stores

- *entry*.adj_i, for $i = 0, 1, 2$, (a pointer to) the triangle adjacent to edge i

- *entry*.j_i, for each adjoining triangle *entry*.adj_i, the index of the adjoining edge, so *entry*.adj_i.$adj_{entry.j_i}$ = *entry*

- *entry*.*obsolete*, a Boolean flag to denote whether the triangle is visible from the new support point.

The indexing of triangle edges requires further explanation. All triangles in the polytope are oriented in the same way, either clockwise or counterclockwise. The actual orientation is irrelevant as long as we use the same orientation for all triangles. We assume, without loss of generality, that the triangles are oriented counterclockwise (i.e., the vertices of the triangle are enumerated in counterclockwise order). The edge indexed by i, $i = 0, 1, 2$, is the edge connecting the vertices \mathbf{y}_i and $\mathbf{y}_{i\oplus 1}$, where \oplus is addition modulo 3. Figure 4.17 illustrates this relation.

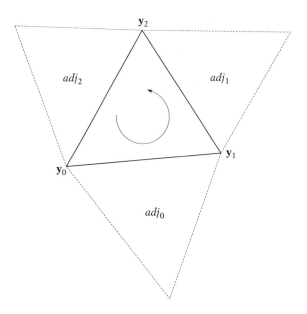

Figure 4.17 Adjoining triangles are stored in the order given by the vertices. The ith adjoining triangle is the triangle adjacent to the edge $\overline{\mathbf{y}_i\mathbf{y}_{i\oplus1}}$, where \oplus is addition modulo 3.

As mentioned, the silhouette is a sequence of connecting edges. An edge is represented by a pair $(sentry, i)$, where $sentry$ is a triangle not visible from \mathbf{w}, and i is the index of the silhouette edge in $entry$. Thus, for each pair $(sentry, i)$ in the silhouette, $sentry.adj_i$ is a visible triangle. The flood fill is performed by a recursive procedure *silhouette* described in Algorithm 4.7.

Algorithm 4.7

Recursive flood-fill algorithm for retrieving the silhouette as seen from \mathbf{w}.

silhouette$(entry, i, \mathbf{w}, E)$
begin
 if not $entry.obsolete$ then
 {{ *Facet "entry" is visited for the first time.* }}
 begin
 if $entry.\mathbf{v} \cdot \mathbf{w} < \|entry.\mathbf{v}\|^2$ then
 {{ *Facet "entry" is not visible from* \mathbf{w}. }}
 $E := E$ ++ $(entry, i)$;
 else
 {{ *Mark "entry" visible, and search its neighbors.* }}
 begin
 $entry.obsolete :=$ true;

$$silhouette(entry.adj_{i\oplus1}, entry.j_{i\oplus1}, \mathbf{w}, E);$$
$$silhouette(entry.adj_{i\oplus2}, entry.j_{i\oplus2}, \mathbf{w}, E)$$
 end
 end
end

We perform the flood fill in the following way. First, the current best triangle *entry* is marked "obsolete." The current best triangle must be visible from \mathbf{w}, since $\mathbf{w} = s_{A-B}(entry.\mathbf{v})$, and thus must lie above the plane of *entry*. The sequence of edges E is initialized as the empty sequence \emptyset. Next, for each edge i of *entry*, we call $silhouette(entry.adj_i, entry.j_i, \mathbf{w}, E)$. By traversing the adjoining triangles in strict counterclockwise order, we make sure that the edges found by *silhouette* are indeed connected. Note that the recursive algorithm cannot run in cycles, since triangles already marked "obsolete" are skipped.

If the polytope is convex, then the flood fill will result in a single connected chain of edges. This chain is used to construct the new polytope. For each edge $(sentry, i)$ in the sequence, a triangle $\{sentry.\mathbf{y}_{i\oplus1}, sentry.\mathbf{y}_i, \mathbf{w}\}$ is constructed. This wigwam-shaped sequence of triangles closes up the polytope such that the resulting polytope is convex.

Removing other than the current best triangle from the current polytope has some consequences for the candidate list. The triangle entries marked "obsolete" should be removed from the candidate list, since they are no longer part of the boundary of the new polytope. However, removing arbitrary entries from a candidate list represented by a binary heap is quite tricky, since we either have to retrieve the obsolete candidates by linear search or have to maintain additional search data for quick retrieval. So, the cheap solution is to keep the obsolete entries in the candidate list and simply ignore them when they pop up as the best candidate. Having a larger than necessary candidate list is not that much of a burden, considering the $O(\log n)$ time push and pop operations. The 3D variant of the EPA is described in Algorithm 4.8.

Algorithm 4.8

The theoretical expanding-polytope algorithm in 3D.

$P := $ *"a convex polyhedron containing the origin"*;
$Q := \emptyset$;
for *"each triangle X of P"*
begin
 $entry := construct_entry(X)$;
 if $closest_is_internal(entry)$ then $push(Q, entry)$
end;

```
repeat
  entry := best(Q);
  pop_best(Q);
  if not entry.obsolete then
    {{ Facet "entry" is a proper best candidate. }}
  begin
    v := entry.v;
    w := s_{A−B}(v);
    close_enough := v · w/‖v‖ − ‖v‖ ≤ ε_abs;
    if not close_enough then
      {{Blow up the current polytope by adding vertex w. }}
    begin
      entry.obsolete := true;   {{ Facet "entry" is visible from w. }}
      E := ∅;
      for i = 0, 1, 2 do
        silhouette(entry.adj_i, entry.j_i, w, E);
      {{E is the silhouette of the current polytope as seen from w. }}
      for (sentry, i) ∈ E do
      begin
        new_entry := construct_entry({sentry.y_{i⊕1}, sentry.y_i, w});
        if closest_is_internal(new_entry) then push(Q, new_entry)
      end
    end
  end
until close_enough;
return ‖v‖
```

Note that, when constructing the initial polytope and when adding new faces to the polytope, we must make sure that the adjacency information in the triangle entries is kept up-to-date and in the correct orientation. The operations needed for maintaining the adjacency information are not included in Algorithm 4.8. These operations are quite elaborate (hence their omission here), but not too hard, so the attentive reader is expected to be capable of implementing these operations from the text provided above.

Initialization

As mentioned earlier, we initialize the algorithm with a polytope that contains the origin and has its vertices on the boundary of the CSO. We saw that for intersecting objects, GJK returns a simplex that contains the origin. By choosing a support mapping that returns points on the boundary only, we can make sure that the vertices of the simplex are points on the

boundary of the CSO. This simplex will in most cases be a tetrahedron, which is just what we need for the EPA. However, in some cases, GJK may also return a point, a line segment, or a triangle as the simplex.

The point case is the easiest to deal with. When GJK returns a point as the simplex, the point must be the origin. Since the point lies on the boundary, the objects are in touching contact, and thus, the penetration depth is zero. Most applications do not have a use for a zero penetration depth, so you might want to ignore these cases and simply return a nonintersection for touching contacts.

In the case where the simplex returned by GJK is a line segment, we are dealing most likely with a pair of intersecting spheres. Other configurations of intersecting objects that result in GJK returning a line segment are cylinders or cubes that are aligned along their diagonals. We could simply return the vertex of the line segment that lies closest to the origin, which is the correct penetration depth vector for these special cases. However, GJK returns line segments for other cases as well. So, in order to cover all cases, we should create a convex polyhedron containing the origin and use the EPA to find the penetration depth.

We already have the two vertices of the line segment and need to add three additional vertices to construct a hexahedron with triangular facets (two tetrahedra glued together), as depicted in Figure 4.18. We use the

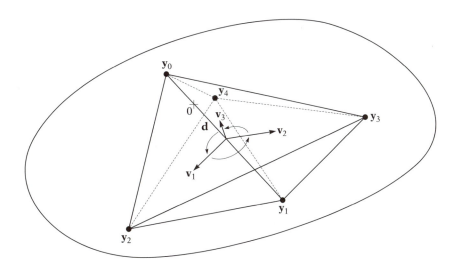

Figure 4.18 Constructing an initial polytope for the EPA, in the case where GJK returns a line segment $\overline{\mathbf{y}_0\mathbf{y}_1}$ containing the origin. A hexahedron is constructed by adding three vertices \mathbf{y}_2, \mathbf{y}_3, and \mathbf{y}_4. These additional vertices are the support mappings of three vectors \mathbf{v}_1, \mathbf{v}_2, and \mathbf{v}_3 that are orthogonal to the direction of the line segment $\mathbf{d} = \mathbf{y}_0 - \mathbf{y}_1$ and have a relative angle of $\frac{2}{3}\pi$ radians.

CSO's support mapping for computing the additional vertices. First we construct three vectors orthogonal to the line segment and with a relative angle of $\frac{2}{3}\pi$ radians (120°). This is done in the following way.

The first vector \mathbf{v}_1 is the cross product of the direction \mathbf{d} of the line segment and a coordinate axis. The best coordinate axis is the axis \mathbf{e}_i for which the ith component of \mathbf{d} has the smallest absolute value. In this way, the angle between \mathbf{d} and \mathbf{e}_i is the largest, and thus, the cross product has the largest length. We do not want the cross product to be (close to) the zero vector, since it then becomes useless for computing the support point.

The other vectors are constructed by rotating the first vector about the direction \mathbf{d} of the line segment. There are several ways in which this can be done. One way is to construct a quaternion $\mathbf{q} = \cos(\frac{1}{3}\pi) + \hat{\mathbf{d}}\sin(\frac{1}{3}\pi)$, where \mathbf{d} has unit length. Using this quaternion, we compute $\hat{\mathbf{v}}_2 = \mathbf{q}\hat{\mathbf{v}}_1\mathbf{q}^*$ and $\hat{\mathbf{v}}_3 = \mathbf{q}\hat{\mathbf{v}}_2\mathbf{q}^*$. However, it takes fewer arithmetic operations if we construct a rotation matrix \mathbf{R} and compute the two remaining vectors as $\mathbf{v}_2 = \mathbf{R}\mathbf{v}_1$ and $\mathbf{v}_3 = \mathbf{R}\mathbf{v}_2$. The rotation matrix \mathbf{R} can be constructed from the quaternion \mathbf{q}, or directly from the axis and angle of rotation [35]. The three additional vertices are the support points $s_{A-B}(\mathbf{v}_i)$. With these five vertices we construct the boundary triangles of the hexahedron.

For degenerate cases, the line segment returned by GJK may be contained by the boundary of the CSO. This happens only if the objects are in touching contact, since the origin lies on the boundary of the CSO. In that case, a triangle of the hexahedron may have coinciding vertices, or the distance from the origin to the triangle's affine hull may be zero. So, for each boundary triangle of the hexahedron we need to check whether it is a proper triangle and whether its affine hull does not contain the origin. Should any of the triangles fail the check, then we return a zero penetration depth, since the objects are in touching contact.

In the case where the simplex returned by GJK is a triangle, we also construct a hexahedron, but this time we need to add only two additional vertices. The additional vertices are the support points $s_{A-B}(\mathbf{n})$ and $s_{A-B}(-\mathbf{n})$, where \mathbf{n} is a normal to the triangle. Figure 4.19 illustrates how the hexahedron is constructed. Again, if the triangle returned by GJK is part of the boundary, then a boundary triangle of the hexahedron has coinciding vertices or its affine hull contains the origin. We check the boundary triangles of the hexahedron in the same way as we did for the line segment case, and return a zero penetration depth if one of the triangles fails the check.

Care should be taken in constructing the triangle entries for the hexahedron, since all entries need to have the same orientation. As mentioned, a hexahedron is basically two tetrahedra glued together, so we can rid ourselves immediately of one half of the hexahedron by testing each tetrahedron for containment of the origin. The tetrahedron containing

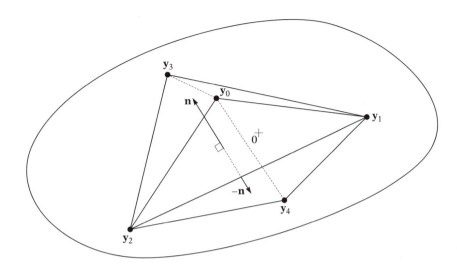

Figure 4.19 In the case where GJK returns a triangle $\mathbf{y}_0, \mathbf{y}_1, \mathbf{y}_2$ containing the origin, we also construct a hexahedron as the initial polytope for the EPA, but this time we need to add only two vertices, \mathbf{y}_3 and \mathbf{y}_4. These two additional vertices are the support mappings of \mathbf{n}, the triangle's normal, and $-\mathbf{n}$, the normal pointing in the opposite direction.

the origin is the one we will use to initialize the EPA. In this way, the initial polytope is always a tetrahedron, which simplifies the initialization process.

Testing a tetrahedron for containment of the origin is quite easy. For each of the four triangles we test whether the origin lies in between the triangle's supporting plane and a parallel plane through the point not in the triangle. Only if this is true for all four triangles is the origin contained in the tetrahedron. Algorithm 4.9 describes this operation in pseudocode.

Algorithm 4.9

Testing a tetrahedron $\{\mathbf{p}_0, \mathbf{p}_1, \mathbf{p}_2, \mathbf{p}_3\}$ for containment of the origin.

$\mathbf{n}_0 := (\mathbf{p}_1 - \mathbf{p}_0) \times (\mathbf{p}_2 - \mathbf{p}_0)$;
if $\mathbf{n}_0 \cdot \mathbf{p}_0 > 0 \equiv \mathbf{n}_0 \cdot \mathbf{p}_3 > 0$ then return false;
$\mathbf{n}_1 := (\mathbf{p}_2 - \mathbf{p}_1) \times (\mathbf{p}_3 - \mathbf{p}_1)$;
if $\mathbf{n}_1 \cdot \mathbf{p}_1 > 0 \equiv \mathbf{n}_1 \cdot \mathbf{p}_0 > 0$ then return false;
$\mathbf{n}_2 := (\mathbf{p}_3 - \mathbf{p}_2) \times (\mathbf{p}_0 - \mathbf{p}_2)$;
if $\mathbf{n}_2 \cdot \mathbf{p}_2 > 0 \equiv \mathbf{n}_2 \cdot \mathbf{p}_1 > 0$ then return false;
$\mathbf{n}_3 := (\mathbf{p}_0 - \mathbf{p}_3) \times (\mathbf{p}_1 - \mathbf{p}_3)$;
if $\mathbf{n}_3 \cdot \mathbf{p}_3 > 0 \equiv \mathbf{n}_3 \cdot \mathbf{p}_2 > 0$ then return false;
return true

Numerical Aspects of the Expanding-Polytope Algorithm

When implementing the EPA using finite-precision arithmetic, we encounter a number of potential problems. For point sets X that are close to being affinely dependent, the computed value for $v(\text{aff}(X))$ may have a considerable error. Since we have little control over the triangle subdivision process, we cannot avoid generating oblong triangles, so we will have to cope with errors in the computed closest points. As a result of an error in the computed value of $v(\text{aff}(X))$, we may run into the following problems:

1. A triangle is falsely accepted, since the computed closest point of its affine hull is an internal point of the triangle, whereas the theoretical closest point is not an internal point.

2. A triangle is falsely rejected, since the computed closest point of its affine hull is not internal, whereas the theoretical closest point is internal.

3. The computation of the $v(\text{aff}(X))$ fails. Recall from page 99 that the parameters λ_i are computed by applying Cramer's rule. For affinely independent triangles the sum of the determinants should be positive. However, due to rounding errors, the computed sum of the determinants can be zero or negative.

4. The termination condition $\mathbf{v} \cdot \mathbf{w}/\|\mathbf{v}\| - \|\mathbf{v}\| \leq \varepsilon_{\text{abs}}$ is not met where it should be met. In theory, the termination condition should hold when the current triangle is part of the boundary of the CSO; however, due to an error in $\hat{\mathbf{v}}$, this may not be the case.

Problem 1 is pretty harmless. Even if the triangle is selected as the best candidate, which is theoretically impossible, then iterating further using this triangle can do little damage.

Problem 2 is more serious, since we potentially reject the triangle that would result in the closest point on the boundary. The algorithm may terminate on a nonoptimal boundary point by expanding the remaining candidate triangles, or it may simply run out of candidate triangles to expand.

During the process of expanding triangles there is no way of telling whether a triangle is falsely rejected, given the numerical precision of the floating-point format used. However, we can detect whether the current best candidate results in a nonoptimal solution by maintaining the tightest upper bound for the penetration depth.

Since, for each support plane $H(\mathbf{v}, -\mathbf{v} \cdot \mathbf{w})$, the CSO is contained in the negative closed halfspace defined by the support plane, the distance from

the origin to the plane is an upper bound for the penetration depth. We define δ_k as the distance to the plane $H(\mathbf{v}_k, -\mathbf{v}_k \cdot \mathbf{w}_k)$, where \mathbf{v}_k is the closest point on the affine hull of the kth triangle, and \mathbf{w}_k is the corresponding support point. Thus,

$$\delta_k = \mathbf{v}_k \cdot \mathbf{w}_k / \|\mathbf{v}_k\|.$$

Unlike $\|\mathbf{v}_k\|$, the upper bound δ_k may not be monotonic in k; that is, it is possible that $\delta_j > \delta_i$ for $j > i$. Therefore, we use

$$\mu_k = \min\{\delta_0, \ldots, \delta_k\}$$

as the upper bound, which is often tighter than δ_k.

The distance from the origin to the current best candidate can become larger than the current tightest upper bound μ only if in an earlier expansion a proper triangle was falsely rejected. Thus, before we expand a best candidate we must check whether its distance to the origin is at most the current upper bound. If its distance is larger than the current upper bound, we terminate and return the distance to the previous best candidate as the penetration depth.

In the same way, if we run out of candidates, we simply return the distance to the last expanded candidate as the penetration depth. Since we do not meet the original termination condition, it is not guaranteed that the error in the computed penetration depth is smaller than our set tolerance. However, rest assured that the error in $\|\mathbf{v}\|$ is probably much smaller than the difference between μ and $\|\mathbf{v}\|$, since, as we recall from our discussion on GJK termination, the computation of $\mathbf{v} \cdot \mathbf{w}/\|\mathbf{v}\|$ tends to be on the low side due to ill-conditioning.

Since the upper bound μ is monotonically nonincreasing, it is useless to add triangles to the priority queue for which the distance to the origin is larger than the current upper bound. Furthermore, theoretically it is impossible that the split parts of a triangle are closer to the origin than the original, so if one of the parts of a triangle after splitting is closer to the origin than the current best candidate, we know that the computation of the closest point suffered from numerical errors. In order to guarantee that $\|\mathbf{v}\|$ is strictly nondecreasing, we reject triangles that are closer to the origin than the current best candidate. So, only triangles for which the closest point of the affine hull is an internal point of the triangle and for which the distance to the origin lies in the interval $[\|\mathbf{v}\|, \mu]$ are added to the priority queue.

As with GJK, we will use a relative error tolerance rather than an absolute one for termination of the EPA. Thus, EPA terminates as soon as the

following criterion is met:

$$\mu - \|\mathbf{v}\| \leq \varepsilon_{\text{rel}} \|\mathbf{v}\|.$$

We rid ourselves of the evaluation of a square root in $\|\mathbf{v}\|$ by moving the term $\|\mathbf{v}\|$ from the left-hand side to the right-hand side of the inequality and squaring both sides:

$$\mu^2 \leq (1 + \varepsilon_{\text{rel}})^2 \|\mathbf{v}\|^2.$$

Squaring is allowed since both sides are nonnegative. We know that if the origin is contained in $A - B$, then $\mathbf{v} \cdot s_{A-B}(\mathbf{v})$ is nonnegative, and thus $\delta_k = \mathbf{v}_k \cdot \mathbf{w}_k / \|\mathbf{v}_k\|$ is nonnegative for each iteration k. Therefore,

$$\mu_k^2 = (\min\{\delta_0, \ldots, \delta_k\})^2 = \min\{\delta_0^2, \ldots, \delta_k^2\}.$$

We see that computation of $\delta^2 = (\mathbf{v} \cdot \mathbf{w})^2 / \|\mathbf{v}\|^2$ does not require evaluating a square root.

We cope with Problem 3 simply by terminating as soon as an expansion results in a bad triangle. For a bad triangle, the computed numerator of the parameters λ_i is zero or negative. Since the numerator is twice the area of the triangle, theoretically it cannot be negative and can only be zero if the triangle is affinely dependent. However, for a triangle that is (almost) affinely dependent, the computed numerator can be negative due to rounding errors. In that case, there is no proper way to compute the closest point $\mathbf{v} = v(\text{aff } X)$ of triangle X. We need \mathbf{v} not only for the best candidate, but also for its adjoining triangles. Furthermore, we need $\|\mathbf{v}\|$ to decide whether or not to add the triangle to the candidate list. So, as soon as an expansion results in a bad triangle, we have no other choice than to terminate and return the distance to the last expanded candidate as the penetration depth.

Problem 4 is quite similar to the GJK termination issue we discussed on page 143. Due to the ill-conditioning of the upper bound μ, the EPA may not terminate even if the current best triangle is part of the boundary of the CSO. For such a triangle, the support point \mathbf{w} is most likely one of the vertices of the triangle. If the new support point \mathbf{w} is a vertex of the current triangle, then expansion of this triangle results in a number of fragments that are affinely dependent. Since construction of affinely dependent triangles during an expansion results in immediate termination, there is no need to check whether the new support point is equal to one of the vertices of the current best triangle, as we did in GJK. So, the solution we presented for Problem 3 fixes Problem 4 as well. Algorithm 4.10 summarizes

all the adaptions to the theoretical EPA in order to cope with numerical errors.

Algorithm 4.10

The numerical expanding-polytope algorithm in 3D.

$P := $ *"a convex polyhedron containing the origin"*;
$Q := \emptyset$;
for *"each triangle X of P"*
begin
 $entry := construct_entry(X)$;
 if *closest_is_internal*$(entry)$ then *push*$(Q, entry)$
end;
$\mu := $ infinity; {{ *Upper bound for the squared penetration depth.* }}
repeat
 $entry := best(Q)$;
 $pop_best(Q)$;
 if not *entry.obsolete* then
 {{ *Facet "entry" is a proper best candidate.* }}
 begin
 $\mathbf{v} := entry.\mathbf{v}$;
 $\mathbf{w} := s_{A-B}(\mathbf{v})$;
 $\mu := \min(\mu, (\mathbf{v} \cdot \mathbf{w})^2 / \|\mathbf{v}\|^2)$;
 $close_enough := \mu \leq (1 + \varepsilon_{\text{rel}})^2 \|\mathbf{v}\|^2$;
 if not *close_enough* then
 {{ *Blow up the current polytope by adding vertex* \mathbf{w}. }}
 begin
 $entry.obsolete := $ true; {{ *Facet "entry" is visible from* \mathbf{w}. }}
 $E := \emptyset$;
 for $i = 0, 1, 2$ do
 $silhouette(entry.adj_i, entry.j_i, \mathbf{w}, E)$;
 {{ *E is the silhouette of the current polytope as seen from* \mathbf{w}. }}
 for $(sentry, i) \in E$ do
 begin
 $new_entry := construct_entry(\{sentry.\mathbf{y}_{i \oplus 1}, sentry.\mathbf{y}_i, \mathbf{w}\})$;
 if *affinely_dependent*(new_entry) then return $\|\mathbf{v}\|$;
 if *closest_is_internal*(new_entry) and $\|\mathbf{v}\|^2 \leq \|new_entry.\mathbf{v}\|^2 \leq \mu$
 then
 $push(Q, new_entry)$
 end
 end
 end
until *close_enough* or $Q = \emptyset$ or $\|best(Q).\mathbf{v}\|^2 > \mu$;
return $\|\mathbf{v}\|$

Penetration Depth Using a Hybrid Technique

The EPA is numerically not very well-behaved when interpenetrations are relatively small. Unfortunately, in real-life simulations such types of contacts are very common. Movement of objects per frame are usually small; thus objects will interpenetrate only a small amount. Also, the EPA is computationally more expensive than GJK, since it requires more advanced data structures and usually does not converge as fast as GJK. In order to warrant a faster and more stable penetration depth computation, the following hybrid technique can be used.

The hybrid technique uses GJK when interpenetrations are small and EPA when interpenetrations are large. The objects are slightly enlarged by adding a tiny sphere to the original objects, thus creating a small margin around them. If a pair of objects intersect only in the margins, then a closest point pair is computed for the original nonintersecting objects. The witness points of the distance are projected to the boundaries of the enlarged objects in order to return the penetration depth for the enlarged objects. If the original objects intersect as well, then EPA is used for computing the penetration depth of the enlarged objects. See Figure 4.20 for a visual description of this technique.

When performing an intersection test on enlarged objects using GJK, we do not compute support points for the enlarged objects. Instead, we use the GJK distance algorithm on the original objects and enable an early exit when the lower bound for the distance exceeds the sum of the margins of the two objects. We could have used ISA-GJK on the enlarged objects for the intersection test, since we have support mappings of Minkowski sums of convex object and spheres at our disposal. However, support mappings for Minkowski sums are computationally more expensive than support mappings for plain objects. Moreover, since we need to compute the closest points in the common case where the enlarged objects only slightly intersect, it is faster to start off by computing the distance rather than performing a distance computation as a second step.

We saw in Section 4.3.7 that in GJK a lower bound for the distance is given by the distance to the support plane $H(-\mathbf{v}, \mathbf{v} \cdot \mathbf{w})$, which is $\mathbf{v} \cdot \mathbf{w}/\|\mathbf{v}\|$. If the lower bound is greater than $\mu_A + \mu_B$, the sum of the margins of objects A and B, then the enlarged objects do not intersect, as depicted in Figure 4.21, and thus we may exit early without computing the exact closest points. In order to improve performance, we rid ourselves of the square root in the evaluation of $\|\mathbf{v}\|$ by squaring both the left-hand and right-hand side of the inequation. However, note that $\mathbf{v} \cdot \mathbf{w}$ can be negative, so we should first check whether $\mathbf{v} \cdot \mathbf{w}$ is positive before testing the inequality for the squared values. Thus, we may exit, returning a nonintersection, if

$$\mathbf{v} \cdot \mathbf{w} > 0 \quad \text{and} \quad (\mathbf{v} \cdot \mathbf{w})^2/\|\mathbf{v}\|^2 > (\mu_A + \mu_B)^2.$$

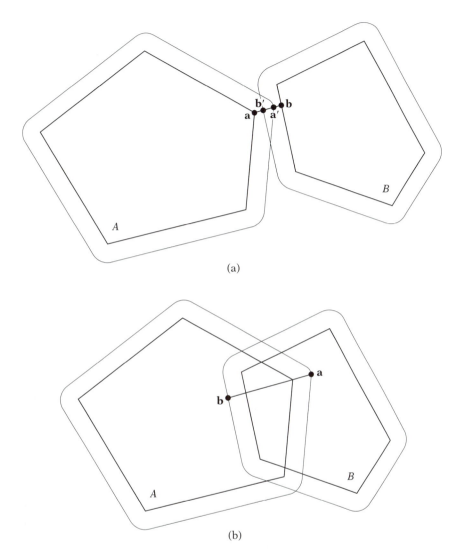

Figure 4.20 A hybrid technique for a faster penetration depth computation when interpenetrations are small. (a) The objects intersect only in the margins. Closest points **a** and **b** are computed for the original objects using GJK and projected to the points **a**′ and **b**′ on the boundaries of the enlarged objects. (b) The original objects intersect as well. Witness points **a** and **b** of the penetration depth are computed for the enlarged objects using EPA.

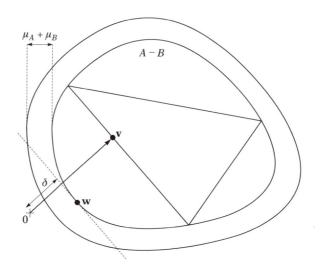

Figure 4.21 If the lower bound $\delta = \mathbf{v} \cdot \mathbf{w}/\|\mathbf{v}\|$ for the distance between the original objects is greater than $\mu_A + \mu_B$, the sum of the margins, then the enlarged CSO does not contain the origin, and thus the enlarged objects do not intersect.

In the case where the enlarged objects intersect, then the GJK distance algorithm terminates in the usual way. If the enlarged objects intersect only in the margins, then GJK terminates, returning a nonzero distance, and we are done. Whereas if the original objects intersect, then GJK returns a zero distance, in which case we need to rerun GJK for the enlarged objects in order to construct an initial polytope and compute the penetration depth using the EPA.

One issue remains in this approach. ISA-GJK is capable of exploiting frame coherence by reusing a separating axis from an earlier frame. As can be seen in Figure 4.21, the vector \mathbf{v} is a separating axis for the enlarged objects; thus in the case of a nonintersection we have a proper separating axis that can be cached for future calls. However, unlike ISA-GJK, the GJK distance algorithm needs to be initialized by a vector \mathbf{v} that points to a point in $A - B$, rather than an arbitrary vector. GJK needs an initial \mathbf{v} that is contained in the CSO because $\|\mathbf{v}\|$ serves as an upper bound for the distance. We can get rid of the constraint that \mathbf{v} needs to lie in the CSO by using infinity rather than $\|\mathbf{v}\|^2$ as the initial upper bound for the distance. In this way, we can use the cached separating axis from an earlier frame as the initial vector \mathbf{v} regardless of whether it lies in the CSO. Algorithm 4.11 summarizes the hybrid technique for computing the penetration depth of objects that are enlarged by a small margin.

**Algorithm
4.11**

Penetration depth of objects that are enlarged by a margin. The margins of the original objects A and B are μ_A and μ_B, respectively. This algorithm is capable of exploiting frame coherence by caching separating axes as in ISA-GJK.

$\mathbf{v} := $ *"arbitrary vector"*;
$\upsilon := $ infinity; {{*Upper bound for the squared distance.*}}
$W := \emptyset$;
$Y := \emptyset$;
repeat
 $\mathbf{w} := s_{A-B}(-\mathbf{v})$;
 if $\mathbf{v} \cdot \mathbf{w} > 0$ and $(\mathbf{v} \cdot \mathbf{w})^2 / \|\mathbf{v}\|^2 > (\mu_A + \mu_B)^2$ then
 {{*The enlarged objects do not intersect.*}}
 return 0;
 if $\mathbf{w} \in Y$ or $\upsilon - \mathbf{v} \cdot \mathbf{w} \leq \varepsilon_{\text{rel}}^2 \upsilon$ then
 {{*The objects intersect only in the margins.*}}
 return $\mu_A + \mu_B - \sqrt{\upsilon}$;
 $Y := W \cup \{\mathbf{w}\}$;
 $\mathbf{v} := \upsilon(\text{conv}(Y))$;
 $W := $ *"smallest $X \subseteq Y$ such that $\mathbf{v} \in \text{conv}(X)$"*;
 $\upsilon := \|\mathbf{v}\|^2$
until $|W| = 4$ or $\upsilon \leq \varepsilon_{\text{tol}} \max\{\|\mathbf{y}\|^2 : \mathbf{y} \in W\}$;
{{*The original objects intersect as well.*}}
return *"penetration depth of enlarged A and B returned by the EPA"*

Spatial Data Structures

5

I feel like a million tonight, but one at a time.

—Mae West

In no other problem area of interactive 3D animation are the often conflicting constraints on space and time so critical as in collision detection of complex environments. In environments composed of hundreds of objects, in which each object may again be composed of thousands of primitives, the number of pairwise primitive intersection tests that need to be performed can become huge. In this chapter, we will discuss spatial data structures for accelerating collision detection of complex environments.

Spatial data structures are used in two ways. First, they are used for reducing the number of intersection tests among static and freely moving objects in an environment. For n objects there are $\binom{n}{2} = \frac{1}{2}n(n-1)$ potentially colliding pairs of objects. Additional search structures can be used to quickly reject the majority of these pairs. Second, they are used for reducing the number of pairwise primitive intersection tests in intersection testing between two complex models or a complex model and a primitive. In the latter case, the data structures are constructed as a preprocessing step and are usually static.

An important concept in this context is *geometric coherence*, as defined in Chapter 2. Geometric coherence is important because it enables us to quickly reject pairs of objects based on the region of space that they occupy. Spatial data structures, such as voxel grids, hierarchical space partitioning structures, and bounding-volume hierarchies, can be used for "capturing" geometric coherence. Basically, the data structures that are used for this purpose fall into two categories: space partitioning and model partitioning. In the following sections, we will discuss the advantages and drawbacks of data structures for each category. But first, let's explore how to deal with concave polyhedra.

5.1 **Nonconvex Polyhedra**

So far, we covered intersection tests for a variety of (mostly convex) primitive shape types. Interactive 3D environments are usually modeled using complex shapes that cannot be represented by a single primitive. Most commonly used are polyhedral meshes, such as triangle or quadrilateral meshes. Polyhedral meshes are used for modeling curved surfaces and polyhedra. A polyhedron is a region of space that is enclosed by a polyhedral mesh. Thus, the region of space that is enclosed by the mesh is usually considered part of the object.

For convex polyhedra we can use the collision detection methods discussed in Chapter 4. Concave polyhedra need to be decomposed into a collection of primitives. Here, we will look into decomposition methods for nonconvex polyhedra.

5.1.1 **Convex Decomposition**

One way to tackle this problem is to decompose a nonconvex polyhedron into convex subpolyhedra. Convex polyhedra can be tested for intersection using, for instance, GJK, as discussed in Chapter 4.

Convex decomposition of nonconvex polyhedra is more difficult than its two-dimensional counterpart, convex decomposition of polygons. In particular, some polyhedra cannot be tetrahedralized (i.e., partitioned into tetrahedra) such that each tetrahedron's vertices are vertices of the polyhedron. In fact, polyhedra exist that require $\Omega(n^2)$ convex pieces in the best partitioning, where n is the number of vertices [100].

The problem of partitioning a nonconvex polyhedron into a minimal number of convex pieces is known to be NP-hard [3]. Thus, shooting for a minimal partitioning does not seem practical. However, we need not stray too far from the mark, since algorithms exist that partition a polyhedron of n vertices into $O(n^2)$ convex pieces in polynomial time [20].

An easy, implementable partitioning method is *binary space partitioning* (BSP) [125]. A BSP is a recursive subdivision of a space into convex cells, using partitioning planes. By choosing the partitioning planes from the set of supporting planes of the polyhedron's facets, a BSP can be formed such that the polyhedron is the union of a subset of cells. A drawback of the BSP method is that it often results in unnecessarily many components. We will further discuss the use of BSPs for representing polyhedra in Section 5.2.3.

It is worth noting that, for the purpose of collision detection, it is not necessary to decompose a concave polyhedron into disjoint pieces. We may decompose a polyhedron into overlapping pieces, as depicted in Figure 5.1, since we are interested in intersections with the union of

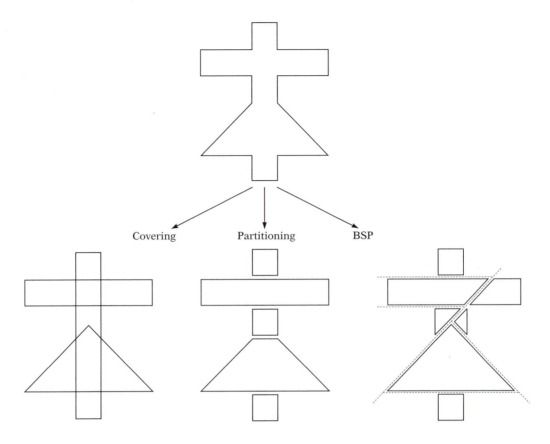

Figure 5.1 Convex decomposition methods.

all pieces. The question remains unanswered how this added freedom can be exploited for constructing decompositions that have significantly fewer components than the best partitionings. Surprisingly little is found in the literature on this intriguing problem.

Convex decomposition is still an important research topic. Existing partitioning methods often generate an unacceptable number of convex pieces ($O(n^2)$, where n is the number of vertices). A more feasible approach is to test only the boundaries of polyhedra for intersection.

5.1.2 **Polyhedral Surfaces**

In most applications, we are content if we can detect intersections of boundaries of polyhedra. We do not care too much about detecting

polyhedra that are fully contained in the interior of another polyhedron, simply because most collision response handlers will prevent a simulation from ever generating such a configuration. If objects move at a limited velocity, and if they have a large enough size, it will be impossible for a pair of objects to travel in one frame from a disjoint configuration to a configuration in which one object is enclosed by the other. In these cases, a boundary intersection must occur before one of the objects is enclosed by the other.

Nonconvex polyhedra are thus handled as polyhedral surfaces. In most collision detection techniques of polyhedral surfaces no adjacency of facets is assumed. The surfaces are considered sets of polygons without any further constraints. Such sets are commonly referred to as *polygon soups*. Polygon soups need not form connected surfaces and may contain intersecting polygons.

Examples of techniques that use adjacency information of polyhedral surfaces do exist. Ehmann and Lin [41] describe an algorithm for incremental distance computation of polyhedral surfaces that is based on convex surface decomposition. A convex surface decomposition is a decomposition of a polyhedral surface into convex patches—surface patches that lie entirely on their convex hull. Amanatides and Choi [1] describe another example that uses adjacency information of polyhedral surfaces. They establish a reduction in the cost of ray casting of triangle meshes by amortizing the cost of ray-triangle tests over adjacent triangles. Reduced amortized costs are realized by caching intermediate results in the edge nodes of the mesh.

5.1.3 Point in Nonconvex Polyhedron

In cases where we do need to detect objects that are enclosed in a nonconvex polyhedron, we require a point-in-polyhedron test. A point-in-polyhedron test can be done similar to its two-dimensional variant, a point-in-polygon test. A ray with the query point as its starting point extending infinitely in one direction crosses the boundary an even number of times if the query point lies outside and an odd number of times if the query point lies inside the polyhedron. Hence, by counting the number of times the ray crosses the boundary we can classify the location of a given query point with respect to a polyhedron.

Although rather straightforward in theory, this method is quite tricky in practice. Due to precision problems, degenerate cases, where the ray passes (nearly) through an edge of the boundary, may cause incorrect results. O'Rourke [101] presents a robust implementation of the ray intersection count. He uses an approach in which a randomly generated ray is used. If the chosen ray happens to result in a degeneracy, then another

random ray is tried. This process is repeated until a ray is found that does not result in a degeneracy.

5.2 Space Partitioning

A space partitioning is a subdivision of space into convex regions, called *cells*. Each cell in the partitioning maintains a list of references to objects that are (partially) contained in the cell. Using such a structure, a lot of object pairs can be quickly rejected from intersection testing, since we only need to test the pairs of objects that share a cell. Many space partitioning structures have been borrowed from rendering [43, 53]. We will briefly discuss a number of commonly used space partitionings. For a more thorough discussion, the reader is referred to [106].

5.2.1 Voxel Grids

A *voxel grid* is a space partitioning into uniform rectangular cells. A voxel grid is represented by an axis-aligned box enclosing all objects in the model and a three-dimensional array of cells of size $N_1 \times N_2 \times N_3$, where N_1, N_2, and N_3 are the number of subdivisions along the respective axes. Other than the position and size of the box, no further geometric data need to be maintained in the grid structure.

Let $(\beta_1, \beta_2, \beta_3)$ be a vertex of the box and η_1, η_2, and η_3 the extents along the respective axes, such that the box is the Cartesian product of the intervals $[\beta_k, \beta_k + \eta_k)$ for $k = 1, 2, 3$. Then, the cell indexed by (i_1, i_2, i_3) is the box defined by the product of intervals

$$[\beta_k + i_k \frac{\eta_k}{N_k}, \beta_k + (i_k + 1)\frac{\eta_k}{N_k}) \quad \text{for } 0 \leq i_k < N_k \text{ and } k = 1, 2, 3.$$

Given a point $\mathbf{x} = (\alpha_1, \alpha_2, \alpha_3)$ inside the box, the indices i_k of the cell containing \mathbf{x} are

$$i_k = \left\lfloor (\alpha_k - \beta_k)\frac{N_k}{\eta_k} \right\rfloor.$$

The translation from coordinates to cell indices is basically a conversion to a fixed-point number format of resolution N_k and can be done in a constant number of operations.

Each cell maintains a list of objects that intersect the cell. Adding, moving, or removing an object in the grid boils down to updating the lists of all cells that cover the object. This operation is similar to scan

conversion of geometric objects to bitmaps in computer graphics [43]. Often, we do not scan-convert the actual object to the grid, but add the object to all cells that cover the object's axis-aligned bounding box, which is a much simpler operation. Since the grid serves only as a first phase for fast rejection of pairs of objects, adding an object to more cells than strictly necessary is not harmful for the correctness. The larger number of exact object intersection tests that result from the use of bounding boxes are usually justified by the faster scan conversion of boxes.

Assume we have a collection of objects of more or less the same size, and assume that the set has a high degree of geometric coherence and is distributed evenly over the space. Then, for a grid that has a number of cells that is linear in the number of objects, adding or moving an object can be done in roughly constant time, since only a constant number of cells need to be visited, and object lists in cells contain only a limited number of entries [19, 75]. This is useful in an environment with lots of similar moving objects such as described in [138].

Voxel grids have been shown to be useful also in real-time intersection testing between complex rigid objects [48, 49]. Here, each object's primitives are maintained in a grid that is aligned to the local coordinate system of the object. The algorithm finds all pairs of overlapping nonempty cells of a pair of relatively oriented grids, and tests for intersections between primitives for these pairs of cells.

The benefits of using a voxel grid are low storage usage and fast cell access. However, the biggest drawback of voxel grids, which is common to all bucketing techniques, is the fact that performance greatly depends on the density of objects in the space being uniform. If the objects in an environment are clustered, which is commonly the case in many applications, then a few cells contain most of the objects, whereas the majority of cells are empty. In such cases, a grid is not very useful in rejecting pairs of objects for intersection testing.

Choosing the best resolution for a voxel grid is hard. If there are too few cells in the grid, then the cells will be crowded and thus a lot of intersection tests will be performed among objects in each cell. If there are too many cells, then the grid takes up a lot of storage, and many cells will maintain references to identical objects. Moving a large object in the grid space can become quite expensive, since the object may cover a lot of cells. Also, in order to avoid repeating a lot of intersection tests in cells that maintain the same pair of objects, we need to keep track of the pairs of objects that have been tested for intersection. The overhead of maintaining these data results in added computational and storage costs.

An example of such a bookkeeping technique, know as *mailboxing*, is used a lot in ray tracing [53]. For each intersection query of an object against a collection of objects maintained in a voxel grid, we generate a positive integer ID. We maintain for all grid objects an integer

representing the ID of the last query object this object was tested with. All IDs are initially zero. Each time we perform an intersection test between a query object and an object in the grid, the ID of the grid object is set to the query object's ID. Intersection tests are performed only for grid objects whose ID differs from the query object's ID. In this way, grid objects are never tested more than once with the same query object. Since a new ID is generated for each query, we may quickly run out of IDs. We may reuse IDs of earlier queries; however, before we do this, we must reset the IDs of the grid objects back to zero.

Voxel grids work best for geometrically coherent sets of primitives of uniform density and size. However, in practice, few models satisfy these conditions. Hence, adaptive partitioning schemes, using recursive space partitioning, often yield better results. In the following sections, we will discuss a number of hierarchical space partitioning methods that are better suited for dealing with clusters of objects.

5.2.2 Octrees and *k*-d Trees

Octrees and k-d trees are hierarchical structures for partitioning space into rectangular cells. Each node in the tree corresponds with a rectangular region of the space. The root node corresponds with the whole space, represented by a rectangular box enclosing the complete model. Each internal node in the tree represents a subdivision of its corresponding region into smaller regions, which correspond with the children of the node. The regions of the leaf nodes are the cells in which the objects are maintained.

Octrees and k-d trees differ in the way the regions are subdivided. Each internal node in an octree divides its corresponding region into eight octants by splitting the region along the three coordinate axes. In a k-d tree, the region of an internal node is subdivided into two regions by splitting the region along an arbitrary coordinate axis. See Figure 5.2 for a visual representation of the two structures. It can be seen that the best k-d tree often has fewer cells than the best octree for the same configuration of objects.

In the standard representation, a region is split into subregions of equal size. However, octree or k-d tree variants, in which regions are split at arbitrary points along the axis, are possible as well. These tree variants require more storage, since the positions of the partitioning planes need to be stored in the internal nodes, but the added freedom in choosing the partitioning results in a structure that is more adaptive to the configuration of objects.

It can be seen that in a standard octree each node's region has the same aspect ratio as the root's region. This property often results in poor

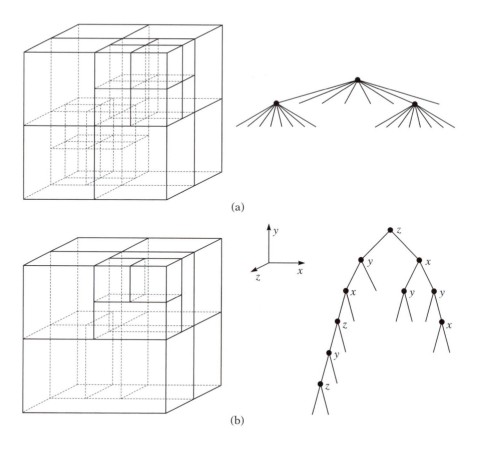

Figure 5.2 Two hierarchical structures for partitioning space into rectangular cells: (a) octree and (b) k-d tree.

partitionings if the root region is oblong. Often, partitioning a space into fat cells (aspect ratio ≈ 1) results in better performance for intersection queries than a partitioning into thin cells, since a given query object can overlap more thin cells than fat cells of the same volume, as depicted in Figure 5.3. Hence, in the cases where the root's region is oblong, it is better to use k-d trees, rather than octrees, since in a k-d tree a cell's aspect ratio need not be equal to the root region's aspect ratio. Of course, for octrees the root region can be taken to be a cube enclosing the objects in the model; however, this may result in a larger number of cells, of which some are always empty. A more general definition of fatness and its significance to space partitioning are presented in [27].

The benefit of using a recursive space partitioning is the fact that it is adaptive to local densities in a model. In regions where a lot of objects are

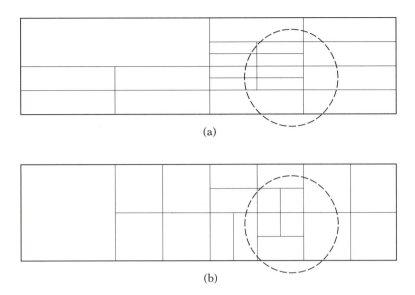

(a)

(b)

Figure 5.3 A query object (dashed circle) can overlap fewer fat cells than thin cells: (a) octree vs. (b) k-d tree.

clustered the space is partitioned into many small cells, whereas in regions where there are hardly any objects the cells can be large. In environments in which the local densities of objects change over time, for instance, as in simulations of chemical phenomena, dynamic hierarchical space partitioning structures may be applied. If a cell becomes crowded, it can be subdivided into smaller cells containing less objects. Conversely, if the children of a node, which are all leaves, contain few objects, the corresponding cells can be united and the internal node is transformed into a leaf.

Octrees and k-d trees can be used for reducing the number of pairwise intersection tests among objects in a model, as well as for reducing the number of intersection tests between the primitives of a pair of complex models. An example of a k-d-tree-type data structure that is used in the latter application is the BoxTree by Zachmann and Felger [137]. A BoxTree is constructed a priori for each complex model in its local coordinate system. It is a static structure and is therefore applicable to rigid (i.e., nondeformable) models only. Examples of uses of octrees for deformable models are described in [91, 115]. In both methods, a single octree, maintaining primitives for different objects in the scene, is constructed anew for each frame. In Section 5.3 we will present another scheme for detecting collisions among deformable models, which is based on axis-aligned bounding-box trees.

Octrees and *k*-d trees are popular space partitioning structures, since they require relatively little storage and are adaptive to differences in local densities in a model. Next, we explore the most general of all recursive space partitioning structures, the binary space partitioning tree.

5.2.3 Binary Space Partitioning Trees

A *binary space partitioning* (BSP) tree is a hierarchical structure for partitioning space recursively into convex cells. Each internal node in the tree divides the convex region associated with the node into two regions by means of a freely oriented partitioning plane. Phrased differently, a BSP tree is a variable split *k*-d tree, but without the restriction that the partitioning planes are oriented orthogonal to the coordinate axes. A variant of the BSP tree in which the orientations of the partitioning planes are chosen from a finite set of orientations, similar to DOPs, may be useful in some applications. We refer to this type of BSP tree as a *discrete-orientation BSP* (DOBSP) tree. Representing cell structures using DOBSP trees requires less storage than using general BSP trees, since in a DOBSP tree the partitioning plane orientations are described by an index number rather than a 3D vector. Figure 5.4 shows a taxonomy of recursive hierarchical space partitioning structures.

BSP trees can be used to represent cell structures in which objects are maintained. However, a more interesting application of BSP trees is found in representing concave polyhedra, as an alternative to boundary representations. As we saw in Section 5.1, a concave polyhedron can be represented as the union of a subset of cells in a binary space partitioning. For this purpose, the leaves of the BSP tree are labeled *in* or *out*, depending on whether the corresponding cell lies inside or outside the polyhedron [125],[1] as depicted in Figure 5.5. We will refer to this type of BSP tree as a *solid-leaf BSP tree*.

Construction

A solid-leaf BSP tree representing a polyhedron is constructed by choosing support planes of boundary facets as partitioning planes. Such a construction is called an *autopartitioning*. Algorithm 5.1 illustrates how a solid-leaf BSP tree of a polyhedron is constructed. The choice of the "best" partitioning plane in the BSP tree construction affects the size of the tree as well as the performance of the queries performed on the tree.

1. Explicit labeling of leaf nodes is not necessary if we adopt the convention that a leaf node that is the child corresponding with the positive halfspace of an internal node is *out*, and *in* otherwise.

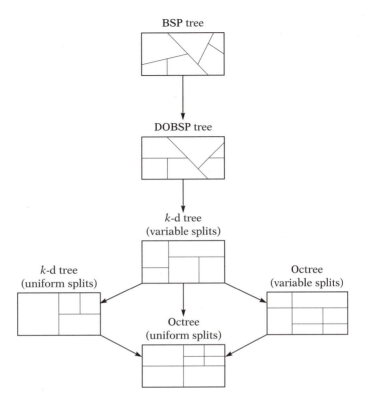

Figure 5.4 A taxonomy of recursive hierarchical space partitioning structures. The arrows in the diagram denote the relation "is a generalization of."

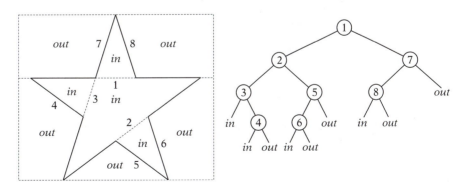

Figure 5.5 A polygon and its BSP tree representation.

Algorithm 5.1

Recursive algorithm for constructing a solid-leaf BSP tree of a set of boundary facets *P*. The flag *label* denotes whether the associated region is contained in the positive or negative halfspace of the parent's partitioning plane, and is *out* for the root node.

autopartition (*P, label*)
begin
 if *P* = ∅ then return *label*
 else
 begin
 H := "the 'best' partitioning plane supporting a facet in *P*";
 $P^- := \emptyset; P^+ := \emptyset$;
 for *facet* ∈ *P* do
 begin
 if "*facet*' is not contained in *H*" then
 begin
 if "*facet*' intersects *H*" then
 begin
 $P^- := P^- \cup \{facet\}$;
 $P^+ := P^+ \cup \{facet\}$
 end
 else if "*facet*' completely beneath *H*" then
 $P^- := P^- \cup \{facet\}$
 else {{ '*facet*' completely above *H* }}
 $P^+ := P^+ \cup \{facet\}$
 end
 end;
 $child^- := autopartition(P^-, "in")$;
 $child^+ := autopartition(P^+, "out")$;
 return *construct_node*($H, child^-, child^+$)
 end
end

First of all, it is important to keep the number of nodes in the BSP tree as small as possible. We see in Algorithm 5.1 that the number of nodes in the constructed tree is larger if a lot of facets are intersected by partitioning planes. Paterson and Yao [103] show that for a set of *n* disjoint facets a BSP tree can be constructed that has $O(n^2)$ nodes. Furthermore, they prove that this bound is worst-case optimal; that is, sets of disjoint facets exist for which the smallest BSP tree representation still has $\Omega(n^2)$ nodes.

For polyhedral meshes, however, the number of nodes in an autopartitioning is generally closer to $O(n \log n)$ [96]. This is due to the usually higher degree of geometric coherence in a mesh. So, any reductions in

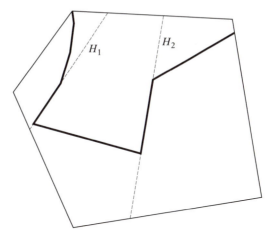

Figure 5.6 Choosing a partitioning plane. The thick line segments represent facets; the dashed lines represent partitioning planes. Plane H_1 splits the set of facets into two sets of equal size. Plane H_2 splits the region into two fat regions of roughly equal volume. Choosing H_1 results in minimal worst-case query times, whereas choosing H_2 results in minimal average-case query times.

BSP tree size that are gained by selecting minimal-split partitioning planes are only marginal. Simply choosing a random partitioning plane from the set of facets often yields trees of very acceptable sizes.

For the purpose of collision detection, however, it is important to construct BSP trees that result in minimal average-case query times for intersection queries. The time it takes to perform a query is linear in the number of nodes visited during the query. Since we want to optimize the average case and not necessarily the worst-case query time, the best heuristic is to choose a partitioning plane that splits the convex region associated with the node into two fat regions of roughly equal volume, rather than a plane that splits the set of facets into sets of roughly equal size (see Figure 5.6) [96].

Note that for some polyhedra, in particular for (almost) convex ones, none of the facets are proper candidates for partitioning planes. Any autopartitioning of a convex polyhedron is a single string of nodes, and thus not very well balanced. In such cases, we can improve the balance of the BSP tree by using auxiliary planes that are not supporting planes of a facet. For instance, we could choose an axis-aligned plane that splits the longest axis of the bounding box of the set of facets along the median vertex, or we could randomly generate a number of planes that contain an edge of one facet and a vertex of another, and choose the best one.

BSP Trees and Collision Detection

Solid-leaf BSP trees are quite useful for point-in-polyhedron tests. The only geometric operation needed for performing the test is the classification of a point with respect to a partitioning plane. Algorithm 5.2 describes the recursive point-in-polyhedron test. Notice that for each visited node the associated region contains the query point. Thus, only the cells that contain the query point are visited.

Algorithm 5.2

Testing a point **p** for inclusion in a polyhedron represented by a BSP tree.

point_in_polyhedron(**p**, *node*)
begin
 if *node* = *"in"* then
 return true
 else if *node* = *"out"* then
 return false
 else {{ *"node" is an internal node.* }}
 begin
 n := *node.H*.**n**; {{ *Plane normal* }}
 δ := *node.H*.δ; {{ *Plane offset* }}
 hit := false;
 if **n** · **p** + $\delta \leq 0$ then
 {{**p** $\in H^-$(**n**, δ)}}
 hit := *point_in_polyhedron*(**p**, *node.child$^-$*);
 if not *hit* and **n** · **p** + $\delta \geq 0$ then
 {{**p** $\in H^+$(**n**, δ)}}
 hit := *point_in_polyhedron*(**p**, *node.child$^+$*);
 return *hit*
 end
end

Generally, we are not that interested in testing points for inclusion. Rather, we want to test volumes for intersection with complex polyhedral environments. We saw in Chapter 2 that an intersection between two objects can be expressed as an inclusion of a point in their configuration-space obstacle (CSO). Let A be a static environment, and let $B + \{\mathbf{p}_t\}$ be a moving object. Then,

$$A \cap (B + \{\mathbf{p}_t\}) \neq \emptyset \equiv \mathbf{p}_t \in A - B.$$

In simple terms, we shrink the moving object to a point and blow up the environment by adding the negate of the query object.

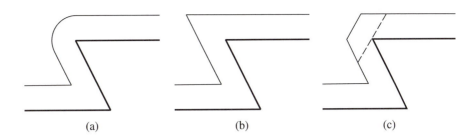

(a) (b) (c)

Figure 5.7 Using offset surfaces for approximating the CSO of a polyhedron and a sphere. Acute convex edges result in a large error with respect to the actual CSO. This error can be reduced by inserting auxiliary bevel planes (dashed line). (a) Actual CSO, (b) offset surface, and (c) beveled offset surface.

Representing the exact CSO of a polyhedron and a query object by a BSP tree is generally too expensive in terms of tree size (for polytopes) or simply impossible (for quadrics). In common applications, the CSO is approximated by offsetting the partitioning planes, thus creating a volume that encloses the CSO [86], as depicted in Figure 5.7. Notice that for acute convex edges the error of this approximation can be large. In order to reduce the error, we insert auxiliary planes in the BSP tree. These auxiliary planes do not modify the original object; however, they support the convex edges in such a way that offsetting them results in beveled edges [86].

Since both halfspaces of a partitioning plane may contain parts of the polyhedron, we need to offset the plane in two directions. Given a partitioning plane $H(\mathbf{n}, \delta)$, the offset in the direction of normal \mathbf{n} is

$$\delta^+ = \delta - \max\{-\mathbf{n} \cdot \mathbf{x} : \mathbf{x} \in B\}.$$

Similarly, the offset in the direction opposite to \mathbf{n} is

$$\delta^- = \delta + \max\{\mathbf{n} \cdot \mathbf{x} : \mathbf{x} \in B\}.$$

If object B is a sphere centered at the origin, then the added offsets are equal to the radius of the sphere, that is, if the normal has unit length.

For polytopes and other types of convex objects, we can use support mappings for computing the offsets. See page 130 for a discussion on support mappings. Expressed in terms of s_B, a support mapping of object B, the offset in the direction of \mathbf{n} is

$$\delta^+ = \delta + \mathbf{n} \cdot s_B(-\mathbf{n}),$$

and the offset in the opposite direction is

$$\delta^- = \delta + \mathbf{n} \cdot s_B(\mathbf{n}).$$

Since only support mappings are required, this offset-surface technique is applicable to the same class of convex object as defined in the context of the GJK algorithm and derived algorithms. In this class we find object types that are commonly used as proxies for navigating an avatar through an environment, such as cylinders [86] and capsules (spheres extruded over a line segment) [83].

This offset-surface technique is applied in popular video games such as Quake [18]. Here, a separate offset-surface BSP tree is used for collision detection besides the BSP tree used for rasterization. A drawback of the use of static offset-surface BSP trees is the fact that when query objects of different sizes are used, we need to construct an offset-surface BSP tree for each query object. Moreover, query objects cannot have angular degrees of freedom. Melax [86] presents a solution to this problem in which offset surfaces are computed and tested on the fly. Algorithm 5.3 describes the use of this dynamic plane-shifting technique for testing intersections between convex objects and polyhedra. Notice that by shifting the planes the two regions associated with the children of an internal node overlap each other to some extent.

Since Algorithm 5.3 is applicable to objects that are extrusions of convex objects along a line segment, it is possible to detect in-between-frame collisions of a moving convex object against a static environment. However, for simulating physics or navigating smoothly through an environment, we not only need to detect these collisions, but we also need the first time of impact. This dynamic plane-shifting technique can be applied for computing the first time of impact as well [86].

Algorithm 5.3

Dynamic plane-shifting BSP traversal for testing a convex object $B + \{\mathbf{p}\}$ for intersection with an environment represented by a BSP tree. This algorithm requires a support mapping s_B for object B.

```
intersect(B, p, node)
begin
    if node = "in" then
        return true
    else if node = "out" then
        return false
    else  {{ "node" is an internal node. }}
    begin
        n := node.H.n;  {{ Plane normal }}
        δ := node.H.δ;  {{ Plane offset }}
        hit := false;
        δ⁺ := δ + n · s_B(−n);
        if n · p + δ⁺ ≤ 0 then
```

```
        {{ p ∈ H⁻(n, δ⁺) }}
        hit := intersect(B, p, node.child⁻);
    if not hit then
    begin
        δ⁻ := δ + n · s_B(n);
        if n · p + δ⁻ ≥ 0 then
            {{ p ∈ H⁺(n, δ⁻) }}
            hit := intersect(B, p, node.child⁺);
    end;
    return hit
  end
end
```

As we saw on page 48, the first time of impact can be found by performing a ray cast on the CSO of the environment and the object. This ray cast is formulated as follows. For an object $B + \{\mathbf{p}_t\}$, where $\mathbf{p}_t = (1-t)\mathbf{p}_0 + t\mathbf{p}_1$ for $t \in [0, 1]$, we need to find the earliest time t at which the object hits the environment A. This query can be answered by performing a ray cast of ray \mathbf{p}_t onto the CSO $A - B$.

The BSP tree that represents $A - B$ splits the ray \mathbf{p}_t in a number of overlapping segments. The segments are represented by intervals $[t_0, t_1]$ that are subintervals of $[0, 1]$. The first time of impact is given by the minimum t_0 over all segments that are contained in solid cells (cells that are labeled *in*).

The segments are computed while traversing the BSP tree. For each visited node we compute the part of the interval that is contained in the convex region associated with the node. Let $[t_0, t_1]$ be the intersection of the ray segment and the convex region associated with the node. Then, the intersection of the segment and the region associated with the negative child is the intersection of the segment and the halfspace $H^-(\mathbf{n}, \delta^+)$. We find the subinterval of $[t_0, t_1]$ that is contained by the halfspace in the following way.

We first compute the point of intersection of the line through \mathbf{p}_0 and \mathbf{p}_1 and the plane $H(\mathbf{n}, \delta^+)$. Let $\mathbf{r} = \mathbf{p}_1 - \mathbf{p}_0$ be the direction of the ray. The line and the plane intersect only if $\mathbf{n} \cdot \mathbf{r} \neq 0$. In that case, the point of intersection is given by

$$t^+ = -\frac{\mathbf{n} \cdot \mathbf{p}_0 + \delta^+}{\mathbf{n} \cdot \mathbf{r}}.$$

If $\mathbf{n} \cdot \mathbf{r} > 0$, then t^+ is an upper bound for the subinterval of $[t_0, t_1]$ contained in the halfspace. Thus, the sought subinterval is $[t_0, \min(t_1, t^+)]$, that is, if $t_0 < t^+$, since otherwise the subinterval is empty. If $\mathbf{n} \cdot \mathbf{r} < 0$, then t^+ is a lower bound, and the subinterval is $[\max(t_0, t^+), t_1]$. If $\mathbf{n} \cdot \mathbf{r} = 0$,

then the ray is parallel to the plane. In that case, we test point \mathbf{p}_0 for inclusion in the halfspace. If \mathbf{p}_0 is contained in the halfspace, then the complete segment must be contained in the halfspace.

A similar exercise is performed for finding the subinterval that is contained by the halfspace of the positive child. If a solid cell is reached, then we return t_0 as the first time of impact for this cell. For empty cells, we return infinity as the earliest time. Algorithm 5.4 is a complete description of the sketched algorithm.

Algorithm 5.4

Determining the first time of impact of a moving convex object $B + \{\mathbf{p}_t\}$ and a static environment represented by a BSP tree. The trajectory \mathbf{p}_t is given by $(1 - t)\mathbf{p}_0 + t\mathbf{p}_1$ for $t \in [t_0, t_1]$. If no intersection is found, then infinity is returned.

first_hit$(B, \mathbf{p}_0, \mathbf{p}_1, t_0, t_1, node)$
begin
 if $node = $ "*in*" then return t_0
 else if $node = $ "*out*" then return infinity
 else begin
 $\mathbf{n} := node.H.\mathbf{n}$;
 $\delta := node.H.\delta$;
 $\delta^+ := \delta + \mathbf{n} \cdot s_B(-\mathbf{n}); \quad \delta^- := \delta + \mathbf{n} \cdot s_B(\mathbf{n})$;
 $\mathbf{r} := \mathbf{p}_1 - \mathbf{p}_0$;
 $t_{impact} := $ infinity;
 if $\mathbf{n} \cdot \mathbf{r} = 0$ then begin
 if $\mathbf{n} \cdot \mathbf{p}_0 + \delta^+ \leq 0$ then
 $t_{impact} := first_hit(B, \mathbf{p}_0, \mathbf{p}_1, t_0, t_1, node.child^-)$;
 if $\mathbf{n} \cdot \mathbf{p}_0 + \delta^- \geq 0$ then
 $t_{impact} := \min(t_{impact}, first_hit(B, \mathbf{p}_0, \mathbf{p}_1, t_0, t_1, node.child^+))$;
 return t_{impact}
 end
 else begin
 $t^+ := -(\mathbf{n} \cdot \mathbf{p}_0 + \delta^+)/\mathbf{n} \cdot \mathbf{r}; \quad t^- := -(\mathbf{n} \cdot \mathbf{p}_0 + \delta^-)/\mathbf{n} \cdot \mathbf{r}$;
 if $\mathbf{n} \cdot \mathbf{r} > 0$ then begin
 if $t_0 \leq t^+$ then
 $t_{impact} := first_hit(B, \mathbf{p}_0, \mathbf{p}_1, t_0, \min(t_1, t^+), node.child^-)$;
 if $t_1 \geq t^-$ then
 $t_{impact} := \min(t_{impact}, first_hit(B, \mathbf{p}_0, \mathbf{p}_1, \max(t_0, t^-), t_1,$
 $node.child^+))$;
 return t_{impact}
 end
 else begin
 if $t_1 \geq t^+$ then
 $t_{impact} := first_hit(B, \mathbf{p}_0, \mathbf{p}_1, \max(t_0, t^+), t_1, node.child^-)$;

```
                 if  t_0 ≤ t⁻  then
                    t_{impact} := min(t_{impact}, first_hit(B, p_0, p_1, t_0, min(t_1, t⁻),
                               node.child⁺));
                 return  t_{impact}
              end
           end
        end
     end
```

Note that this algorithm is applicable to objects that have angular degrees of freedom. However, the orientation can only be changed instantaneously at discrete time steps. Over the course of a single integration step the orientation remains fixed. See Figure 2.13 on page 49 for a description of this motion type.

Merging BSP Trees

In [97], an algorithm is presented for performing Boolean operations on a pair of polyhedra represented by solid-leaf BSP trees. The result of a Boolean operation, which is also represented by a BSP tree, is obtained by merging the two BSP trees. A merge of a pair of BSP trees involves splitting one of the trees according to the root partitioning plane of the other tree, and recursively merging the split trees with the corresponding children of the other tree.

In order to achieve faster splits, the split BSP tree maintains, besides a partitioning plane, also a convex polygon in each internal node. The polygon represents the intersection of the partitioning plane and the convex region associated with the node and is explicitly represented by a list of vertices. Both children need to be split only if the splitting plane intersects the convex polygon. Otherwise, only one of the children needs to be split, while the other child stays intact.

This merge operation can be used for efficiently computing the intersection of a pair of concave polyhedra. The algorithm can also be applied to testing the intersection between a pair of polyhedra, with some adaptations for speed to enable early exit in case an intersection is found [95]. However, note that these adaptations will only marginally improve performance for intersection testing, since it seems that the BSP tree split, the most expensive operation in the intersection computation, cannot be removed or simplified for the collision detection problem.

BSP tree representations of polyhedra are expensive with respect to the storage requirements, especially the ones that maintain a convex polygon in the internal nodes for fast tree merges. Due to their large storage usage and high computational cost, we consider it therefore unlikely that

intersection tests between polyhedra that utilize BSP trees will outperform algorithms that use bounding-volume hierarchies. For a discussion of bounding-volume hierarchies see Section 5.3.

5.2.4 Discussion

A drawback of space partitioning methods is the fact that objects that straddle cell boundaries are maintained in multiple cells. This may lead to structures with sizes that exceed the number of stored objects by orders of magnitude. Maintaining multiple references to the same object results in either a lot of intersection tests being repeated for the same pair of objects, or additional overheads for keeping records of the pairs of objects that have been tested for intersection.

Hence, it seems better to store objects in search structures in such a way that each object is referred to only once. For hierarchical space partitioning structures, this can be achieved by maintaining objects in all the nodes rather than in the leaves only. Each object is maintained in the node that corresponds with the smallest region that encloses the object. The *interval tree* is an example of such a data structure for one-dimensional space and is used for efficiently reporting all intervals in a set that intersect a query interval [104].

However, if we allow objects to be stored in all nodes rather than leaf nodes only, intersection testing among objects is more complicated, since intersecting objects may be maintained at different levels in the tree. In a dynamic setting, we find intersections among objects maintained in the tree by performing range queries in which we use the moving objects as query objects. The computational cost of a range query depends on the number of objects maintained in nodes that are visited during the query. A node is visited if the corresponding region overlaps the query box.

A problem that occurs when objects are maintained in this way in recursive space partitioning trees (octrees, k-d trees, BSP trees) is the fact that small objects may be stored at all levels in the tree; that is, there is no upper bound for the extent of the region in relation to the size of the object stored in the corresponding node. Figure 5.8(a) illustrates this property for a quadtree. Hence, the upper levels of the tree may contain an unacceptable number of objects. Since the nodes at the upper levels are visited more often than the nodes close to the leaves, the range queries are slowed down considerably by a lot of small objects at upper levels. We say "slowed down" because these objects have a low probability of intersecting with the query object due to their size. Therefore, most of the intersection tests on small objects at upper levels are wasted.

A data structure known from geographic information systems (GIS) literature, referred to as a *fieldtree*, can be used to solve this problem [45].

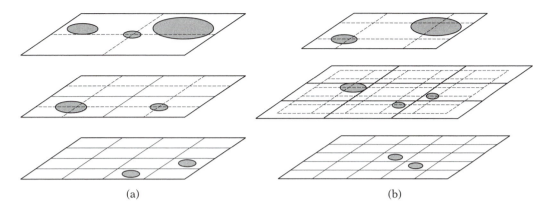

 (a) (b)

Figure 5.8 Two spatial data structures used in GIS: (a) quadtree and (b) fieldtree. In both structures the objects are stored in the node that corresponds with the smallest region enclosing the object. Notice that in the quadtree small objects are stored at all levels, whereas in the fieldtree small objects are stored close to the leaves only.

In a fieldtree, a node may have up to nine children, and a child node may have multiple parents; hence, a fieldtree is actually a directed acyclic graph (DAG). The extent of a child's region is half the extents of its parents' regions as in a quadtree; however, the different levels of the tree are shifted with respect to their parent nodes. The shift of region boundaries allows objects to be stored in a node for which the size of the region is approximately the size of the objects. Thus, large objects are stored close to the root, whereas smaller objects are stored close to the leaves. Figure 5.8(b) shows how objects are stored in a fieldtree.

 A generalization of the fieldtree to three-dimensional space is possible and may be useful as an alternative to the voxel grid. However, we expect such a structure to be less useful as a dynamic data structure, since the time complexity of adding and deleting nodes in the tree is quite high because the children may have multiple parents.

 To conclude this survey of space partitioning structures, we present an overview of structures that are, or may be, used for speeding up collision detection. Depending on the type of intersection problem, we recognize the following solutions using space partitioning techniques:

■ Finding all intersecting pairs among a set of moving objects.

 —Evenly distributed objects of more or less equal size. *Voxel grid* [75, 138]—Merits: fast access and update times, low storage cost. Drawbacks: bad performance and/or high storage cost if object sizes or densities vary.

—Changes in local densities of objects over time.	*Octree, k-d tree, (DO)BSP tree*—Merits: adaptive to differences in local densities of objects, low storage cost (octree, *k*-d tree, DOBSP tree). Drawbacks: bad performance when objects straddle cell boundaries: either maintain objects in the leaves (cells) only and keep multiple references to objects, or maintain objects in all nodes, possibly resulting in small objects being stored close to the root, and thus inefficient range queries.
—Wide variations in object sizes.	*3D fieldtree*—Merits: fast query times due to single references to object, and size-sensitive storage of objects. Drawbacks: complex structure and algorithms, fairly high storage cost.

- Finding intersecting primitives between a pair of complex models.

—Rigid models.	*Voxel grid* [48, 49]—Merits: fast access, low storage cost. Drawbacks: bad performance due to multiple references to objects that straddle cell boundaries. *k*-d *tree* [137]—Merits: adaptive, low storage cost. Drawbacks: bad performance when objects straddle cell boundaries.
—Deformable models.	*Octree* [91, 115]—Merits: fast construction times, low storage cost. Drawbacks: bad performance when many objects straddle cell boundaries.

In the following section, we discuss spatial data structures in which the set of objects in a model is partitioned rather than the space in which the objects are placed.

5.3 Model Partitioning

Model partitioning is often a better choice than space partitioning, since model partitioning structures do not suffer from the problem of having multiple references to the same object. The basic strategy is to subdivide a

set of objects into geometric coherent subsets and compute a tight-fitting bounding volume for each subset of objects, such that in intersection tests, subsets of objects can be quickly rejected from intersection testing depending on whether their bounding volumes overlap. In the following section we discuss a number of commonly used bounding-volume types.

5.3.1 Bounding Volumes

A bounding volume of a model is a primitive shape that encloses the model and has the following desired properties:

1. A bounding volume should fit the model as tightly as possible in order to have a low probability of a given query object intersecting the volume but not the model.

2. Overlap tests between bounding volumes should be computationally cheap. In particular, they should be much cheaper than intersection tests for the enclosed models.

3. A bounding volume should be representable using a relatively small amount of storage; thus, the amount of storage used by the bounding volume is preferably smaller than the storage used by the model.

4. The cost of computing a bounding volume for a given model should be low. This property is relevant only if the volume is recomputed regularly.

Examples of bounding-volume types are spheres, axis-aligned bounding boxes (AABBs), discrete-orientation polytopes (k-DOPs), and oriented bounding boxes (OBBs). We will briefly discuss the different volume types.

Bounding Spheres

Spheres are the simplest and one of the most commonly used bounding-volume types. A sphere can be stored using only four scalars. Testing a pair of spheres for intersection takes only 11 primitive operations (see page 67). For many shapes, spheres are not the most tightly fitting volume types. However, their simplicity and the fact that they are invariant under rotations make them a popular bounding-volume type in dynamic environments.

The problem of computing the smallest enclosing sphere of a set of points can be solved quite easily using a randomized algorithm [132]. Welzl shows that this algorithm runs in expected linear time.

However, as for other randomized algorithms [111], the expected amount of processing per point is quite large.

A reasonable approximation of the smallest enclosing sphere of a set of points can be computed using the following heuristic presented by Wu [134]. First, we apply multivariate analysis to find the principal axes of the distribution of the points. For each axis i, we find the extreme points—the points $\mathbf{p}_{min}^{(i)}$ and $\mathbf{p}_{max}^{(i)}$ for which the projection onto the axis is the minimum and maximum, respectively, of all points. We construct a tentative sphere whose diameter is the line segment connecting the points $\mathbf{p}_{min}^{(i)}$ and $\mathbf{p}_{max}^{(i)}$ for the axis i for which the distance between $\mathbf{p}_{min}^{(i)}$ and $\mathbf{p}_{max}^{(i)}$ is the largest. Next, for each point that is not yet contained by the tentative sphere, we expand the sphere such that it contains the vertex and the original sphere.

Axis-Aligned Bounding Boxes and k-DOPs

Even more widely used than spheres are axis-aligned bounding boxes (AABBs). Although they take up more storage than spheres (six scalars), AABBs can be tested faster for intersections (at most six primitive operations). For the average shape, the smallest AABB fits as badly as the smallest bounding sphere. By maintaining bounds for additional axes besides the three coordinate axis, we can create a volume that generally has a better fit than an AABB. The common name for such a volume is discrete-orientation polytopes or k-DOPs. Here, k is the number of axes over which bounds are stored. A k-DOP uses $2k$ scalars of storage and can be tested for intersection with another k-DOP in at most $2k$ primitive operations.

In contrast with spheres, AABBs and k-DOPs are not invariant under rotations. AABBs and k-DOPs are either recomputed whenever the enclosed object is rotated or set large enough so that the object can be enclosed in all possible orientations. Computing the smallest AABB or k-DOP for an object can be done reasonably fast. We simply compute the projection intervals of the object onto the axes and store for each axis the minimum and maximum value of these intervals.

The projection interval of a convex object onto an axis can be computed straightforwardly by using a support mapping. See page 130 for a discussion of support mappings. The projection of object A onto axis \mathbf{v} is the interval

$$[\mathbf{v} \cdot s_A(-\mathbf{v}), \mathbf{v} \cdot s_A(\mathbf{v})].$$

For an object A whose placement is given by an affine transformation $\mathbf{T}(\mathbf{x}) = \mathbf{B}\mathbf{x} + \mathbf{c}$, the computation of the AABB of $\mathbf{T}(A)$ with respect to

the standard (world) coordinate system can be further optimized. The projection of $\mathbf{T}(A)$ on coordinate axis \mathbf{e}_i is

$$[\mathbf{e}_i \cdot \mathbf{T}(s_A(-\mathbf{B}^T\mathbf{e}_i)), \mathbf{e}_i \cdot \mathbf{T}(s_A(\mathbf{B}^T\mathbf{e}_i))].$$

We see that the vector $\mathbf{B}^T\mathbf{e}_i = (\mathbf{e}_i^T\mathbf{B})^T$ is simply the ith row of \mathbf{B}. Furthermore,

$$\begin{aligned} \mathbf{e}_i \cdot \mathbf{T}(\mathbf{x}) &= \mathbf{e}_i \cdot \mathbf{B}\mathbf{x} + \mathbf{e}_i \cdot \mathbf{c} \\ &= \mathbf{b}_i \cdot \mathbf{x} + \gamma_i, \end{aligned}$$

where \mathbf{b}_i is the ith row of \mathbf{B} and γ_i is the ith component of \mathbf{c}. We can thus reduce the projection of $\mathbf{T}(A)$ onto coordinate axis \mathbf{e}_i to

$$[\mathbf{b}_i \cdot s_A(-\mathbf{b}_i) + \gamma_i, \mathbf{b}_i \cdot s_A(\mathbf{b}_i) + \gamma_i].$$

Since we have not made any special assumptions about matrix \mathbf{B}, this computation is valid for any type of transformation, including nonuniform scalings.

The smallest AABB of a nonconvex polyhedron is equal to the smallest AABB of its convex hull. So, for quickly computing the smallest AABB of a nonconvex polyhedron, we compute its convex hull as a preprocessing step and use a support mapping of the hull for computing the AABB. Again, we may exploit temporal coherence when evaluating support mappings by applying the hill-climbing technique discussed on page 132.

Oriented Bounding Boxes

Oriented bounding boxes (OBBs) are not the most economical bounding-volume types in terms of storage cost and cost of intersection testing. However, since they are for many shapes the most tight-fitting volume type, this high cost is often justified.

An OBB's orientation is represented by a 3×3 matrix, which defines a local basis with respect to the model's local coordinate system. Although representation in Euler angles or quaternions (see page 42) uses less storage space (3 versus 9 scalars), we prefer a matrix representation, since it is more efficient in intersection tests [59]. We test a pair of OBBs for intersection using the separating-axes test discussed on page 82. This test uses at most 200 primitive operations.

Finding the smallest OBB of a set of points is hard; however, we can get reasonably tight-fitting boxes by applying heuristics [134]. As for spheres,

Table 5.1 A comparison of a number of bounding-volume types. "Test" denotes the cost, in primitive operations, of testing a pair of volumes for intersection and does not include the cost of (re)computing the volume.

Volume	Fit	Test (operations)	Storage (scalars)
Sphere	poor	11	4
AABB	poor	≤ 6	6
k-DOP	fair	$\leq 2k$	$2k$
OBB	good	≤ 200 (cf. [59])	15

we first compute the principal axes of the distribution of the points using multivariate analysis. The principal axes are mutually orthogonal and can therefore serve as a local basis for rectangular boxes. This method results in tight-fitting boxes for many models; however, for some cases, such as the vertices of a cube, the returned orientations are quite bad.

Gottschalk [59] proposes a heuristic that uses axes based on the weighted spread of sample points on the surface of the convex hull of the set of points in order to get a tight fit for a wider range of models. Evidently, this method is more expensive, since a convex hull computation requires $O(n \log n)$ time for n points.

Table 5.1 shows an overview of the characteristics of the mentioned bounding-volume types. We see that a tighter fit is acquired at a higher cost of storage space and processing time for overlap testing. The choice of bounding volumes for a particular application depends on the shapes and complexities of the enclosed objects, as well as the densities of the objects in the space.

Case Study

Let us discuss a real-life example of the use of bounding volumes on the basis of the average time formula presented in Chapter 2. Recall that the average time of a sequence of intersection tests can be expressed as

$$T_{\text{avg}} = \sum_{i=1}^{n} P[f_1 \cdots f_{i-1}] C_i,$$

where f_i represents the event that test i fails, and C_i, the average time necessary for performing test i. A bounding volume overlap test fails iff the volumes overlap.

For this example, we use a model of a torus composed of a large number of triangles. The torus has a major radius of 10 and a minor radius of 2.

Table 5.2 Average performance of an intersection test on a pair of tori, using a single bounding-volume test. The value of "Cube size" is the length of the sides of the cube in which the centers of the tori are placed.

Bounding sphere		
Cube size	$P[f_{\text{sphere}}]$ (%)	T_{avg} (ops)
100	4.6	471
20	98.7	9881

OBB		
Cube size	$P[f_{\text{OBB}}]$ (%)	T_{avg} (ops)
100	4.1	610
20	86.9	8890

The test is performed by placing a pair of tori randomly in space and testing them for intersection. The tori have arbitrary orientations. The space size in which the tori are placed is determined by a cube in which the centers of the tori are randomly positioned. By scaling the cube the probability of an intersection can be tuned.

We first examine the use of a single bounding-volume test. The average time formula for such a test is given by

$$T_{\text{avg}} = C_{\text{volume}} + P[f_{\text{volume}}]C_{\text{torus}}.$$

The cost of testing a pair of tori for intersection, denoted here by C_{torus}, depends on the number of triangles, but should at its best be on the order of 10^4 operations for a torus composed of a hundred triangles, so for the sake of our discussion let us assume $C_{\text{torus}} = 10,000$ ops. Table 5.2 shows the average times over 100,000 runs for a bounding sphere and an OBB. The smallest sphere enclosing the torus has a radius of 12. The smallest OBB has a size of $24 \times 24 \times 4$. The cost of overlap testing can be found in Table 5.1 for both volume types. We see that for both bounding-volume types the use of the overlap test is justified, since the average time when using the volume is smaller than C_{torus} for the tested space sizes. Moreover, we see that the bounding spheres perform better than the OBBs when the density is low, whereas OBBs perform better for high densities.

Often, it makes sense to use a combination of bounding-volume types. A cheap, loose-fit volume type yields quick rejections of pairs of objects that are at some distance from each other, and a tighter, more expensive volume type is used for rejecting closer configurations of objects.

The average time formula for a test with two bounding-volume types is given by

$$T_{\text{avg}} = C_{\text{volume}_1} + P[f_{\text{volume}_1}]C_{\text{volume}_2} + P[f_{\text{volume}_1}f_{\text{volume}_2}]C_{\text{torus}}.$$

We examine this idea using OBBs as the tight-fitting volumes in the second bounding-volume test. For the choice of the first volume we have several options.

Our first option is to use a dynamic AABB enclosing the OBB. A dynamic AABB is recomputed for each placement of the torus. Although the smallest AABB enclosing the torus is usually smaller than the smallest AABB enclosing the OBB, we opt for the latter construction, since computing the smallest AABB of an OBB is much cheaper than computing the smallest AABB of the set of triangles that represents the torus. The smallest AABB enclosing an OBB can be computed using 24 operations. For this purpose, we compute the projections of the OBB onto the coordinate axes, which takes 8 operations for each axis, as we saw in Chapter 3. Hence, the total cost for performing an overlap test for a pair of AABBs is 2×24 operations for the AABB computations plus 6 operations for the actual overlap test, which makes a total of 54 operations. See Table 5.3 for the results of this experiment. Notice that this combined approach performs better than the bounding sphere only for the high-density case, and better than the single OBB only for the low-density case.

Table 5.3 Average performance when combining two bounding-volume types.

Dynamic AABB and OBB			
Space size	$P[f_{\text{AABB}}]$ (%)	$P[f_{\text{AABB}}f_{\text{OBB}}]$ (%)	T_{avg} (ops)
100	9.1	4.1	482
20	99.0	86.9	8942

Fixed-size AABB and OBB			
Space size	$P[f_{\text{AABB}}]$ (%)	$P[f_{\text{AABB}}f_{\text{OBB}}]$ (%)	T_{avg} (ops)
100	7.8	3.9	412
20	100	86.9	8896

Bounding sphere and OBB			
Space size	$P[f_{\text{sphere}}]$ (%)	$P[f_{\text{sphere}}f_{\text{OBB}}]$ (%)	T_{avg} (ops)
100	4.6	3.4	360
20	98.7	86.5	8858

Due to the recomputations, the cost of overlap testing for dynamic AABBs is high compared to the cost for fixed-size AABBs—AABBs that are set at a fixed size that is large enough to enclose the model in each configuration. An overlap test for fixed-size AABBs takes only 6 operations. Moreover, since the cost of computing the AABB is not an issue for fixed-size AABBs, we can use the smallest fixed-size AABB of the actual model rather than the smallest AABB of the model's OBB. For the torus we use a fixed-size AABB with sides of length 24. As can be seen in Table 5.3, the fixed-size AABB performs better than the dynamic AABB for both space sizes, even though the overlap test for fixed-size AABBs is wasted in the high-density case ($P[f_{AABB}] = 100\%$, since two cubes of size 24 placed such that their centers lie in a cube of size 20 always overlap).

Finally, we test a combination of a bounding sphere and an OBB. Table 5.3 shows that this is the best combination for our torus model. The sphere-OBB test shows the best performances for both space sizes of all the tests performed in this example. Also, notice that there are configurations of tori for which the bounding spheres do not overlap but the OBBs do overlap. This is shown by the fact that $P[f_{sphere}f_{OBB}] < P[f_{OBB}]$.

Generally speaking, bounding spheres yield in most cases better performance than fixed-size AABBs for intersection testing of objects that have three rotational degrees of freedom, since in this case, the smallest bounding sphere is enclosed by the smallest fixed-size AABB and, thus, is tighter than the AABB, whereas the cost of a sphere intersection test is only slightly higher than the cost of an AABB intersection test.

5.3.2 Bounding-Volume Hierarchies

We can "capture" geometric coherence in a model by means of a bounding-volume hierarchy. A bounding-volume hierarchy is a tree structure in which primitives are stored in the leaves. Each node maintains a bounding volume of the subset of primitives represented by the node. The bounding volumes of the children of a node may, and often do, overlap. Examples of bounding-volume hierarchies are sphere trees [73, 102], oriented-bounding-box (OBB) trees [59], and k-DOP trees [76, 135].

The benefits of using bounding-volume hierarchies are the fast query times for intersection testing and the linear space requirements with respect to the number of objects in the model. The major drawback is the high cost of constructing a bounding-volume hierarchy and maintaining a hierarchy under model changes. Therefore, bounding-volume hierarchies are generally used only for complex rigid models, for which construction is performed only once as a preprocessing step. Nevertheless, applications of bounding-volume hierarchies to collision detection among freely moving objects have been considered [130]. Further on, we will present an

application of AABB trees to collision detection between complex models undergoing deformation.

An intersection test between two models represented by bounding-volume hierarchies is performed by recursively testing pairs of nodes. The intersection test handles the following cases:

1. If the bounding volumes of the nodes do not intersect, then false is returned.

2. If both nodes are leaves, then the primitives are tested for intersection and the result of the test is returned.

3. If one of the nodes is a leaf and the other an internal node, then the leaf node is tested for intersection with each of the children of the internal node.

4. If both nodes are internal nodes, then the node with smaller volume is tested for intersection with the children of the node with the larger volume.

The latter heuristic choice of first unfolding the node whose volume is the largest results in the largest reduction of total volume size in the following bounding-volume tests, thus the lowest probability of following bounding-volume tests returning an intersection.

Note that we do not perform volume-primitive intersection tests. Volume-primitive tests are often as expensive as primitive-primitive tests and have a high probability of failure; that is, the chance of a volume-primitive test returning false under the assumption that the volume-volume test returned true is rather small. Hence, adding volume-primitive tests as a prestep in case 2 of the recursive intersection test is likely to worsen the performance, rather than improve it.

However, if the cost of a volume-primitive test is comparable to the cost of a volume-volume test, then it would make sense to introduce a separate case for leaf nodes that are tested against internal nodes and perform case 1 for internal nodes only. In this way, it is no longer necessary to maintain bounding volumes in leaf nodes, and thus we need only store half the number of volumes. Terdiman applies this technique in his OPCODE collision library for triangle meshes [124]. The triangle-box test can be performed roughly as fast as a box-box test using the separating-axes test discussed on page 81. This added case not only results in a lower memory footprint, but the higher accuracy of the triangle-box test also results in fewer nodes being visited and, thus, better performance.

For our performance analysis of bounding-volume hierarchies, we return to the initial intersection test that uses only volume-volume and primitive-primitive tests. The total cost of testing a pair of models

represented by bounding-volume hierarchies is expressed in the following cost function [59, 131]:

$$T_{total} = N_b * C_b + N_p * C_p,$$

where

T_{total} = the total cost of testing a pair of models,

N_b = the number of bounding-volume pairs tested for intersection,

C_b = the cost of testing a pair of bounding volumes for intersection,

N_p = the number of primitive pairs tested for intersection, and

C_p = the cost of testing a pair of primitives for intersection.

The parameters in the cost function that are affected by the type of bounding volume are N_b, N_p, and C_b. A tight-fitting bounding-volume type, such as the OBB, results in a low N_b and N_p, but has a relatively high C_b, whereas an AABB will result in more tests being performed, but the value of C_b will be lower.

5.3.3 AABB Trees versus OBB Trees

Let us compare the performance of AABB trees versus OBB trees. Both tree types are binary trees. They are constructed top-down, by recursive subdivision. At each recursion step, the smallest bounding box of the set of primitives is computed, and the set is split by ordering the primitives with respect to a well-chosen partitioning plane. This process continues until each subset contains one element. Thus, a bounding-box tree for a set of n primitives has n leaves and $n - 1$ internal nodes.

At each recursion step, we choose the partitioning plane orthogonal to the longest axis of the bounding box. In this way, we get a "fat" subdivision. In general, fat boxes (i.e., cubelike rather than oblong) yield better performance in intersection testing, since under the assumption that the boxes in a tree mutually overlap as little as possible, a given query box can overlap fewer fat boxes than thin boxes.

We position the partitioning plane along the longest axis by choosing δ, the offset on the longest axis where the partitioning plane intersects the axis. We then split the set of primitives into the negative and positive subsets that correspond with the respective halfspaces of the plane. A primitive is classified as positive if the midpoint of its projection onto the axis is greater than δ, and negative otherwise. Figure 5.9 shows a primitive that straddles the partitioning plane depicted by a dashed line.

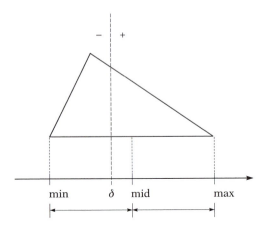

Figure 5.9 The primitive is classified as positive, since its midpoint on the coordinate axis is greater than δ.

This primitive is classified as positive. It can be seen that by using this subdivision method, the degree of overlap between the AABBs of the two subsets is kept small.

For choosing the partitioning coordinate δ we tried several heuristics. Our experiments with AABB trees for a number of polygonal models show that, in general, the best performance is achieved by simply choosing δ to be the midpoint of the AABB, thus splitting the box in two equal halves. Using this heuristic, it may take $O(n^2)$ time in the worst case to build an AABB tree for n primitives; however, in the average case, where the primitives are distributed more or less uniformly over the box, building an AABB tree takes only $O(n \log n)$ time.

Other heuristics we have tried that didn't perform as well are (1) subdividing the set of primitives into two sets of equal size, thus building an optimally balanced tree, and (2) building a halfbalanced tree—the larger subset is at most twice as large as the smaller one, and the overlap of the subsets' AABBs projected onto the longest axis is minimized.

Occasionally, it may occur that all primitives are classified to the same side of the plane. This will happen most frequently when the set of primitives contains only a few elements. In this case, we simply split the set into two subsets of (almost) equal size, disregarding the geometric location of the primitives.

Building an AABB tree of a given model is faster than building an OBB tree for that model, since the estimation of the best orientation of an OBB for a given set of primitives requires additional computations. We found that building an OBB tree takes about three times as much time as building an AABB tree.

Intersection Testing

Since for both tree types the boxes that are tested for intersection may be arbitrarily oriented, we need an overlap test for relatively oriented boxes. A fast overlap test for oriented boxes is the separating-axes test (SAT), presented by Gottschalk [59]. For a pair of oriented boxes, the SAT tests 15 potential separating axes (3 facet orientations per box plus 9 pairwise combinations of edge directions). The SAT exits as soon as a separating axis is found. If none of the 15 axes separate the boxes, then the boxes overlap.

We refer to page 82 for details on how the SAT is implemented such that it uses the least number of operations. For the following discussion, it is important to note that this implementation requires the relative orientation represented by a 3×3 matrix and its absolute value (i.e., the matrix of absolute values of matrix elements) to be computed before performing the 15 axes tests.

In general, testing two AABB trees for intersection requires more box overlap tests than testing two OBB trees of the same models, since the smallest AABB of a set of primitives is usually larger than the smallest OBB. However, since each tested pair of boxes of two OBB trees normally has a different relative orientation, the matrix operations for computing this orientation and its absolute value are repeated for each tested pair of boxes, whereas for AABB trees the relative orientation is the same for each tested pair of boxes, and thus needs to be computed only once. Therefore, the performance of an AABB tree might not be as bad as we would expect.

In order to compare the performances of the AABB tree and the OBB tree, we have conducted an experiment, in which a pair of models were placed randomly in a bounded space and tested for intersection. The random orientations of the models were generated using the method described by Shoemake [113]. The models were positioned by placing the origin of each model's local coordinate system randomly inside a cube. The probability of an intersection is tuned by changing the size of the cube. For all tests, the probability was set to approximately 60%.

For this experiment we used Gottschalk's RAPID package [58] for the OBB tree tests. For the AABB tree tests, we used a modified RAPID, in which we removed the unnecessary matrix operations. We experimented with three models: a torus composed of 5000 triangles, the Utah Teapot model composed of 3752 triangles, and the Bunny model (courtesy of the Stanford Computer Graphics Laboratory) composed of 69451 triangles, as shown in Figure 5.10. The Bunny model's vertices were translated by 0.1 down the y-axis in order to place the local origin inside the model. Each run performs 1,000,000 random placements and intersection tests, resulting in approximately 600,000 collisions for all tested models. An intersection test immediately terminates after detecting the first intersecting pair of triangles, and does not continue to search for other intersecting

(a) (b)

Figure 5.10 Two models that were used in our experiments: (a) Utah Teapot and (b) Stanford Bunny.

Table 5.4 Performance of the AABB tree versus the OBB tree, both using the SAT. N_b and N_p are, respectively, the total number of box and triangle intersection tests; C_b and C_p, the per-test times in microseconds for, respectively, the box and triangle intersection tests; $T_b = N_b * C_b$ is the total time in seconds spent testing for box intersections; $T_p = N_p * C_p$ is the total time used for triangle intersection tests; and finally T_{total} is the total time in seconds for performing 1,000,000 intersection tests.

OBB tree							
Model	N_b	C_b	T_b	N_p	C_p	T_p	T_{total}
Torus	100,971,773	0.53	53.57	1,946,006	1.56	3.03	56.6
Teapot	119,828,088	0.53	62.91	1,861,728	1.68	3.12	66.0
Bunny	180,084,565	0.54	97.35	1,349,839	1.97	2.66	100.0

AABB tree							
Model	N_b	C_b	T_b	N_p	C_p	T_p	T_{total}
Torus	451,627,619	0.29	133.06	37,173,201	0.54	20.02	153.1
Teapot	360,367,257	0.29	103.90	19,693,604	0.63	12.44	116.3
Bunny	506,440,438	0.30	153.51	14,135,544	0.74	10.49	164.0

pairs. Table 5.4 shows the results of the tests for both the OBB tree and the AABB tree. The tests were performed on an AMD Athlon clocked at 1.4 GHz with 512 MB of PC2100 (DDR266) memory, compiled using the GNU C++ compiler version 3.3 with "-O2" optimization, and run under Linux kernel version 2.4 (glibc version 2.3.2).

The results show that an AABB tree requires approximately three to four times as many box intersection tests as an OBB tree; however, the time used for intersection testing is in two cases only around 50% longer for AABB trees. The exception here is the torus model, for which the AABB

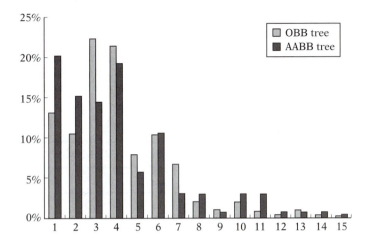

Figure 5.11 Distribution of axes on which the SAT exits in the case of the boxes being disjoint. Axes 1 to 6 correspond with the facet orientations of the boxes, and axes 7 to 15 correspond with the combinations of edge directions.

tree uses almost three times as much time as the OBB tree. Apparently, the OBB tree is able to fit this model much better than the AABB tree, which is probably due to the fact that the torus has a smooth surface composed of a regular grid of rectangular quadrilaterals. Furthermore, we observe that, due to its tighter fit, the OBB tree requires much fewer triangle intersection tests (less than two triangle intersection tests per placement).

For both tree types, the most time-consuming operation in the intersection test is the SAT, so let's see if there is room for improvement. We found that, in the case where the boxes are disjoint, the probability of the SAT exiting on an axis that corresponds with a pair of edge directions is about 15%. Figure 5.11 shows a distribution of the separating axes on which the SAT exits for tests with a high probability of the models intersecting. Moreover, for both the OBB and the AABB tree we found that about 60% of all box overlap tests resulted in a positive result. Thus, if we remove from the SAT the nine axis tests that correspond with the edge directions, we will get an incorrect result only 6% (40% of 15%) of the time.

Since the box overlap test is used for quick rejection of subsets of primitives, exact determination of a box overlap is not necessary. Using a box overlap test that returns more overlaps than there actually are results in more nodes being visited, and thus more box overlap and primitive intersection tests. Testing fewer axes in the SAT reduces the cost of a box overlap test, but increases the number of box and primitive pairs being tested. Apparently, when we use a SAT that tests fewer axes, there is a trade-off of per-test cost against number of tests.

In order to examine whether this trade-off is in favor of performance, we repeated the experiment using a SAT that tests only the six facet

Table 5.5 Performance of AABB tree versus OBB tree, both using the SAT lite.

			OBB tree				
Model	N_b	C_b	T_b	N_p	C_p	T_p	T_{total}
Torus	130,139,725	0.39	50.92	3,671,005	1.34	4.92	55.8
Teapot	143,540,360	0.39	56.62	2,794,760	1.27	3.56	60.2
Bunny	216,946,083	0.41	89.05	1,964,455	1.77	3.48	92.5
			AABB tree				
Model	N_b	C_b	T_b	N_p	C_p	T_p	T_{total}
Torus	547,995,855	0.18	99.58	48,685,371	0.51	25.05	124.6
Teapot	420,645,385	0.17	72.59	23,096,133	0.58	13.44	86.0
Bunny	589,819,356	0.19	111.92	16,755,783	0.71	11.96	123.9

orientations. We refer to this test as the *SAT lite*. The results of this experiment are shown in Table 5.5. We see a performance increase of about 25% for the AABB tree, whereas the change in performance for the OBB tree is only marginal.

We found that the AABB tree's performance benefits from a cheaper but sloppier box overlap test in all cases, whereas the OBB tree shows hardly any change in performance. This is explained by the higher cost of a box overlap test for the OBB tree due to extra matrix operations.

We see that despite our efforts to improve the performance of the intersection test for AABB trees, OBB trees still beat AABB trees on performance. However, the OBB tree's higher performance comes at the price of longer construction times and a larger memory footprint. Which of these qualities turns out to be the most important depends, of course, on the computer platform and application.

5.3.4 AABB Trees and Deformable Models

AABB trees lend themselves quite easily to speeding up collision detection of deformable models. In this context, a deformable model is a set of primitives in which the placements and shapes of the primitives within the model's local coordinate system change over time. A typical example of a deformable model is a triangle mesh in which the local coordinates of the vertices are time-dependent.

Instead of rebuilding the tree after a deformation, it is usually a lot faster to refit the boxes in the tree. The following property of AABBs allows an AABB tree to be refitted efficiently in a bottom-up manner. Let S be a

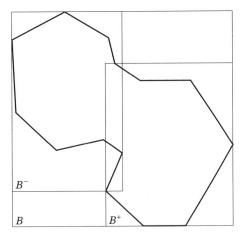

Figure 5.12 The smallest AABB of a set of primitives encloses the smallest AABBs of subsets of the set.

set of primitives and S^+, S^-, subsets of S such that $S^+ \cup S^- = S$, and let B^+ and B^- be the smallest AABBs of S^+ and S^-, respectively. Then, the smallest AABB enclosing $B^+ \cup B^-$ is also the smallest AABB of S. This property is illustrated in Figure 5.12. Of all bounding-volume types we have seen so far, AABBs share this property only with DOPs, and this property does not hold for OBBs.

This property of AABBs yields a straightforward method for refitting a hierarchy of AABBs after a deformation. First, the bounding boxes of the leaves are recomputed, after which each parent box is recomputed using the boxes of its children in a strict bottom-up order. This operation may be implemented as a postorder tree traversal; that is, for each internal node, the children are visited first, after which the bounding box is recomputed. However, in order to avoid the overhead of recursive function calls, we propose a different implementation.

Since the number of primitives in the model is static and known a priori, we are able to allocate the leaves and the internal nodes of an AABB tree as contiguous arrays of nodes. Furthermore, the tree is built such that each internal child node's index number in the array is greater than its parent's index number. In this way, the internal nodes are refitted properly by iterating over the array of internal nodes in reversed order. Since refitting an AABB takes constant time for both internal nodes and leaves, an AABB tree is refitted in time linear in the number of nodes. Refitting an AABB tree of a triangle mesh takes less than 48 arithmetic operations per triangle. Experiments have shown that for models composed of over 6000 triangles, refitting an AABB tree is about 10 times as fast as rebuilding it.

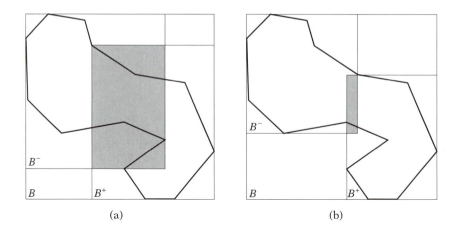

Figure 5.13 (a) Refitting versus (b) rebuilding a model after a deformation.

There is, however, a drawback to this method of refitting. Due to relative position changes of primitives in the model after a deformation, the boxes in a refitted tree may have a higher degree of overlap than the boxes in a rebuilt tree. Figure 5.13 illustrates this effect for the model in Figure 5.12. A higher degree of overlap of boxes in the tree results in more nodes being visited during an intersection test and, thus, worse performance for intersection testing.

We observe a higher degree of overlap among the boxes in a refitted tree mostly for radical deformations such as excessive twists, features blown out of proportion, or extreme forms of self-intersection. However, for deformations that keep the adjacency relation of triangles in a mesh intact (i.e., the mesh is not torn up), we found no significant performance deterioration for intersection testing, even for the more severe deformations. This is due to the fact that the degree of overlap increases mostly for the boxes that are maintained high in the tree, whereas most of the box-box tests are performed close to the leaves.

Refitting AABB trees of triangle meshes takes asymptotically 51 primitive operations per triangle (15 comparisons, 36 arithmetic operations). The question arises how the time used for refitting an AABB tree compares to the intersection testing time. We found that on our testing platform, refitting a triangle mesh takes roughly 0.6 microseconds per triangle. For instance, for our torus model composed of 5000 triangles, refitting takes 3 milliseconds, which is about 25 times the amount of time it takes to test two tori for intersection. Hence, refitting is likely to become the bottleneck if many of the models in a simulated environment are deformed and refitted in each frame. However, for environments with many moving

Table 5.6 Comparing the times for building, refitting, and testing. All times are in milliseconds.

Operation	Torus	Teapot	Bunny
Build an OBB tree	35.9	28.0	681
Build an AABB tree	6.1	5.0	192
Refit an AABB tree	3.1	2.4	50.2
Test a pair of OBB trees	0.06	0.06	0.10
Test a pair of AABB trees	0.12	0.09	0.12

models, in which only a few are deformed in each frame, refitting will not take much more time in total than intersection testing.

Table 5.6 presents an overview of the times we found for operations on the two tree types. We see that for deformable models the OBB's faster intersection test is not easily going to make up for the high cost of rebuilding the OBB tree, even if only a few of the models are deformed. For these cases, an AABB tree, which is refitted in less than 10% of the time it takes to rebuild an OBB tree, will yield better performance and is therefore the preferred method for collision detection of deformable models.

5.4 **Broad Phase**

Although bounding-volume tests are relatively cheap, testing all $\binom{n}{2}$ pairs in a collection of n bounding volumes still gives rise to a lot of computations. In the common case, where configurations of objects are geometrically coherent, only a small number of all pairs of bounding volumes are overlapping. Hence, an output-sensitive algorithm for finding all overlapping pairs of volumes should perform better than the naive $O(n^2)$ test-all-pairs algorithm.

An output-sensitive algorithm for reporting all overlapping pairs of AABBs has been presented by Six and Wood [114]. Their algorithm has a time complexity of $O(n \log^2 n + k)$, where n is the number of AABBs in the set and k is the number of overlapping pairs of boxes and requires $O(n \log^2 n)$ space. The algorithm applies a space-sweeping technique— that is, a plane orthogonal to a coordinate axis is swept from $-\infty$ to ∞ iterating over the coordinates that correspond with the extremes of the boxes. As the plane is swept, the intersections of boxes that are cut by the plane are maintained in data structures. The data structures used, a segment tree and a range tree [104], enable fast insertion, deletion, and query operations, such that a subquadratic time bound can be attained. A similar technique is applied in [69] for detecting intersections among n spheres.

5.4.1 **Sweep and Prune**

Algorithms that apply space-sweeping essentially have a worst-case lower time bound of $\Omega(n \log n)$ since it is necessary to sort the input with respect to a given coordinate axis. However, if frame coherence is high, the sorted sequence of box coordinates from a previous frame is likely to be nearly sorted in the current frame, in which case sorting will take only linear time using *insertion sort* [109]. Baraff exploits this idea in an incremental algorithm for maintaining the set of overlapping AABBs during a simulation [6]. In his approach, the endpoints of the intervals of projection of the boxes onto the three coordinate axes are maintained in three sorted sequences. Each endpoint maintains, besides its coordinate, also a reference to its box, and whether it is a lower or upper bound of the interval.

The ordering of endpoints is based on their coordinate. For endpoints that have the same coordinate, lower-bound endpoints precede upper-bound endpoints. In this way, adjacent intervals will be counted as overlapping.

In each frame, the coordinates of the endpoints are updated, and the three sequences are sorted using insertion sort. Insertion sort is performed as follows. Assume that the sequence is sorted up to a certain element. This element is found to be less than its predecessor, and has to be inserted in the segment of the sequence from the head up to the current location. Insertion is performed by swapping the element with its predecessor until an element is reached that is less than the current element. After the element is inserted, we continue sorting the remaining elements from the previous location of the inserted element. This process continues until we reach the end of the sequence.

When during a sort a lower-bound endpoint of one interval and an upper-bound endpoint of another interval are swapped, the intervals will either start or cease to overlap. Note that insertion sort performs swaps of adjacent elements only; thus the only intervals that may be affected by the swap are the ones that correspond with the swapped endpoints. Figure 5.14 illustrates how changes in overlap status of box intervals can be detected.

When a pair of intervals changes from nonoverlapping to overlapping, the corresponding pair of boxes is tested for overlap with respect to the other two coordinate axes. If the boxes overlap, then the pair is inserted in a set of overlapping pairs of boxes. When a pair of intervals ceases to overlap and the intervals of the corresponding boxes overlap with respect to the other two coordinate axes, the pair of boxes is removed from the set of overlapping pairs of boxes. In order to keep the times of insertions and deletions of pairs of boxes short, the set of overlapping box pairs is best implemented using a balanced binary-search tree (AVL tree, red-black tree) or a hash table [85].

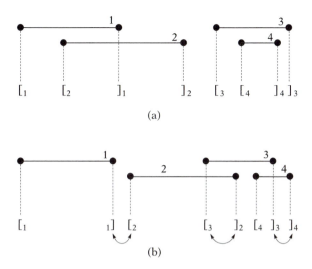

(a)

(b)

Figure 5.14 Incrementally sorting a sequence of endpoints: (a) $t = 0$ and (b) $t = 1$. Interval 2 moves and causes two swaps in the sequence of endpoints. The swap of $[_2$ and $]_1$ indicates that the intervals 1 and 2 cease to overlap. The swap of $[_2$ and $]_3$ indicates that the intervals 2 and 3 begin to overlap. The move of interval 4 causes a swap of $]_4$ and $]_3$. The overlap status of 3 and 4 does not change.

Each swap can be performed in constant time, except for the swaps that result in an insertion or deletion of a box pair. Insertions and deletions of box pairs take linear time in the worst case and roughly constant time on average for a set of box pairs represented by a hash table. Since a nearly sorted sequence can be sorted in linear time, we find that when frame coherence is high, the worst-case cost of updating the set of overlapping box pairs is $O(n + ck)$, where c is the total number of box pairs whose overlap status changed with respect to the previous frame.

Often, only a few of the boxes in a scene are moving at a given time. In order to exploit this, Baraff's sweep-and-prune algorithm can be adapted such that it enables update of the set of overlapping box pairs in linear time in the number of *moving* boxes. Instead of performing an insertion sort on the sequences of endpoints once for all endpoints, we propose an incremental approach in which insertions are performed immediately for each displaced endpoint.

Each time an endpoint is assigned a new position, the endpoint is immediately inserted at the correct location in the sequence. Unlike insertion sort, where insertions are only done downward, we allow insertions to be performed upward as well as downward. We are able to do this since both the segments of the sequence below and above the displaced endpoint are always sorted, whereas with insertion sort only the segment

below the current endpoint is sorted. In this way, the worst-case update time per frame is expected to be $O(m+ck)$ when frame coherence is high, where m is the number of moving boxes.

5.4.2 Implementing the Sweep-and-Prune Algorithm

Although the sweep-and-prune algorithm can be explained in simple terms, designing an efficient implementation of the algorithm cannot be dismissed as trivial. The performance of the sweep-and-prune algorithm is highly determined by the choice of data structure used for storing sequences of endpoints. This data structure needs to support the following operations:

- Insertion and deletion of endpoints, when boxes are created or destroyed.

- Displacement of endpoints, when boxes are moved. If the degree of frame coherence is high, then the displacements are expected to be relatively short.

For insertions and deletions of elements in a sorted sequence, the best time bounds are attained for balanced binary-search trees and hash tables [85]. However, these structures do not support displacements very well. Displacements are performed by a small number of swaps with adjacent endpoints, so it is important to have fast access to adjacent elements. Sequential structures, such as arrays and doubly linked lists, are better suited for performing swaps of adjacent elements. Since it is expected that, during a simulation, performance is mostly governed by displacements, the need for fast swaps is considered more important.

Insertions and deletion of elements in a sorted sequence take linear time for both arrays and doubly linked lists. However, on current computer architectures, arrays are likely to be faster. Current CPUs keep blocks of memory in cache, so it pays to organize data in contiguous blocks of memory. Inserting an element in a sorted array involves finding the location of the new element by binary search, and moving all elements from that location to the end of the array one location to the right. Memory blocks can be moved quickly using dedicated hardware. Inserting an element in a sorted doubly linked list involves a linear search on the list, and thus is likely to be slower. So, the preferred data structure for storing endpoints is an array.

In cases where we know a priori the maximum number of boxes in the simulated environment, we can allocate arrays that are large enough to store all endpoints. In other cases we can use dynamically resizeable

arrays. The Standard Template Library offers a C++ implementation of dynamically resizeable arrays in the form of the *vector* class [93].

Insertions and Deletions

Each time a box is inserted to or deleted from the scene, we have to add or remove the box pairs for the boxes that overlap the inserted or deleted box. In order to find all boxes that overlap a query box, we perform range queries on the set of intervals for each of the three coordinate axes. These range queries report all intervals that overlap the interval of the query box for that axis. A box overlaps the query box if for all three coordinate axes the corresponding interval is reported.

The intervals $[\alpha_i, \beta_i]$ that overlap a given query interval $[\alpha_q, \beta_q]$ can be categorized into two classes: either $\alpha_q < \alpha_i < \beta_q$ or $\alpha_i \le \alpha_q < \beta_i$. The first class of intervals can be found by iterating over the array from the location of α_q to the location of β_q. Reporting the second class requires iterating from the location of α_q to the start of the array.

Under the assumption that the set of intervals is geometrically coherent (i.e., it contains intervals that are relatively short and are distributed evenly), the first class of intervals does not pose too many problems. The number of endpoints enclosed by α_q and β_q is likely to be small. However, for the second class of intervals, things do not look as good. We have to iterate back over all endpoints from α_q to the start of the array and cannot exit early, since there is no way we can tell whether we are going to encounter any intervals of the second class while iterating. Thus, without any further knowledge, a range query would take linear time.

The solution to this problem is quite simple. With each endpoint, we maintain a counter containing its *stabbing number*—the number of lower-bound endpoints minus the number of upper-bound endpoints located to left of the endpoint. For each lower-bound endpoint, this stabbing number is equal to the number of intervals of the second class. In order to retrieve all second-class intervals for a query interval $[\alpha_q, \beta_q]$, we read the stabbing number n of the endpoint to the right of α_q, and iterate backward until we have found n second-class intervals. Since, for geometrically coherent sets of intervals, the stabbing number is fairly small, we probably do not have to iterate backwards over a lot of endpoints.

Updating stabbing numbers under the different operations does not take a lot of overhead. An insertion or deletion of an interval involves updating only the stabbing numbers of the endpoints in the array that are enclosed by the endpoints of the interval. Furthermore, swaps of endpoints affect only the stabbing numbers of the swapped endpoints. Figure 5.15 shows how the stabbing numbers change under different types of swaps.

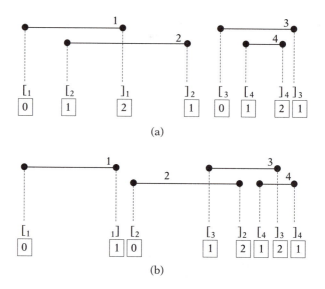

Figure 5.15 Each endpoint maintains a counter containing its stabbing number: (a) $t = 0$ and (b) $t = 1$. Swapping $[_2$ and $]_1$ results in a decrease of both counters by one. Swapping $[_2$ and $]_3$ results in an increase of both counters by one. Swapping $]_4$ and $]_3$ results in an exchange of counter values; that is, everything is swapped except the counters.

Box Structure

As mentioned, each endpoint maintains a reference to its corresponding box. This is necessary for testing the other two axes if the overlap status of a pair of boxes changes for one axis. Furthermore, whenever a pair of boxes starts or ceases to overlap, we need to update the set of overlapping pairs.

We also need a reference the other way around, from boxes to endpoints. If the bounds of a box are updated, then we need fast access to the corresponding endpoints in the three arrays in order to update the overlap status of the boxes. Furthermore, during range queries we need to retrieve the upper-bound endpoints corresponding with the lower-bound endpoints that are encountered.

These operations require us to maintain indices of the locations of the endpoints of each box. These indices have to be updated when endpoints are inserted, deleted, and swapped. In order to enable fast updates of these indices, each endpoint refers directly to its corresponding index, rather than maintain a reference to the box itself. The indices of endpoint locations are stored in a single array for all boxes. Each box owns a block of six indices in the index array. The endpoints refer to their indices by

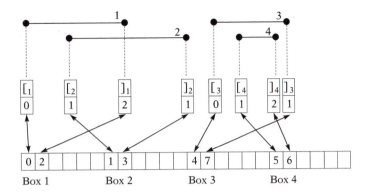

Figure 5.16 Indexing endpoints in box structures. Boxes maintain indices of locations in the endpoint arrays. Endpoints maintain indices of locations in the index array.

means of indices of locations in the index array. In this way, endpoints can refer implicitly to their box, since the index of the location in the index array divided by six yields the box index.

Furthermore, we make sure that the index structure of an upper-bound endpoint is allocated adjacent to the index structure of the corresponding lower-bound endpoint. This is convenient for retrieving the upper-bound endpoint corresponding with a lower-bound endpoint. Figure 5.16 shows an overview of the different references between box structures and endpoint arrays.

5.4.3 Ray Casting and AABBs

The structure we described above suits perfectly for performing ray queries on sets of AABBs [25]. Given a set of AABBs, three-dimensional space can be thought of as a nonuniform grid subdivided by axis-aligned planes that support the sides of the AABBs. By performing a grid traversal along the ray using 3D-DDA [2], we can detect all AABBs that intersect the ray (see Figure 5.17).

The first step is to locate the cell containing the source $\mathbf{s} = (\sigma_1, \sigma_2, \sigma_3)$ of the ray. This operation is similar to the insertion operation discussed on page 213. For each axis \mathbf{e}_i, we locate the leftmost endpoint greater than σ_i, read its stabbing number n, and retrieve all n intervals that contain this coordinate by iterating backwards.

The box indices corresponding to the reported intervals for the three coordinate axes are stored in a *multiset*—a set in which multiple instances of the same element may occur. Thus, for each reported interval an instance of the corresponding box index is inserted in the multiset.

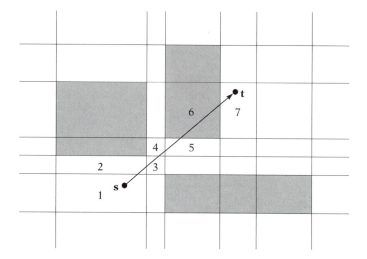

Figure 5.17 Ray casting AABBs using 3D-DDA on a nonuniform grid. The numbers indicate the order in which the cells are visited.

Any box for which three instances of its index are contained in the multiset must contain **s**, and thus is reported as one of the boxes that are hit by the ray.

The remaining boxes that are hit by the ray are found by applying 3D-DDA. Since we have located the cell that contains the ray's source, we can compute the plane in the grid that the ray hits first. Let $\mathbf{r} = (\rho_1, \rho_2, \rho_3)$ be the direction $\mathbf{t} - \mathbf{s}$ of the ray. For each coordinate axis \mathbf{e}_i, we compute the parameter λ_i for the point of intersection of the ray component and the next plane. If the sign of the direction component ρ_i is positive, then we take the upper bound of the current cell as plane coordinate δ. Otherwise, we take the lower bound as δ. The resulting parameter λ_i of the point of intersection is given by

$$\lambda_i = \frac{\delta - \sigma_i}{\rho_i}.$$

If the ray component is zero, or if the cell is not bounded in the direction of the ray, we return infinity.

The smallest of the three parameters λ_i corresponds with the cell bound that is hit first by the ray. If the direction component ρ_i is positive and the hit plane corresponds with a lower-bound endpoint, or if ρ_i is negative and the hit plane corresponds with an upper-bound endpoint, then the box index corresponding with this endpoint is added to the multiset. Otherwise, the box index is removed from the multiset. Again, if the multiplicity

of the added box in the multiset reaches three, the box is reported as being hit by the ray. Next, we proceed to the cell corresponding with the closest plane and compute a new parameter λ_i for this axis. This process is repeated until the smallest λ_i is greater than 1.

For ray casting we usually return only the object that is hit first. Since the AABBs in this algorithm are commonly used as bounding boxes for more complex shapes, the following modification may result in speedups for some applications. Rather than report all boxes that are hit by the ray, we can immediately start testing the enclosed shapes of the hit boxes using an exact ray cast. The smallest parameter λ_{exact} returned by an exact ray cast can then be used for tightening the stop criterion. As soon as the smallest λ_i of the three cell bounds is larger than the smallest λ_{exact}, we may exit, since the ray cannot hit any of the shapes enclosed by the remaining boxes before λ_{exact}. Care should be taken when applying this modification, since modern CPUs employ code cache, so executing different parts of code simultaneously may turn out to be slower than running the same code parts sequentially.

Chapter 6

Design of SOLID

Quote under construction.

—Gino van den Bergen

In this chapter we discuss the design of SOLID, a Software Library for Interference Detection. We discuss the goals and constraints involved in the design of SOLID and give a brief description of its functionality. The motivations behind major design decisions, and some implementation details are discussed. We evaluate the current version of SOLID with respect to the goals that were originally set out. Finally, we share some of the C++ coding details that we find worthwhile to mention.

6.1 Requirements

We set out in 1996 to design a general-purpose software library for collision detection in interactive 3D applications. At that time, continuous space-time collision tests of arbitrary objects were not considered to be feasible at interactive rates. So, we aimed at developing a library for intersection testing of complex environments at consecutive time intervals.

The library should provide a simple, yet versatile, interface to the application program. Furthermore, in order to reduce the calling overhead, the *application program interface* (API) should allow low-bandwidth data exchange between the application program and the library. We will further refer to the application program as the *client*.

Graphical rendering and collision detection are the two tasks[1] of a 3D engine that processes geometric objects. However, the manner in which geometric data is processed in these two tasks differs to a large extent. Rasterization hardware typically renders geometric objects represented

1. 3D sound modules, however, may also require geometric data for rendering reflection and occlusion of sound.

219

as triangle meshes. Triangle meshes are stored as strips or fans of adjacent triangles, such that they can be efficiently passed to and processed by the graphics library. In collision detection, we are not forced to use triangle meshes for modeling geometric objects. Furthermore, since usually only a few triangles at a time will be queried for collisions, there is less need for optimizing the processing of multiple triangles. Therefore, it does not seem sensible to use the same geometric representation for both rendering and collision detection.

Collision detection is performed in the animation loop, where the behavior of objects in a 3D environment is processed. In distributed 3D environments, the animation loop and rendering loop may be executed on different machines and can therefore not physically share the same data. So, early in the design of SOLID, we opted for the collision detection library to maintain its own internal representation of geometric objects, rather than to rely on the geometry representations that are used for rendering. This enables the application of faster data structures for collision queries at the cost of additional storage space. However, for data that can be shared between rendering and collision detection, the library should facilitate sharing.

We aimed at providing collision detection for all shapes and motions that can be described in VRML [10]. VRML was launched as a standard for describing interactive 3D content on the Web and, as such, the language seemed general enough to base our library on. The major issues that need to be addressed in order to achieve compliance with VRML are the following:

- Models are built using VRML primitive shapes, such as boxes, cones, cylinders, spheres, and complex shapes, represented by soups of points, line segments, and polygons.

- Objects are instances of shapes; that is, a shape may be used to instantiate multiple objects. This requirement captures the DEF/USE mechanism of VRML.

- The types of movement should be as general as possible. Mostly rigid motions (translations and rotations) are used, but also nonuniform scalings and deformations of complex shapes can be described in VRML. Nonuniform scalings enable us to use instances of the same shape at different dimensions and, less commonly, to change the scale of an animated object.

Keep in mind that VRML serves solely as a format for exchanging interactive 3D content in an open manner. It does not necessarily reflect the format in which content is stored and used internally in 3D graphics applications. VRML shapes are generally converted to a format that can

be processed faster by the 3D graphics library. However, since we want to keep a separate shape representation for collision detection, independent of the representation used for rendering, we might as well keep the format for collision shapes as universal as the underlying algorithms allow.

Furthermore, the library should allow the collision handling to be defined by the application program and should compute different types of response data depending on the needs of the application program. In particular, response data that is used for physics-based simulations, such as approximations of contact points and a contact plane, should be computed by the library.

Since the library should be able to perform within the limitations of current platforms for interactive 3D, we should also address issues such as performance, accuracy, storage usage, and versatility, which express quality, rather than functionality. The following design constraints determine the usefulness of the library for general purposes and received a lot of attention in the design:

- The library should perform collision detection of complex environments at interactive rates. In the early design of SOLID, around 1997, we aimed at a performance that would allow up to a hundred moving objects composed of thousands of primitives to be tested for collisions in less than 10 milliseconds on the high-performance computer platforms of that time. Since 1997, the processing power of computers has increased by an order of magnitude, so on current computer platforms this task should take less than 1 millisecond.

- The library should be able to detect collisions accurately. Thus, given a configuration of objects the library should return the pairs of objects that are actually intersecting. This requires that the library should be able to use the same shape types as used for rendering, and that the used algorithms for intersection testing are sufficiently accurate.

- The library should not use too much storage. What is considered "too much" depends largely on the constraints imposed by the target platform and application. As a rule of thumb we imposed that the amount of storage used by the library is asymptotically linear in the number of primitives in the shape representations, with a constant factor that should not exceed 100 bytes per primitive. Thus, a model composed of 10,000 polygons should fit in 1 megabyte of memory. Through the years, the complexity of simulated environments has grown faster than the available memory, so a reduction of the constant factor is up for discussion.

- The library should not impose constraints on the data structures that are used by the client. The client should be free in the choice of shape

representations used for the different tasks. In particular, the library should allow the client to choose a shape representation for collision detection that differs from the representation used for other tasks, such as rendering. This is useful for scaling down the accuracy of the collision detection in favor of the performance by using simpler shapes.

The lack of support for continuous space-time collision testing became painfully apparent in early applications. Detecting collisions too late or missing them altogether, as a result of intersection testing at sampled time intervals, is often highly undesired. So, in addition to static intersection testing, the library should offer support for detecting in-between-frames collisions.

6.2 Overview of SOLID

This section provides an overview of the SOLID framework. The motivations behind design decisions are discussed in Section 6.3.

SOLID is a true *software library*—a collection of functions that can be linked to and used by application programs. The functions are referred to as *commands*. The names and types of these commands, as well as the data types that are used as input and output for these commands, comprise the API. SOLID provides an API conforming to the C programming language, although the library itself is coded in C++. See the accompanying CD-ROM for a complete description of the commands and data types in the SOLID API. The commands of SOLID fall into five categories:

- *Shape definition and deformation:* Commands for defining and deforming shapes relative to a local coordinate system.

- *Object creation and motion:* An object is an instance of a shape. An object is placed or moved by setting or changing the placement of its local coordinate system.

- *Scene management:* A scene is a collection of objects on which a global collision query can be performed.

- *Response definition:* Collision handling is defined by the client by means of callback functions.

- *Global controls:* This category includes commands for controlling the global behavior of the library in terms of performance, storage usage, and precision.

SOLID maintains a separate shape representation for collision detection. Shapes are referred to by the client via handles to the internal shape

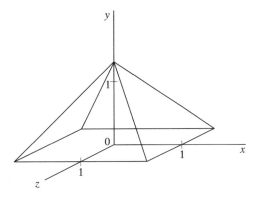

Figure 6.1 A pyramid relative to its local coordinate system.

structures maintained by **SOLID**. These handles are used exclusively as shape references; thus the client cannot access these structures. The shapes are built using commands similar to OpenGL. All commands and data types defined in the **SOLID** API are prefixed by "DT_". For instance, the pyramid in Figure 6.1 may be built in the following manner:

```
DT_ShapeHandle pyramid = DT_NewComplexShape();

DT_Begin();
DT_Vertex( 1.0f, 0.0f,  1.0f);
DT_Vertex(-1.0f, 0.0f,  1.0f);
DT_Vertex(-1.0f, 0.0f, -1.0f);
DT_Vertex( 1.0f, 0.0f, -1.0f);
DT_End();

DT_Begin();
DT_Vertex(-1.0f, 0.0f,  1.0f);
DT_Vertex( 1.0f, 0.0f,  1.0f);
DT_Vertex( 0.0f, 1.27f, 0.0f);
DT_End();

...
DT_EndComplexShape();
```

Thus, the pyramid shape is described by enumerating the vertices of its five facets. See the API reference on the accompanying CD-ROM for an overview of the different commands for specifying geometry.

The shape types currently supported by SOLID include primitive shapes, such as boxes, spheres, cones, and cylinders; convex polyhedra;

and complexes of simple polytopes. Here, a simple polytope is either a simplex or a convex polygon or polyhedron that has a small number of vertices (typically fewer than 10). No constraints with respect to the topology of polytopes in a complex shape are assumed. For instance, a set of polygons need not define a closed surface. We refer to complex shapes defined in this way as *polytope soups*, in accordance with the terminology used by Gottschalk [59].

An object is an instance of a shape placed relative to the world coordinate system. A shape may be used to instantiate multiple objects. Note that each object maintains a reference to a shape structure, rather than a copy of the shape representation. In this way, we mimic VRML's DEF/USE mechanism. The client refers to objects using handles to internal structures maintained by SOLID. Furthermore, each SOLID object maintains a void pointer to an associated structure maintained by the client. These pointers to client structures provide easy access to object-related data maintained by the client for collision handling in callback functions. We discuss the callback mechanism further on. Figure 6.2 shows a simplified diagram of the SOLID framework.

For the placement of objects, we use commands similar to the commands of OpenGL. However, unlike 3D rasterization, for which the geometries and placements of all visible objects is specified each frame, we have to specify only the placements of objects that are displaced with respect to the previous frame, since SOLID maintains an internal representation of each object's geometry and placement.

Objects are placed using translations, rotations, and nonuniform scalings of their local coordinate systems. Each transformation is defined relative to the world coordinate system. The following sample code demonstrates how objects are created and placed relative to the world coordinate system:

```
MyObject clientKhufuObject;

DT_Vector3 khufuPosition = {248.0f, 0.0f, 312.0f};
DT_Vector3 khufuScaling = {115.0f, 115.0f, 115.0f};

DT_ObjectHandle khufuHandle =
    DT_CreateObject(&clientKhufuObject, pyramid);

DT_SetPosition(khufuHandle, khufuPosition);
DT_SetScaling(khufuHandle, khufuScaling);
```

Unlike OpenGL, rotations are specified using quaternions, rather than axis-angle pairs. We discuss the benefits of quaternions over axis-angle pairs in Section 6.3.

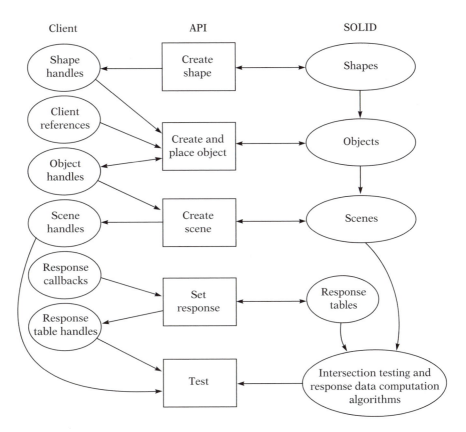

Figure 6.2 A diagram of the SOLID framework. Ellipses denote data structures, boxes denote API commands, and arrows denote data dependencies.

Objects can be expanded by Minkowski addition of an origin-centered sphere. Thus, the actual object used for collision detection is the set of points for which the distance to the transformed shape is at most the sphere's radius. In this context, the radius of the added sphere is called the *margin* of the object. By setting an object's margin to a positive value, we create rounded corners and edges on a sharp-edged shape, such as a box. Larger margins enable us to create "sensitive" regions around objects. Moreover, using small margins is advisable in cases where we need to compute penetration depths of slightly interpenetrating objects, since it enables faster and more robust penetration depth computation using Algorithm 4.11 on page 169.

Objects are managed in scenes. By managing objects in scenes, the client can conveniently perform collision queries for all objects at once. Also, scenes enable the exploitation of temporal coherence by maintaining

data from previous collision queries. Each scene maintains a list of pairs of possibly colliding objects. This list is updated each time an object is added, displaced, or removed. SOLID applies the sweep-and-prune algorithm discussed on page 210 for updating this list. For each pair of possibly colliding objects, SOLID caches data computed in previous collision queries. These cached data are reused in calls to incremental algorithms. For instance, ISA-GJK, discussed on page 145, reuses separating axes for speeding up intersection testing.

Collisions are handled by means of callback functions. A *callback function* is a function that is defined by the client and is called by the library for each pair of intersecting objects. Response callbacks are functions of the type

```
void (*)(void *client_data,
         void *client_object1,
         void *client_object2,
         const DT_CollData *coll_data)
```

Here, client_data is a pointer to an arbitrary structure maintained by the client. This structure corresponds with a specific response defined by the client. The client_object1 and client_object2 pointers refer to object-specific structures. They are passed to SOLID at the time of creation of an object. The coll_data pointer refers to response data computed by SOLID.

For example, a client that counts the number of times two given objects collide would use a callback similar to

```
void collide(void *client_data,
             void *client_object1,
             void *client_object2,
             const DT_CollData *coll_data)
(                 )
{
    ++(*(int *)client_data);
    printf("Object %d and %d collide \n",
           ((MyObject *)object1)->id,
           ((MyObject *)object2)->id);
}
```

Here, client_data points to the counter that tracks the number of collisions.

The type of response data that need to be computed by SOLID is specified by the response type. Currently, there are three response types:

1. *Simple response:* No additional response data is computed.

2. *Witnessed response:* An arbitrary common point is computed.

3. *Depth response:* A penetration depth vector and a pair of witness points of this vector are computed.

Thus, a response is defined by a callback function, a `client_data` pointer, and a response type. For each pair of objects that requires collision handling, we associate one or more responses.

Responses are managed in *response tables*. To each object on which a response is defined in a response table a *response class* is assigned. Responses are defined per pair of response classes, rather than per pair of objects. So, the response for a pair of objects is the response defined for their respective response classes. Multiple response tables can be used simultaneously. Each response table has its own range of response classes. A different response class can be assigned to an object for each of the response tables. The response class of an object can be changed or cleared during the lifetime of the object.

Responses can be defined per pair of response classes, for all pairs containing a given response class, or as a default response for all pairs of objects. For example, suppose we want to write a space game. The game involves spaceships, of which some are minesweepers, and mines. The rules of this game are as follows:

1. If two spaceships collide, then both sustain damage.

2. If a spaceship hits a mine, then the spaceship and the mine are both destroyed.

3. If a minesweeper hits (detects) a mine, then the mine is destroyed.

We may implement these events using the following responses:

1. Both objects sustain damage.

2. Both objects are destroyed.

3. The mine is destroyed.

Mines are considered static, so no responses need to be defined on pairs of mines.

As a default response we choose Response 1, which implements Rule 1. Rule 2 is implemented as class responses for mines using Response 2. Since we already defined Response 1 as a default response, we remove this response for the class of mines. Finally, we overrule the mine class response for pairs of mines and minesweepers by adding Response 3 and removing Response 2 for this pair of classes. We see that with SOLID's

response-handling mechanism different responses can be applied to different object pairs in a simple manner requiring little overhead.

The actual collision query is performed by the `DT_Test` command. This command takes a scene and a response table as argument, and calls response callbacks for all colliding pairs of objects for which a response is defined in the response table. The command returns the number of callbacks that have been called. Depending on the type of response data required, response data pertaining to the colliding object pairs are computed and passed to the callbacks as argument.

The use of scenes and the `DT_Test` command is not mandatory. SOLID also performs proximity queries directly on any pair of SOLID objects. For this purpose, we have the commands `DT_GetClosestPair` (for computing the distance and a pair of closest points), `DT_GetCommonPoint` (for intersection testing and computing a common point), and `DT_GetPenDepth` (for computing the penetration depth and witness points for the penetration depth). These commands are useful for tracking the distance between objects, or in response callbacks for checking the overlap status when manipulating object placements.

The algorithms for intersection testing and response data computation are maintained in a table, such that for each pair of shape types, one intersection test and some response data computation algorithms can be defined. In the current SOLID, the choice of algorithms is fixed and cannot be altered at run time by the client.

6.3 Design Decisions

In this section, we look at the motivations behind the main design decisions for SOLID. Here, we will have a closer look at the algorithms and data structures that are used.

6.3.1 Shape Representation

SOLID maintains internal shape representations for performing collision detection. Rather than sharing shape representations with other tasks such as rendering, we chose to keep the representations internal for the following reasons:

- Shape representations used for interactive graphics generally do not allow fast collision detection. Most graphics hardware currently used for interactive graphics renders shapes represented by polygon meshes. These polygonal data are represented in a form that enables low-bandwidth interfacing with and fast processing by the graphics library,

for instance, as strips or fans of triangles [133]. Meshes are basically processed as complete entities in each frame. For collision detection, only a small portion of a mesh needs to be processed for intersection testing in each frame. Spatial data structures, as described in Chapter 5, are used to get rid of most of the geometry early in the collision pipeline, and only a small fraction of the mesh data is tested for intersections. These data structures are constructed on top of the mesh data and take up the lion's share of storage required for the internal mesh representation.

■ A design in which the collision detection library uses shape representations that are maintained by the client inevitably imposes constraints on the client's choice of shape representation. Often these constraints are unacceptable, and the client is forced to maintain two separate shape representations for collision detection and rendering. For instance, applications may generate view-dependent mesh data on the fly by dynamically tessellating curved surfaces represented by Bézier patches or height maps. However, fast collision detection algorithms for polygon meshes often require the mesh data to be preprocessed, and thus rely on an explicit representation of the polygon mesh.

■ Graphics libraries can essentially render polygons only. However, for collision detection, it is possible and often desired to use exact representations of quadric shapes. For instance, in physics-based simulation, it is better to represent the wheels of a vehicle by cylinders rather than by polyhedra.

■ Clients should be free to choose different shape representations for rendering and collision detection. Often, less-accurate representations for collision detection are less disturbing than less-accurate visual representations. Trading shape complexity for performance is often desired in game programming.

■ In order to keep the bandwidth of data exchange between the client and the library narrow, the collision detection library should maintain its own shape representation. An API that supports a wide range of shape representation formats inevitably has a large overhead cost for adapting to the different formats.

■ By hiding the internal shape representation from the client, future changes in the data structures and algorithms used by the library do not result in compatibility issues.

In multiuser environments simulated across a network, consistent behavior of the environment for all users may be achieved by performing the simulations remotely on a single server. This server computes the new configuration of the environment globally for all users. For this purpose,

(a)

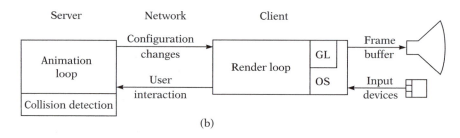

(b)

Figure 6.3 Two environment simulation architectures: (a) monolithic architecture and (b) networked architecture.

the server performs collision handling. The configuration changes computed by the server are sent to the individual users, where they are processed in order to update the local environment configuration maintained by the user. Each user renders the updated environment locally according to its own viewpoint and returns the user interactions to the server. Figure 6.3 shows a networked and a monolithic environment simulation architecture. Obviously, in multiuser applications, using separate shape representations for collision detection and rendering is a necessity rather than an option.

In single-user applications, however, maintaining two sets of geometric data seems rather wasteful. Notably, vertex data in polygon meshes takes up a lot of storage space and desirably should not be duplicated. Moreover, when using two sets of vertex data for deformable shapes, copying vertex data results in a performance penalty. Hence, in these cases, a shape representation that uses a single set of vertex data is more appropriate.

In order to cope with the conflicting demands regarding shape representations for rendering and collision detection, and still keep the vertex data maintained at a single storage location, we use the following storage method. We borrow a data structure used in graphics libraries, such as OpenGL, called a vertex array. A *vertex array*, as the name suggests, is a contiguous block of vertex data in which each vertex can be randomly accessed. Instead of storing the actual vertices in the primitives, we use

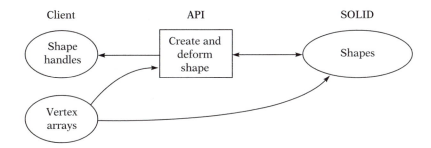

Figure 6.4 Vertex arrays are maintained by the client. SOLID may directly access data maintained in vertex arrays. API commands are used to pass or change the memory location of a vertex array to the shape representation used by the library.

array indices to refer to the vertices in the array. Since an integer uses less storage than a 3D vertex (4 versus 12 bytes, using 32-bit integers for indices, and 32-bit floating-point numbers for scalars), sharing vertex data saves a considerable amount of storage. Figure 6.4 illustrates the use of vertex arrays.

Moreover, vertex arrays allow easy interfacing of shape deformations, without the need for copying vertex data. Shape deformations may be specified in two ways: (1) the vertex data in the array of the shape are explicitly changed, after which SOLID is notified of the change, or (2) the current vertex array of the shape is replaced by a vertex array at a different address, that is, in a different block of memory. The latter method enables double buffering of vertex data, for instance, in parallel processed animation loops.

The use of vertex arrays seemingly conflicts with the requirement that the library should not impose constraints on the shape representation used by the client, and the requirement that the data exchange between the client and the collision detection library should be kept minimal. Regarding the first requirement, we note that flexible dereferencing methods, for instance as used in OpenGL [133], give the client quite a lot of freedom in arranging the vertex data in arrays. The client is free to choose any numerical format and spacing between the memory locations of the individual array items. Regarding the second requirement, we note that no copying of vertex data is necessary, since SOLID accesses the external vertex array directly, rather than keeping an internal copy of the vertex array.

SOLID uses bounding-volume hierarchies for speeding up collision queries on complex shapes. As discussed in Chapter 5, bounding-volume hierarchies result generally in the fastest query times of all spatial data structures for arbitrary meshes. As a bounding-volume type, SOLID uses bounding boxes that are aligned to the shape's local coordinate system. Although oriented bounding box (OBB) trees have been shown to be faster

than axis-aligned bounding box (AABB) trees, we chose the latter tree type for the following reasons:

- An AABB tree requires less storage than an OBB tree for the same model. An AABB uses 24 bytes (6 scalars), whereas an OBB uses 60 bytes (15 scalars). An OBB can be represented using only 40 bytes (10 scalars) if we represent its orientation by a unit quaternion, or even 36 bytes if we further leave out the scalar part of the quaternion. However, the less-compact representation of the orientation as a 3×3 matrix is preferred, since the performance penalty for converting quaternions to matrices is simply too high. Both tree types are binary trees and thus require $2n - 1$ nodes for n primitives. Each node in the tree stores a bounding box. Considering the fact that for triangle meshes, the per-triangle storage requirements are roughly 20 bytes (vertex data is shared among the triangles in a mesh), we see that the storage used by the tree structures takes up the larger part of the internal shape representations. Hence, for complex models the excessive storage usage of the OBB tree may turn out to be a problem. In these cases, the AABB tree, which has a more moderate storage usage, is preferred.

- OBB trees are not easily adapted to shape deformations. OBB trees need to be rebuilt whenever the shape they represent deforms. AABB trees, on the other hand, can quite easily be adapted to deformations, as discussed in Chapter 5. Refitting an AABB tree is roughly 30 times faster than rebuilding an OBB tree.

Since for intersection testing, AABB trees are not much slower than OBB trees, even for highly concave models at close proximity, we found the AABB tree to be the preferred spatial data structure for complex shapes. Moreover, AABB trees can be built faster than OBB trees, although this feature is not crucial since a bounding-volume tree is constructed once as a preprocessing stage. The construction of an AABB tree is performed automatically by SOLID and does not require instructions by the client. Experiments with different tree-building heuristics have shown that the trees constructed by SOLID are generally close to optimal; hence we consider it unlikely that any hints given by the client on how to perform the model partitioning will result in significantly faster trees.

On platforms that have a very limited amount of memory, such as game consoles, the large storage usage of bounding-volume hierarchies can be a problem. Fortunately, the memory footprint of an AABB tree can be further reduced by applying aggressive compression techniques [57]. Again, compressed data structures require additional processing for converting the bounding boxes to a representation that can be used in intersection tests. However, on platforms that are bound by memory-access bandwidth

rather than processing power, using compressed bounding-box trees may actually result in a performance increase [124].

6.3.2 Motion Specification

Except for shape deformations, motions are specified by changing the placement of the local coordinate system of an object relative to the world coordinate system. Most commonly used are rigid motions, which are composed of translations and rotations. We translate an object by changing the position of the local origin and rotate an object by changing the orientation of the local basis relative to the world coordinate system. Translations are specified using vectors; rotations are specified using quaternions.

Quaternions have some benefits over axis-angle orientation representations as used in popular graphics libraries [133]. Most notably, they enable smooth interpolation over a sequence of key orientations [112], and cheap and simple numerical integration. Furthermore, for computing an orthonormal basis whose orientation is given by an axis-angle tuple, we need to evaluate the sine and cosine of the angle, whereas computing a basis given by a quaternion requires only primitive arithmetic operations. Of course, transforming an axis-angle tuple to a quaternion involves sine and cosine evaluations.

The sin and cos functions included in the standard C library are computationally quite expensive. Quick and dirty sine/cosine evaluation using lookup tables is faster and may yield reasonable results for most applications. Because enforcing a specific sine/cosine routine deteriorates the versatility, we opt for quaternions instead of axis-angle tuples, since with quaternions calls to sine and cosine routines can be avoided in our library.

Besides rigid motions, we also support nonuniform scalings on the placement of local coordinate systems. Including scalings adds to the versatility of the library. Nonuniform scalings can be used for instantiating a single shape multiple times at different dimensions, and for animation effects such as shears and other deformations.

There is, however, a small performance penalty to be paid for allowing general affine transformation rather than restricting object placements to length-preserving transformations. Results of queries that rely on a metric given by the Euclidean distance, such as closest-point pair and penetration depth computation, depend on the coordinate system in which the queries are performed. If a local coordinate system is scaled nonuniformly with respect to the world coordinate system, then the closest points that are computed in the local coordinate system and transformed to the world coordinate system may not be equal to the closest points computed in the world coordinate system, as illustrated in Figure 6.5. The length of a vector

Figure 6.5 The closest points of a pair of objects in a given coordinate system may not be the closest points after scaling the coordinate system nonuniformly.

v given relative to a coordinate system that is nonuniformly scaled with respect to the world coordinate system is not $\sqrt{\mathbf{v}^\mathsf{T}\mathbf{v}}$. Phrased differently, the dot product is invariant under translations, rotations, and reflections only.

So, if we allow coordinate systems to be scaled, we need to transform coordinates to the world coordinate system before applying the distance metric. If we use length-preserving transformations only, however, we can use the same distance metric in all coordinate systems. In the latter case, we may choose the local coordinate system of one of the objects as the reference system, and thus have to transform only the other object's coordinates to the reference system. Allowing only length-preserving transformations saves us roughly half the number of coordinate transformations.

We did not decide to impose this restriction in favor of performance, since the portion of time spent transforming coordinates was not large enough to get a substantial gain in performance. Note that intersection testing and common-point computation do not rely on a distance metric, so in these queries we are still free to choose any coordinate system as a reference system.

Exploiting frame coherence is crucial for attaining a good performance in collision detection. Hence, we chose a method for specifying object placements that is persistent between frames. Only the object placements that have changed relative to the previous frame are specified in each frame. The static objects keep their placements from the previous frame.

SOLID does not provide a mechanism for handling transformation hierarchies, such as OpenGL's matrix stacks. The client should take care of computing the local-to-world transformations of each object in the scene. Usually, the graphics engine performs this task, so an internal transformation hierarchy maintained by the collision detection library would only result in duplicated computations.

Transformations computed by OpenGL can be used to specify object placements in SOLID. In OpenGL, affine transformations are represented by 4×4 matrices and are stored as arrays of 16 scalars in column-major order. Matrices can be loaded into, or multiplied with, the top matrix of the OpenGL model-view matrix stack. These matrices representing affine transformations can be used to place SOLID objects as well. In this

way, SOLID benefits from the computations performed for rendering. Moreover, consistency between the configuration of objects used by OpenGL and the configuration maintained by SOLID is established quite easily, since both libraries use identical object placements.

6.3.3 Response Handling

Callbacks provide an elegant mechanism for handling collision responses. A callback is a function that handles a specific event. In our case, the event is the collision of a pair of objects. Callbacks are defined by the client, but are not called directly by the client. Instead, a callback that handles the response for a pair of objects is called by the library when a collision is detected for the pair of objects. In event-driven systems, such as graphical user interfaces, the use of callbacks for handling all sorts of events is quite common. The idea of using callbacks for response handling in collision detection has been applied earlier by Zachmann [136].

Some response types require additional data pertaining to the configuration of the intersecting objects. These response data are computed by the library and are passed as arguments to the callback functions. Currently, SOLID supports two response data types. The first type is a pair of common points. The common points computed by SOLID for the pair of intersecting objects are, as the name suggests, common to both objects. However, they need not be equal. The reason for this freedom will become apparent further on. In our space game, for example, we might want to use a common point if the amount of damage a spaceship sustains depends on the location on its hull where the spaceship is hit.

The second response type is a pair of witness points of the penetration depth together with the penetration depth vector. A goal in the design was to provide response data that can be used for resolving collisions in physics-based simulations. For this purpose, we need to have an approximation of a pair of contact points and a contact plane of a pair of colliding objects. In Chapter 2 we saw that these data are best approximated using witness points of the penetration depth. The penetration depth vector is the shortest vector over which an object needs to be translated in order to bring the objects into touching contact. It therefore has to be orthogonal to the objects' surfaces (that is, if the surfaces are differentiable at the contact points), and thus can serve as a contact normal. Moreover, the witness points can be used as attachment points for the reaction forces or impulses that resolve the collision.

The assignment of responses to pairs of objects is managed in response tables. In SOLID, multiple response tables can be defined. Response tables are defined independently of the scenes in which they are used, so multiple response tables can be used in one scene and a response table can

be shared among multiple scenes. In this way, we achieve maximum flexibility using a simple interface.

This flexibility, however, comes at a price. In the broad phase, a list of potentially colliding object pairs is maintained. The scene's broad phase could benefit from information stored in the response table, since pairs of objects for which no response is defined need not be processed in the narrow phase and can thus be left out of the list of potentially colliding object pairs. In this way, the list can be shorter, and thus accessing it takes less time. However, since multiple response tables can be used with the same scene, object pairs cannot be discarded from the list.

In SOLID, the list of possibly colliding object pairs in a scene is implemented as a balanced binary search tree, for which access times are logarithmic in the number of pairs. So, the added overhead of maintaining a full list of object pairs should not be that high in comparison to a list from which the pairs that do not have an entry in the response table are pruned.

However, besides insertions and deletions, we also need to traverse the list of possibly colliding pairs for performing exact collision tests. Iterating over all entries in a balanced binary search tree is relatively expensive, since a tree traversal involves multiple pointer dereferences per entry. For large scenes, processing a complete list of object pairs thus takes somewhat longer, even though the pairs for which no entry is defined in the given response table are immediately rejected. Nevertheless, we decided to keep the extra flexibility in allowing multiple response tables per scene, since the performance loss turns out to be only minor for most applications.

Usually a scene contains classes of objects for which the same response needs to be defined. In order to accommodate assignment of responses to classes of objects, response tables manage responses defined on pairs of response classes rather than on pairs of objects. The required response classes are generated per response table and assigned to SOLID objects, so a SOLID object on which responses are defined in multiple response tables gets assigned a response class for each response table. The response class that is assigned to an object can be changed during the lifetime of the object to another response class of the response table. In this way, the collision response on an object can be changed without changing the response table.

On a pair of response classes, multiple responses can be defined. This enables us to manage responses to a single collision event into separate response callbacks. For instance, in our space game, we respond to a spaceship-spaceship collision by playing a sound and updating the amount of damage. Since the two responses have very little in common besides the fact that they are triggered by the same collision event, we might want to separate the play-sound code from the damage-update code, and write them as separate response callbacks.

Since the required response data type differs per response callback, we should compute response data for each of the callbacks defined on a pair of objects. However, if we let go of the restriction that common points should be identical, a pair of witness points of the penetration depth can serve as a pair of common points. We therefore compute only one response data type for object pairs on which multiple callbacks are defined. Thus, for a pair of objects on which both a common-point and a penetration depth callback is defined, we pass the witness points of the penetration depth as common points to the common-point callback.

The combination of using multiple response tables, in which multiple callbacks can be defined per pair of response classes, and allowing response class assignment to change during an object's lifetime gives us maximum flexibility in handling collisions for different tasks and stages of a 3D simulation system. Although we trade in some performance in exchange for this flexibility, the performance loss is only marginal and does not harm us too much.

6.3.4 Algorithms

In order to speed up the broad phase, SOLID maintains a list of object pairs whose bounding boxes overlap. This list is incrementally updated each time an object is moved, using the enhanced version of Baraff's incremental sweep-and-prune algorithm, as described on page 210. The update time per moved object for this algorithm is in the worst case $O(nk)$, for n objects and a list of k object pairs. However, when frame coherence is high, the update time per moved object is expected to be roughly constant.

The broad phase used by SOLID is linked as a separate library with its own abstract API. In this way, alternative broad-phase implementations can be used in combination with the narrow-phase library. Using a different broad phase is desirable if the degree of frame coherence is low or the library is used for single-shot interference detection.

Similar to the narrow-phase library, the broad-phase library supports multiple scenes. A scene maintains a collection of axis-aligned bounding boxes. The API offers commands to create, destroy, and update the boxes. Whenever a pair of boxes start or cease to overlap, the narrow-phase library is notified of this event via callback functions. The narrow-phase library provides callback functions that update the list of potentially intersecting object pairs.

As mentioned, the bounding boxes used in the incremental sweep-and-prune algorithm are aligned to the world coordinate system. An object's bounding box is recomputed each time the object is moved. The alternative choice of maintaining bounding boxes that have fixed dimensions is

not possible, since objects may also be scaled and deformed. For rigid objects, we can maintain fixed-size bounding boxes that are large enough to enclose the objects in any orientation. However, for most shape types, recomputing a bounding box is quite cheap and well worth the effort since dynamically updated axis-aligned bounding boxes are usually smaller than fixed-size bounding boxes and, thus, result in fewer entries in the list of possibly colliding object pairs.

The bounding boxes of primitive convex shapes, such as spheres or cones, can be straightforwardly computed. However, for complex shapes composed of thousands of primitives, computing the smallest enclosing box is a little more expensive. For such shapes we opt for a fast but sloppy solution. Recall that for complex shapes we maintain an AABB tree, which is aligned to the shape's local coordinate system. We take the smallest world-axes-aligned box that encloses the root box of the AABB tree as bounding box of a complex shape. Figure 6.6 illustrates this bounding box computation. As shown in Chapter 5, computing a bounding box of an oriented box takes only 24 arithmetic operations.

Computing the smallest AABB of a polytope soup can be done reasonably fast. As discussed on page 194, the bounding box of a convex object can be computed using support mappings. We saw that computing support points of convex polyhedra can be sped up by applying hill

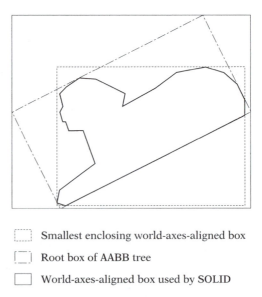

⌐¨¬ Smallest enclosing world-axes-aligned box

⌐⎺¬ Root box of AABB tree

□ World-axes-aligned box used by SOLID

Figure 6.6 Although it is usually larger in size, we use the world-axes-aligned bounding box of the AABB tree's root box rather than the smallest world-axes-aligned bounding box of a complex shape, since it can be computed much faster.

climbing over the vertex adjacency graph of the polyhedron. By caching support points for each of the six sides of the box, computing a bounding box of a preprocessed convex polyhedron takes roughly constant time when the degree of frame coherence is high.

Since the smallest AABB of a polytope soup is equal to the smallest AABB of its convex hull, we can compute the vertex adjacency graph of the convex hull of the polytope soup as a preprocessing step and use the convex hull for computing the AABB. This method is more expensive than the sloppy AABB computation method; however, it yields tighter-fitting boxes. Whether the extra effort in computing the bounding box is in favor of the performance depends on the application. Currently, SOLID supports only sloppy bounding-box computation for complex shapes.

The list of possibly colliding object pairs is processed in the narrow phase each time the test command is issued. Processing an object pair involves testing whether the objects intersect and, if so, computing the specified response data. The algorithms for intersection testing and for response data computation depend on the shape types of the objects in the pair. For instance, testing a sphere for intersection with a polygon soup requires a different algorithm than testing a sphere and a cone.

In C++, we can implement algorithms as a virtual method if the choice of algorithm depends on the dynamic type of only one of its parameters. However, in our case the algorithms depend on the dynamic types of two data types. This kind of dependency is commonly referred to as *double dispatch* in object-oriented programming [87]. Since C++ does not offer a straightforward double-dispatch construction, we chose to apply algorithm tables for implementing double dispatch.

An *algorithm table* is a mapping of pairs of shape types to function pointers. For instance, suppose all intersection testing algorithms are functions of the type

```
bool (*)(const Shape& a, const Shape& b);
```

Here, Shape is the base type of all shape types. Suppose we have the following function for testing the intersection of a convex and a complex shape:

```
bool intersect(const Convex& a, const Complex& b);
```

Then, the function returned by the algorithm table for the pair of shape types (CONVEX, COMPLEX) is the function given by

```
bool intersectConvexComplex(const Shape& a,
                            const Shape& b)
```

```
    {
      return intersect(static_cast<const Convex&>(a),
                       static_cast<const Complex&>(b));
    }
```

Note that we may safely cast objects of the base class Shape to the derived classes Convex and Complex using a static cast, since the types of the objects are checked by the algorithm table.

The *dynamic type* of an object—the type of the object at the time of creation—can be retrieved at run time using the C++ run-time type identification (RTTI) mechanism [120]. However, since the RTTI mechanism is not the most elegant solution—both in terms of performance and ease of use—and since it was not supported by most compilers at the time we developed SOLID, we chose to give each shape a type tag that is used to identify the shape's dynamic type.

SOLID currently supports two basic shape types: convex shape and complex shapes. The number of basic shape types can easily be increased for future extensions, if necessary. New shape types can be added by inserting new entries in the algorithm table. For each pair of shape types that contains the new shape type, we add an intersection testing and, for all response data types, a response data computation algorithm to the algorithm table.

The class of convex shapes is specialized into subclasses for spheres, boxes, cones, cylinders, and polytopes. The class of polytopes again is further specialized into simplices, convex polygons, and convex polyhedra. Complex shapes are representations of polytope soups. A complex shape maintains an AABB tree of the set of polytopes. Figure 6.7 shows a diagram of the hierarchy of shape classes used in SOLID.

We test pairs of convex shapes using ISA-GJK, a GJK-based incremental separating-axis computation algorithm discussed in Chapter 4 on page 146. The common-point response data type is also computed using ISA-GJK. The penetration depth is computed using the hybrid technique described on page 166.

Two complex shapes are tested for intersection using the AABB tree intersection test described in Chapter 5. Currently, we use ISA-GJK for testing pairs of polytopes also. For some polytope types, such as triangles, using a dedicated intersection test may be faster. However, polytope intersection tests take only a small portion of the time used for testing a pair of AABB trees, as we saw in Chapter 5. Hence, the loss of performance is not dramatic when a general approach is taken.

Finally, for testing a convex shape and a complex shape we apply the following technique. First, we compute a bounding box of the convex shape aligned to the local coordinate system of the complex shape. Overlap tests on aligned bounding boxes are cheap, thus, an AABB tree

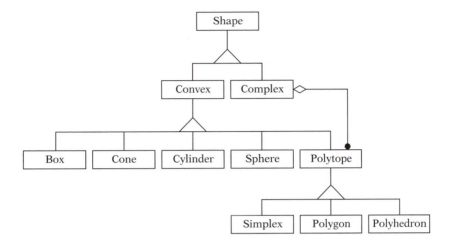

Figure 6.7 An OMT diagram of the class hierarchy of shape types used in SOLID.

can be quickly traversed depth-first, using the convex shape's bounding box as a query volume. On arriving at a leaf node, the polytope maintained in the leaf is tested for intersection with the convex shape and the result is returned. Again, we use GJK-based algorithms for primitive intersection testing and response data computation.

SOLID caches a separating axis for each disjoint object pair in the list of object pairs updated by the sweep-and-prune algorithm. This axis is used for initializing the ISA-GJK algorithm and the penetration depth algorithm. Separating axes are also cached for complex shapes. If multiple primitive pairs are tested during a traversal of the AABB tree, then all primitive tests share the same cached separating axis. Thus, a primitive intersection test that is performed after another primitive test uses the separating axis found by this earlier primitive test as an initial axis. If none of the primitive intersection tests results in an intersection, the last found separating axis is cached. In this way, coherence between the placements of consecutively tested primitives in a complex shape is exploited.

As previously mentioned, support point computation of objects that are represented by convex polyhedra can be speeded up by caching the last-found support point. For such objects we store the last-found support point per pair of objects in the list of object pairs. It is less profitable to cache the support point in the object itself, since the object may be tested for intersection with many other objects. Thus, for each occurrence of a convex polyhedron in the list of object pairs, the last-found support point is cached.

6.4 **Evaluation**

In this section we discuss the goals that were attained for SOLID. We also discuss some shortcomings that need to be addressed in future revisions.

One major goal was to provide collision detection for a wide variety of shapes and motions. At that time, VRML seemed to capture the modeling and animation practices that are common in interactive 3D graphics [10], so we set out to support an almost one-to-one mapping of VRML shapes to our collision shapes. We achieved compliance with VRML by incorporating the following features:

- Models can be built using boxes, cones, cylinders, spheres, and complexes of points, line segments, and convex polygons.

- Shapes can be instantiated multiple times. This feature captures VRML's DEF/USE mechanism.

- Object placement and motion are specified using translations, rotations, and nonuniform scalings of the object's local coordinate systems.

- Complex shapes can be deformed.

Note that we did not achieve full compliance, since VRML supports nonconvex polygons. However, this hardly poses a problem, since the bulk of polygonal models that are currently used in interactive 3D graphics are composed of convex polygons (triangles, in most cases). Moreover, code for decomposing a concave polygon into convex components (triangulation) can easily be obtained [94].

We found it useful also to include convex polyhedra in our set of collision shapes. In this way, we can trade accuracy for performance by using, instead of the actual mesh, the convex hull of a polygon mesh as the shape representation for collision detection. A convex hull representation uses far less storage and results generally in faster query times than its exact counterpart.

Thanks to GJK we are able to handle all convex shape types in a unified manner. As an added bonus, we are offered two powerful methods for constructing compound shapes out of arbitrary convex objects: Minkowski addition and convex hulls. Both construction methods can be used for detecting potential in-between-frames collisions. Let $\mathbf{T}_t(\mathbf{x}) = \mathbf{B}_t\mathbf{x} + \mathbf{c}_t$ be the placement of a convex object A at time $t = 0, 1$. Thus, $\mathbf{T}_t(A)$ is the object A at time t. Then, as an approximation of $\mathbf{T}_t(A)$ swept over $t \in [0, 1]$, we can use $\mathbf{B}_1(A) + \overline{\mathbf{c}_0, \mathbf{c}_1}$, the Minkowski sum of A at the orientation of $t = 1$ and the line segment from \mathbf{c}_0 to \mathbf{c}_1. Another approximation of the swept object A is $\mathrm{conv}\{\mathbf{T}_0(A), \mathbf{T}_1(A)\}$, the convex hull of the placements of A at $t = 0$ and $t = 1$. See Figure 6.8 for an illustration of the two constructions.

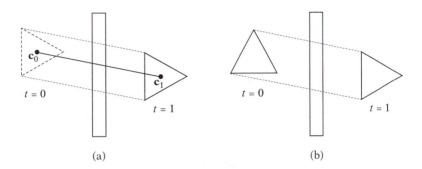

(a) (b)

Figure 6.8 Both Minkowski addition and convex hulls can be used for detecting in-between-frames collisions. (a) Minkowski sweep: Addition of the oriented object and a line segment connecting the positions at $t = 0$ and $t = 1$. (b) Convex hull sweep: Convex hull of the placements at $t = 0$ and $t = 1$.

As we saw in Chapter 4, GJK is capable of handling both types of swept objects.

With the current library we can detect intersections between swept objects in three-dimensional space. However, we saw on page 46 that we actually need an intersection test in continuous four-dimensional space (space-time) if we want accurate results and a time of collision for in-between-frames collisions. Currently, SOLID does not support four-dimensional intersection testing for general objects.

SOLID is capable of computing contact data for resolving collisions in physics-based simulation, although with some restrictions. These contact data of a pair of colliding objects are approximated by a penetration depth vector. A penetration depth vector does not always render a good representation of the contact point and normal at the first time of contact, as we saw on page 52. Furthermore, for complex shapes, SOLID may return multiple penetration depths for each of the intersecting pairs of primitives. These penetration depth vectors cannot be combined in a simple way into a single penetration depth vector for complex shapes. So, the physics solver should be capable of resolving multiple simultaneous contacts.

SOLID uses the ISA-GJK algorithm for testing intersections between any pair of convex primitives. This choice offers us the highest flexibility at a minimum of coding effort. However, for certain shape types, such as boxes and triangles, ISA-GJK may not be the fastest choice. Dedicated algorithms for these shape types may yield shorter times, albeit those primitive intersection tests take up only a small portion of the total collision processing time. For the sake of simplicity, we decided not to include dedicated algorithms for any pair of primitive shape types, although in applications where flexibility is of less importance than performance, the use of dedicated algorithms for these shape types may be preferable.

Performance-wise, SOLID does not do a bad job in comparison to other libraries [127, 128]. However, with respect to its memory usage, there is some room for improvement. SOLID's AABB-tree implementation uses roughly 64 bytes per primitive. Note that the severe memory constraints of game consoles have forced implementors to look for ways to reduce the memory footprint of AABB trees [57, 124].

6.5 Implementation Notes

This section is a collection of implementation details concerning the fundamental data structures used in SOLID. Here, we take the opportunity to evangelize on generic programming and the Standard Template Library (STL) [93].

6.5.1 Generic Data Types and Algorithms

Many of SOLID's container data types are implemented using template container classes from the STL. For instance, the set of possibly colliding object pairs is implemented as an STL set. The std::set and std::map container types are implemented as balanced binary search trees, which support logarithmic access and update times [77, 85].

As an example, we will show how the std::set is used. A possibly colliding object pair is called an *encounter* in the SOLID context. An encounter is an object of the following type:

```
struct Encounter {
    Encounter() {}
    Encounter(Index obj1, Index obj2);

    Index      m_obj1;
    Index      m_obj2;
    CachedData m_cached;
};
```

Here, m_obj1 and m_obj2 are indices of entries in the scene's object array, and m_cached is cached data from the previous collision query.

In order to store encounters in a std::set, we need to define an ordering on the Encounter class. Phrased differently, for each two encounters we need to be able to tell which one is "less than" than the other. The std::set needs this ordering in order to perform binary search on the set of encounters.

Encounters are unordered pairs of objects and are constructed such that m_obj1 is always less than m_obj2:

```
Encounter::Encounter(Index obj1, Index obj2)
{
    if (obj1 < obj2)
    {
        m_obj1 = obj1;
        m_obj2 = obj2;
    }
    else
    {
        m_obj1 = obj2;
        m_obj2 = obj1;
    }
}
```

Thus, encounters are uniquely identified by their index pairs. As "less than" operator on encounters we take the lexicographic order, which is implemented by overloading the "<" operator:

```
inline bool operator<(const Encounter& a,
                      const Encounter& b)
{
    return a.m_obj1 < b.m_obj1 ||
        (a.m_obj1 == b.m_obj1 && a.m_obj2 < b.m_obj2);
}
```

The list of encounters can now be constructed as an object of the following type:

```
typedef std::set<Encounter> EncounterList;
```

Entries can be added to and removed from the set using the methods insert and erase. In the narrow phase, each encounter in the scene's set is tested for exact intersections. We iterate over sets of encounters using STL iterators. An iterator is best viewed as a generalized pointer:

```
EncounterList::iterator it;

for (it = encounters.begin();
     it != encounters.end(); ++it)
{
    if (exactCollision(objects[(*it).m_obj1],
```

```
                    objects[(*it).m_obj2],
                    (*it).m_cached))
        {
           ++count;
        }
    }
}
```

Here, `objects` is the scene's object array.

The standard template container classes have proven to be very useful for implementing SOLID's container types. The benefit of using standard template classes over hand-coded classes is the fact that these classes are readily available without requiring coding and testing effort from the developer. Also, since all the STL container classes have similar interfaces, changing from one type of container to another is easy.

The use of STL template classes introduces hardly any performance penalty. Most template classes result in code that is as fast as the equivalent hand-coded classes. Moreover, when used properly, STL classes do not require significantly more storage than hand-coded classes would use.

Besides container classes, the STL also offers a number of template algorithms and functions, such as sort, copy, and search routines. We found the performance of these algorithms to be as good as hand-coded, and often better than the standard C library functions. In particular, sorting using the STL sort is significantly faster than using `qsort` from the standard C library.

However, there are some drawbacks to the use of the STL. Since all template code is inlined, executable code is generated for each type that instantiates a template function. Hence, an executable that is built from templates is likely to be larger in bytes of memory than a fully hand-coded executable. For SOLID, we managed to keep the total size of the library's executable code close to a modest 200 kilobytes; hence, code size was not a problem.

Another issue has to do with the software development process itself. For the developer a library should function as a black box, and should not expose too much of its internals to the application programmer. However, since templates offer functionality that still needs to be parsed by the compiler, improper use of templates in application programs usually results in compiler errors in the template code. These error messages often contain little information that can be of any help to the programmer.

Furthermore, since STL uses rather advanced template constructions, C++ compilers from a number of vendors currently fail to compile some STL constructions. As a result of this, STL implementations that are shipped with the current vendor's C++ compilers differ in the set of

supported types and constructions. With the adoption of the STL in the ISO/ANSI C++ standard [120], this problem is expected to be solved in the near future. A complete third-party multiplatform STL implementation is currently available for all major vendor C++ compilers under the name *STLport* [44].

6.5.2 Fundamental 3D Classes

The fundamental linear algebra classes for representing 3D vectors, points, quaternions, and 3×3 matrices that are used in SOLID were developed from scratch. It would have been desirable to use existing linear algebra classes for these data types, since implementation of these classes requires considerable effort and affects the performance of the library to a large extent. However, at the time we started to develop SOLID, no usable C++ linear algebra classes were freely available.

Similar to the STL, our 3D linear algebra classes have all their code inlined. We chose to use inline methods, since they allow better performance than explicitly called functions. Since these methods usually require only a few statements, the increase in executable code that results from using inline methods is insignificant. A number of operations, such as vector addition, scalar multiplication, and matrix operations, are denoted by overloaded operators such as + and *=. Overloading of elementary operations for algebraic types greatly enhances the readability of the code.

In SOLID, affine transformations are represented by instances of the `Transform` class. A `Transform` object contains a row-major 3×3 matrix as the linear component and a vector as the translational component. Affine transformations represent local coordinate systems. The columns of the matrix represent the basis axes and the vector represents the position of the origin relative to a reference coordinate system. We did not decide for a 4×4 matrix representation as used in OpenGL, since projections are not used in SOLID. In our case, the fourth row of a 4×4 matrix representation would always contain $(0, 0, 0, 1)$ and, thus, such a representation would result in unnecessary memory usage and computations.

The `Transform` class contains a method for mapping points from local to reference coordinates. In order to give a `Transform` object the appearance of a function, we chose to implement this method as a function operator. This function operator may be implemented in the following way:

```
Transform::operator()(const Point& p) const
    {
```

```
        return basis * p + origin;
}
```

and may be used as follows:

```
Point world = xform(local);
```

where `xform` is a `Transform` object, and `local` a point given in coordinates relative to the local coordinate system represented by `xform`.

Using the function operator in this way allows easy application of STL algorithms. For instance, an array `local_array` containing n points in local coordinates can be transformed to an array `world_array` in world coordinates using STL's `transform` algorithm in the following way:

```
std::transform(&local_array[0], &local_array[n],
              &world_array[0], xform);
```

These types of constructions are easy to program, easy to read, and result in fast code.

As a conclusion, we present some brief recommendations for developing code in C++ :

- Exploit the STL as much as possible. STL offers template container classes and algorithms that generally perform as well as your own hand-coded efforts.

- Operator overloading for fundamental types is useful, since it improves the readability of the code and allows easy interfacing with STL algorithms.

- In C++, it is OK to return objects. Code efficiency is not harmed by the construction of superfluous temporary objects, as long as there is a fair chance that the returned temporary is optimized out by the compiler. In this respect, it is preferable not to introduce a name for the resulting object, but to always return a constructor call [87]. For instance, compilers stand a better chance of eliminating the temporary returned by

```
inline Vector3 operator+(const Vector3& v1,
                         const Vector3& v2)
{
    return Vector3(v1[0] + v2[0],
                   v1[1] + v2[1],
                   v1[2] + v2[2]);
}
```

than the temporary returned by

```
inline Vector3 operator+(const Vector3& v1,
                         const Vector3& v2)
{
    Vector3 result;
    result.setValue(v1[0] + v2[0],
                    v1[1] + v2[1],
                    v1[2] + v2[2]);
    return result;
}
```

In order to facilitate return value optimization, you should make sure that the value type has the proper constructors for creating return values.

- Short functions are best inlined, since the overhead of explicit function calls deteriorates performance. However, do not overdo inlining. If the overhead of a function call is small in comparison with the operations performed by the function, inlining yields little performance gain and increases the size of the executable code if the function is called from multiple places in the code. Moreover, inlining forces us to expose class implementation details in header files, thus creating dependencies between source files.

Chapter 7

Conclusion

A movement is accomplished in six stages,
and the seventh brings return.
— **Syd Barrett**

In this final chapter we summarize the state of the art in 3D collision detection and present some pointers to new trends and interesting topics for future work.

7.1 State of the Art

Our research on collision detection methods was mostly motivated by the development of SOLID. The development of SOLID started in 1996, when interactive 3D graphics on personal computers was starting to take form with the arrival of 3D graphics accelerators. At that time, processing power for animation and collision detection was still limited; however, the use of graphics accelerators for rasterization enabled us to free up more processing time for animation tasks.

This notion sparked the idea that exact collision detection for complex scenes should be possible at interactive rates. Our goal was to develop a general-purpose collision detection library for performing exact collision detection in interactive 3D applications. We targeted the application domain of SOLID at environments that can be described in VRML [10]. VRML emerged as the standard file format for interactive 3D environments on the Web and supports description formats for the most commonly used geometric modeling techniques.

To this date, the building blocks for constructing 3D environments have changed little. Geometric models are still mainly polygonal, although the complexity of current models has grown with the increase of the processing power of CPUs and graphics accelerators. 3D environments, however, have become more and more dynamic. Advanced animation techniques, such as skinned meshes and other types of mesh deformation, have found a place in interactive 3D graphics applications. Uses of parametric

251

surfaces, implicit surfaces, and constructive solid geometry for animation, in combination with dynamic surface tessellation, are finding their way into interactive 3D graphics. These developments have complicated the task of performing exact collision detection and will demand our attention in further developing collision detection methods.

In the last decade, algorithms for collision detection of convex objects have received much attention in research. Convex objects allow easy exploitation of frame coherence by caching separating axes or closest-feature pairs. Since animated environments usually have a high degree of frame coherence, algorithms that exploit frame coherence take little processing time per frame and are therefore ideal for interactive applications.

Currently, algorithms for incremental collision detection of convex objects are based on either the Lin-Canny closest-feature tracking algorithm or the GJK distance algorithm. In this book, GJK receives our main attention, since it excels in versatility, being applicable to general convex objects.

Since algorithms for convex polyhedra are a lot faster than algorithms for general nonconvex polyhedra, it makes sense to decompose concave polyhedra into (possibly overlapping) convex pieces. Convex decomposition of concave polyhedra is still an ongoing research topic. Recently, a technique for decomposing polyhedral surfaces has been published [21]. Since convex decomposition of a polyhedral surface is easier than convex decomposition of a polyhedral solid and does not result in as many convex pieces, this technique is found to be more useful for proximity queries [41].

The increase in the processing power of current computers has enabled us to perform physics simulations at interactive rates. Interactive physics, provided by software libraries such as Karma [82], Havok [65], and the Open Dynamics Engine (ODE) [116], is now applied in 3D games. In order to resolve collisions in a physically correct way, the physics engine has to rely on accurately computed collision times and contact points and normals. Approximate contact information can be derived from the penetration depth vector of a pair of intersecting objects, as discussed in Chapter 2. However, such an approach may turn out to be less robust due to sampling artifacts in collision detection of object configurations at discrete time steps. Physics-based simulation asks for a continuous four-dimensional space-time approach. In the last few years, continuous collision detection at interactive rates has become feasible on current mainstream hardware platforms [105].

For complex environments composed of a large number of objects, the cost of collision detection can be reduced by exploiting geometric coherence. We discern two types of problems: (1) finding all intersecting pairs of objects among freely moving objects, the so-called broad phase,

and (2) finding all intersecting pairs of primitives of two complex shapes composed of thousands of primitives.

For the broad phase, the incremental sweep-and-prune scheme by Baraff is most commonly used [6]. This scheme involves maintaining a list of pairs of objects whose world-axes-aligned bounding volumes overlap by sorting the endpoints of the boxes along the three coordinate axes.

For the second problem, the oriented-bounding box (OBB) tree by Gottschalk is currently the fastest data structure available. However, the axis-aligned-bounding-box (AABB) tree, as described in this book, is not a lot slower and takes roughly half as much storage as an OBB tree. Another significant benefit of AABB trees over OBB trees concerns shape deformations. In Chapter 5 we presented a fast method for updating an AABB tree after a shape deformation. Updating an OBB tree after a shape deformation is more complex and involves reconstructing the tree for the deformed shape.

Storage overhead used by bounding-volume hierarchies quickly becomes a problem when the number of primitives in a model increases. Using single-precision floating-point numbers, an AABB tree still takes around 64 additional bytes per primitive. New developments aimed at compressing the storage usage of bounding-volume hierarchies have yielded considerable reductions. Gomez [57] describes techniques that can be used to reduce the memory footprint of an AABB tree to 11 bytes per primitive.

7.2 Future Work

The beauty of working in the field of interactive 3D computer graphics is that it continues to innovate at a fast pace. Faster hardware offers more possibilities for applications and new challenges in developing solutions for simulated 3D environments. As a result of this, the work on collision detection algorithms is never done. In this section, we discuss a number of interesting research topics that may be addressed in future work.

Implicit surfaces, parametric surfaces (NURBs, Bézier patches), and constructive solid geometry (CSG) are popular shape representations in geometric modeling. The rendering of these shape representations at interactive rates using current graphics hardware requires a (possibly dynamic) translation to tessellated surfaces. However, for the purpose of collision detection, implicit surfaces, parametric surfaces, and CSG representations may in some cases be more suitable than polyhedral surfaces. For instance, they enable smoother and less memory-consuming shape representations. We expect that the focus of collision detection algorithms will gradually shift from polyhedral surfaces to these implicit shape types.

In general, OBB trees yield the best performance of all bounding-volume hierarchies currently used for testing intersections between complex shapes. It shows that the relatively high cost of testing a pair of OBBs for overlap is largely made up for by its tighter fit. In this respect, it may be a good idea to take this one step further. The convex hull of a set of polytopes is in general smaller than the smallest OBB of the set. However, the cost of testing a pair of convex hulls for overlap is considerably higher than for OBBs. If the cost of testing a pair of convex hulls for overlap is sufficiently small, a hierarchy of convex hulls for a set of polytopes might perform better than an OBB tree.

The cost of overlap testing for convex hulls may be reduced by exploiting coherence. For instance, by exploiting frame coherence, we can reduce the cost of each overlap test to almost constant time, as described in Chapter 4. Moreover, overlap tests on the child hulls of an internal node may repeat some of the computations performed for overlap tests on the parent node's convex hull. For instance, in GJK, the same support points will often be computed for both the parent and the child hulls. Hence, by caching and reusing these computed values, we may speed up hull tests for the child nodes if the hull test for the parent node fails.

Using convex hulls as bounding volumes in volume hierarchies seems promising. However, in order to exploit the different types of coherence, intricate data structures and algorithms are needed. Altogether, we reckon convex hull hierarchies to be well worth examining further.

Further, we would like to hint at a topic that has received a lot of attention in the graphics community lately, namely, the use of progressive mesh representations for smooth level of detail [70]. Smooth level of detail is mostly used for rendering complex terrains. A *progressive mesh* representation is a way of storing triangle meshes that allows selective refinement of parts of the mesh. This is useful in interactive graphics, since it allows maintaining in memory at a given time only those parts of a shape that are actually rendered. This results in higher rendering performance, since fewer triangles need to be processed, and lower memory usage.

Storage usage is also critical for mesh representations used for collision detection. However, unlike rendering, the mesh should have its finest detail in areas where the interaction takes place in collision detection. Progressive mesh representations of complex models may be an interesting research topic in the context of collision detection as well. For this purpose, the progressive mesh representation should include a description of the bounding-volume hierarchy used for speeding up intersection testing. Given such a progressive bounding-volume hierarchy, the bounding volumes that are traversed during an intersection test can be generated on the fly. Whenever a bounding volume test fails (i.e., does not result in an early rejection), the bounding volumes of the child nodes are generated and tested. By caching the generated bounding volumes and removing the

ones that are no longer interesting, the bounding-volume hierarchy of a mesh can be kept small. In this way, a limited amount of memory is used to store a mesh, so complex meshes can be used for collision detection without sacrificing too much performance.

Continuous four-dimensional space-time collision detection is the latest trend in interactive physics-based simulation of rigid bodies [105]. Here, the trajectories of points on a rigid body over a time interval are represented by parametric curves. For polyhedral surfaces, the actual time of collision, as well as the contact points and normal, can be determined by algebraically solving systems of polynomial equations. Similar approaches may be applied as well to quadric objects, such as ellipsoids, cones, and cylinders. However, for more complex shapes, such as Minkowski sums of convex objects, such an approach is no longer feasible.

A reasonable compromise between reliability and ease of computation is obtained by sweeping only the positions of the rigid bodies in space-time while keeping the orientations constant over the time interval. As we saw in Chapter 2, such a swept four-dimensional intersection test boils down to a ray cast on the CSO of the queried objects. For a limited number of primitive types, the CSO can be represented explicitly. For instance, the CSO of two spheres is itself a sphere. However, for most pairs of shape types, an explicit representation of the CSO is difficult to obtain. These cases beg for a ray-cast algorithm that relies solely on support mappings, similar to the GJK distance algorithm. Such an algorithm would be extremely powerful since it is applicable to any convex shape you can think of, including Minkowski sums of convex objects. Finding an iterative method for performing a ray cast on a convex object given by a support mapping still remains a challenge for the future.

Bibliography

[1] J. Amanatides and K. Choi. Ray tracing triangular meshes. In *Proc. 8th Western Computer Graphics Symposium*, pages 43–52, 1997.

[2] J. Amanatides and A. Woo. A fast voxel traversal algorithm for ray tracing. In *Proc. Eurographics '87*, pages 3–10, 1987.

[3] C. Bajaj and T. K. Dey. Convex decomposition of polyhedra and robustness. *SIAM Journal on Computing*, 21:339–364, 1992.

[4] D. Baraff. Analytical methods for dynamic simulation of non-penetrating rigid bodies. In *Proc. SIGGRAPH '89*, volume 23, pages 223–232, 1989.

[5] D. Baraff. Curved surfaces and coherence for non-penetrating rigid body simulation. In *Proc. SIGGRAPH '90*, volume 24, pages 19–28, 1990.

[6] D. Baraff. *Dynamic Simulation of Non-Penetrating Rigid Bodies*. PhD thesis, Computer Science Department, Cornell University, 1992. Technical Report 92-1275.

[7] C. B. Barber, D. P. Dobkin, and H. Huhdanpaa. The Quickhull algorithm for convex hull. *ACM Transactions on Mathematical Software*, 22:469–483, 1996.

[8] C. B. Barber and H. Huhdanpaa. Home page for qhull. *http://www.geom.umn.edu/software/qhull/*, 1995. Software library.

[9] B. G. Baumgart. A polyhedron representation for computer vision. In *Proc. AFIPS National Computer Conference*, volume 44, pages 589–596, 1975.

[10] G. Bell, R. Carey, and C. Marrin. VRML97: The Virtual Reality Modeling Language. *http://www.vrml.org/Specifications/VRML97*, 1997.

[11] J. F. Blinn. A trip down the graphics pipeline: Line clipping. *IEEE Computer Graphics and Applications*, 11(1):98–105, 1991.

[12] J. W. Boyse. Interference detection among solids and surfaces. *Communications of the ACM*, 22:3–9, 1979.

[13] S. Cameron. A study of the clash detection problem in robotics. In *Proc. IEEE International Conference on Robotics and Automation*, pages 488–493, 1985.

[14] S. Cameron. Collision detection by four-dimensional intersection testing. *IEEE Transactions on Robotics and Automation*, 6(3):291–302, 1990.

[15] S. Cameron. Enhancing GJK: Computing minimum and penetration distances between convex polyhedra. In *Proc. IEEE International Conference on Robotics and Automation*, pages 3112–3117, 1997.

[16] S. A. Cameron and R. K. Culley. Determining the minimum translational distance between convex polyhedra. In *Proc. IEEE International Conference on Robotics and Automation*, pages 591–596, 1986.

[17] J. Canny. Collision detection for moving polyhedra. *IEEE Transactions on Pattern Analysis and Machine Intelligence*, PAMI-8(2):200–209, 1986.

[18] J. Carmack and M. Abrash. Quake source. *http://www.idsoftware.com/business/home/techdownloads/*, 1997.

[19] F. Cazals and C. Puech. Bucket-like space partitioning data structures with applications to ray-tracing. In *Proc. 13th Annual ACM Symposium on Computational Geometry*, pages 11–20, 1997.

[20] B. Chazelle. Convex partitions of polyhedra: A lower bound and worst-case optimal algorithm. *SIAM Journal on Computing*, 13:488–507, 1984.

[21] B. Chazelle. Decomposing the boundary of a nonconvex polyhedron. *Algorithmica*, 17:327–342, 1997.

[22] B. Chazelle and D. P. Dobkin. Detection is easier than computation. In *Proc. 12th Annual ACM Symposium on Theory of Computing*, pages 146–153, 1980.

[23] K. Chung and W. Wang. Quick collision detection of polytopes in virtual environments. In *Proc. ACM Symposium on Virtual Reality Software and Technology*, pages 125–131, 1996.

[24] J. D. Cohen, M. C. Lin, D. Manocha, and M. K. Ponamgi. I-COLLIDE: An interactive and exact collision detection system for large-scale environments. In *Proc. ACM Symposium on Interactive 3D Graphics*, pages 189–196, 1995.

[25] E. Coumans. 3D-DDA on a dynamic grid. Posted on the *comp. graphics.algorithms* newsgroup, Feb. 2003.

[26] H. S. M. Coxeter. *Introduction to Geometry*. Wiley, New York, 2nd edition, 1989.

[27] M. de Berg. Linear size binary space partitions for fat objects. In *Proc. 3rd Annual European Symposium Algorithms*, volume 979 of *Lecture Notes in Computer Science*, pages 252–263. Springer-Verlag, New York, 1995.

[28] E. W. Dijkstra. A note on two problems in connexion with graphs. *Numerische Mathematik*, 1:269–271, 1959.

[29] D. P. Dobkin and D. G. Kirkpatrick. Fast detection of polyhedral intersection. *Theoretical Computer Science*, 27:241–253, 1983.

[30] D. P. Dobkin and D. G. Kirkpatrick. A linear algorithm for determining the separation of convex polyhedra. *Journal of Algorithms*, 6:381–392, 1985.

[31] D. P. Dobkin and D. G. Kirkpatrick. Determining the separation of preprocessed polyhedra—a unified approach. In *Proc. 17th International Colloquium on Automata, Languages and Programming (ICALP)*, volume 443 of *Lecture Notes in Computer Science*, pages 400–413. Springer-Verlag, New York, 1990.

[32] V. J. Duvanenko, W. E. Robbins, and R. S. Gyurcsik. Improving line segment clipping. *Dr. Dobb's Journal*, pages 36–45, July 1990.

[33] V. J. Duvanenko, W. E. Robbins, and R. S. Gyurcsik. Line-segment clipping revisited. *Dr. Dobb's Journal*, pages 107–110, Jan. 1996.

[34] M. E. Dyer. Linear time algorithms for two- and three-variable linear programs. *SIAM Journal on Computing*, 13:31–45, 1984.

[35] D. H. Eberly. *3D Game Engine Design: A Practical Approach to Real-Time Computer Graphics*. Morgan Kaufmann Publishers, San Francisco, 2001.

[36] D. H. Eberly. *Game Physics*. Morgan Kaufmann Publishers, San Francisco, 2002.

[37] J. Eckstein and E. Schömer. Dynamic collision detection in virtual reality applications. In *Proc. 7th International Conference in Central Europe on Computer Graphics and Visualization and Interactive Digital Media, WSCG '99*, pages 71–78, 1999.

[38] H. Edelsbrunner. *Algorithms in Combinatorial Geometry*, volume 10 of *EATCS Monographs on Theoretical Computer Science*. Springer-Verlag, New York, 1987.

[39] S. A. Ehmann. SWIFT—speedy walking via improved feature testing. *http://www.cs.unc.edu/~geom/SWIFT/*, 2000. Software library.

[40] S. A. Ehmann and M. C. Lin. Accelerated proximity queries between convex polyhedra by multi-level Voronoi marching. In *Proc. International Conference on Intelligent Robots and Systems*, 2000.

[41] S. A. Ehmann and M. C. Lin. Accurate and fast proximity queries between polyhedra using convex surface decomposition. In *Computer Graphics Forum (Proc. EUROGRAPHICS 2001)*, 2001.

[42] J. Fenlason and R. Stallman. *GNU gprof: The GNU Profiler*. Free Software Foundation, 1992.

[43] J. D. Foley, A. van Dam, S. K. Feiner, and J. F. Hughes. *Computer Graphics: Principles and Practice*. Addison-Wesley, Reading, MA, 2nd edition, 1990.

[44] B. Fomitchev. STLport. *http://www.stlport.org/*, 1999. Software library.

[45] A. U. Frank and R. Barrera. The Fieldtree: A data structure for geographic information systems. In A. Buchmann, O. Günther, T. R. Smith, and Y.-F. Wang, editors, *Proc. 1st Symposium SSD on Design and Implementation of Large Spatial Databases*, volume 409 of *Lecture Notes in Computing Science*, pages 29–44. Springer-Verlag, New York, 1990.

[46] H. Fuchs, Z. M. Kedem, and B. Naylor. On visible surface generation by a priori tree structures. In *Proc. SIGGRAPH '80*, volume 14, pages 124–133, 1980.

[47] K. Y. Fung, T. M. Nicholl, R. E. Tarjan, and C. J. Van Wyk. Simplified linear-time Jordan sorting and polygon clipping. *Information Processing Letters*, 35:85–92, 1990.

[48] M. A. Ganter and B. P. Isarankura. Dynamic collision detection using space partitioning. *Journal of Mechanical Design*, 115:150–155, 1993.

[49] A. Garcia-Alonso, N. Serrano, and J. Flaquer. Solving the collision detection problem. *IEEE Computer Graphics and Applications*, 14:36–43, 1994.

[50] E. G. Gilbert. An iterative procedure for computing the minimum of a quadratic form on a convex set. *SIAM Journal on Control*, 4:61–80, 1966.

[51] E. G. Gilbert and C.-P. Foo. Computing the distance between general convex objects in three-dimensional space. *IEEE Transactions on Robotics and Automation*, 6(1):53–61, 1990.

[52] E. G. Gilbert, D. W. Johnson, and S. S. Keerthi. A fast procedure for computing the distance between complex objects in three-dimensional space. *IEEE Journal of Robotics and Automation*, 4(2):193–203, 1988.

[53] A. S. Glassner. *An Introduction to Ray Tracing*. Academic Press, Boston, 1989.

[54] A. S. Glassner. Clipping a concave polygon. In A. W. Paeth, editor, *Graphics Gems V*, pages 50–54. Academic Press, Boston, 1995.

[55] D. Goldberg. What every computer scientist should know about floating-point arithmetic. *ACM Computing Surveys*, 23(1):5–48, 1991.

[56] G. H. Golub and C. F. Van Loan. *Matrix Computations*. Johns Hopkins University Press, Baltimore, MD, 3rd edition, 1996.

[57] M. Gomez. Compressed axis-aligned bounding box trees. In M. DeLoura, editor, *Game Programming Gems 2*, pages 388–393. Charles River Media, Hingham, MA, 2001.

[58] S. Gottschalk. RAPID: Robust and accurate polygon interference detection system. *http://www.cs.unc.edu/~geom/OBB/OBBT.html*, 1996. Software library.

[59] S. Gottschalk, M. C. Lin, and D. Manocha. OBBTree: A hierarchical structure for rapid interference detection. In *Proc. SIGGRAPH '96*, pages 171–180, 1996.

[60] D. Green and D. Hatch. Fast polygon-cube intersection testing. In A. W. Paeth, editor, *Graphics Gems V*, pages 375–379. Academic Press, Boston, 1995.

[61] B. Grünbaum. *Convex Polytopes*. Wiley, New York, 1967.

[62] L. J. Guibas, D. Hsu, and L. Zhang. H-walk: Hierarchical distance computation for moving convex bodies. In *Proc. 15th Annual ACM Symposium on Computational Geometry*, pages 265–273, 1999.

[63] J. K. Hahn. Realistic animation of rigid bodies. In *Proc. SIGGRAPH '88*, volume 22, pages 299–308, 1988.

[64] E. Haines. Point in polygon strategies. In P. Heckbert, editor, *Graphics Gems IV*, pages 24–46. Academic Press, Boston, 1994.

[65] Havok. Havok game dynamics sdk. *http://www.havok.com/*, 2000. Software library.

[66] M. Held. ERIT—A collection of efficient and reliable intersection tests. *Journal of Graphics Tools*, 2(4):25–44, 1997.

[67] K. Hoffmann, K. Mehlhorn, P. Rosenstiehl, and R. E. Tarjan. Sorting Jordan sequences in linear time using level-linked search trees. *Information and Control*, 68:170–184, 1986.

[68] M. Hohmeyer. LP, a C implementation of Seidel's randomized linear programming algorithm. *http://graphics.lcs.mit.edu/~seth/geomlib/geomlib.html*, 1990. Software library.

[69] J. E. Hopcroft, J. T. Schwartz, and M. Sharir. Efficient detection of intersections among spheres. *International Journal of Robotics Research*, 2(4):77–80, 1983.

[70] H. Hoppe. Progressive meshes. In *Proc. SIGGRAPH '96*, pages 99–108, 1996.

[71] P. M. Hubbard. Space-time bounds for collision detection. Technical Report CS-93-04, Dept. of Computer Science, Brown University, 1993.

[72] P. M. Hubbard. Collision detection for interactive graphics applications. *IEEE Transactions on Visualization and Computer Graphics*, 1(3):218–230, 1995.

[73] P. M. Hubbard. Approximating polyhedra with spheres for time-critical collision detection. *ACM Transactions on Graphics*, 15(3):179–210, 1996.

[74] L. Kettner. Designing a data structure for polyhedral surfaces. In *Proc. 14th Annual ACM Symposium on Computational Geometry*, pages 146–154, 1998.

[75] D.-J. Kim, L. J. Guibas, and S.-Y. Shin. Fast collision detection among multiple moving spheres. In *Proc. Computer Animation '97*, pages 1–7, 1997.

[76] J. T. Klosowski, M. Held, J. S. B. Mitchell, H. Sowizral, and K. Zikan. Efficient collision detection using bounding volume hierarchies of k-DOPs. *IEEE Transactions on Visualization and Computer Graphics*, 4(1):21–36, 1998.

[77] D. Knuth. *The Art of Computer Programming*. Addison-Wesley, Reading, MA, 1973.

[78] Y.-D. Liang and B. A. Barsky. A new concept and method for line clipping. *ACM Transactions on Graphics*, 3:1–22, 1984.

[79] M. C. Lin and J. F. Canny. A fast algorithm for incremental distance computation. In *Proc. IEEE International Conference on Robotics and Automation*, pages 1008–1014, 1991.

[80] T. Lozano-Pérez. Spatial planning: A configuration space approach. *IEEE Transactions on Computers*, C-32:108–120, 1983.

[81] D. G. Luenberger. *Linear and Nonlinear Programming*. Addison-Wesley, Reading, MA, 2nd edition, 1984.

[82] MathEngine. Karma. *http://www.mathengine.com/*, 2001. Software library.

[83] M. McLaurin. Outsourcing reality: Integrating a commercial physics engine. *Game Developer Magazine*, 9(8):40–46, August 2002.

[84] N. Megiddo. Linear-time algorithms for linear programming in R^3 and related problems. *SIAM Journal on Computing*, 12:759–776, 1983.

[85] K. Mehlhorn. *Data Structures and Algorithms 1: Sorting and Searching*, volume 1 of *EATCS Monographs on Theoretical Computer Science*. Springer-Verlag, New York, 1984.

[86] S. Melax. Dynamic plane shifting BSP traversal. In *Proc. Graphics Interface*, pages 213–220, May 2000.

[87] S. Meyers. *More Effective C++*. Professional Computing Series. Addison-Wesley, Reading, MA, 1996.

[88] B. Mirtich. V-Clip: Fast and robust polyhedral collision detection. *ACM Transactions on Graphics*, 17(3):177–208, 1997.

[89] T. Möller. A fast triangle-triangle intersection test. *Journal of Graphics Tools*, 2(2):25–30, 1997.

[90] T. Möller and B. Trumbore. Fast, minimum storage ray-triangle intersection. *Journal of Graphics Tools*, 2(1):21–28, 1997.

[91] M. Moore and J. Willhelms. Collision detection and response for computer animation. In *Proc. SIGGRAPH '88*, volume 22, pages 289–298, 1988.

[92] D. E. Muller and F. P. Preparata. Finding the intersection of two convex polyhedra. *Theoretical Computer Science*, 7:217–236, 1978.

[93] D. R. Musser and A. Saini. *STL Tutorial and Reference Guide*. Professional Computing Series. Addison-Wesley, Reading MA, 1996.

[94] A. Narkhede and D. Manocha. Fast polygon triangulation based on Seidel's algorithm. In A. W. Paeth, editor, *Graphics Gems V*, pages 394–397. Academic Press, Boston, 1995.

[95] B. F. Naylor. Interactive solid geometry via partitioning trees. In *Proc. Graphics Interface '92*, pages 11–18, 1992.

[96] B. Naylor. Constructing good partitioning trees. In *Proc. Graphics Interface '93*, pages 181–191, 1993.

[97] B. Naylor, J. A. Amanatides, and W. Thibault. Merging BSP trees yields polyhedral set operations. In *Proc. SIGGRAPH '90*, volume 24, pages 115–124, 1990.

[98] C. J. Ong and E. G. Gilbert. The Gilbert-Johnson-Keerthi distance algorithm: A fast version for incremental motions. In *Proc. IEEE International Conference on Robotics and Automation*, pages 1183–1189, 1997.

[99] C. J. Ong and E. G. Gilbert. Fast versions of the Gilbert-Johnson-Keerthi distance algorithm: Additional results and comparisions. *IEEE Transactions on Robotics and Automation*, 17(4):531–539, 2001.

[100] J. O'Rourke. *Art Gallery Theorems and Algorithms*. Oxford University Press, New York, 1987.

[101] J. O'Rourke. *Computational Geometry in C*. Cambridge University Press, New York, 2nd edition, 1998.

[102] I. J. Palmer and R. L. Grimsdale. Collision detection for animation using sphere-trees. *Computer Graphics Forum*, 14(2):105–116, 1995.

[103] M. S. Paterson and F. F. Yao. Efficient binary space partitions for hidden-surface removal and solid modeling. *Discrete and Computational Geometry*, 5:485–503, 1990.

[104] F. P. Preparata and M. I. Shamos. *Computational Geometry: An Introduction*. Springer-Verlag, New York, 1985.

[105] S. Redon, A. Kheddar, and S. Coquillart. Fast continuous collision detection between rigid bodies. In *Proc. EUROGRAPHICS 2002*, 2002.

[106] H. Samet. *The Design and Analysis of Spatial Data Structures*. Addison-Wesley, Reading, MA, 1990.

[107] P. J. Schneider and D. H. Eberly. *Geometric Tools for Computer Graphics*. Morgan Kaufmann Publishers, San Francisco, 2002.

[108] E. Schömer and C. Thiel. Efficient collision detection for moving polyhedra. In *Proc. 11th Annual ACM Symposium on Computational Geometry*, pages 51–60, 1995.

[109] R. Sedgewick. *Algorithms*. Addison-Wesley, Reading, MA, 2nd edition, 1988.

[110] R. Segura and F. Feito. Algorithms to test ray-triangle intersection: Comparative study. In *Proc. WSCG'01*, 2001.

[111] R. Seidel. Small-dimensional linear programming and convex hulls made easy. *Discrete and Computational Geometry*, 6:423–434, 1991.

[112] K. Shoemake. Animating rotations with quaternion curves. In *Proc. SIGGRAPH '85*, volume 19, pages 245–254, July 1985.

[113] K. Shoemake. Uniform random rotations. In D. Kirk, editor, *Graphics Gems III*, pages 124–132. Academic Press, Boston, 1992.

[114] H. W. Six and D. Wood. Counting and reporting intersections of *d*-ranges. *IEEE Transactions on Computers*, C-31:181–187, 1982.

[115] A. Smith, Y. Kitamura, H. Takemura, and F. Kishino. A simple and efficient method for accurate collision detection among deformable polyhedral objects in arbitrary motion. In *Proc. IEEE Virtual Reality Annual International Symposium*, pages 136–145, 1995.

[116] R. Smith. Open dynamics engine. *http://opende.sourceforge.net/*, 2001. Software library.

[117] J. M. Snyder. Interval analysis for computer graphics. In *Proc. SIGGRAPH '92*, volume 26, pages 121–130, 1992.

[118] J. Stolfi. *Oriented Projective Geometry: A Framework for Geometric Computations*. Academic Press, New York, 1991.

[119] D. Stoyan, W. S. Kendall, and J. Mecke. *Stochastic Geometry and Its Applications*. Wiley, Chichester, UK, 1987.

[120] B. Stroustrup. *The C++ Programming Language*. Addison-Wesley, Reading, MA, 3rd edition, 1997.

[121] I. E. Sutherland and G. W. Hodgman. Reentrant polygon clipping. *Communications of the ACM*, 17:32–42, 1974.

[122] I. E. Sutherland, R. F. Sproull, and R. A. Schumacker. A characterization of ten hidden-surface algorithms. *ACM Computing Surveys*, 6(1):1–55, 1974.

[123] F. Tampieri. Newell's method for computing the plane equation of a polygon. In D. Kirk, editor, *Graphics Gems III*, pages 231–232. Academic Press, Boston, 1992.

[124] P. Terdiman. Memory-optimized bounding-volume hierarchies. *http://codercorner.com/CodeArticles.htm*, Mar. 2001.

[125] W. C. Thibault and B. F. Naylor. Set operations on polyhedra using binary space partitioning trees. In *Proc. SIGGRAPH '87*, volume 21, pages 153–162, 1987.

[126] F. Thomas and C. Torras. Interference detection between non-convex polyhedra revisited with a practical aim. In *Proc. IEEE International Conference on Robotics and Automation*, pages 587–594, 1994.

[127] G. van den Bergen. Efficient collision detection of complex deformable models using AABB trees. *Journal of Graphics Tools*, 2(4): 1–14, 1997.

[128] G. van den Bergen. A fast and robust GJK implementation for collision detection of convex objects. *Journal of Graphics Tools*, 4(2):7–25, 1999.

[129] D. Voorhies. Triangle-cube intersection. In D. Kirk, editor, *Graphics Gems III*, pages 236–239. Academic Press, Boston, 1992.

[130] R. Webb and M. Gigante. Using dynamic bounding volume hierarchies to improve efficiency of rigid body simulations. In T. L. Kunii, editor, *Visual Computing (Proc. CG International '92)*, pages 825–842. Springer-Verlag, New York, 1992.

[131] H. Weghorst, G. Hooper, and D. P. Greenberg. Improved computational methods for ray tracing. *ACM Transactions on Graphics*, 3(1):52–69, 1994.

[132] E. Welzl. Smallest enclosing disks (balls and ellipsoids). In H. Maurer, editor, *New Results and New Trends in Computer Science*, volume 555 of *Lecture Notes in Computer Science*, pages 359–370. Springer-Verlag, New York, 1991.

[133] M. Woo, J. Neider, and T. Davis. *OpenGL Programming Guide*. Addison-Wesley, Reading, MA, 2nd edition, 1997.

[134] X. Wu. A linear-time simple bounding volume algorithm. In D. Kirk, editor, *Graphics Gems III*, pages 301–306. Academic Press, Boston, 1992.

[135] G. Zachmann. Rapid collision detection by dynamically aligned DOP-trees. In *Proc. IEEE Virtual Reality Annual International Symposium*, pages 90–97, 1998.

[136] G. Zachmann. *Virtual Reality in Assembly Simulation: Collision Detection, Simulation Algorithms, and Interaction Techniques*. PhD thesis, Dept. of Computer Science, TU Darmstadt, 2000.

[137] G. Zachmann and W. Felger. The BoxTree: Enabling real-time and exact collision detection of arbitrary polyhedra. In *Proc. Workshop on Simulation and Interaction in Virtual Environments*, pages 104–113, 1995.

[138] M. J. Zyda, D. R. Pratt, W. D. Osborne, and J. G. Monahan. NPSNET: Real-time collision detection and response. *Journal of Visualization and Computer Animation*, 4(1):13–24, 1993.

Index

A

AABB *see* axis-aligned bounding box (AABB)

affine combination, 15, 127, 129

affine hull, 15, 126

affine set, 15

 dimension, 15

affine spaces, 14–17

affine transformation, 15–16, 19–21, 40, 130, 233, 247

 angle-preserving, 20

 composition, 16

 group of, 20

 length-preserving, 19

 support mapping, 137–138

affinely independent, 15

affinely independent triangles, 162

algorithm table, 239

algorithms

 crossings test, 90

 Dijkstra's shortest path algorithm, 150

 distance computation, 120

 feature-walking, 6

 finite-precision, 64

 future work, 253–255

 geometric, 64

 Johnson's, 97, 126–130, 139–144

 line segment–sphere test, 71–72

 nonconvex polygons, 95

 polytopes, 108–121

 randomized linear-programming, 120

 rasterization, 31

 ray-box test, 75

 ray cast, 70–71

 ray-triangle test, 85–86

 recursive, solid-leaf BSP tree, 182

 recursive flood-fill, for retrieving silhouette, 156–157

 single-shot, 106

 SOLID, 237–41

 sweep-and-prune, 210–215, 237

 unstable, 60–62

 weakly separating plane, 115

 see also CW algorithm; EPA algorithm; GJK algorithm; ISA-GJK algorithm; LC algorithm; LP algorithm; V-Clip algorithm

angle between two nonzero vectors, 17

angle-preserving transformations, 20

angular degrees of freedom, 189

animation, 2, 6, 41–46

API *see* application program interface (API)

application program interface (API), 219, 237

arithmetic operations, 60

automation, 5

autopartitioning, 180, 182

avatar, 67

average time, 56–57

AVL tree, 210

axis, 18

axis-aligned bounding box (AABB), 7, 29, 72–73, 193–195

 and ray casting, 215–217

 overlapping, 210

 overlapping pairs, 209

axis-aligned bounding box (AABB) trees, 199, 232, 253

 and deformable models, 206–207

 intersection testing, 203

 refitting, 207–208

axis-aligned bounding box (AABB)
 trees *(continued)*
 SOLID, 238
 versus OBB trees, 201–206

B

balanced binary-search tree, 210
barycentric coordinates, 84, 97–98
basic primitives, 67–104
basis, 13
binary space partitioning (BSP), 5, 7,
 172
binary space partitioning (BSP)
 trees, 180
 merging, 189–190
 number of nodes, 182
 offset-surface, 186
binary space partitioning (BSP) trees
 and collision detection,
 184–189
boundary representation, 24–26
bounded, 22
bounding spheres, 193–194, 198
bounding volume, 55
bounding volumes, 193–199
 average time formula, 198
 case study, 196–199
 comparison of types, 196
 convex hulls as, 254
 desired properties, 193
 types, 193
 types for tree structures, 7
bounding-volume hierarchies,
 199–201, 254
 storage overhead, 253
box, 4, 28
 projection interval, 79
 support mapping, 135
box-box test, 82–83
box coordinates, 210
box structures
 indexing endpoints, 215
 sweep-and-prune algorithm,
 214–215
BoxTree, 179
broad phase, 56, 209–217, 252–253

speeding up, 237
BSP *see* binary space partitioning
 (BSP); solid-leaf BSP tree
bullet-wall problem, 48

C

caching, 140
caching overhead, 139
callback functions, 226–227
cancellation, 60
Cartesian system, 18, 40
 right-handed, 21
CD-ROM, 65
cell indices, 175
cells, 175–176
client, 219
closed, 22
closed halfspaces, 18, 110
closest axis to the plane normal, 89
closest features of convex polyhedra,
 116
closest point query, 107
closest points
 of a pair of objects, 234
 of two convex objects, 106–107
cofactor, 14
cofactor expansion, 14, 127–128
Cohen-Sutherland (CS) line clipper,
 73–74
collinear line segments, intersection
 of two sequences, 96–97
collision, 1
 definition, 1–2
collision detection
 cost of, 252
 reason for performing, 2
 speeding up, 191, 206
collision detection methods, state of
 the art, 251–253
collision response, 49–53
commands, 222
common point detection, 108–110
common point query, 107
common points, 106
complex shapes, 4, 84, 240
 and scenes, 38–41

complex vertices, 133
compound shapes, 4
computational geometry, 5
computed signed distance, 62
computer animation *see* animation
concave object, 22
concave polygons, 32
cone, 4, 33
 support mapping, 135–136
configuration of objects, 2
configuration space obstacle (CSO),
 35–40, 48, 50, 68–69, 78, 81,
 115–116, 138, 143, 151–153,
 164, 168, 184–185, 187, 255
conjugate, 44
constructive solid geometry (CSG),
 39, 253
contact normal, 49–52
contact plane, 50
contact point, 49–51
contact region, 50
continuous four-dimensional
 space-time collision detection,
 255
convergence, 123–126
convex combination, 23, 126
convex decomposition, 172–173, 252
convex hulls, 4, 23, 130, 155, 243
 as bounding volumes, 254
 computation, 133
 cost of overlap testing, 254
 support mapping, 138–139
convex objects, 22–23, 38, 105–169
 extrusions, 186
 first time of impact, 188–189
 Minkowski sums of, 255
convex polygons, 32
convex polyhedra, 4, 242
 distance computation algorithms
 for, 120
convex polytopes, 4
convex shapes, 240
convexity, 4
coordinate system
 multiple, 15
 origin of, 15–16
 parent, 15–16

right-handed, 21
 world, 16
coordinates, 15
cost values, 56–57
Cramer's rule, 13–14, 85, 99, 127, 162
cross product, 21–22
 properties, 22
crossings test, algorithm, 90
CSO *see* configuration space obstacle
 (CSO)
cube size, 197
CW algorithm, 111–114
cylinder, 4, 33
 support mapping, 136

D

DAG *see* directed acyclic graph (DAG)
DCEL *see* doubly connected edge list
 (DCEL)
3D-DDA, 216
deformable models, 206–209
deformation, 41
degrees of freedom (DOF), 41–42, 48
 angular, 189
determinant function, 14
Dijkstra's shortest path algorithm,
 150
dimension, 13
dimension of an affine set, 15
directed acyclic graph (DAG), 39, 191
direction, 18
discrete-orientation BSP (DOBSP)
 tree, 180, 192
discrete-orientation polytopes (DOP),
 7, 23, 28, 193–195
discrete time steps, 47
distance between two objects, 36
distance between two points, 17
distance computation, 115–121
distance computation algorithms for
 convex polyhedra, 120
Dobkin-Kirkpatrick algorithm, 120
Dobkin-Kirkpatrick hierarchical
 representation, 27, 120, 131
DOBSP *see* discrete-orientation BSP
 (DOBSP) tree

DOF *see* degrees of freedom (DOF)
DOP *see* discrete-orientation
polytopes (DOP)
dot product, 17
double dispatch, 239
doubly connected edge list (DCEL),
25, 108
dynamic axis-aligned bounding box
(AABB), 198–199
dynamic plane-shifting BSP
traversal, 186–187
dynamic plane-shifting technique,
186
dynamic type of an object, 240

E

edge-box intersection test, 104
edge determinants, 100
edge directions, 78
edge nodes, 25–26
edges, 29
Elite, 5–6
ellipsoids, 4
encapsulation, 49
encounters, 244–245
endpoints, incrementally sorting,
211
entering intersection point, 74
EPA algorithm, 148–151, 159, 166
in 2D, 151–152
in 3D, 157–158, 165
initial polytope, 159
numerical aspects, 162–165
termination, 163–164
Euclidean space, 17–18
Euler angles, 42–44, 46
Euler parameters, 45
Euler's formula, 25
exact signed distance, 62
exiting intersection point, 74
exponent, 58

F

face, 24

facet orientations, 78
feasibility test, 109
feature of a polytope, 24
feature-walking, 133
feature-walking algorithm, 6
fieldtree, 190–191
3D, 192
generalization to
three-dimensional space, 191
FIFO (first-in-first-out) queue, 152
finite-precision algorithm, 64
fixed-orientation objects, 50
fixed-size axis-aligned bounding box
(AABB), 198–199
floating-point numbers, 57–60, 62–65
floating-point operations, 63
four-dimensional intersection
detection problem, 47
four-dimensional intersection test,
49, 68–69
four-dimensional space, 46
frame coherence, 54, 106, 114
function composition, 16
function objects, 245

G

geographic information systems
(GIS), 190
geometric algorithms, 64
geometric coherence, 54–55, 171,
182, 252
geometry, 11–22
notational conventions, 11–12
Gilbert-Johnson-Keerthi (GJK)
algorithm *see* GJK algorithm
GJK algorithm, 4, 97, 111, 114,
121–169, 242, 252
implementation, 139–141
incremental version, 132
numerical aspects, 141–145
overview, 121–123
reasons for selecting, 121
separating-axis algorithm, 146
termination, 123–126, 142–143,
151–152, 162–164
global convergence, 124

GMP *see* GNU Multiple Precision Arithmetic Library (GMP)
GNU Multiple Precision Arithmetic Library (GMP), 62
gprof, 57
grouping node, 40

H

halfedge structure, 26
halfspace representation, 27–29
hexahedron, 160–161
hierarchical data structures, 7
hill climbing, 132, 134
hyperplane, 18
 orientation of, 18

I

I-COLLIDE, 116, 120
identity, 12
IEEE Standard 754, 58, 60–61, 143
iff, 12
ill-conditioned, 143
ill-conditioned error bounds, 143–145
ill-conditioning, 163
implicit surfaces, 253
impulse-based methods, 52
incremental separating-axis GJK algorithm *see* ISA-GJK algorithm
infimum, 36
initialization, 158–161
insertion sort, 210
instantaneous orientation changes, 49
interactive 3D applications, 3
 historical background, 5
interactive 3D media, 63
internal nodes, 39–40
intersecting pairs among set of moving objects, 191–192
intersecting pairs of primitives of two complex shapes composed of thousands of primitives, 253

intersecting primitives between pair of complex models, 192
intersection query, 56
intersection testing, 145–147
 for nonconvex polygons, 97
interval tree, 190
ISA-GJK algorithm, 146–147, 166, 168, 226, 240–241, 243

J

Johnson's algorithm, 97, 126–130, 139–144
Jordan curve, 94
Jordan sorting, 94–95

K

k-d tree, 177–180, 192
k-DOP tree, 83, 199
Kronecker symbol, 12

L

LC algorithm, 116–117, 146, 252
length of a vector, 17
length-preserving transformations, 19–20
Liang-Barsky (LB) line clipper, 73–74
LIFO (last-in-first-out) queue, 152
Lin-Canny (LC) algorithm *see* LC algorithm
line segment, 4, 159–160
line segment–box test, 80–81
line segment–sphere test, 71–72
 algorithm, 72
line segment–triangle test, 79, 87–88
linear combination, 12–14
linear programming (LP), 108–110
linear transformation, 13
linearly independent, 13
local coordinate system, 39–40
local minimum condition, 119
LP algorithm, 114

M

machine epsilon, 59
mailboxing, 176
mantissa, 58
margin of an object, 225
matrix notation, 12
memory usage, 53
Mercator projection, 42–43
mesh representations, storage usage
 for, 254
Minkowski addition, 33–37, 225, 243
Minkowski sum, 4, 33, 47, 52, 130,
 166
 of convex objects, 255
 support mapping, 138
model partitioning, 7, 192–209
motion, 2
moving objects, 3
multilayered vertex adjacency graph,
 131, 133–135
multiple cells, 190
multiple coordinate system, 15
multiset, 215

N

naive split, 153
narrow phase, 48, 56
Newell's method, 31
noncommutative product rule, 44
nonconvex polygons, 32, 93
 algorithm, 95
 intersection test for, 97
nonconvex polyhedra, 172
 axis-aligned bounding box
 (AABB), 195
 handled as polyhedral surfaces,
 174
nonintersecting convex objects, 106
nonintersecting polytopes, 78
nonsingular, 12
nonuniform scalings, 20–21
norm of a quaternion, 44
normal, 18
normalization, 18
numerical problems, 62–65

O

OBB *see* oriented bounding box
 (OBB)
objects, 22–41
 definition, 22–23
octrees, 177–180, 192
offset, 18
offset surfaces, 185–186
 BSP tree, 186
 support mappings, 185–186
OMT diagram, class hierarchy of
 shape types, 241
OPCODE collision library for
 triangle meshes, 200
open halfspaces, 18
OpenGL, 31, 224, 230, 234–235, 247
orientation of hyperplane, 18
oriented bounding box (OBB), 193,
 195–199
oriented bounding box (OBB) trees,
 199, 231–232, 253
 future work, 254
 intersection testing, 203
 rebuilding, 209
 versus axis-aligned bounding box
 (AABB) trees, 201–206
oriented boxes, 7
origin of coordinate system, 15–16
orthogonal, 17, 19, 21
orthonormal, 18
outcode, 6-bit, 73
overflow, 58

P

pair of closest points, 51–52
parallelepiped, 28
parametric curves, 255
parametric surfaces, 253
parent coordinate system, 15–16
partitioning coordinate, 202
partitioning methods, 172–173
 see also model partitioning; space
 partitioning
partitioning plane, 182–183, 185
penalty-based methods, 52

penetration depth, 36, 68, 77, 147–169
 candidates for, 163
 computation, 115–121
 hybrid technique, 166–169
 objects enlarged by a margin, 169
penetration depth vector, 52–53, 151
performance improvements, 140
performance of collision detection, 53–57
physics-based simulation, 53, 252
pitch, 42–43
placement change, 41
planar graph, 25
plane, 18
Plücker coordinates, 87–88
point in nonconvex polyhedron, 174–175
point-in-polygon test, 103, 174
point-in-polyhedron test, 174, 184
points, 14
polygon, 29–32, 84–104
 BSP tree representation, 181
 definition, 29
 ray-triangle test, 84–86
 simple, 29
polygon-box test, 103–104
polygon-polygon test, 92–97
polygon soups, 39, 174
polygon-sphere test, 102–103
polygon-volume test, 101–104
polyhedra, 108
 BSP tree representations, 189–190
polyhedral cone, 132
polyhedral meshes, 172, 182
polyhedral surfaces, 173–174, 255
 decomposing, 252
polytope soup, 224, 238–240
polytopes, 23–29
 algorithms, 108–121
 expanding in 3D, 152–158
 sum of, 34
 support mappings, 131–136
 three-dimensional, 153
 vertices of, 24
positive integer ID, 176–177
positively oriented, 21

power-set, 12
precision, 62–63, 140
primitive, positive, 202
primitive operations, 57
primitive shapes, 23
primitives, 23
 taxonomy, 24
priority queue, 151
probability values, 57
progressive mesh, 254
 representations for smooth level of detail, 254
proximity queries, 105–107
 types considered, 105
Pythagorean theorem, 70

Q

quadrics, 32
quadtree, 190
Quake, 7, 186
quaternions, 44–46
query object, 179, 186
query point, 89
Quickhull alogrithm, 26

R

randomized linear-programming algorithm, 120
range query, computational cost, 190
RAPID, 82, 203
rasterization algorithms, 31
ray-box test, 73–75
 algorithm, 75
ray cast, 48, 69
 algorithm, 70–71
ray casting and AABBs, 215–217
ray-polygon test, 88–90
ray-sphere test, 68–71, 102
ray test, 50
ray-triangle test
 algorithm, 85–86
 polygons, 84–86
real-life simulation, 64
real-time constraint, 53

real-time response, 53
recursive defintion, 129
recursive flood-fill algorithm for
 retrieving silhouette, 156–157
recursive hierarchical space
 partitioning structures, 181
recursive space partitioning trees,
 190
red-black tree, 210
reflection, 19
reflex edge, 154
relative error tolerance, 163
response, 49–53
response callbacks, 236
response class, 227
response data, 2
rhombic dodecahedron, 81
rigid body, 41
rigid motion, 19, 41
robotics, 5
robustness, 57–65
roll, 42–43
rotations, 19, 21
run-time type identification (RTTI),
 240

s

SAT *see* separating-axes test
SAT lite, 205–206
scalars, 12, 57
scene graph, 39, 41
segment clipping, 73
separability degree, 55
separating axes, 54, 77–80, 106,
 146
 weakly, 111
separating-axes query, 107
separating-axes test (SAT), 78–83, 90,
 104, 203, 205
separating plane, 54, 106, 110–114
 weakly, 110
shape types, 4
signed distance, 18
silhouette, recursive flood-fill
 algorithm for retrieving,
 156–157

simplex, 24
single-shot algorithms, 106
singular, 12
singularities, 42
skin-bone technique, 52
slab, 28
software library, 222
SOLID, 219–249
 algorithms, 237–241
 axis-aligned bounding box (AABB)
 tree, 238
 basic shape types, 240
 bounding-volume hierarchies,
 231
 caches, 226
 class hierarchy of shape types, 241
 command categories, 222
 contact data for resolving
 collisions in physics-based
 simulation, 243
 container types, 246
 design constraints, 221–222
 design decisions, 228–241
 design requirements, 219–222
 development, 251
 environment simulation
 architectures, 230
 evaluation, 242–244
 frame coherence, 234
 framework, 224
 goals attained, 242
 implementation details, 244
 motion specification, 233–235
 multiple callbacks, 237
 multiple response tables, 237
 multiple responses, 236
 multiuser applications, 230
 object placements, 234
 overview, 222–228
 performance, 244
 response data, 226–228
 response handling, 235–237
 shape deformations, 231
 shape representations, 228–233
 shape types supported by,
 223–224
 single-user applications, 230

solid-leaf BSP tree, 180, 184
 construction, 180–183
 recursive algorithm, 182
space partitioning, 175–192
 drawback of methods, 190
 into rectangular cells, 178
space-time interference checking, 5
span of a set of vectors, 13
spatial coherence, 3
spatial data structures, 171–217
special orthogonal, 19
sphere, 4, 8, 32–33, 67–72
 support mapping, 135
 support mapping for convex hull,
 139
sphere-box test, 76–77
sphere-OBB test, 199
sphere-sphere test, 67–68
sphere trees, 199
splitting triangles, 153–154
square matrix, 12
stabbing number, 213–214
stability, 60–62
standard basis, 17
Standard Template Library (STL),
 151, 213, 244–248
standard (world) coordinate system,
 195
static objects, 3–4
stochastic geometry, 57
storage usage for mesh
 representations, 254
support mapping, 111, 122, 130–139,
 158, 238
 affine transformation, 137–138
 box, 135
 cone, 135–136
 convex hull, 138–139
 cylinder, 136
 Minkowski sum, 138
 offset surfaces, 185–186
 polytopes, 131–136
 sphere, 135
support plane, 123, 162
support point, 111, 122, 131,
 138–139, 153–154, 160, 163
 computation, 241

computing, 132, 134
 two-phase procedure, 134
supporting plane, 97, 101
sweep-and-prune algorithm,
 210–215, 237
 box structure, 214–215
 insertions and deletions, 213
swept volumes, 35
SWIFT library, 120

T

temporal coherence, 3, 6
termination, 123–126, 142–143,
 151–152, 162–164
 EPA, 163–164
tetrahedron, testing for containment
 of the origin, 161
three-dimensional polytope, 153
three-dimensional space, 21–22
time, 46–48
time constraint, 56
time of collision, 50
torus
 bounding volume, 196–199
 intersection test, 197
transform node, 40
translations, 19, 21
transpose, 12
tree structures, bounding-volume
 types for, 7
triangle, 4
 falsely accepted, 162
 falsely rejected, 162
triangle-box test, 81–82, 200
triangle edges, indexing, 155
triangle entry, 155, 157–158, 160
triangle inequality, 125
triangle-sphere test, 97–101
triangle-triangle test, 79, 90–91
triple product, 22

U

underflow, 58
uniform scalings, 20
unstable algorithms, 60–62

V

V-Clip algorithm, 120
vector components, 13
vector differences, 140
vector space, 12–14
 basis, 13
 dimension, 13
vectors, 12
vertex adjacency graph, 26, 132–133
vertex array, 230–231
vertex containment test, 102–103
vertex degree, 25
vertex depth, 134
vertices, 29
 of a polytope, 24
video games, 5
virtual reality, 1
volume-primitive tests, 200
Voronoi regions, 116–119
voxel grid, 175–177, 191–192
VRML, 220, 242, 251
VRML97, 23, 32, 40

W

weakly separating axis, 111, 113
weakly separating plane, 110
weakly separating plane algorithms, 115
winged-edge structure, 25–26
winged-type boundary representations, 26
witness, 54
witness points, 68, 76–77
world coordinate system, 16, 237

Y

yaw, 42–43

Z

zero vector, 12

About the CD-ROM

The accompanying CD-ROM contains source code and demos that demonstrate the techniques described in this book. The source code has been tested to compile on Linux IA32 and Win32 platforms, but will probably compile on other platforms without problems. Please refer to the website http://www.dtecta.com for errata and updates.

Contents

- solid-3.5: The SOLID version 3.5 source code, documentation, and demos. See the doc directory for documentation in HTML and PDF formats. This open-source edition of SOLID version 3 is released under the terms of either the GNU Public License (GPL) or the Q Public License (QPL). This means that for software created with SOLID version 3 you must comply with the terms of one of these licenses. You may choose which of these licenses best suits your purpose. See the following files contained in this distribution for a complete list of terms and conditions of these licenses.

 LICENSE_QPL.txt The Q Public License
 LICENSE_GPL.txt The GNU General Public License

- qhull2002.1: The Qhull library is Copyright 1993 by The Geometry Center of the University of Minnesota. Qhull is used in SOLID for convex hull computations. On Linux platforms Qhull needs to be installed in a directory that is included in the compiler's search path. Under Visual C++ development, Qhull is incorporated in the solid.dsw workspace file, and does not need to be installed separately.

- glut-3.7.6-bin: Win32 run-time libraries for GLUT 3.7.6 by Nate Robins. GLUT is a utility toolkit for creating OpenGL applications. The original source code for GLUT is Copyright 1997 by Mark J. Kilgard. GLUT for Win32 is Copyright 1997 by Nate Robins. You need to install the GLUT run-time library on Win32 if you want to build the demos in the SOLID distribution that utilize OpenGL. See the file README-Win32.txt in the GLUT directory for details on how to install the GLUT SDK under Visual C++.

Trademarks

The following trademarks, mentioned in this book and the accompanying CD-ROM, are property of the following organizations.

- AMD Athlon is a trademark of Advanced Micro Devices, Inc.
- Linux is a trademark of Linus Torvalds
- OpenGL is a trademark of Silicon Graphics, Inc.
- Quake is a trademark of Id Software, Inc.
- Visual C++ is a trademark of Microsoft Corporation

Algorithms on the CD-ROM

All implementations of algorithms described in this book that are used in SOLID can be found in the solid-3.5/src directory. The code in the root of the src directory is needed for memory management, management of response related data, and generally tying things together. The more interesting code for the reader is found in the three subdirectories of the src directory. The subdirectory broad contains all code for the broad phase of SOLID. The subdirectory complex contains code that is related to algorithms for constructing and querying AABB trees. Finally, the convex subdirectory contains code for doing primitive-primitive tests. The following list links the algorithms described in the text to the SOLID C++ source files on the accompanying CD-ROM.

Chapter 3

Section	Algorithm	Files
3.1.2	Ray-Sphere (Algorithm 3.1)	convex/DT_Sphere.cpp
3.2.1	Ray-Box (Algorithm 3.3)	convex/DT_Box.cpp
3.3.1	Line Segment-Box SAT	complex/DT_CBox.h
3.3.3	Box-Box SAT	complex/DT_BBoxTree.h
3.4.1	Ray-Triangle (Algorithm 3.4)	convex/DT_Triangle.cpp

Chapter 4

Section	Algorithm	Files
4.3.3	Johnson's algorithm	convex/DT_GJK.h
4.3.4	Support mappings	convex/DT_Box.cpp
		convex/DT_Cone.cpp
		convex/DT_Cylinder.cpp
		convex/DT_LineSegment.cpp
		convex/DT_Point.cpp
		convex/DT_Polyhedron.cpp
		convex/DT_Polytope.cpp

Section	Algorithm	Files
		convex/DT_Sphere.cpp
		convex/DT_Triangle.cpp
		convex/DT_Hull.h
		convex/DT_Minkowski.h
		convex/DT_Transform.h
4.3.6	GJK (Algorithm 4.4)	convex/DT_Convex.cpp
4.3.7	ISA-GJK (Algorithm 4.5)	convex/DT_Convex.cpp
4.3.8	EPA (Algorithm 4.10)	convex/DT_PenDepth.cpp
4.3.8	Hybrid (Algorithm 4.11)	convex/DT_Convex.cpp

Chapter 5

Section	Algorithm	Files
5.3.3	AABB tree	convex/DT_BBoxTree.cpp
		convex/DT_BBoxTree.h
5.4	Sweep and Prune	broad/BP_*.cpp
		broad/BP_*.h

Glossary of Notation

\mathbb{R}	set of scalars (real numbers)		
$\alpha, \beta, \gamma, \ldots$	scalars		
\mathbb{R}^d	set of d-dimensional tuples of scalars		
$\mathbf{a}, \mathbf{b}, \mathbf{c}, \ldots$	tuples of scalars (vectors, points, quaternions)		
$\mathbf{0}$	zero vector		
\mathbf{e}_i	ith vector of the standard basis		
$\mathbf{v} \cdot \mathbf{w}, \mathbf{v} \times \mathbf{w}$	dot and cross product of vectors \mathbf{v} and \mathbf{w}		
$\|\mathbf{v}\|, \|\mathbf{v}\|^2$	length and squared length of vector \mathbf{v}		
$\mathbf{A}, \mathbf{B}, \mathbf{C}, \ldots$	matrices over \mathbb{R}		
$[\alpha_{ij}]$	matrix with element α_{ij} in the ith row and jth column		
$[\mathbf{v}_i]$	matrix with vector \mathbf{v}_i as ith column		
$\mathbf{A}^\mathrm{T}, \mathbf{A}^{-1}$	transpose and inverse of matrix \mathbf{A}		
\mathbf{I}	identity matrix		
$\det(\mathbf{A})$	determinant of matrix \mathbf{A}		
A, B, C, \ldots	point sets (objects, planes), predicates		
$\{\mathbf{x}_i\}$	set of points \mathbf{x}_i		
$\{\mathbf{x} : P(\mathbf{x})\}$	set of points for which predicate $P(\mathbf{x})$ holds		
\emptyset	empty set		
$A \cup B, A \cap B, A \backslash B$	union, intersection, and set difference of sets A and B		
$A \subseteq B$	A is a subset of B and is possibly equal to B		
$	A	$	number of elements in set A
$A + B, A - B$	Minkowski sum and CSO of objects A and B		
$[\alpha, \beta]$	interval of \mathbb{R} containing all γ for which $\alpha \leq \gamma \leq \beta$		
$P \equiv Q$	predicates P and Q are equivalent		
$f \circ g$	function composition operator ($f \circ g(\mathbf{x}) = f(g(\mathbf{x}))$)		
$f(n) = O(g(n))$	constants k and c exist such that $f(n) \leq cg(n)$ for all $n \geq k$		
$f(n) = \Omega(g(n))$	constants k and c exist such that $f(n) \geq cg(n)$ for all $n \geq k$		
$\mathrm{aff}(A), \mathrm{conv}(A)$	affine and convex hull of point set A		
$\mathrm{vert}(P)$	the set of vertices of polytope P		
$\mathrm{adj}(\mathbf{p}), \mathrm{deg}(\mathbf{p})$	set and number of adjacent vertices of vertex \mathbf{p}		